Elusive Birds of the Tropical Understory

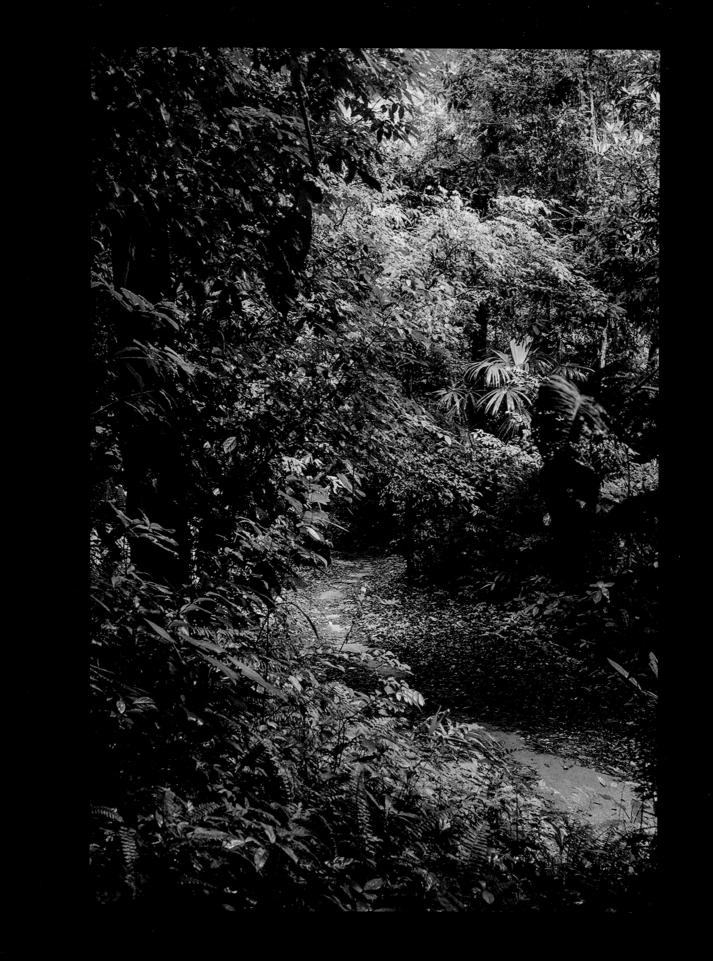

Elusive Birds of the Tropical Understory

Edited by

JOHN P. WHITELAW, JEFFREY D. BRAWN,
HENRY S. POLLOCK & JOHN W. FITZPATRICK

Photographs by John P. Whitelaw

Foreword by Victor Emanuel
Afterword by John Kricher

Comstock Publishing Associates
an imprint of
Cornell University Press
Ithaca and London

First published 2022 by Cornell University Press
Printed in China

Library of Congress Cataloging-in-Publication Data
Names: Whitelaw, John P., 1943– editor. | Brawn, Jeffrey D., editor.
 | Pollock, Henry S., 1986– editor. | Fitzpatrick, John W., editor.
Title: Elusive birds of the tropical understory / edited by John P. Whitelaw,
 Jeffrey D. Brawn, Henry S. Pollock & John W. Fitzpatrick.
Description: Ithaca [New York : Comstock Publishing Associates,
 an imprint of Cornell University Press, 2022. | Includes bibliographical
 references and index.
Identifiers: LCCN 2021039831 | ISBN 9781501759468 (hardcover)
Subjects: LCSH: Forest birds—Tropics. | Forest birds—Tropics—
 Pictorial works. | LCGFT: Essays.
Classification: LCC QL695.5 .E48 2022 | DDC 338.1/7268—dc23
LC record available at https://lccn.loc.gov/2021039831

Design and composition by Chris Crochetière, BW&A Books, Inc.

For Christine Whitelaw, who was the catalyst and linchpin for this book in so many ways.
—JOHN P. WHITELAW

For Orrin M. Brawn, who, given the chance, would have been a heck of a scientist, and for Marilyn O'Hara, who was a heck of a scientist.
—JEFFREY D. BRAWN

For my parents Michael and Renee Pollock, who convinced me I could do anything I wanted and always supported me along the way.
—HENRY S. POLLOCK

For our great friend and pioneering tropical biologist, the late Russ Greenberg, who discovered many secrets about the lives of understory birds that are featured in this book.
—JOHN W. FITZPATRICK

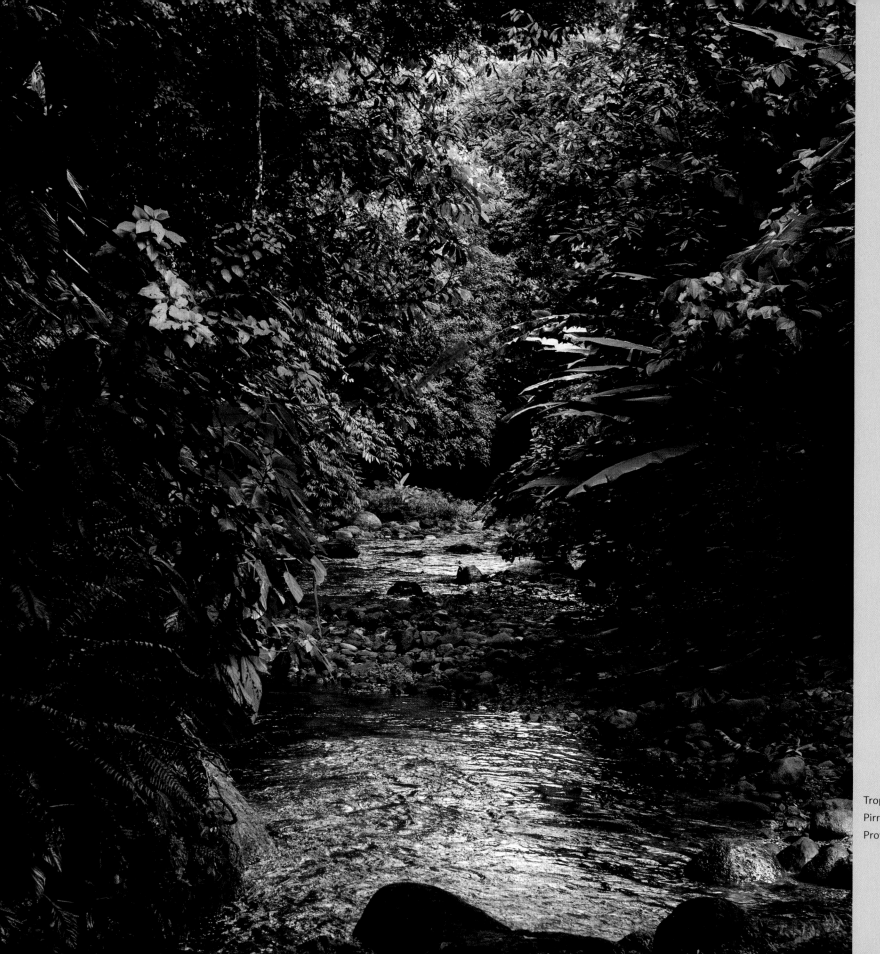

Tropical forest understory,
Pirres River, Darién
Province, Panama

Contents

Foreword by Victor Emanuel viii

Preface ix

Acknowledgments xii

Introduction | Jeffrey D. Brawn and John W. Fitzpatrick 1

Challenges to Biodiversity Conservation in Panama |
 Samuel Valdés Díaz 9

Portraits in Words and Pictures 13

Ruddy Quail-Dove | Scott Robinson 15

White-tipped Sicklebill | Christoph Hinkelmann 16

Band-tailed Barbthroat | Christoph Hinkelmann 19

Green Hermit | Christoph Hinkelmann 20

Long-billed Hermit | Jay J. Falk 23

White-whiskered Puffbird | John P. Whitelaw 24

Golden-olive Woodpecker | John P. Whitelaw 27

Black-crowned Antshrike | Corey E. Tarwater 28

Russet Antshrike | Phred M. Benham 32

Checker-throated Stipplethroat | John W. Fitzpatrick 35

White-flanked Antwren | Scott Robinson 38

Chestnut-backed Antbird | Thomas W. Sherry
 and Deborah Visco 42

Bicolored Antbird | Jeffrey D. Brawn 46

Spotted Antbird | J. Patrick Kelley 50

Ocellated Antbird | Henry S. Pollock 53

Black-faced Antthrush | Henry S. Pollock 57

Plain-brown Woodcreeper | Henry S. Pollock
 and Jeffrey D. Brawn 58

Cocoa Woodcreeper | Jeffrey D. Brawn 61

Plain Xenops | Phred M. Benham 62

Buff-throated Foliage-gleaner | Jared Wolfe 65

Ruddy-tailed Flycatcher | Thomas W. Sherry 66

Ants and Ant Followers | John P. Whitelaw 69

Sulphur-rumped Flycatcher | Thomas W. Sherry 73

Golden-crowned Spadebill | John P. Whitelaw and excerpts
 from the work of Alexander F. Skutch 77

Olive-striped Flycatcher | Scott Robinson 78

Ochre-bellied Flycatcher | John W. Fitzpatrick 81

Avian Malaria in the Forest Understory | Emma I. Young 83

Scale-crested Pygmy-Tyrant | John W. Fitzpatrick 84

Eye-ringed Flatbill | Jared Wolfe 89

Olivaceous Flatbill | J. Patrick Kelley 90

Yellow-breasted Flycatcher | John P. Whitelaw 93

Southern Bentbill | Thomas W. Sherry 94

Ectoparasites on Panamanian Birds | Sergio E. Bermúdez
 Castillero 97

Mountain Elaenia | Peter A. Hosner 101

Long-billed Gnatwren | Jeffrey D. Brawn
 and Henry S. Pollock 102

Scaly-breasted Wren | Henry S. Pollock
 and John P. Whitelaw 105

White-breasted Wood-Wren | Jeffrey D. Brawn
 and Henry S. Pollock 106

Gray-breasted Wood-Wren | Caroline Dingle 109

Song Wren | Henry S. Pollock 113

Black-faced Solitaire | K. Greg Murray 114

Hummingbird Tongues: An Ingenious Adaptation | John P.
 Whitelaw 117

Ruddy-capped Nightingale-Thrush | Scott Robinson 119

Slate-throated Redstart | Ronald L. Mumme 120

Rictal Bristles | John W. Fitzpatrick 123

Blue-black Grosbeak | Henry S. Pollock 127

Gray-headed Tanager | Jeffrey D. Brawn 130

Afterword by John Kricher 132

Brief Descriptions of the Species 135

About the Photographs | John P. Whitelaw 139

Notes 141

References 145

Contributor Biographies 152

Index 155

Foreword

It is not surprising that the birds that get the most attention are the ones clad in beautiful colors, such as American wood-warblers, hummingbirds, and tanagers, but the birds that live mostly hidden lives in the understory deserve equal attention. Some produce songs or calls that are among the loveliest sounds in nature. John James Audubon's favorite bird was the Wood Thrush. He wrote about waking up in his tent after a stormy night and hearing its beautiful song. One of my most wonderful experiences in Amazonia was being in the forest and hearing a Southern Nightingale Wren (now known as Scaly-breasted Wren) singing on one side of the trail while a Song Wren sang on the other.

Birds that live in the understory, such as antbirds, antpittas, antthrushes, and others, can be difficult to see. That challenge makes it all the more special when such a bird comes into view, giving the observer an opportunity to savor the subtle and delicate pattern of its plumage.

Because their presence is an indication of the health of an area of forest, understory birds actually deserve special attention.

If you love all birds, you will find this book an essential addition to your library. It will provide you with fascinating information about the lives of understory birds. The only way to really know a bird is to understand how it lives.

VICTOR EMANUEL

An idea, an influence, and an aesthetic led to this book. The idea was to link images of underappreciated Neotropical birds that are uncommonly seen, and more likely to be heard than seen, to short accounts of the species written by ornithological scientists in a style that the average birdwatcher would find readable. The species illustrated are not rare or imminently endangered, but their dark, cluttered habitats and furtive behavior make them difficult to spot and even more difficult to photograph. In truth, not all that much is known about many of them, and much of what has been recorded rests in historical accounts.

The influence was supplied from the naturalists–watercolorists of the last three centuries. In the natural setting, contemporary conventional photography techniques, even with state-of-the-art equipment, cannot control such inherent variables in the understory environment as available light, background, and subject motion. Artistic elements such as gesture and design are especially elusive. In contrast, traditional avian portraitists frequently used crude taxidermy and vegetation to construct their own settings. The resultant watercolors and etchings are meticulously detailed and tend to have natural hues uninfluenced by available light intensity and color shifts. And, of course, everything is in focus.

The aesthetic factor came from the Japanese concept of "Wabi-Sabi," which "is not about gorgeous flowers, majestic trees, or bold landscapes. Wabi-Sabi is about the minor and the hidden, the tentative and the ephemeral: things so subtle and evanescent that they are invisible to vulgar eyes."[1]

The impetus for the book came from my own experiences as a casual birdwatcher and an amateur photographer. It has been estimated that, in the United States alone, some 47 million people spend 9.3 billion US dollars annually on birding-related activities.[2] Each year, scores of new bird-centered books support this phenomenon. The majority are geographically based field guides (from backyards to continents), descriptions of groups of birds such as gulls, birds of prey, and warblers, recommendations for the best places to birdwatch, birding adventures, avian natural history, and bird art and photography.

This is a different kind of bird book, which stands apart in three ways. The photographs are technically and artistically unusual, if not unique. Many of the species illustrated qualify as what birdwatchers are fond of calling "LBJs"—little brown jobs. And last, the species accounts are lyrical admixtures of avian lore and ornithological science.

I owe my interest in birds to my father, a birder of the

Preface

If you look closely enough, a tortoise is as magnificent as a tiger.
JOEL SARTORE, *THE PHOTO ARK*

We need to marshal support not only for such impressive species (as cranes) but also for those that are much less conspicuous.
MURRAY GELL-MANN,
AFTERWORD TO
LAST OF THE CURLEWS

"lister" ilk, who set aside early Sunday mornings for walking with his young sons through the forests and along the shores near Vancouver, British Columbia. He also tried his hand at bird photography, at a time when a week's wait for a photo lab to develop the film often ended in devastating disappointment.

At home, several volumes of the Canadian bird portraitist Fenwick Lansdowne's work lay beside two tattered rain-damaged copies of Roger Tory Peterson's *A Field Guide to Western Birds*. As a boy, I had spent a day with Mr. Lansdowne in his Victoria studio, surrounded by preliminary sketches and museum skins. Years later, I thanked Mr. Peterson for influencing my career choice: there are uncanny similarities between bird identification and histopathological surgical diagnosis.

I was introduced to Neotropical forests by professional birding guides in Costa Rica, where I saw the jungle as a collage of fractals, so different from the relatively spare, quiet, coniferous forests of British Columbia. Instead of constantly moving through the forest in quest of a new "lifer," I often selected a spot in the humid undergrowth where I could sit silently and wait for whatever happened by. In so doing, my interest in the large flashy species waned, to be replaced by a fascination with the group of small, secretive, unheralded birds, dressed in subdued hues, that skulk and flit in the dense understory vegetation—all the more appealing because of their beguiling names such as antpittas, woodcreepers, hermits, leaftossers, foliage-gleaners, and xenops.

Despite a considerable investment in sophisticated camera gear, my own initial attempts to photograph these shifty species were futile. Accordingly, I acquired National Geographic photographer Joel Sartore's books *Rare* and *The Photo Ark*, which inspired me to fashion a crude facsimile of his studio set-up, which I tested on my basement workbench, using our Amazon parrot as a subject.

In 1994, an internet appeal from a remarkable Central American involved in an avian rescue-and-release effort afforded a unique opportunity. Jacobo Lacs, a former director of the Peregrine Fund, was seeking medical supplies and used medical laboratory equipment for use in his efforts to rehabilitate intercepted smuggled parrots and macaws. As the director of a hospital pathology department, I had access to both. Señor Lacs invited me to Panama's Chiriquí highlands where, as a conservationist, he was periodically granted permission by his government's department of wildlife to mist net certain species in order to raise them in captivity. Because mist nets are not selective, most of the birds captured fell outside his permit's limited scope, which meant they would be released. Of these, most were insectivores, the little birds with their muted colors that I found so appealing.

In preparation, I built a small, collapsible, portable bird-tight studio in which artistic "sets" could be constructed. The birds would be held briefly and released unharmed. I gave the contraption its initiation in the fickle light of a cloud forest. The first image aligned with elements of Wabi-Sabi that I have used successfully in other photographic contexts: the beauty

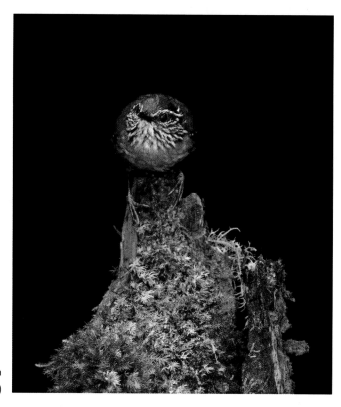

Gray-breasted Wood-Wren
(*Henicorhina leucophrys*)

of things modest and humble, the beauty of things imperfect, of things incomplete, and of things impermanent.

I then sought out Jeffrey Brawn, who generously invited me to accompany his research crew to Pipeline Road near Gamboa, Panama, where he had been conducting avian research in the area for many years. This experience resulted in a more diversified collection of images and, as importantly, introduced me to a community of ornithological scientists and their research. It was here that the idea for this book first occurred to me. I subsequently chanced upon a *New York Times* article entitled "Saving Our Birds," by John Fitzpatrick of Cornell University's Lab of Ornithology, who immediately offered to assist. Señor Lacs introduced me to Señor Samuel Valdés Díaz, former director of Panama's Protected Areas and Environmental Biodiversity Ministry. Samuel organized a visit to the Darién devoted, in part, to my photography. As much as this book is a collaborative effort, it owes its creation to the boundless generosity of Jacobo Lacs.

The essays that accompany the photos were written by sixteen authors, most of whom are, or were, engaged in ornithological research. All were invited to write short accounts of species with which they were familiar, especially if they had a special interest. Their essays, which naturally vary in approach and style, are supplemented by a section of brief species descriptions for each of the birds featured, giving their size, range, and elevations. A few of the essays are not species-specific but are included because they provide a closer look at some especially interesting avian subjects, for example, rictal bristles and ectoparasites.

I hope the book raises public awareness of these unchampioned species, which are, for biological and ecological reasons, more susceptible to extinction than their popular, larger, and more colorful kin, which are so attractive to ecotourists. I came to call these birds "underdogs of the understory"—a legion of often-overlooked, inconspicuous denizens of the Neotropical forest.

On May 10, 1854, Henry David Thoreau wrote in his journal, "In Boston yesterday an ornithologist said significantly, 'If you held the bird in your hand—;' but I would rather hold it in my affections."[3] In the words of John Hay, "Thoreau's purpose is profoundly realistic: to see in a bird the dimensions of its surroundings."[4]

JOHN P. WHITELAW

Acknowledgments

My indebtedness to Jeff Brawn, Samuel Valdés, and Jacobo Lacs has been explained in the preface. My field trips could not have happened without them and without the expertise and assistance of Panamanians Juan Pablo Rios and Euclides (Kilo) Campos, the hard work and guidance of Kique Ortega and Lionel Atencio, and the protection and instruction of expert woodsmen Samuel, Kilo, and Juan Pablo. I am grateful to all for their forbearance toward the *Canadiense loco*. I am very thankful for the efforts of Henry Pollock, both in the field and at the desk, as well as for his constant advocacy, friendship, and support.

I am especially grateful to the many contributors who wrote the species accounts, most of whom I have never met and all of whom showed great enthusiasm and tolerance for my unsolicited and audacious requests. And I speak for all the authors in saying that we are most appreciative of the assistance given and patience shown by Kitty Liu, Alexis Siemon, Allegra Martschenko, Susan Specter, and Eva Silverfine of the editorial staff at Cornell University Press.

I owe, by far, the most thanks to my wife, Christine, who not only endured uncomfortable days in the heat and humidity of the tropics but who edited all the species accounts, formatted and assembled the manuscript and bibliography, made insightful suggestions about the book's form and content, and encouraged me to press on when its completion often seemed out of reach.

JOHN P. WHITELAW

Long-term bird research in Panama benefited greatly from the cooperation and support offered by the Smithsonian Tropical Research Institute; in particular, we wish to thank George Angehr, Allen Herre, Reinaldo Urriola, and Joe Wright. Cooperation from the Republic of Panama's Ministerio de Ambiente is most appreciated. The Panama bird study was initiated by James Karr, whose cooperation has been instrumental in helping the research continue for over forty years. Of course, we all owe John Whitelaw a big thanks for his vision, skills, and "Canadian patience."

JEFFREY D. BRAWN

I would like to acknowledge John Whitelaw, first and foremost, for his friendship and for giving me the opportunity to participate in this book. I am immensely grateful to Jeff Brawn for taking a chance on me as a graduate student and for funding my research in Panama. Thanks to Catherine Keane and Brian Miller for helping spark my interest in birds. I also owe a debt of gratitude to my parents, Renee and Michael Pollock, for always encouraging me to pursue my passions and for supporting my wanderlust.

HENRY S. POLLOCK

The main person I would like to acknowledge is John Whitelaw, for his novel and brilliant idea of this book, his endearing photographs that give real nobility to the little-heralded birds of tropical understories, and his enduring grace and patience with me throughout. In addition, I am eternally grateful to two mentors during my teens and twenties—Raymond A. Paynter Jr. and John W. Terborgh—who introduced me to the American tropics and were instrumental in kindling my lifelong passion for little green birds.

JOHN W. FITZPATRICK

Elusive Birds of the Tropical Understory

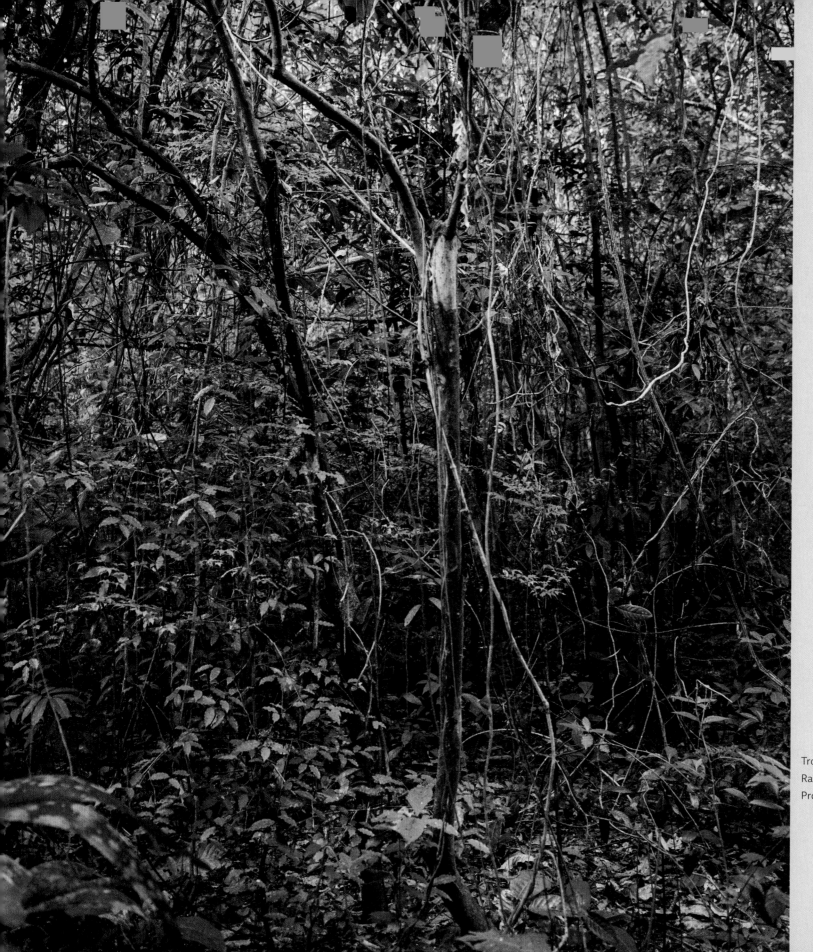

Tropical forest understory,
Rancho Frio, Darién
Province, Panama

Geographers define the tropics as regions between the Tropic of Cancer (23°27' N) and the Tropic of Capricorn (23°27' S). This broad belt incorporates huge areas of Central and South America (the Neotropics) and also equatorial Africa, Southeast Asia, Indonesia, and islands of the western Pacific Ocean. In this book, we focus exclusively on birds of the Neotropics.

The climates and ecosystems within the world's tropical zones are exceptionally variable, and the popular view of "the tropics" (besides lovely sand beaches shaded by palm trees) refers to places that are warm throughout the year, with lush, forested habitats nourished by plentiful rainfall. Actually, the amount and timing of annual rainfall varies considerably across the tropics. Indeed, many large areas do experience significant rains throughout the year, with rainfall in some areas even exceeding ten meters! Such areas support true rainforest, also called "tropical evergreen forest" or "equatorial tropics" in many scientific references. Other tropical places, however, are much drier, and many of these experience distinct wet and dry seasons annually. The wettest of these places are often called seasonal or monsoonal tropical forests, while those with the least rainfall (often having prolonged dry seasons) vary from tropical dry forest to arid scrub, and even to tropical desert.

Tropical Rainforest Structure

What makes mature tropical rainforests so magical (and the Neotropical bird fauna the world's most diverse) is that they contain so many different structural "layers" of vegetation, all stratified by height. To simplify this idea, picture a layer cake filled with lavish ingredients, most of which are myriad shades of green or brown and vary in density from light and airy to nearly solid, tangled masses. Because this book features birds of this cake's lowest layer, we will start with brief descriptions of the uppermost layers and work our way down to the dark interior, where our featured species make their living.

The topmost layer of an old-growth tropical forest consists of the widely scattered and immensely tall giants that tower over all the layers below. These so-called emergents can reach heights of 55 m (180 ft) and include some of the most picturesque trees in the world. In the Neotropics, two widespread and especially famous emergents are the kapok tree (*Ceiba pentandra*) and the legume cumaru (*Dipteryx micrantha*). Emergents are old trees and are often home to an astounding ecosystem all their own consisting of air plants, ferns, lianas, and leafy vines. Eagles and hawk-eagles build their nests almost exclusively in these tallest trees.

Below the emergents is a broad layer of mature treetops, often called the "canopy." Highly variable in structure, and immensely diverse in species composition, the canopy is a well-lit, leafy paradise for tropical life. Many groups of tropical trees produce vast quantities of fruits, including the figs (genus *Ficus*), annonas (*Annonaceae*), and laurels (*Lauraceae*), and these in turn support hundreds of species of exclusively canopy-dwelling birds, such as parrots, toucans, pigeons, and cotingas. Many groups of canopy birds are extraordinarily colorful, including tanagers, euphonias, cotingas, woodpeckers, barbets, toucans, and orioles. Such colorful birds are the icons of many popular books about tropical forests; in contrast, with this book we celebrate birds that tend to be darker and more subtly patterned and often overlooked in the shadows far below.

Below the canopy is the midstory of the forest, where light levels are still high and many tree groups, especially the palms, reach their uppermost heights. The structure of the midstory is highly variable, with wide openings interspersed among palm crowns, tree trunks of varying diameters, the tops of sapling trees, and the lowest leafy branches of the taller canopy trees. The midstory of Neotropical forests supports numerous bird species, many of which travel together in family groups or mixed-species flocks. Thick vine tangles are abundant throughout the midstories of tropical forests. These dense labyrinths of vines, lianas, twigs, branches, leaves, air plants, and fallen debris sometimes constitute a structural connection between midstory and canopy. A variety of bird species occupy these complex knots of vegetation, and be-

Introduction

JEFFREY D. BRAWN AND
JOHN W. FITZPATRICK

cause the tangles are so dense and so high over our heads, these wrens, antbirds, antshrikes, and tiny flycatchers are far more easily heard than seen.

Down below the midstory is the dark understory of the forest, which extends little more than about 5 m (16 ft) above the ground. Besides the scattered, "teenaged" canopy-tree saplings trying to "shoot for the moon," the understory is a layer of shrubs and miniature trees that specialize in doing all of their flowering, fruiting, and recruiting in low-light environments. The understory is generally humid throughout the year, and although heavily shaded and mostly dark, the light environment is not uniform. During the middle of the day, the understory is a jumble of green leaves and bright sun flecks. Vegetation within the understory can be quite dense in younger, second-growth forests or tree fall gaps but is surprisingly open in older forests. In the Neotropics, one family of plants—the melastomes—plays an especially huge role for birds in this layer because these plants produce copious crops of white, red, or purple berries that support dozens of bird species almost year-round. Without melastomes, this book would be much shorter and far less colorful. All understory plants support a bewildering array of arthropods, which may be directly consumed by insectivorous birds or by arthropod predators such as spiders and mantises, which understory birds are especially fond of capturing and eating. Because of this incredibly rich abundance of arthropod prey, the tropical forest understory supports an amazing assemblage of birds, including many of the species featured in this book.

Ground-story plants, within a meter or two of the ground, vary from delicate fungi, forbs, and moss-like *Selaginella* to miniature palms and freshly sprouting saplings. The banana-like *Heliconia* and waxy-leafed gingers sport large, brilliantly red and yellow flowers that are main staples for dozens of hummingbird species. This layer also includes jumbled debris in the aftermath of great trees that have fallen over recent years; these tree falls create large openings and a flood of light in an otherwise dank and darker forest under-

story. Many understory birds seek out and live mainly in these sunny, vine-covered tangles just above the ground.

Although a few tropical forest birds do nest in burrows, there are no truly burrowing birds, but a wide variety of bird groups contain ground walkers, including doves, curassows, ground-cuckoos, many antbirds, antpittas, and antthrushes, gnatwrens, leaftossers, and even a few flycatchers. In the tropical forest, the ground layer is extremely dark (remember, it's overshadowed by up to 50 m (164 ft) of leafy vegetation) and is covered in dead leaves—rapidly decaying, yes, but perpetually replenished from above and fed by excrement from a bewildering diversity of creatures from the upper layers. This ground layer is a vast, constantly refurbished ocean of nutrients supporting creatures of all kinds, from snails and slugs to beetles (and their larvae), moths and butterflies (and their caterpillars), flies (and their maggots), ants, roaches, spiders, millipedes, scorpions, lizards, and frogs. The ground also serves as the final resting place (and for the lucky few, the recruitment opportunity) for myriad fruits and seeds that fall from the upper layers. This ground layer plays a huge role for the birds of this book.

Pioneers

A few twentieth century ornithologists deserve to be recognized for their influential research, which opened the world's eyes to the intricate life histories of this very special, but underheralded, bird community. Alexander Skutch, who died just days before his 100th birthday, helped bring tropical birds to life with his pioneering trilogy, *Life Histories of Central American Birds,* volumes 1, 2, and 3, followed by half a century of additional life histories of the birds in his beloved Costa Rica. Edwin Willis set legendary standards of detail, beginning with his doctoral research, *The Behavior of Bicolored Antbirds,* followed by more than two hundred additional scientific papers, many of which revealed details about the behavior of understory birds that follow army ants. In the 1970s, James Karr launched the long-term banding study of understory birds in

central Panama, which continues to this day under coauthor Jeff Brawn and provided the opportunity for coauthor John Whitelaw to photograph many of the birds that grace this very book. Thomas Lovejoy originally founded the Amazon Biodiversity Center near Manaus, Brazil, as the Biological Dynamics of Forest Fragmentation Project in 1979, which documented how understory birds respond as their tropical forest habitats become fragmented into "islands" of different size and isolation. John Terborgh and several of his students documented mixed-flock territoriality and community structure in the understory of Peru's Manu National Park, which supports the most diverse bird fauna in the world. Theodore A. Parker III was an extraordinary field ornithologist who helped inspire a generation of tropical forest ornithologists before his untimely 1993 death in a plane crash while scouting a mountainous region of Ecuador for possible government protection. The brilliant Russ Greenberg studied the ecology of understory songbirds in Central America during the 1970s and 1980s, paying special attention to the behavior of North American breeders that spend more than half their lives in the tropics. He shed light on the vital role played by shade-grown coffee plantations for tropical birds and then established and led the Smithsonian Migratory Bird Lab.

Forest Understory Birds and Their Habits

What makes the understory of a tropical forest truly fascinating is its birds, which vary from drab to colorful, rare to abundant, secretive to obvious, and solitary to highly social. How these different species make their livings within the rich environs of the understory makes for fascinating natural history and has been the subject of intense study by generations of ornithologists.

General Characteristics

Except for tinamous, doves, and cracids, plus the occasional visit by forest raptors, birds of the tropical understory tend to be small and, befitting their ecological places in the shade, their plumages are mostly subtle variations of black, brown, and olive green. Some antbirds and flycatchers have hidden patches of white or yellow in the back, under the wing, or in the crown, which they flash during aggressive encounters or courtship. But by and large, these are inconspicuous birds that rarely perch in the bright sunlight, almost never make long flights through the forest, and are much more easily detected by their vocalizations than by first spotting them. While the wrens, thrushes, and tanagers have sweet and often quite elaborate songs, the antbirds, foliage-gleaners, woodcreepers, and flycatchers vocalize with simple notes, trills and rattles, unmelodious series of slurred notes, or thin whistles.

Understory Mixed-Species Flocks

A distinctive feature of the understory bird community is the propensity of many species to travel in mixed-species assemblages, which in more diverse tropical forest communities may contain up to twenty or more species. Indeed, for birdwatchers walking along a trail through an Amazonian understory, the forest can seem surprisingly silent and devoid of birds for extended periods. Suddenly, the looming boredom is broken by a dizzying array of actively foraging antbirds, antwrens, woodcreepers, woodpeckers, flycatchers, foliage-gleaners, and understory tanagers all moving together through the vegetation in a loose band sometimes just 10 to 20 m (33–66 ft) across. These mainly insectivorous birds display a range of foraging styles, including picking and probing, dead-leaf foraging, bark creeping, and sallying out to pursue escaping arthropods. Mixed flocks usually contain one or two "core species" that have conspicuous predator alarm vocalizations, an advantage that no doubt provides a key incentive for the other species to join them. Mixed understory flocks typically contain no more than one pair of each species, and the flocks have well-defined territories that remain more or less stable over many years. When flocks happen to meet one another at their territory boundaries, "all hell breaks loose" as members of each species

actively vocalize and display against their counterpart individuals in the other flock.

Midstory Flocks

Just as in the understory, many bird species move about the midstories of the tropical forest in loose flocks, and occasionally these groups actually join up with an understory flock. This makes for exciting birdwatching, as the forest comes alive with birds of all kinds spanning from the ground almost up to the high canopy. Compared with the understory community, midstory flocks contain fewer antbirds and more foliage-gleaners, woodcreepers, tanagers, flycatchers, vireos and greenlets. These flocks are occasionally followed by a Double-toothed Kite (*Harpagus bidentatus*), trogons (*Trogon* spp.), or nunbirds (*Monasa* spp.), which sit for long periods waiting to spot a large insect flying or dropping down to escape being captured by a flock member.

Ant Followers

Among the most extraordinary ecological phenomena of the Neotropical forest understory is the predatory swarming of army ants (*Eciton* spp.), accompanied by the behavioral specialization of numerous bird species that forage over these marauding swarms. Immense colonies of these highly social ants lack permanent nest sites. Instead, they alternate between a stationary "bivouac" phase, during which reproduction occurs, and a swarming phase, during which thousands of ants move together across the forest floor and up the trunks of trees in search of food to carry back to feed their larvae. Army ants are voracious and highly effective predators that can capture and subdue all manner of prey, from larvae and pupae of other ants and wasps to scorpions, roaches, spiders, insects large and small, and even the occasional lizard, frog, or ground nests of birds. Because all these potential prey species react instantaneously to flee an approaching ant swarm, they in turn become fair game for a host of bird species that follow the ants all day long. This remarkable foraging behavior is what gave "antbirds" their common name, and while this family does predominate over active swarms, several species of woodcreepers, tanagers, wrens, flycatchers, and even ground-cuckoos often join them and even outnumber them. Ant-following birds actively vie with one another for prime perches within inches over the marauding ants, so as to get "first dibs" on escaping prey. Perhaps associated with this social competition, many ant-following birds have striking facial patterns that include brightly colored bare skin patches around the eye, contrasting light and dark plumage, and even crown plumes. Recent work in Panama has revealed a fascinating "information network" in this system whereby species eavesdrop on each other to locate swarms and join the attending flock.[1] To encounter and watch the action around an active army ant swarm is truly a highlight of any birding day in the Neotropical understory. Indeed, if an intrepid human were to stand in the middle of an army ant swarm, the ants would certainly climb up that person's legs to at least waist height (if not higher!) before descending, thus affording the brave soul the best view of the foraging birds.

Frugivores

Dozens of plant families in the Neotropical forest understory produce fleshy, nutrient-rich berries that are adapted so as to be conspicuous for consumption by birds, which in turn serve as seed dispersers for the plant. Unlike understory flowers, many of which have coevolutionary relationships with specific bird species, most understory fruits are eaten by many different kinds of birds, from manakins and flycatchers to thrushes, tanagers, and finches. Frugivorous birds range from a handful of species that eat fruit almost exclusively to a vast number with more generalized diets that include arthropod or even vertebrate prey as well as fruit. The most obligatory frugivores in the Neotropical understory are the manakins and a few flycatchers, and their energy-rich diet has resulted in their convergence on an unusual mating system. Because nest at-

tendance by males is unnecessary, males have evolved sexually selected, ritualized displays and vocalizations by which they compete with one another for opportunities to mate with multiple females. Males typically perform these displays in close proximity to one another within a traditional understory location (called a lek) that may remain in the exact same place over decades.

Hummingbirds

Restricted entirely to the New World, the hummingbirds (family Trochilidae) constitute one of the most specialized—and most beautiful—of all the world's bird families. All hummingbirds rely exclusively on flower nectar as their dominant food source. Consequently, thousands of plant species across the Neotropics have evolved floral structures and colors, nectar composition, seasonal schedules of flower provision, and daily schedules of nectar production, all meant to attract and employ hummingbirds as pollinators. Because each flower represents a renewable food source, but becomes depleted after each feeding visit, hummingbirds need to patrol large areas of the forest understory in order to have enough resources to carry them through the day. Understory flowers tend to be distributed irregularly within a bird's home range, and they also come and go through time as different plants have different flowering schedules. With such an irregular and ever-changing resource distribution, it pays for individual hummingbirds to learn and remember the specific locations of their most important flowers and to time their visits according to the replenishment rates of these flowers. This form of foraging behavior—which was first demonstrated among bees—is known as "traplining," and many hummingbird species have now been experimentally demonstrated to be highly efficient trapliners. For such a foraging system to remain effective, of course, it is vital for the hummingbird to protect its known resources from exploitation by other individuals. For this reason, hummingbirds are famous for their highly aggressive behavior around especially productive flowers. Indeed, where humans

hang hummingbird feeders, which function as particularly rich sources of artificial nectar, one can often witness almost constant attacks. In tropical regions where multiple species exist, clear dominance hierarchies can be seen as the larger and more aggressive species routinely fend off smaller ones.

While many hummingbirds are generalists, feeding on a wide variety of flowers, several groups have closely coevolved relationships with a narrow set of plant species. Best known among these specialized relationships are those of the hermit and sicklebill hummingbirds, which feed mainly on flowers of the genus *Heliconia* and whose long, curved bills are well adapted to the curved corollas of individual flowers along the *Heliconia*'s pendulous, multifloral petioles.

Nesting Behavior

Bird communities in the tropical understory face a perpetually daunting challenge when it comes to reproduction because tropical forests are positively teeming with predators of every sort. Reptiles (snakes and lizards), mammals (native cats and dogs, raccoons and coatis, mustelids, peccaries, monkeys, and rodents), birds (especially toucans and aracaris, hawks, kites, and forest-falcons), and even insects (e.g., army ants) are constantly on the prowl for vertebrate prey and eagerly consume any eggs or nestling birds they can find. Studies of nesting success among tropical understory birds routinely show that fewer than 10% of all nest attempts succeed in fledging young, and one extensive study in southeastern Peru showed only 3% nest success at high elevations.[2] Because of such severe predation pressure, understory birds have evolved a suite of behavioral and life history strategies to increase the chances that their nests can go undetected. The most obvious strategies are in nest construction and concealment, as almost all understory species build small, messy nests using materials such as mosses and leaf litter that make the nests blend in perfectly with the ordinary clutter of dead leaves, mossy twigs, vines, and palm fronds that make up the lowest few meters of the understory. Some species build hang-

ing, purselike nests with tiny side-hole entrances that look like leafy refuse caught above the ground by vines. Flycatchers in the genus *Tolmomyias* build a hanging, bag-shaped nest with a downward-facing hole, and their antipredator strategy is to construct these nests very close to active wasp nests.

Most tropical understory birds have small clutch sizes, often limited to two eggs. It has long been hypothesized that smaller clutches help minimize the number of feeding trips that parents need to make in and out of the nest. In addition, because nest success is so low, typically multiple nest attempts are required to fledge any young during the breeding seasons, making it advantageous for pairs to limit energy investments in each individual nest attempt. Moreover, a comparative study of temperate zone and tropical zone incubation patterns showed that tropical species engage in significantly longer incubation bouts, as well as longer periods off the nest, thereby minimizing opportunities for predators to detect parental comings and goings.[3]

The Future of Understory Tropical Birds

Tropical forests worldwide are being lost at an increasing rate owing to direct exploitation of natural resources, agriculture, and urbanization. Add in the inevitable effects of climate change on temperature and precipitation, and you have developments whereby the integrity of tropical forest ecosystems will be challenged in several ways in coming decades. Generalities about the conservation prospects for understory birds under such change are challenging because they are such a diverse group of species and there is regional diversity in the ecologies and behaviors of these species. Conservation biologists often talk about "winners and losers" when predicting the fate of species in a changing world. "Winners" will do well because they tend to thrive across a wide continuum of habitats and environmental conditions. These species are often classified as "generalists" regarding their behavior and ability to persist in places with profound habitat loss and alteration. The "losers" tend to be more specialized and less resilient to

environmental change. These species will decrease in number and range as the climate changes, the forests are lost, and the overall footprint of human activities grows.

Unfortunately, there is clear evidence that, as a group, birds of the understory are especially sensitive to environmental change brought on by human activities. Much needs to be learned about the biology of these species, but there are key long-term studies from the Neotropics that are telling us a worrisome story. Similar studies have also been conducted in tropical Africa, Asia, and Australia (collectively called the Paleotropics).

An inevitable outcome of deforestation (in the tropics and elsewhere) is that the remaining habitat will be fragmented into habitat patches of varying size and isolation from intact tracts of forest. Larger forest fragments support more species. Whereas reasons for this association are many, the pattern is nearly universal and applicable to birds, trees, and other groups. Importantly, the bird species that persist in a fragmented landscape are often those that can traverse from patch to patch over nonforested habitat (e.g., agriculture and water). Long-term studies of habitat loss and fragmentation in Brazil and Panama clearly show that understory species are especially sensitive to habitat fragmentation.[4] While they are not the only birds to be lost, they are usually the first ones to become locally extinct after fragmentation and are disappearing in disproportionate numbers. Why this is so likely has many answers, but we do know that the species most sensitive to fragmentation are often not able to traverse open habitat. A series of innovative experiments conducted by Randy Moore and colleagues in Panama demonstrated that many species of understory birds simply cannot orient and fly significant distances over open water.[5] Moreover, these species are the ones that disappear and remain absent from habitat islands. These studies provide reasonably consistent evidence that birds of the understory will not do well with ongoing habitat loss and fragmentation.

Another emerging threat to the understory birds is global climate change, which may affect birds even within intact for-

ests. The amount and timing of rainfall fundamentally affects the biology of tropical organisms. For example, in the seasonal tropics of Central America, many bird species time their breeding effort to begin with the onset of the rainy season. As the atmosphere and oceans warm, there will likely be changes in precipitation patterns over much of the tropics. Whereas there is much uncertainty as to what will happen, it appears likely that many parts of the tropics will get drier owing to longer dry seasons, less annual rainfall, or both. Other areas may trend toward more rainfall. Several studies indicate that altered rainfall patterns (drier or wetter) will have negative outcomes for populations of tropical birds—especially understory species. In Panama, for example, nearly one-third of the understory species studies had smaller populations after an unusually long dry season.[6] Dry seasons in Panama are longer during "El Niño" years, and these events are expected to become more frequent in coming decades.

Taken together, land use and climate change pose significant challenges for the future integrity of tropical ecosystems and the conservation of many understory forest species. Nonetheless, while there are worrisome trends, it is important to stress that many species of understory birds remain reasonably common throughout much of their range. None of the species featured in this book, for example, is currently classified as threatened or endangered in Panama. Conserving understory tropical forest birds will require significant effort at local and global scales but, at present, we still have much to see and hear.

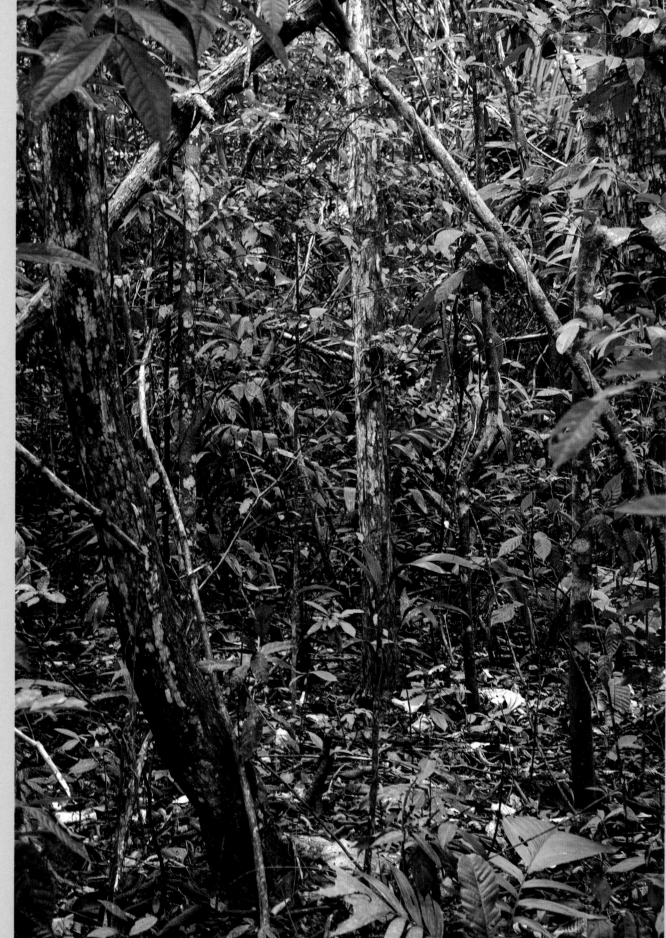

Tropical forest understory,
Rancho Frio, Darién Province,
Panama

Panama is often described as a bridge of life that unites the flora and fauna of the American continents, allowing animals of North American origin to move south and vice versa. This bridge that connects the forests on either side is a lush rainforest that offers an immense area of habitat for thousands of species.

Like big cities, rainforests have several levels. Skyscrapers emerge in the form of huge trees over 40 m (131 ft) in height, below which are other semidiscrete levels closer to the ground. At street level, the forest floor is protected from excessive solar radiation by the shade provided by the upper levels, which makes for a humid and relatively cool environment in which there are myriad interactions between the enormous collection of organisms ranging from unicellular forms to birds and mammals. Mammals, as well as many of the amphibians, reptiles, and dozens of species of birds who reside there, find shady places to build their nests, forage, and mate. These various relationships, including natural predator–prey tensions, exist in equilibrium when the forest is intact and undisturbed.

Thus structured, animals have traveled this bridge, which extends across the Panamanian isthmus connecting the South American jungles with Central America, for millions of years. Today, unfortunately, as a result of human activity, the bridge is weak. Centuries of privileging economic growth over protecting natural areas have taken their toll.

A Divided Panama

The construction of the Trans-isthmus Railway in 1853, and the eventual completion of the Panama Canal in 1914, marked a significant period of deterioration. By connecting the land and river routes of the narrow belt of land separating the waters of the Caribbean from those of the Pacific Ocean, a gap was created between the forests on either side of the interoceanic route. That gap, barely perceptible at first, has expanded over time.

The subsequent construction of a highway between Panama City and Colón—while improving communication and transportation between the two terminal cities—started a process of urbanization that gradually eliminated forests to make room for human settlements. This development prevented animals, especially mammals and understory birds, from moving between the massive, and now isolated, forest areas and ultimately resulted in a loss of the ecological connectivity on both sides of the Panama Canal basin.

Because of their particular size, ecology, and behavior, some mammals have an ability to seek out and move to more suitable habitats, making them more tolerant of changes in the forest structure and more resilient to the loss of ecological connectivity. However, there are many avian species that are specially adapted to living in the shade and humidity of the forest floor. They are slow-moving, short-distance-flying birds whose short blunt wings are more suitable to the aerobatics required for catching insects than they are for flying any significant distance. Such birds travel within their neighborhood by taking short flights or jumping from branch to branch. These species are very vulnerable to loss of connectivity because they cannot survive conditions of sun exposure, such as in deforested areas or those that require long-distance travel. This human-made separation could have an effect on genetic flow, dividing populations into at least two groups. This division, in turn, will have unpredictable consequences for the survival of species, especially in the face of the growing challenges of climate change.

Ironically, deforestation of the rainforest not only affects natural ecology, but it can also devastate the local and global economy. Through a process called transpiration, trees cool local climate and generate rain.[1] This is particularly important for the Panama Canal, whose very operation depends on the jungle of the nearby Chagres National Park. Thus, forest loss is a threat to the country's largest economic asset, to say nothing of international shipping. The region is already experiencing a declining annual rainfall, made worse by the demands of a growing Panama City. More reservoirs will be required to quench the thirst of the capital's nearly one million inhabitants.

Challenges to Biodiversity Conservation in Panama

SAMUEL VALDÉS DÍAZ

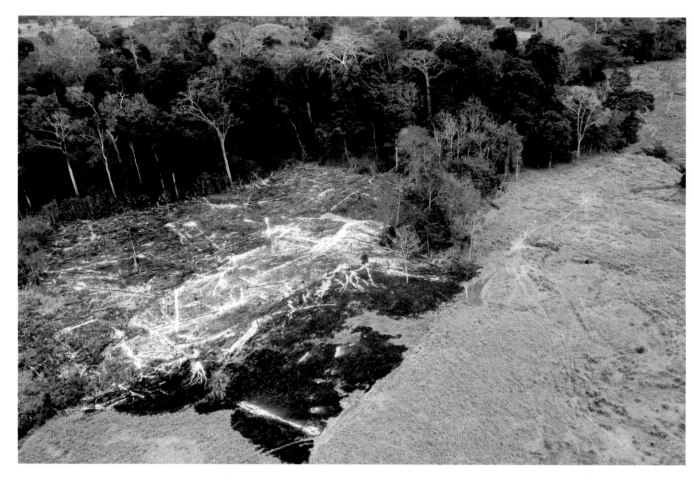

Smoldering ashes from illegally cut forest. Laguna de Matusagaratí, Darién Province, Panama. Photo by S. Valdés Díaz.

The Darién Mystique and Hope for the Future

Panama's approximately 12,491 km² (4823 mi²) Darién Province extends from the Province of Panama to the Colombian border to the east and the region of the Guna Yala to the north. The lore surrounding the province has gained mythical proportions, detailing a long history of conquest and the triumph of nature over civilization that began with pre-Hispanic settlements in the Cana region. By the eighteenth century, Darién Province had become the home to a modern city. In fact, Santa Cruz de Cana was one of the first cities in the Americas to have a railroad, necessitated by its raison d'être—the largest Panamanian gold mine of the time.

Today, Cana is not the same. Nature has largely reclaimed its own, and jaguars and macaws now wander among the ruins of the railway, feeding in the old gardens that have now reverted to jungle. But every dry season, just a few hundred kilometers from Cana, chainsaws roar to life. They are fueled by a lucrative Asian market for exotic lumber. Locals aspire to fabled wealth; among their ranks are politicians, businessmen, corrupt officials, indigenous leaders, loggers, and even some international organizations. All are conspiring to bring down the nearby large trees and sell their valuable wood.

In 2019, the Ministry of the Environment recognized that 97% of the wood extracted from Darién forests was harvested illegally and accounted for a loss of 30 km² (11.6 mi²) of forest

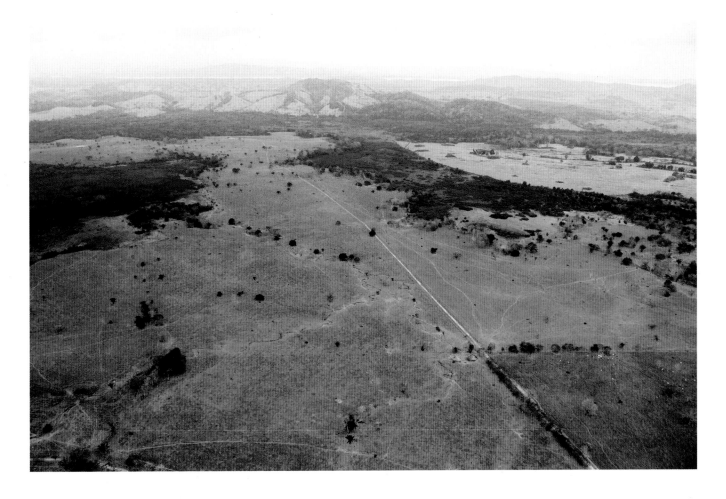

Deforested landscape. Canglón, Darién Province, Panama. Photo by S. Valdés Díaz.

per year. In 2020, the ministry finally moved to prohibit the felling of trees. But criminal activity has not been deterred. Instead, it is conducted in plain sight, with loggers pretending that the wood is being used for local construction purposes. Darién continues to lose hectares of forest, impoverishing communities, enriching corrupt officials and consultants, and threatening the future of Panama's forests. Panama, in this respect, is not alone: while the photos in this book were all taken in Panama and this essay describes the present ecological and political challenges that exist there, these conditions are the same or similar in most of the world's tropical forests. Given the present worldwide conservation crisis, what is ur-

gently needed is the concerted pan-global will to prevent deforestation before more irretrievable losses occur.

In nearby Cana, the bridge remains intact for now—an impassable barrier for humans but a highway for wildlife. Perhaps this is a metaphor, a reminder that our own passage through this earth is fleeting and that we are wise to maintain a balanced relationship with our environment: one that makes it possible for humans and animals to coexist with the forest and with space enough in the skies for birds and humans to fly.

As the Haida First Nations people of Canada say, "We do not inherit this land from our ancestors, we borrow it from our children."

Portraits in Words and Pictures

The species are presented in taxonomic order, the system of scientific classification based on a hierarchical ranking system. Several topics of special interest are interspersed among these portraits. An alphabetical listing of the birds can be found in the brief species descriptions at the back of the book.

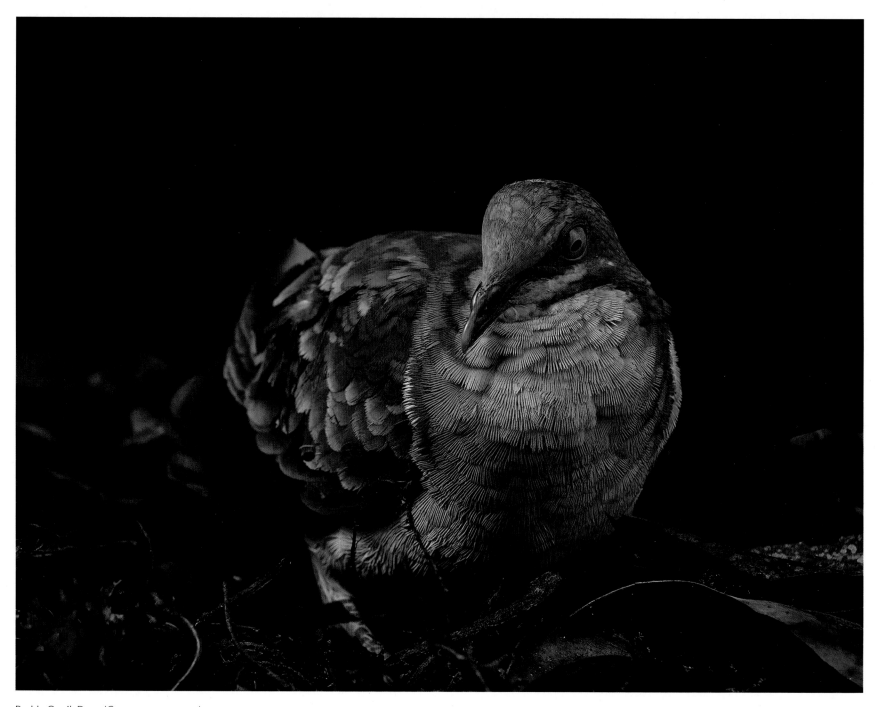

Ruddy Quail-Dove (*Geotrygon montana*)

The Ruddy Quail-Dove (*Geotrygon montana*) is one of the iconic birds of lowland rainforests throughout the Neotropics. Even though they are doves (family Columbidae), which are familiar almost worldwide, they have an exotic, tropical gestalt with their slightly more rounded bodies and dramatic horizontal lines on their faces. They are also shy, retiring tropical birds that take some effort to see well and do not make the long-distance fast flights of most pigeons and doves. Even when they are flushed, their wings make very little noise as they fly a short distance into even denser cover where they quietly walk away from the observer.[1] Their soft cooing calls, which sound much like the calls of the more conspicuous *Leptotila* (ground-foraging) doves, are a familiar sound of the tropical forest understory. In these respects, they fit well with the many obscure brown and rufous birds that share this habitat.

In some respects, however, Ruddy Quail-Doves are not typical. Unlike the vast majority of tropical birds of the forest understory that seem to live permanently in small areas, they may be nomadic, at least in the Amazon.[2] Banded individuals are rarely recaptured in nets, and their numbers vary widely in mist net samples from the same net lines in different years. Some of this possible nomadism may be due to variation in food supplies, but little is known about their diet and ecology.[3] While they eat some fallen fruit and invertebrates, seeds are their main diet. They have even been observed feeding under manakin leks, possibly on the seeds regurgitated by the manakins, which only consume the flesh surrounding the seed.[4]

Ruddy Quail-Doves occur in most humid lowland forests from Mexico to Argentina and on some islands in the Caribbean and are usually at least moderately common.[5] They are readily captured in mist nets, where they always seem to leave behind many of their loosely attached feathers. Many doves and pigeons have what is called a "fright molt" when attacked by a predator: their feathers, which are held in place by muscles, are ejected to create a distracting cloud that may make it hard for a predator to find the center of the dove's body. This effect is similar to the "chaff" released by fighter airplanes to escape missile attacks.[6] Removing doves from nets, especially when your hands are sweaty (an occupational hazard of tropical ornithologists), can be disconcerting because your hands become covered with feathers while you handle them. Indeed, the slightly loose plumage of the birds in these superb photos may be a result of this tactical loss of feathers when the birds were being removed from the mist nets.

Ruddy Quail-Doves are sexually dimorphic—the males are a richer shade of chestnut above.[7] Males and females, however, do not differ in size, and both participate in incubation, which suggests that they are monogamous. Their bills are long and slender and tilted sharply downward, unlike their pigeon relatives.

The nesting ecology of the Ruddy Quail-Doves seems to be typical of doves—they build simple stick platform nests placed in shrubs and vines near the ground and suffer mightily from nest predation.[8] All doves have two-egg clutches, even those in the temperate zone, but they make up for this limitation by nesting early and often. Perhaps to minimize their exposure to nest predation, Ruddy Quail-Doves have an extremely short nesting cycle with 10-day incubation and nestling periods.[9] This is a very rapid developmental rate for a dove of their size, but it is not unusual among the many other species that face the intense nest predation pressure of tropical forest understories. They may also be able to minimize visits to the nest, which might attract nest predators, by feeding their young "pigeon's milk," a nutrient-rich liquid that is regurgitated to the nestlings and even to the fledglings for about a week after they leave the nest.[10] When a nest is lost, often to a snake or a primate, they simply move a few meters and start over. Even when a nest fledges young, they start a new one almost immediately, with the male caring for the fledged young while the female starts the new nest. This is an enormously successful strategy; pigeons and doves are among the oldest of bird lineages and thrive everywhere from the smallest islands to the largest urban centers.

Ruddy Quail-Dove
(*Geotrygon montana*)
SCOTT ROBINSON

White-tipped Sicklebill

(*Eutoxeres aquila*)

CHRISTOPH HINKELMANN

In popular books on ornithology featuring the incredible variety of biological phenotypes, an array of strikingly different bill shapes is often found. Sicklebills are prime examples. Their bills are indeed unique among birds: about halfway along its 28 to 30 mm (1–1.2 in.) length, the bill takes a 90° downward curve. It is because of the bill's similarity to the sickle, a tool once widely used in agriculture, that the birds were given their distinctive name.

How does a species survive with a bill developed in such a peculiar way? Sicklebills are the result of a long coevolution of a scant number of food-source plants and the birds on which those plants depend for pollination. These plants produce large amounts of nectar, rewarding the very specialized vector for carrying the pollen to other plants of the same species. This arrangement is an almost perfect lock-and-key relationship, with the blossom's tube having the same shape as the bird's bill. Insects or bats are not sufficiently reliable to ensure that pollen is always carried from one plant to the other, but birds are able to fulfill this need. Sicklebills also occur at higher elevations, where the lower temperatures reduce insect activities and plants do not flower year-round. Since more than one species of plant have coevolved with the sicklebills, the birds are able to find food-source flowers in every month of the year. Specialized species of *Heliconia* and *Centropogon* are their favorite nectar producers.[1] The birds forage in "trapline" fashion along pathways with the most food-source flowers.[2] Unlike most other hummingbirds, the comparatively heavy sicklebills avoid hovering whenever possible, and their feet have adapted such that they are stronger than those of almost every other hummingbird. *Heliconia* plants, in particular, provide sufficient structure to allow them to perch. Sicklebills also feed on small arthropods, and they have been regularly observed picking up their victims from the webs of spiders.

Two species of sicklebills occur in south Central America and northwest South America. The remarkably elusive White-tipped Sicklebill (*Eutoxeres aquila*) is distributed from Costa Rica to Colombia, along the western Andes to southern Ecuador and along the eastern Andes to northern Peru. Its primary habitat is the understory of humid and wet forest, old second-growth and forest edge, often close to rivers or *Heliconia* shrubs.[3] While their usual altitude ranges between 300 and 700 m (1000–2300 ft), several sightings have been recorded as high as 2100 m (6900 ft). Their sister species, the Buff-tailed Sicklebill (*E. condamini*), is limited to the eastern Andes, where it is distributed from southern Colombia to northwest Bolivia, inhabiting mossy or swamp forest and more open spaces such as disturbed or cultivated areas, plantations, or bamboo thickets. Where the two congeners meet, the White-tipped appears to be more successful in competition for food sources. Males of both species have a body mass of 10 to 12.5 g (0.35–0.4 oz), while females are lighter at 8 to 10 g (0.28–0.35 oz).

Sicklebills are very specialized members of the hermit hummingbirds. They do not defend a territory, but males have been observed chasing other sicklebills away from single feeding flowers or thickets. While they also build their nests of tendrils, fibers, and rootlets, stacked together and affixed with cobwebs to the inner tip of a long, broad leaf, the sicklebills' nests look untidy or loosely woven compared with those of other hermit hummingbirds. Male sicklebills display alone; there are no reports of them gathering for singing and attracting females.

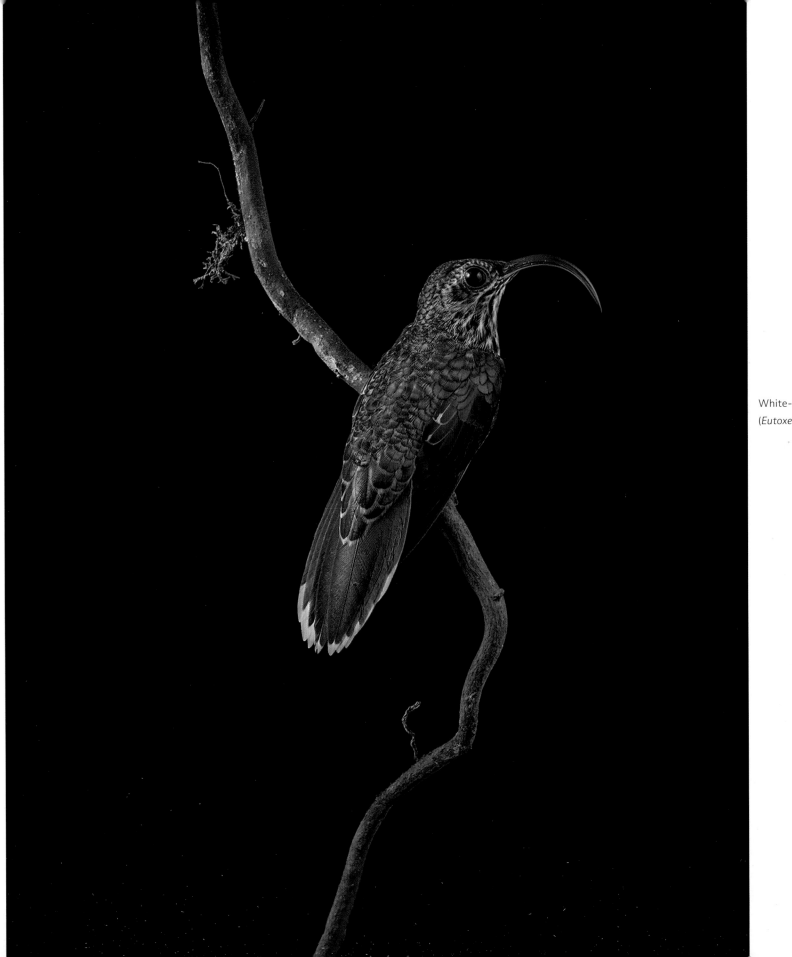

White-tipped Sicklebill
(*Eutoxeres aquila*)

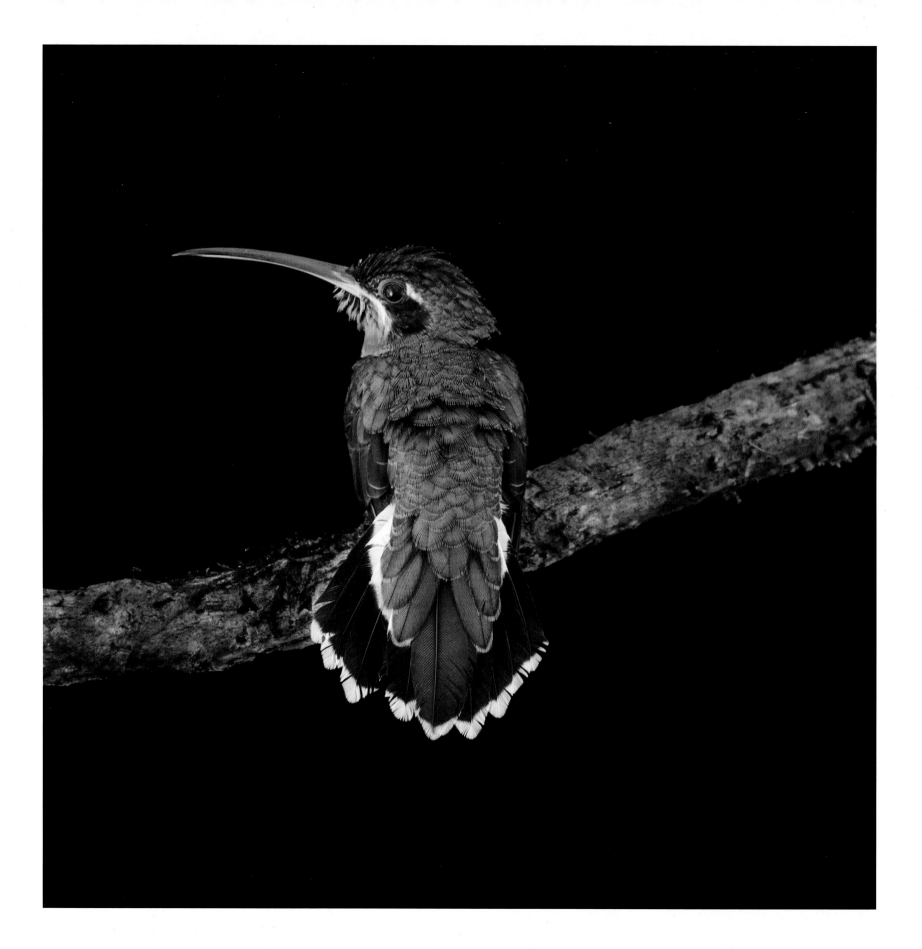

Within the hummingbird family, the two species of barb-throats belong to a particularly interesting, though small, subfamily—the hermits. They differ not only in coloration and biology but also in ethology from the "typical" hummingbirds. They are dull colored and do not defend a territory. During the mating season, the males gather in singing assemblies, where the females show up to choose their best-suited mating partner. This behavior has developed in several bird families or genera, such as grouse, ruffs, and cocks-of-the-rock, but its appearance in hummingbirds is surprising. Unlike the aforementioned, hermit hummingbirds do not dance or display in these locations, called leks. They simply sit on a tiny twig continuously uttering a very simple "song" of squeaky calls while waiting for the female's approach.[1]

This is the sole contribution of the males to the continuation of the species. The females gather nesting material such as rootlets, plant fibers, and trichomes (plant hairs), which they assemble into a cup or cone shape. This nest is attached with a cobweb to the inner side of an overhanging long and broad leaf, at its lower end, where it is protected from rain and from the view of predators. There the female incubates two eggs for a period of 15 to 18 days.[2] The female alone cares for the hatchlings for 23 to 25 days. During these first days of life, the hatchlings are fed only regurgitated, partially digested small arthropods. Once they leave the nest, the mother nurtures the fledglings for another 3 or 4 weeks until they are sufficiently independent. There have been very occasional instances of males being observed in the vicinity of a breeding female at the nest but not enough to confirm the male's presence was for the purpose of either support or defense.

Barbthroats were so named because of their dark chin and upper throat coloration, clearly underlined with a rufous band. There are two species: the Band-tailed Barbthroat (*Threnetes ruckeri*), found from Belize and Guatemala to southern Ecuador, to the northern mountains of Venezuela, and on the west side of the northern Andes; and the Pale-tailed Barbthroat (*Threnetes leucurus*), distributed in northwest South America east of the Andes. The range of the two species includes all altitudes from sea level to 1200 m (3900 ft), and it does not overlap anywhere. Band-tailed Barbthroats inhabit the understory of primary forest and dense second growth, semi-open shrubbery, thickets, and plantations. They are regularly observed at forest edges where they trapline, that is, they visit one blossoming flower after the other along a certain route up to about 1 km (0.62 mi). Their main feeding flowers are species of *Heliconia* and *Costus* with long and slightly curved tubular blossoms, to which their bill shape is perfectly adapted, and they are probably the only legitimate pollinators of these plant species.[3] A long and continually improving selective coevolution has resulted in this almost perfect lock-and-key relationship for mutual benefit. However, on several occasions, Band-tailed Barbthroats have been observed piercing the basal parts of longer tubular blossoms with their bill tips to suck on the nectar concentrated there. Like many other hummingbirds with shorter bills, they feed illegitimately from time to time on the nectar provided by plants, without pollinating them. Like all hummingbirds, barbthroats need proteins and feed on small arthropods, particularly on little spiders.

Band-tailed Barbthroats do not differ much from most other "typical" hummingbirds. Their tail is short and rounded, and it offers a particularly distinguishing coloration. When the bird encounters other hummingbirds, it spreads its tail feathers, displaying an unmistakable pattern of two white quarter rings in combination with the white tips of every tail-feather on a black background. In addition, the tail is constantly moved upward and downward. On the underside, there is a broad white, almost semicircular pattern visible. Males and females are similarly colored, for the most part, with a little more brilliance to the males' plumage; the males have slightly longer wings, and the females' bills are somewhat more decurved.

Band-tailed Barbthroat
(*Threnetes ruckeri*)
CHRISTOPH HINKELMANN

Green Hermit
(*Phaethornis guy*)
CHRISTOPH HINKELMANN

In the undergrowth of a Neotropical forest, where the light is weak, you may suddenly be surprised to encounter a medium-sized hummingbird. It appears unexpectedly to hover in front of you as though it is interested in discovering who came to visit its home range, and it may vanish into the vast complexity of leaves, mosses, ferns, and vines as quickly as it came. First encounters with one of the larger hermit hummingbird species are commonly similar to this one.

One of these species, the Green Hermit (*Phaethornis guy*), is about 13 cm (5 in.) long, large parts of its length being made up of its bill and tail. They are distributed from Costa Rica to Colombia and along the east Andean slopes to southeast Peru. As well, Green Hermits occur in Trinidad and northeast Venezuela, well separated from their western relatives.[1] Their distribution is the result of interspecific competition.

Green Hermits have a body mass of 4 to 7 g (0.14–0.25 oz) and a long, slightly decurved bill, which is slightly more arched in females than in males. It is adapted to long, tubular blossoms of 3 to 5 cm (1–2 in.) in length and 2 to 7 mm (0.08–0.27 in.) in width. Such flower tubes belong to several species of *Heliconia*, *Columnea*, and *Drymonia*, as well as other genera, and Green Hermits have been observed at a large variety of blossoms including introduced species such as *Musa* (bananas) and *Canna*.

In addition to their restricted distribution, Green Hermits are limited to premontane areas that are both hilly and wet, between 600 and 2200 m (2000–7200 ft) in Central America and northwest South America.[2] While there are similar habitats and feeding flower sources below this altitude, they are inhabited by other species of hermits with similar size and bill shape. These are the Long-billed Hermit (*Phaethornis longirostris*) in Central America and northwest Colombia and the Great-billed Hermit (*P. malaris*) along the east Andes in South America. Furthermore, in some even higher mountain range regions in the Andes, where the Green Hermit inhabits elevations up to 2700 m (8900 ft), it is supplanted by the Tawny-bellied Hermit (*P. syrmatophorus*), which itself is distributed up to 3100 m (10,000 ft). In Trinidad and northeast Venezuela, however, where there are no congeners of similar size and bill shape, the Green Hermit occurs from sea level to 1000 m (3300 ft) in elevation.

The preferred habitats of Green Hermits are the understory of primary humid montane as well as premontane forest, forest edges, shrubs, clearings, and adjacent plantations with dense vegetation. They are often seen near water and traplining for feeding flowers along water courses. However, they tend to avoid secondary growth in the first stages of their development. Unlike other hermit hummingbirds, Green Hermits have been observed in the canopy of the forest.[3] While there have been some indications of habitat movement described, neither their seasonality nor their range has yet been determined.

Among hermit hummingbirds, the male Green Hermit, along with its closest relative, the White-whiskered Hermit (*P. yaruqui*) has the most brilliant body coloration. The plumage of its head, breast, shoulder, back, and rump is a bright, iridescent green similar to that of the vast majority of "typical" hummingbirds. Females are much duller in color, with less iridescent feathers, and have a markedly longer tail, the central feathers of which have prominent white tips. Thus, the appearance of the female is much more typical of hermits than that of the male.

The name "hermit" derives from the dull plumage of these remarkable small birds, not to their behavior. In fact, that designation is almost inapplicable to their social behavior when compared with that of the large majority of hummingbirds. Typically, members of this family are aggressively individualistic, whereas most hermits tend to gather in common areas.

The present International Union for Conservation of Nature (IUCN) Red List of Threatened Species status of the Green Hermit is Least Concern.[4]

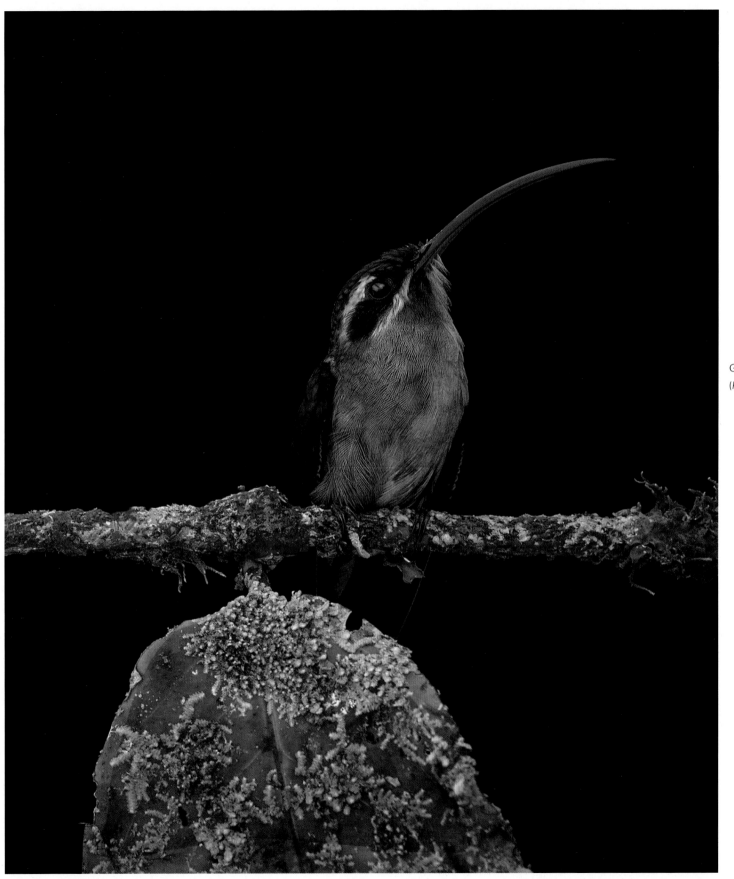

Green Hermit
(*Phaethornis guy*)

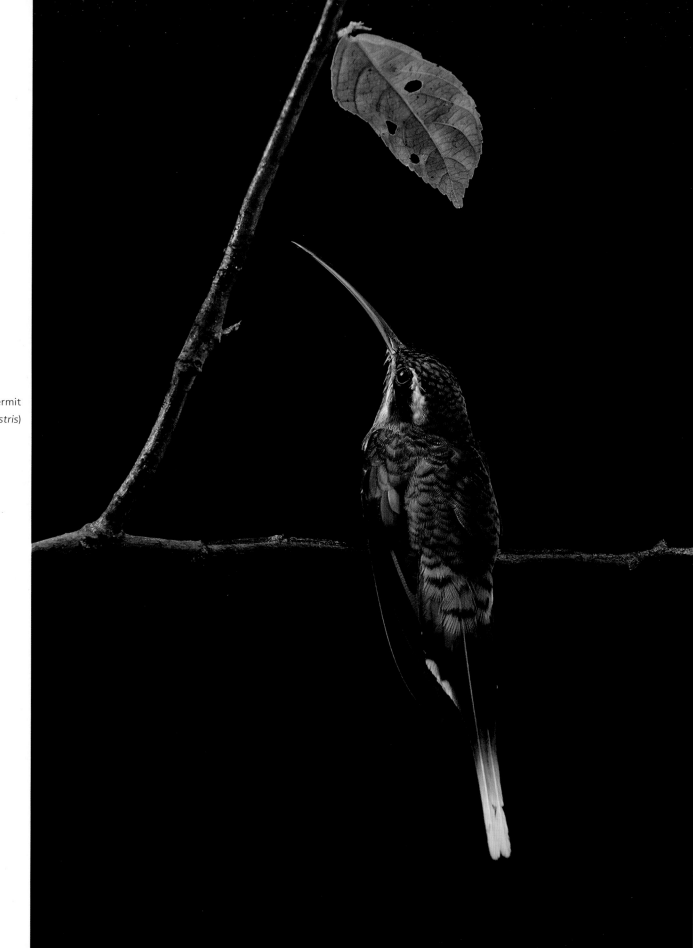

Long-billed Hermit
(*Phaethornis longirostris*)

Most hummingbirds are noticed while they whiz past, displaying flashes of shimmering iridescence on their way from one flower to the next. Long-billed Hermits (*Phaethornis longirostris*), however, are usually heard rather than seen first. When dry season starts in the lowland Neotropics, quiet patches of dense forest suddenly echo with the incessant calls of dozens of lekking male hermits. Their cryptic brown feathers blend perfectly with the dry underbrush, and they are hard to spot even while chirping just feet away. Lekking males stay within their small territory, often choosing just a few favorite perching twigs to sing from continuously during the breeding season. If a male manages to attract the attention of a visiting female, they will quickly mate, and she will fly off to build a cone-shaped nest on the tip of a large leaf in the forest understory. As with all hummingbirds, the female is entirely responsible for parental care. Her two eggs will hatch after 17–18 days of incubation.[1] Freshly hatched chicks have short bills, but they will rapidly grow long and decurved, as their common name suggests. If successful, fledging occurs 22–23 days after hatching.[2]

The seemingly monotonous calls of a Long-billed Hermit lek belie a fascinating complexity. A careful ear can detect multiple distinct song types within a single lek.[3] Nearby males often sing similarly, but males distant from each other rarely sing the same. Regions of the lek, where males have similar songs, are referred to as song "neighborhoods" and can emerge as a product of vocal learning between the males. Vocal learning, a trait found in humans, is rare among animals. In birds, it has evolved three times: in the oscines (songbirds), parrots, and hummingbirds. Long-billed Hermits, in particular, are open-ended song learners.[4] This capability is even more unusual, allowing an individual to change its song throughout its lifetime, rather than being stuck with an unchanging song after a juvenile learning period. The neural architecture underlying open-ended learning and its evolution is an ongoing and active area of research.

Singing for females is just one of many activities that occur on a lek. If a male cannot defend his territory, he will quickly be usurped by another. Tiny hummingbirds like Long-billed Hermits may appear delicate, but ancient Aztecs saw them as anything but. Hummingbirds were associated with *Huitzilopochtli* (meaning "hummingbird on the left," or "hummingbird of the south"), who was their supreme deity and the god of war. Images of hummingbirds were often etched into bone tools used for human sacrifice.[5] True to this more violent depiction, Long-billed Hermit males develop sharpened bill tips as adults and are thought to use this as a weapon during fierce fights with other males that may try to commandeer a valuable nectar recourse or a prized space on the lekking grounds.[6]

"A number of these shade-dwellers have been called 'hermits,' not because they are less sociable than other hummingbirds, but because of their modest attire, in which browns predominate. Usually they have long bills, and often also long tails."[7]

Why do Long-billed Hermits, and most other hermits, eschew the gaudy iridescence of other hummingbirds? Before molecular genetics, taxonomists divided hummingbirds into two subfamilies: the hermits in one and the rest of the hummingbirds in the other. Explaining the drab coloration of hermits was therefore straightforward: hermits simply maintained the cryptic coloration of the drab-colored ancestor of all hummingbirds. Recent genetic studies, however, have shown this to be incorrect.[8] It is much more likely that the ancestor of all living hummingbirds was colorful and that the hermit lineage evolved a drab color pallet later.[9] So, the question remains—why are hermits so plainly colored while other hummingbirds show off? Competition for the attention of females is often invoked as an explanation for flashy and bright ornamentation. Clearly, though, competition for females is very important to male Long-billed Hermits.

Understanding the complex ways that evolutionary forces interact is a continuing challenge for evolutionary biology, but exceptions to the rule like the Long-billed Hermit are necessary for honing and refining theoretical frameworks.

Long-billed Hermit
(*Phaethornis longirostris*)
JAY J. FALK

White-whiskered Puffbird

(*Malacoptila panamensis*)

JOHN P. WHITELAW

The family Bucconidae (the name attributed to the French zoologist Mathurin J. Brisson in 1760, from the Latin *bucca*, for cheek) consists of ten genera, which include nunbirds, nunlets, a monklet, and twenty species of puffbirds.[1] The genus *Malacoptila* (from the Greek *malakos*, for soft, and *ptila*, for feather) includes the White-whiskered Puffbird and six other puffbirds, ranging in size from 12.5 to 27.5 cm (5 to 11 in.). They are chunky, large headed, and short tailed; they have similarly streaked brownish coloration, rounded wings, and hooked bills; and their small feet have two toes facing forward and two backward. Large eyes allow them to forage at dusk, but they are diurnal. Their contour feathers appear fluffed-up and loosely shaped. All are arboreal and share the foraging behavior of perching on exposed small branches 4.5 m (15 ft) or higher, where they sit nearly motionless for long periods, patiently watching for clinging or creeping prey in the surrounding vegetation. They favor large insects, spiders, small lizards, and frogs. Once prey is spotted, the birds dash out, capture it with their hooked beaks, smack it against a perch until it's dead, process it, and then swallow it whole. This strategy of sitting and waiting, along with their tolerance of close human approach, has resulted, perhaps unfairly, in their being dubbed "dumb" or "stupid." In Spanish, they have been nicknamed *bobo* (dummy).

Malacoptila panamensis is found from Mexico to Ecuador. The English lawyer and ornithologist, Philip L. Sclater, called it the "softwing" in 1882, a name now seldom used.[2] In the highlands of Panama, Chiriquí natives refer to it as "*pajaro brujero*" (witch doctor) and have likened its rarely heard sounds to the singing of the *brujos* (sorcerers) of the Guaymi Indians of western Panama.[3] Alexander Skutch regarded it "as among the most silent birds of the tropical forests of America"—a trait that, when combined with the darkish brown plumage, makes it difficult to see.[4] It is an occasional follower of ant swarms and has been observed capturing and eating a small coral snake (*Rhinobothryum bovallii*).[5]

The white facial feathers give this bird a characteristic look, which has been likened to a walrus or a man with a Fu Manchu mustache. In addition to these contour feathers, however, are more interesting feather types—rictal bristles and semibristles—which are a conspicuous feature of many insectivorous bird species, particularly flycatchers. For more on rictal bristles, see the separate account by John W. Fitzpatrick in this volume.

Bristle feathers are among the most interesting adaptations neotropical understory species have evolved in response to their environment. As Skutch observed, "It is distressing to think how many other birds, equally well adapted and equally fascinating, are in danger of extinction before we know how they live."[6]

The White-whiskered Puffbird nests in burrows that are as long as 55 cm (21 in.) and lined with dead leaves and in which two eggs are laid. After the eggs hatch, the male assumes brooding responsibilities while the female forages for food.

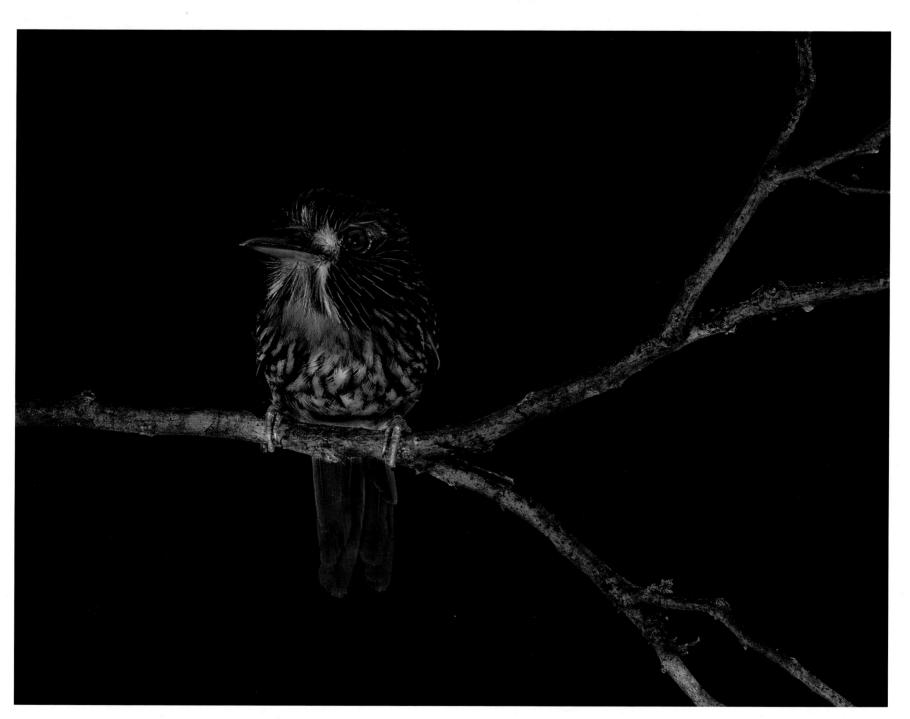

White-whiskered Puffbird (*Malacoptila panamensis*)

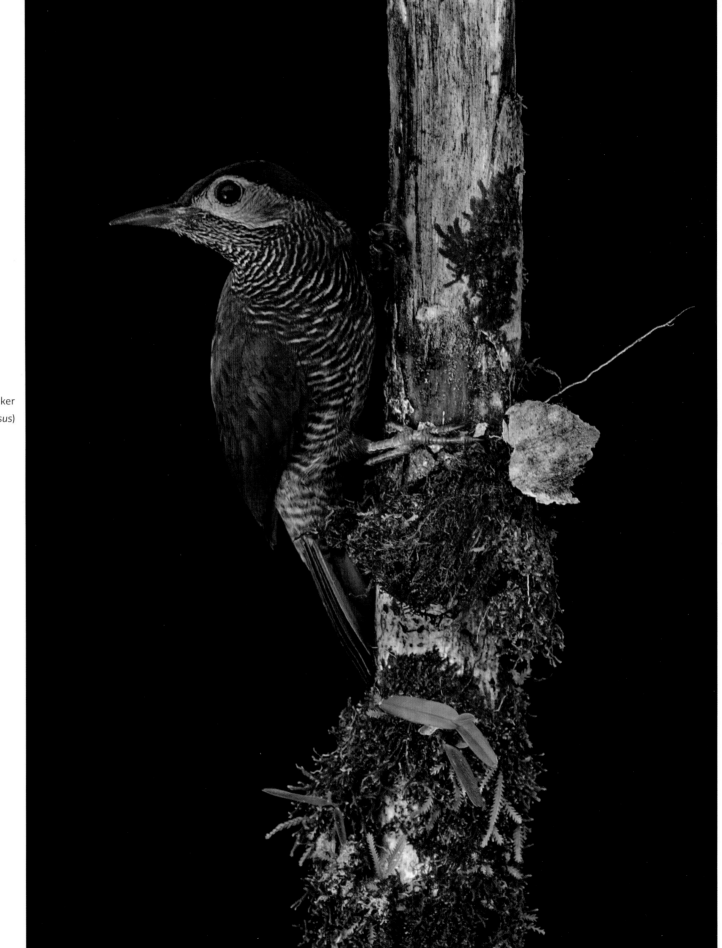

Golden-olive Woodpecker
(*Colaptes rubiginosus*)

The attractive Golden-olive Woodpecker (*Colaptes rubiginosus*) is known as *Carpintero Olivo y Dorado* in Spanish (*carpintero* means "carpenter"). It is, for the most part, commonly resident throughout most of its range in the mountainous tropical and subtropical forests of Central America and the Pacific slopes of Ecuador and Peru. It is not considered globally threatened. The adult coloring is mainly golden olive, with some barring on the tail. The head is slate gray in front and red at the back, hence the *rubiginosus* in its scientific name. The face is yellowish white, the underparts of the body yellowish olive and transversely barred. Both sexes have black bills, but the adult male is distinguished by its red "mustache."[1] Skutch observed that the first plumage of the young of this species is colored like that of the adults of the same sex.[2]

The Golden-olive Woodpecker's preferred diet consists mainly of insects, including ants, termites, beetles, and their larvae, occasionally supplemented with some fruit and berries. It may forage singly or in pairs.

Despite its widespread occurrence, this bird can be easily overlooked because of its somewhat sluggish behavior, unless one is familiar with its call, which has been described as a loud *wheep*. Skutch described it as a "far-carrying . . . high-pitched, clear, powerful note, repeated very rapidly to form a long-continued roll or trill, all in approximately the same key; the call-note of both sexes (being) a high, loud, sharp *beee*, and . . . a dry *churr*."[3] It is easily distinguished from the vocalizations of the other woodpecker species in the same habitat.[4]

The Golden-olive Woodpecker, sometimes referred to as the "green woodpecker," excavates deep nest holes in a stump or tree, which also function as dormitories, although the male and female sleep separately. The female also sometimes uses the abandoned roost holes of other woodpecker species. In breeding season, the female lays two to four glossy white eggs, which Skutch observed resting on clean wood chips at the bottom of the nest hole.[5] Both males and females share in incubation and in feeding of the hatchlings by regurgitation. Not all the hatchlings may survive because of the depth of the nest and the competition for food delivery, where it's "every chick for itself."

Because it mainly inhabits mountain forests separated by large rivers, some authors consider that this species has evolved into an astonishing eighteen to nineteen subspecies, of varying coloration and song.[6]

Golden-olive Woodpecker
(*Colaptes rubiginosus*)
JOHN P. WHITELAW

Black-crowned Antshrike

(*Thamnophilus atrinucha*)

COREY E. TARWATER

The first sound you hear when you walk into a lowland tropical forest in Panama is the harsh, simple song of the Black-crowned Antshrike, consisting of a series of *uh* notes ending with a single *urk*. Even birders who cannot whistle can adequately mimic their sounds. As their name suggests—*Thamnophilus* is derived from the Greek words *thamnos* (shrub) and *philos* (loving)—this small bird often hops slowly through dense vegetation foraging for food. Although these Black-crowned Antshrikes are among the least colorful birds in the forest, they make up for this with some serious charisma.

In lowland forests, Black-crowned Antshrikes are incredibly numerous and highly territorial. At any given time, there are not only territorial neighbors, but there are floaters that don't have territories and are trying to take one over.[1] For this reason, the Black-crowned Antshrikes are often singing or fighting with their neighbors or chasing floaters off their territories when they encounter them. Most of the time, they avoid direct conflict and simply sing from high perches, but you will see a lot of chasing, displaying, and sometimes physical contact when they get angry. Individuals will fly to the intruder, puff out their back feathers to display their white back patch, tilt their head low, and rotate back and forth on a branch while making low guttural sounds. This behavior can escalate into chases and, potentially, even midair hits and biting. Although escalation beyond singing is more frequently seen in males, females are highly territorial as well. Females respond readily to neighbor songs and, if a female intruder is observed, either the male or the female will give chase. When intruders are male, it is more often the territorial male doing the chasing, but females will still engage in singing. While Black-crowned Antshrikes are territorial, they are also somewhat unpredictable. You could use a playback of their song in a pair's territory and find they completely ignore you, they swoop at your head, or you initiate a fight between neighboring territories that goes on for over an hour. It all depends on what they are doing—for example, if they've just captured a desirable prey, they are unlikely to give it up to fight.

Despite being a forest understory insectivore, a group of species that are more vulnerable to habitat fragmentation and other environmental perturbations, Black-crowned Antshrikes are highly flexible. For example, they are adaptable and opportunistic in their foraging behaviors. They can be seen foraging on the ground or 30 m (100 ft) up in the canopy. Their diet varies from small prey that they capture in the air to lizards that are longer than themselves.[2] Antshrikes have a hooked bill that aids in prey capture. They fly or knock larger prey to the ground, where they beat them against a log or the ground until they break apart. It is not uncommon to see an antshrike flipping over leaves on the ground. This isn't because they are looking for something found on the ground but simply because they are looking for the prey that they knocked off a leaf or branch. They utilize a wide variety of foraging behaviors and substrates. Their most common foraging method is simply to perch, look under, above, and inside leaves, and slowly hop through the vegetation until they see a prey item. They will forage with their mated pair, their family group, understory mixed-species antwren flocks, canopy mixed-species flocks, or army ant swarms. They forage in mixed-species flocks opportunistically, joining them when they pass through their territories, rather than being core members. They distinctly favor foraging with understory antwren flocks, which are saturated in most environments, thus almost any antwren flock will contain a Black-crowned Antshrike pair, often being sentinels in these flocks as they are the first to vocalize and freeze when a predator comes close.

Black-crowned Antshrikes are also flexible in many of their reproductive behaviors. Some pairs may start breeding in January, and others may not begin until April.[3] Likewise, many pairs stop breeding in July, but others continue throughout the year; indeed at least one Black-crowned Antshrike nest has been observed in every month of the year. They build small, inconspicuous, open-cup nests that can range from 0.25 m to 7 m (0.8–23 ft) in height, depending upon the vegetation. The number of their nest attempts per year is also highly variable. Owing to high nest predation, many pairs breed repeatedly (up to twelve times!) to achieve one successful nest in

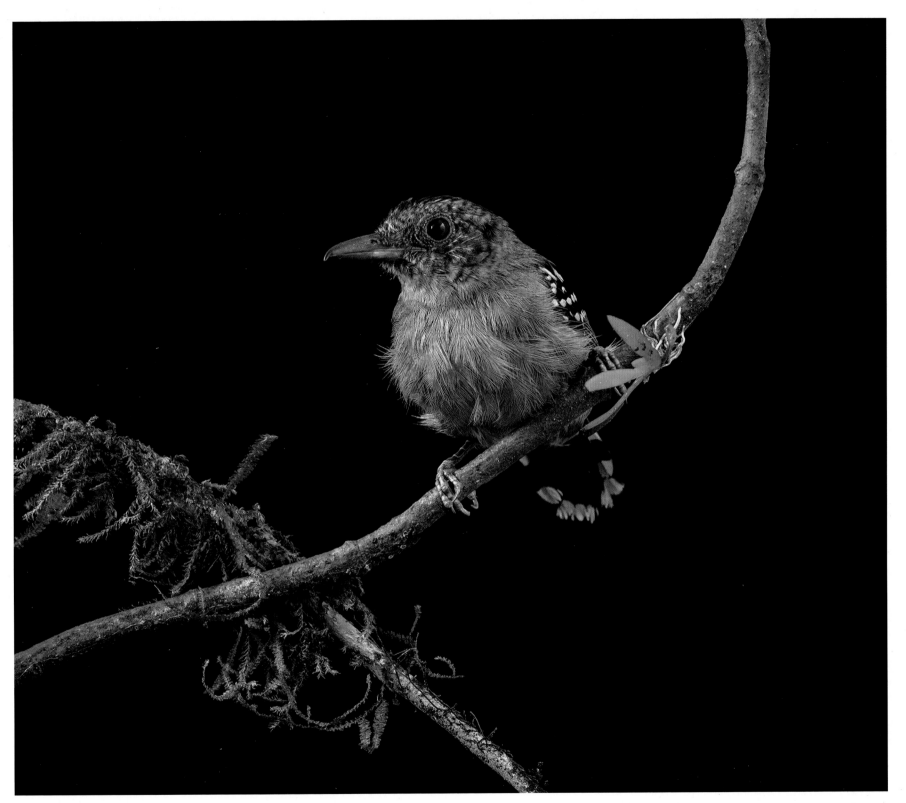

Black-crowned Antshrike (*Thamnophilus atrinucha*)

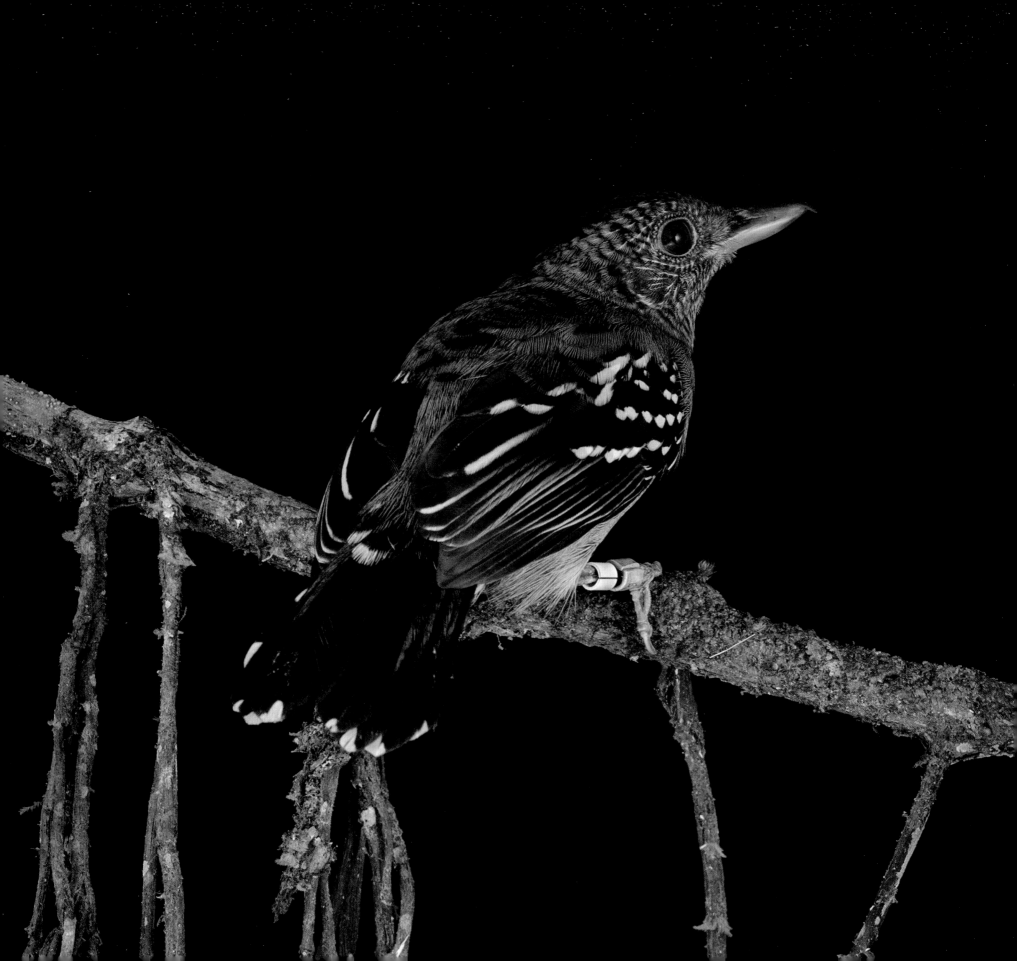

a year.[4] During peak breeding seasons, some pairs may wait only 1 week between nesting attempts. Other pairs produce only a few nests but may be highly successful, producing two broods in a year. Because breeding pairs that have been together for longer will re-nest more rapidly and start breeding earlier, "divorce" and extra-pair paternity is uncommon in this species.[5] Both sexes build nests, equally incubate eggs, and feed nestlings and fledglings. They may feed their fledglings for only 1 month after leaving the nest or up to 3 months, actively chasing some young from their territories after they stop feeding them, while allowing others to remain with them for up to a year.[6] This high flexibility in reproductive behaviors allows these antshrikes to take advantage of good breeding conditions and to maximize their success, even with high nest predation rates.

Black-crowned Antshrikes are inflexible regarding clutch size and brood division, the clutch consisting of two or, only in extremely rare cases, just one.[7] After their offspring leave the nest, the male feeds one and the female feeds the other, exclusively. In the rare instance of an adult's death, its fledgling will likely die unless it is old enough to feed itself. These antshrikes appear incapable of, or unwilling to, feed two fledglings at a time.

The Black-crowned Antshrike is part of the antbird family, and researchers have shown the importance of these insectivores for reducing herbivory and maintaining plant communities.[8] Although it is currently not of conservation concern, 21% of antbird species are at risk, primarily because of habitat fragmentation and loss. Antshrikes are highly adaptable, but they still possess many of the traits thought to put this group of species at risk—limited dispersal being foremost.[9] They have been studied primarily in intact forest, so it is unclear how well they do in fragmented landscapes. An understanding of their future fate is critical.

Black-crowned Antshrike (*Thamnophilus atrinucha*)

Russet Antshrike

(Thamnistes anabatinus)

PHRED M. BENHAM

On the forest floor you can hear the trills, whistles, and chatters of a vibrant avian community drifting down to your ears from the forest canopy far above your head. Rarely do you get decent looks at these birds, and it can take years of experience to connect songs with their difficult-to-see makers. In foothill and adjacent lowland rainforests from southern Mexico to northern Peru, the Russet Antshrike (*Thamnistes anabatinus*) dwells among these canopy birds. A short series of evenly spaced, down-slurred, sweet notes, *tswee-tswee-tswee-tswee-tswee*, may be the primary clue to its presence.[1] Yet, with luck, a good view of the Russet Antshrike can be had when it makes the occasional foray into the lower tiers of the forest, or if you ascend via tower or crane into its canopy domain.

Without a satisfying look, it may be difficult to identify the Russet Antshrike as a member of the antbird family, Thamnophilidae. Given its preference for the canopy and uniformly rufous-brown plumage, you may be tempted to search for this species in the ovenbird section of your field guide or question whether it is some sort of brown shrike-vireo. You would not be alone in your difficulty. The great tropical ornithologist, Alexander Skutch, also struggled to identify it as an antbird at first: "Its whole aspect and manner of life are so different from typical antbirds that I never attributed it to this family until one day, years after I had become familiar with it, I came close enough to a low-foraging individual to detect the revealing hook at the tip of its upper mandible. Until then, I had tried fruitlessly to find its description among the ovenbirds."[2]

The robust, hook-tipped bill observed by Skutch is shared with the other antshrikes in the antbird family (e.g., Black-crowned Antshrike) and reminded early ornithologists of the fearsome bills possessed by the predatory shrikes ("butcherbirds") living in the temperate zone. This shared bill morphology gives both the Russet and Black-crowned Antshrikes their English name. However, this similarity does not reflect a close evolutionary relationship between these species, which last shared a common ancestor about 23 million years ago.[3] Rather, the similar bill morphology reflects independent convergence on an appetite for large insects and small vertebrates. Black-crowned Antshrikes will seek this prey in the understory, and

Russet Antshrikes exploit a similar dietary niche in the canopy. Antshrikes are not the only antbirds that independently arrived at similar morphological solutions to common ecological pressures. Antwrens were initially thought to be closely related to one another based on their similarly diminutive size, but more recent DNA analyses show that the antwren body type evolved multiple times independently within the diverse antbird family.[4] Although about 230 antbird species exist across the Neotropics, the majority tend to be different shades of gray and brown with an occasional sprinkling of white spots. Thus, it may not be too surprising that avian taxonomists incorrectly grouped antbirds together by morphological similarities prior to the advent of DNA sequencing.

Some of the unique features of the Russet Antshrike make sense in light of its distant relationship to other antbirds. Unlike many antbirds, male and female Russet Antshrikes are nearly identical in appearance, with the only difference being a bright orange-rufous feather patch in the center of the male's back. The canopy haunts of the Russet Antshrike are shared by only a few other antwren species and, interestingly, the Spot-winged Antshrike (*Pygiptila stellaris*), which turns out to be the closest relative of the Russet Antshrike.[5] The canopy may seem like a foreign land to most antbirds, but the Russet Antshrike is at home here, traveling through the canopy with other foraging bands such as tanagers, warblers, and flycatchers. It will hop deliberately along branches, jabbing at insects it spies under the surfaces of leaves and branches or occasionally deploying its bill to rip apart dead leaf clusters. When it arrives at the end of a branch, it will often fly to a lower position on the next tree and hitch vertically up smaller stems or vines before arriving at the next promising branch to explore.[6] Only occasionally will it descend lower in the forest to forage in vine tangles or to investigate the commotion raised by an ant swarm stampeding through the understory.[7] The nest, built by both sexes, will also be placed high in the forest. Usually at a height of 7–15 m (23–50 ft), a Russet Antshrike pair will attach their cup-shaped nest to a fork between two twigs by means of cobwebs and fungal strands. The female will lay two white and brown speckled eggs, with both parents sharing in the burden of incubation and feeding young.[8]

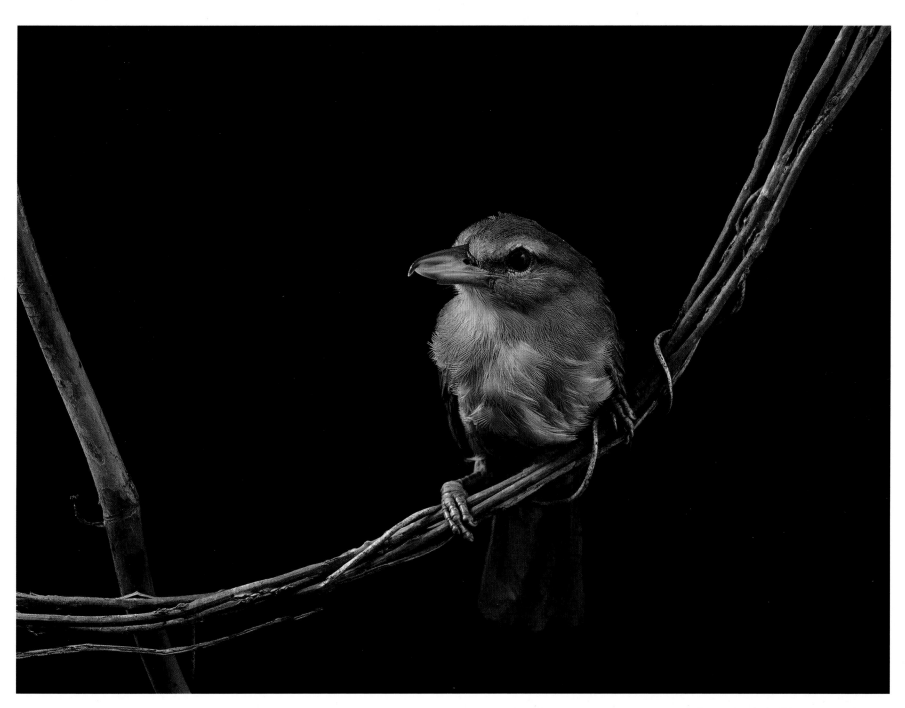

Russet Antshrike (*Thamnistes anabatinus*)

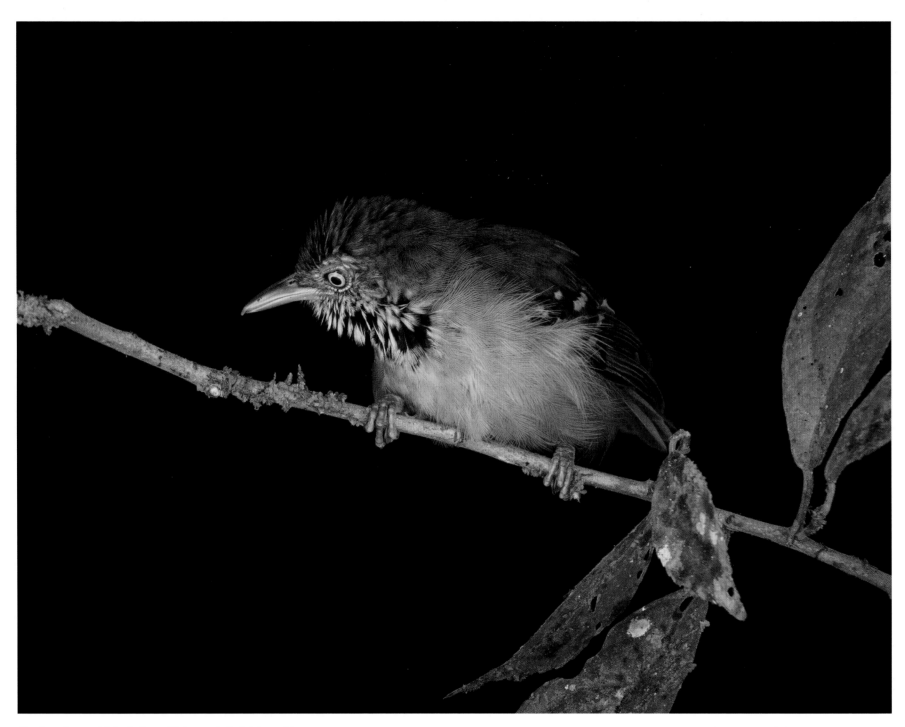

Checker-throated Stipplethroat (*Epinecrophylla fulviventris*)

In the shadowy understory of tropical American forests, where light levels are low and numerous viny thickets obscure vision, most birds don't bother carrying brightly colored plumage because colors are too hard to notice. However, many of these LBJs ("little brown jobs") turn out to be surprisingly colorful in *what they do*, and the Checker-throated Stipplethroat is a prime example.

These little dwarves live as mated pairs and vigorously defend territories against others of their own species. When pairs encounter one another near a territory boundary, the males face off against each other only a few inches apart, lower their heads, fluff up their back feathers, puff out their checkered throat feathers, alternately thrust their heads side to side, and stare at one another with their wild, pale-yellow eyes while— *in unison*—uttering a rapid series of sharp, squeaky notes. If their calling falls out of sync, they stop and start again, in unison. This amazingly choreographed, dancelike aggressive display can last for several minutes before the pairs wander off to resume foraging.

Despite being fiercely territorial, Checker-throated Stipplethroats mostly do not live as isolated pairs. Rather, most pairs spend their days in close company with several other bird species, often including two diminutive and closely related species, the Dot-winged (*Microrhopias quixensis*) and White-flanked (*Myrmotherula axillaris*) Antwrens. They even roost at night together with these other species, sometimes sleeping within inches of each other on the same branch. These mixed-species flocks even co-defend their territories against other, neighboring mixed flocks in the forest understory, engaging in long, ritualized calling bouts with members of each species squaring off against their corresponding rivals in the other flock, often at precisely the same boundary locations day after day. The main advantage of spending most of each day in close proximity with other species seems to be that with more eyes available for spotting predators, individuals find themselves safer foraging within a flock than they would be alone or as a simple pair.

Checker-throated Stipplethroats play a lead role in these mixed-species foraging assemblages because, when they are alarmed, both sexes utter conspicuous *tseek* calls that are louder than those of other birds in the understory. Insectivorous birds possessing unusually loud alarm calls often act as the nucleus for mixed flocks, as other species benefit from foraging within earshot of them. Whether they know it or not, such is the ecological role played by Checker-throated Stipplethroats.

One might imagine that having other birds continually foraging very close by could reduce foraging efficiencies because of competition. After all, most insectivorous birds of the tropical forest understory will eat virtually any living thing they can find, capture, and subdue. Checker-throated Stipplethroats, however, have their own uniquely specialized method for finding food that is mostly out of reach for their flock mates. These acrobatic little birds spend most of their day searching out and landing upon all manner of what Judy Gradwohl and her husband, Russ Greenberg, called "aerial leaf litter"—the curled-up dead leaves, dried leaf clusters, and mats of decaying vines that abound, captured and suspended above the ground, throughout the tropical understory and midstory.[1] While their flock mates forage mainly by moving rapidly through foliage and gleaning insects from live leaves, or sallying out to catch escaping prey, the stipplethroats fly systematically from one dead-leaf cluster to another. While hanging upside down from the edge or bottom of a dead leaf, or sometimes perching on top of it, the stipplethroat probes and rummages inside the folds of the leaf with its bill, sometimes spending up to a minute delving into larger leaves or dead-leaf clusters. When lucky enough to capture a sizeable prey item, such as a roach or large katydid, the bird stabilizes itself on a nearby perch and repeatedly bashes the item against the branch. Stipplethroats can spend so much time inspecting dead leaves and subduing prey that they often lag behind other species as the mixed flock moves through the understory. Other birds occasionally explore dead leaves, but very few species do so in such a systematic and specialized manner as this species and its close relatives.

Checker-throated Stipplethroat
(*Epinecrophylla fulviventris*)
JOHN W. FITZPATRICK

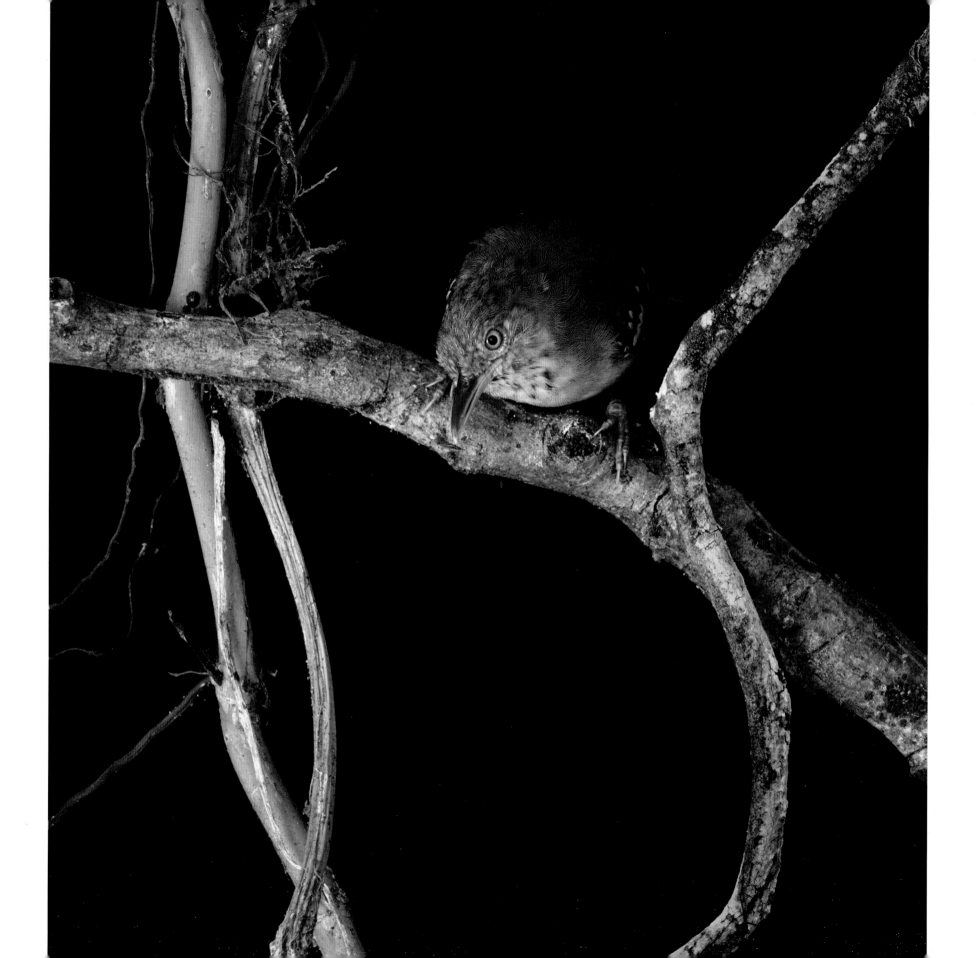

The Checker-throated Stipplethroat is limited to Central and northwestern South America, from eastern Honduras and Nicaragua south to western Colombia and Ecuador. Each of the seven other stipplethroats, distributed through the eastern Andes and Amazon regions, also employs the same, remarkably successful ecological habit of dead-leaf foraging. This unusual specialization helps explain why, following a recent DNA-based revision of antwren taxonomy, a group of scientists highly familiar with these species coined the new genus, *Epinecrophylla*, for this distinctive group of stipple-throated antwrens. That paper explains the name thus: "Etymology.— The feminine generic name is taken from the Greek *epi-* (on), *necro-* (dead) and *phyllo-* (leaf), meaning 'on the dead leaf,' reflecting the strong predilection of members of the genus to search for insects on dead hanging leaves."[2]

The unusual dead-leaf foraging behavior and distinctive stipple-throated plumage patterns of this eight-species group corresponded perfectly with overwhelming DNA evidence that these species are not part of the main, large assemblage of Neotropical antwrens (i.e., their former genus *Myrmotherula*). Moreover, while most antwrens build open-cup nests, all the stipplethroats for which nesting behavior has been documented build distinctively domed, hanging nests that may be up to 15 cm (6 in.) deep, with a small oval opening at the top. These nests are composed of thin rootlets, filaments, and dead leaves and lined inside with very fine fibers. Mostly the nests are low over the ground, attached to the tips of downward drooping branches of understory shrubs. As with so many other tropical understory species, most nests contain just two eggs. Both parents incubate and feed the nestlings. Surviving fledglings will hang around with their parents (and the mixed flock they may live amidst) for 6 months or more after leaving the nest.

Although the charming stipplethroat assemblage comprises eight species, ecologically there seems to be "room" for only one species in any given place, as geographic and habitat overlaps among them are very limited. In the few places where two or three species do come together, as in the southwestern Amazon, they occur at different elevations or in different habitats. As a result, understory mixed flocks across the Neotropics contain just a single stipplethroat pair.

Checker-throated Stipplethroat (*Epinecrophylla fulviventris*)

White-flanked Antwren
(*Myrmotherula axillaris*)
SCOTT ROBINSON

One of the most daunting experiences any birdwatcher faces in the tropics is the sudden appearance of a mixed-species flock of hyperactive, similar-looking birds moving through the forest understory. Most of the members of these flocks seem to have converged on dull gray and brown colors that make them maddeningly difficult to see and to identify in the often-brief time they are visible before disappearing into dense foliage.[1] Yet, every once in a while, there is a brief flash of bright white emanating from one of these flockers. This white flash contrasts so strongly with the rest of the bird, which looks almost black in the field, that the effect is startling. What a relief—here is a species with an obvious field mark! Even better, the field mark matches its name—the White-flanked Antwren (*Myrmotherula axillaries*), which has long, bright white feathers on its flanks and under its wings. Even the females have a hint of this white patch, making them relatively easy to identify.[2]

When White-flanked Antwrens are perched, these bright white feathers are largely hidden. When they fly, however, the patches are obvious. Why evolve bright patches that only show in flight? Wouldn't these bright patches act as a beacon to attract predators? Why might it be advantageous to be conspicuous when moving, but difficult to locate when perched? These questions have long interested ornithologists. Many other birds, and even some mammals, share these "flags"—bright or contrasting color patterns that are visible only when the animal is moving.[3] The white tails of deer are a famous example, and most birdwatchers use flags such as the white outer tail feathers of juncos (*Junco* spp.) or the yellow rumps of Myrtle Warblers (*Setophaga coronata*) for rapid identification. But these signals should also be obvious to predators. Why would these otherwise hidden birds of the dark understory be conspicuous when they fly?

The answers to this question have been surprisingly elusive. Such flashes of contrasting color have been called "cohesion signals" because they might help keep flocks together by letting other flockers know where and when they have moved. In fact, many, if not most, species that have contrasting plumage in their tails or wings live in monospecific flocks. White-flanked Antwrens, however, almost never travel with any others of their species except their mate and offspring.[4] In all other respects, they are fiercely territorial. Rather, the answer may lie in these birds being one of those understory species that depends almost entirely on the mixed-species flocks that are so critical to insect-eating birds of the tropical forest understory worldwide. Two other species that form multi-species flocks are featured in this volume (Checker-throated Stipplethroat and Black-crowned Antshrike), a clear indication that, if you are a foliage-gleaning insectivore in the forest understory, there is a very good chance that you spend most of your waking hours living in one of these flocks.[5] Most of these flocks are permanent—each species joins the same flock each day.[6] They defend the same territory, travel closely together, and sometimes even steal food from one another. When two flocks approach each other, each species fights its counterparts in the other flock, but they ignore all of the members of the flock that are of different species.[7] What do they care if their flock has two pairs of Checker-throated Stipplethroats? Their only concern is that there be no other White-flanked Antwren searching for insects in the same place and trying to steal their mate.[8]

Indeed, these flocks must be important because they have definite downsides. Russ Greenberg and Judy Gradwohl report many instances when they observed Black-crowned Antshrikes stealing large insects such as katydids from antwrens.[9] For the antshrikes, these flocks are clearly advantageous, but for the antwrens, living in a flock can be quite costly, especially when they lose large insects that often provide the same amount of food as ten smaller ones. There is mounting evidence that these flocks exist mainly to protect the members against the many ambush predators that occur in the forest understory—the Barred Forest-Falcons (*Micrastur ruficollis*) and Tiny Hawks (*Accipiter superciliosus*) that are attracted to understory flocks.[10] Losing food, especially katydids, is costly, but it is far less so than being eaten by a raptor. Larger flocks have more eyes searching for predators, which allows birds to

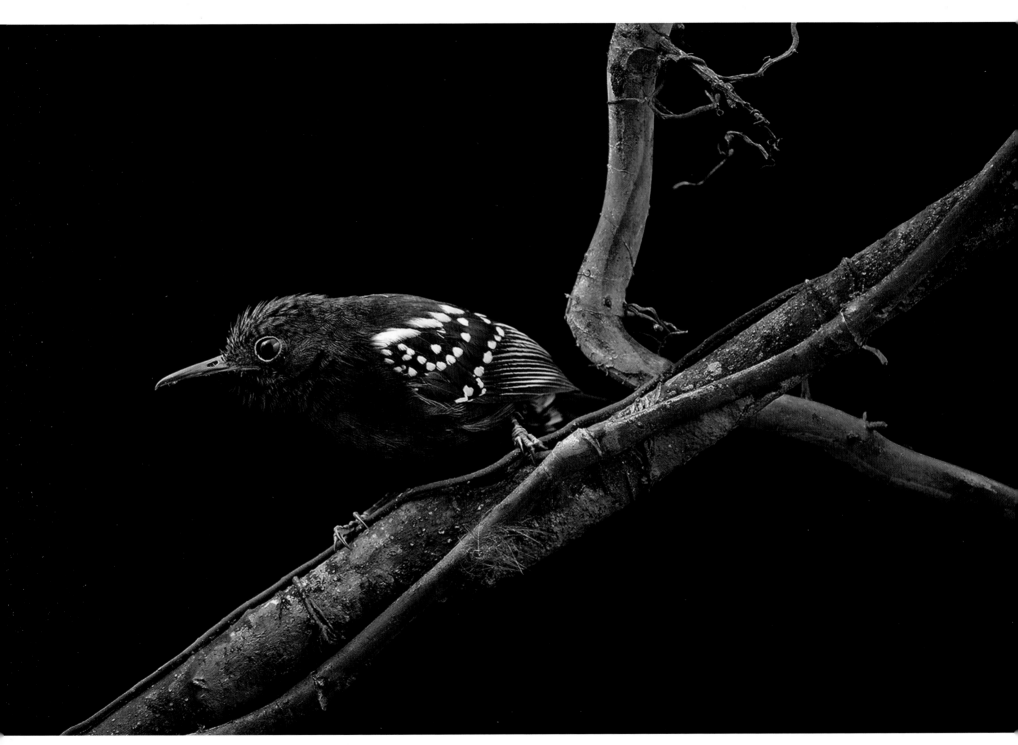

White-flanked Antwren (*Myrmotherula axillaris*)

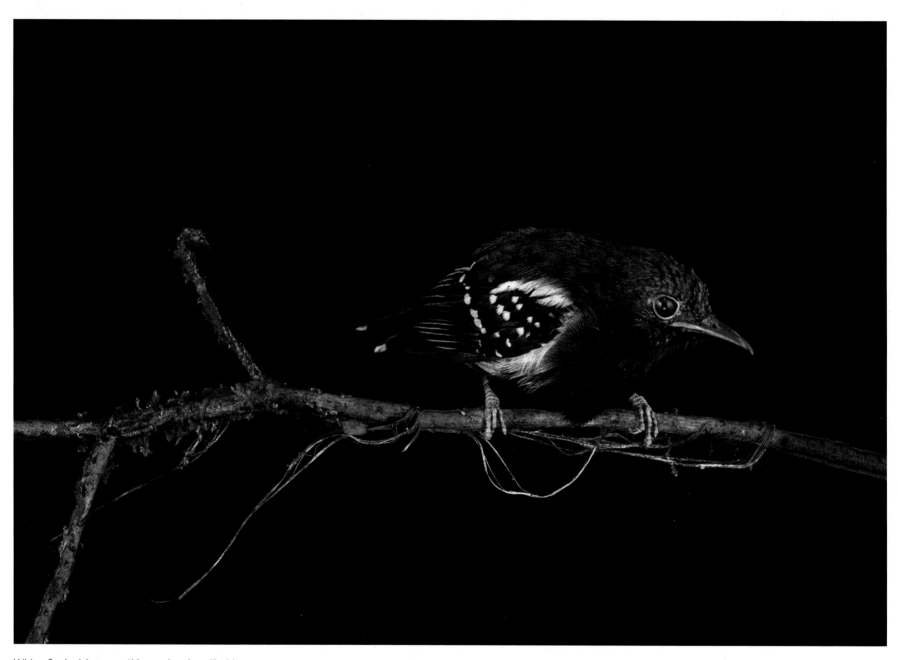

White-flanked Antwren (*Myrmotherula axillaris*)

forage more and decreases the likelihood that any individual bird will be the victim should the predator evade detection and attack.

Multispecies flocks are an elegant solution to the increased competition for food among birds that all forage closely together, while providing the antipredator advantages of living in groups.[11] Each member of a flock has its own foraging niche, which reduces competition because they are unlikely to be capturing the same insects. Stipplethroats search dead leaves; Dot-wings acrobatically chase insects from higher in the foliage. The antshrikes, which are among the largest members of these flocks, search for bigger insects. However, the White-flanked Antwren has, perhaps, the most generalized of all niches in the flock—it searches living leaves for whatever insects are sitting on them.[12] Perhaps for this reason, it is hard to find a flock anywhere in the lowland tropics, including the Amazon basin, that does not contain a pair of this species.[13] This is one of the true icons of the lowland forest understory.

Given the advantages of flocking, it seems logical to hypothesize that the White-flanked Antwren's white patches act as signals to other species that join flocks, and that they help each member of the flock stay close together. The costs of these signals may be reduced by the fact that they only flash when the bird is moving. Once the bird lands and is presumably more vulnerable to predation, the signal disappears, which may reduce the risk. To date, no one has done experiments to test any of the hypothesized advantages of the white flank, including the alternative hypothesis that it simply serves as a signal that identifies the species. Someday, scientists will do the necessary experiments to determine if artificially darkening the white feathers reduces flock cohesion, affects survival, or leads to reduced territorial defense effectiveness and the loss of mates. For now, however, we are free to speculate.

Chestnut-backed Antbird

(*Poliocrania exsul*)

THOMAS W. SHERRY AND
DEBORAH VISCO

One's first encounter with this bird is very likely to be its songs, long before it is actually spotted. The Chestnut-backed Antbird (*Poliocrania exsul*) skulks around old-growth, or old second-growth, tropical wet forest, often near water and away from drier ridges.[1] Their vocalizations, easily imitated by the human voice, are distinctive whistles: "two or three full, mellow whistles, transcribed as *fee, few!* or *fee, feh, few!* . . . the last note is usually slightly down-slurred and may be lower in pitch" and may be given throughout the day but most frequently at dawn.[2] This distinctive song is not easily forgotten, wherever the bird is encountered, from southeast Honduras, through Central America, then generally west of the Andes, south as far as central Ecuador, and from elevations of approximately 50–1000 m (165–3300 ft) and, rarely, up to 1,500 m (4900 ft) in the *cassini* subspecies of Colombia. With luck, one might see either sex singing while simultaneously "pounding the tail."

Although five subspecies are recognized, they are identifiable by only subtle differences in plumage. In addition to its song, the species itself is easily distinguished from others by the bare, bright blue-colored skin surrounding its chestnut-colored eyes, as well as the chestnut coloration over most of its body, contrasting with its dark gray (female) or black (male) head. The lack of any identified closely related species throughout much of its range probably helps distinguish this species from other antbirds. Typically occurring in pairs, occasionally in family groups with up to two additional individuals, these birds can be seen with some effort and are often abundant in their 1–2 ha (2.5–5 ac) home ranges. They rarely, and only opportunistically, follow army ant swarms, as is the case with many other "antbirds," likely earning them the Latin name *exsul*, meaning "stranger." Those who spend time in these tropical understory habitats might perceive the bird as a different sort of stranger: the neighbor whom you know is in his yard, as you hear him whistling, but can never quite catch more than a glimpse of him through his thick fence.

Thus, Chestnut-backed Antbirds are most readily encountered while singing, as they inhabit the often poorly lit understory where they forage and nest in its usually dense vegetation. Members of a pair typically forage within 5–10 m (16–32 ft) of each other and even groom one another. These birds are resident year-round and probably forage and nest where they most frequently find food within dense vegetation, including vine tangles, old tree-fall gaps, and often along streams. Individuals search for food anywhere in these locations, often probing for invertebrates (and rarely small frogs and lizards) in the debris that collects at the base of various palm plants.[3] Not surprisingly, their diet corresponds with what is to be expected in these foraging locations, including a variety of beetles, cockroaches and their egg cases, grasshoppers and crickets, earwigs, true bugs, caterpillars, spiders, centipedes, and, occasionally, even other Orthoptera and ants. Chestnut-backed Antbirds usually nest less than half a meter above ground on either dead or live vegetation. Commonly placed in the center of young palm trees (D. Visco, pers. observ.), their nests are an open 12 cm (5 in.) diameter cup supported from below by vertical stems or crisscrossed vines and protected from above by live leafy vegetation. The cup typically includes intact dead leaves arranged vertically, other dead plant matter, sometimes live green moss on the outside (more so at higher elevations), and a lining of long dark fibers, usually rhizomorphs, from "horsehair fungus."[4]

Their structure and location would appear to render these nests sitting ducks for the many potential predators patrolling the tropical rainforest understory and much less safe than the suspended nests of some flycatcher species nesting in similar habitats, such as the Ruddy-tailed Flycatcher.[5] Indeed, the open cups make the Chestnut-backed Antbird particularly vulnerable to a variety of snakes and other nest- and adult-predators. Herein lie some of the most interesting ironies surrounding this species, for example, that despite its often high rate of nest predation, this species persists as long as it does in remnants of old-growth forest fragments surrounded by pastures, agriculture such as banana plantations, and other human-generated habitats.[6] A particularly dangerous predator, to both eggs and chicks and even adults on the

Chestnut-backed Antbird (*Poliocrania exsul*)

Chestnut-backed Antbird (*Poliocrania exsul*)

nest, is the "bird-eating snake" (*Pseustes poecilonotus*), shown to cause 80% of the nest content losses in one Central American study and generally significant predation of open-cup nesting species in Panama.[7] These studies, and many others, have identified nest predators by recordings from video cameras placed near nests, ideally operating day and night. A variety of studies have identified white-faced capuchin monkeys, coatimundi, weasels, skunks, four-eyed opossums, and ocelots, as well as aracaris and toucans, army ants, fire ants, and forest-falcons as additional nest-content predators.[8] Adult members of the species are preyed upon by *Pseustes* and various other snakes, raptors such as the forest-falcon, *Accipiter* hawks such as the Tiny Hawk (*Accipiter superciliosus*), and likely mammals such as capuchin monkeys, weasels, and small members of the cat family.[9]

Another irony in the Chestnut-backed Antbird's life history is the length of its incubation period (typically 16 days, including 2-day lay period), considering its vulnerability to predatory nest losses.[10] To date, the best explanation is that the adults tend to avoid spending much time at the nests early in the incubation period to minimize drawing the nest to the attention of predators. They increase the amounts of time spent at the nest (which puts the adults themselves at risk of predators) only late in the incubation period, when the nest's survival to this point indicates the eggs are likely to survive to the point of hatching.[11] The nestling period, on the other hand, is relatively short, with fledging typically occurring on day nine. Fledglings spend at least several weeks with their parents.

Recent studies suggest several reasons why Chestnut-backed Antbirds may be able to survive as well as they do in forest fragments. First, they appear able to re-nest up to six times within a season in response to losing nests to predators.[12] Second, the snakes that prey on Chestnut-backed Antbirds are killed by humans indiscriminately—probably because of their similarity to the prevalent venomous types—thereby reducing their numbers, so that these birds may do relatively well in fragments surrounded by humans.[13] Third, this species may have the genetic variability to survive for long periods as small populations within rainforest fragments.[14]

This ability to persist in forest fragments is even more surprising considering how poorly Chestnut-backed Antbirds seem to disperse. Genetic studies suggest that, once birds are isolated within tropical forest fragments, they are unable to disperse easily into or out of them.[15] Even within continuous forest, young birds typically disperse a median distance of only 800 m (2625 ft), and the distance from their birthplace to where they settle as adult breeders is almost always less than 1500 m (4900 ft).[16] The short distances may be partly due to a lack of stamina in these understory-resident insectivorous birds, as demonstrated by a well-known experimental study in which they lacked the endurance to fly 200 m (650 ft).[17] Like many other tropical rainforest insect specialists, the Chestnut-backed Antbird has relatively small rounded wings for its body size, which suffice for its routine hops and short flights and are well suited to compete for prey in the understory environment. The lack of stamina of rainforest insectivores may, in turn, be a consequence of the need for such birds to specialize in order to compete with all the other insectivores in these habitats.[18]

Bicolored Antbird
(*Gymnopithys bicolor*)
JEFFREY D. BRAWN

Often heard uttering what have been termed "whistles," "buzzes," "grunts," and "bugles," the Bicolored Antbird can be especially loud among the other understory species, which tend to be heard more often than seen.[1] The context of these vocalizations is one of the most fascinating and unique behaviors of tropical birds and clearly explains why this species is called an "antbird." Along with several other species, the Bicolored Antbird is what ornithologists call an "ant follower." These species attend or follow swarms of army ants, especially those of the species *Eciton burchellii*, that are out foraging for arthropods and small vertebrates such as lizards. The birds do not eat the ants; rather, as swarms move across the forest floor, their potential prey flush to escape, and the antbirds are there watching and waiting to snatch them up. Some species of birds attend ants only when they are in or near their territory, but the Bicolored Antbird forages almost exclusively at these swarms and is, therefore, known as an "obligate ant follower." Since several species of birds are typically found at swarms, Bicolored Antbirds vocalize constantly to maintain their preferred position near the front of an advancing swarm.

Those lucky enough to observe Bicolored Antbirds and other species in action at ant swarms are in for an unforgettable experience.

The Bicolored Antbird is found in Central America from Honduras south to Panama; in South America, it occurs in western Amazonian Brazil and from northern Columbia to western Ecuador and northern Peru.[2] It is a member of the genus *Gymnopithys*, which currently includes four species, all of which inhabit the understory of moist tropical forests from sea level to about 1000 m (3300 ft). As implied by its common name, the plumage of this species is a stark contrast of white below and rusty or chestnut brown above, sometimes separated by a black line. In some parts of its range, it may also have a bare blue area around its eyes. Weighing about 30 g (1 oz), the Bicolored Antbird is reasonably common throughout its range.[3]

The Bicolored Antbird is not currently of conservation concern. Nevertheless, there is some evidence that it is declining throughout its range. As a group, understory insectivores are particularly vulnerable to loss of habitat, and

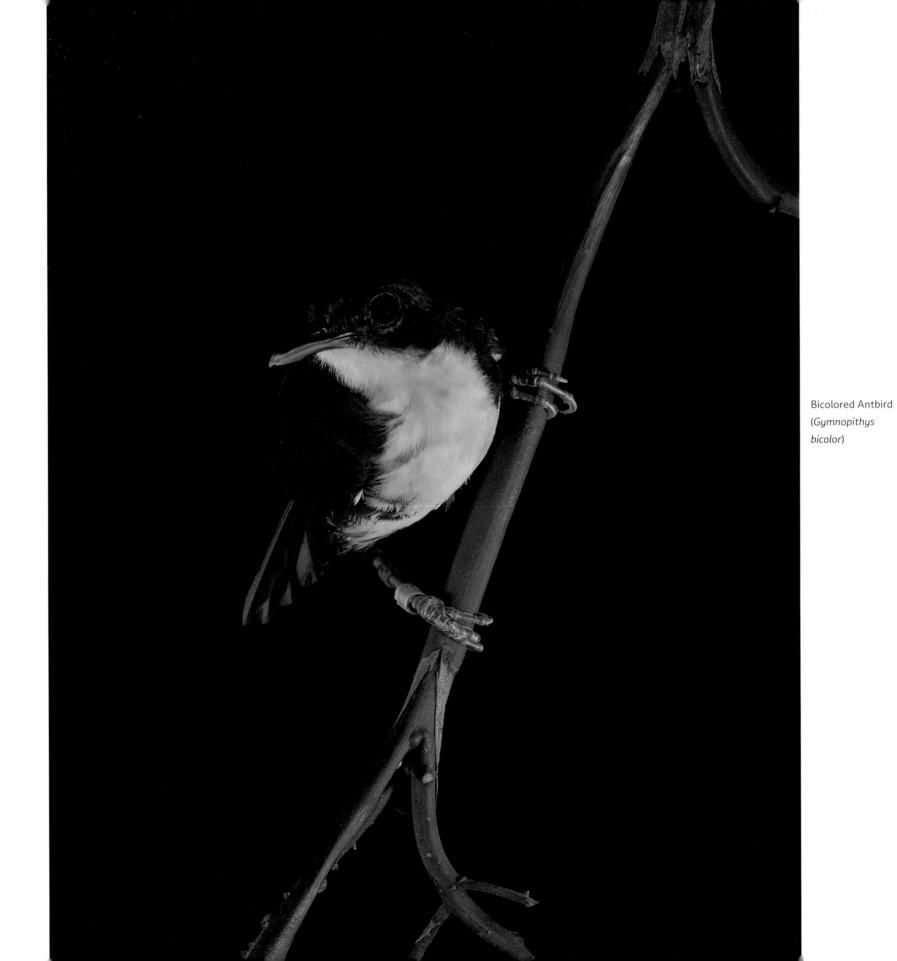

Bicolored Antbird
(*Gymnopithys bicolor*)

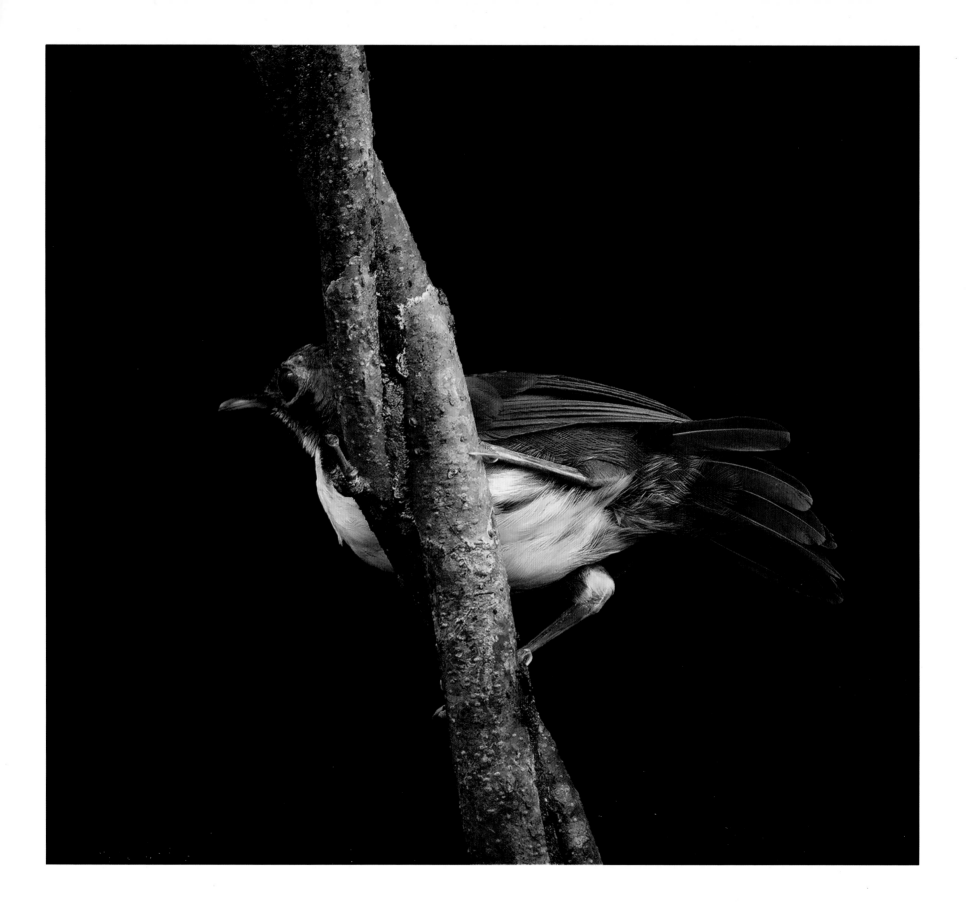

Bicolored Antbirds are reluctant to leave the protection of the forest to cross openings in broad daylight. Moreover, it is possible that many parts of the Bicolored Antbird's range may become warmer and dryer in coming decades, and it is unknown how this will affect the abundance and behavior of army ants.

The bird pictured here with bands on its leg is part of a long-term study in central Panama, where researchers have been capturing, banding, and releasing understory birds since the late 1970s. The metal (lower) band is uniquely numbered and identifies the individual bird when it is captured in mist nets. The orange plastic band, which can be easily seen in the field with binoculars, identifies the year the bird was first captured.

Bicolored Antbird (*Gymnopithys bicolor*)

Spotted Antbird

(*Hylophylax naevioides*)

J. PATRICK KELLEY

Visitors to the lowland rainforests of the Neotropics are awestruck when they happen upon the large flocks of birds scrambling after arthropods flushed by the swarm fronts of raiding army ants. In Central America, observers of these ant-following flocks will often be most enamored by large and dominant species such as the Ocellated and Bicolored Antbirds, frantically fighting for access to the juiciest insects. But, just outside the foraging melee, often near the periphery of the flock avoiding repeated contact with its larger antbird cousins, is the Spotted Antbird (*Hylophylax naevioides*). Its genus name translates to "watcher of the woodland," owing perhaps to the behavior of the Spotted Antbird, perching stoically and calmly at the periphery of an army ant swarm. Indeed, in some locales in the eastern part of its range, it is called *corregidor* (mayor), for its direction of the seemingly choreographed motions of the other ant followers.

Though it forages at army ant swarms less frequently than do the strikingly colored Ocellated or Bicolored Antbirds, the 18 g (0.64 oz) male Spotted Antbird is arguably one of the most charismatic and elegant swarm attendants, showing off its palisade row of black chest spots across a white chest, its rufus back, its rufus and black wings, and its dark gray head. The female is no less elegant, as she too has a necklace of brown spots on her tan breast and has barred wings similar to the male's. The vocal repertoire of the Spotted Antbird is playfully diverse, ranging from aggressive snarls when foraging at ant swarms to frenzied chipping when disturbed at its nest.[1] The loudly broadcast territorial song of Spotted Antbirds is an unmistakable *peeeeeti peeeeeeti peeeeeti peeeti peeti peeti*, which travels surprisingly far in the forest understory and allows them to signal their presence to their neighbors as they guard their 4 ha (10 ac) territories. While foraging together, male and female Spotted Antbirds signal to each other, as is common in other antbirds, with a soft and quiet rendition of their territorial loudsong. If one gets too far from the other, this whispered loudsong serves to reunite the pair, and foraging resumes.

Despite its relatively restricted range in Central and South America, this remarkable little bird is one of the most well studied of all tropical birds. The pioneering natural ecology study of Spotted Antbirds by Edwin O. Willis in the 1960s, which was turned into a monograph, produced the basic information on their ecology and life history needed to provide a strong foundation for new scientific work.[2] From vocalization to physiology to nesting behavior, the Spotted Antbird has helped scientists understand how tropical forest birds—specifically insectivorous ones—cope with the unique challenges of the tropical environment.[3] For instance, though day length does not vary much close to the equator, Spotted Antbirds are able to detect differences in day length as little as 17 minutes.[4] And Spotted Antbirds require the sight of moving insect prey before regenerating their gonads at the start of each breeding season.[5]

The open-cup nests of the Spotted Antbird are usually built less than 2 m (7 ft) off the ground and are constructed using dark, thick fungal rhizomorph and thin roots.[6] Near Volcan Arenal (Costa Rica), the Spotted Antbird carefully adds decorations of leaves and small sticks to the outside of the nest, giving the nest a smooth and finished facade. In central Panama, where the nest was first described as a "pile of debris," the nest of the Spotted Antbird is one of the sturdiest open-cup nests around.[7] Whereas most open-cup antbird nests disintegrate in the torrential downpours of the rainy season, the nests of the Spotted Antbird survive so well that successful ones are often re-used by adults for their next breeding attempt.[8] The nests are even strong enough to survive multiple years, and there are reported cases of their repeated use.

Spotted Antbirds can be found in lowland forests in northern and eastern Honduras, through Central America, and into Colombia and Ecuador (up to an elevation of 1300 m, i.e., 4300 ft) where the rise of the Andes limits their distribution. They are designated as of Least Concern by the IUCN Red List of Threatened Species.[9]

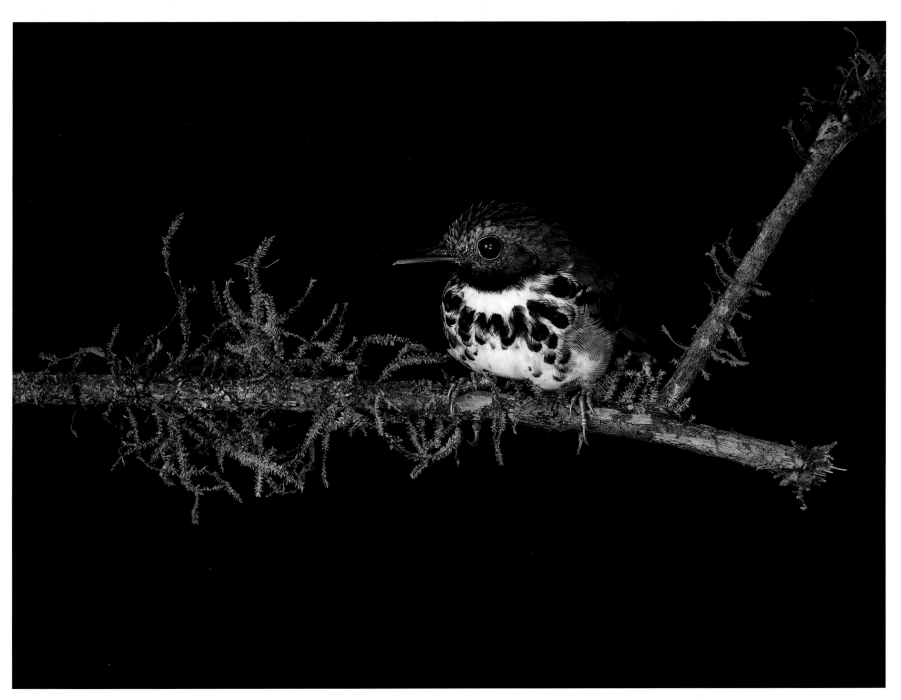

Spotted Antbird (*Hylophylax naevioides*)

Ocellated Antbird
(*Phaenostictus*
mcleannani)

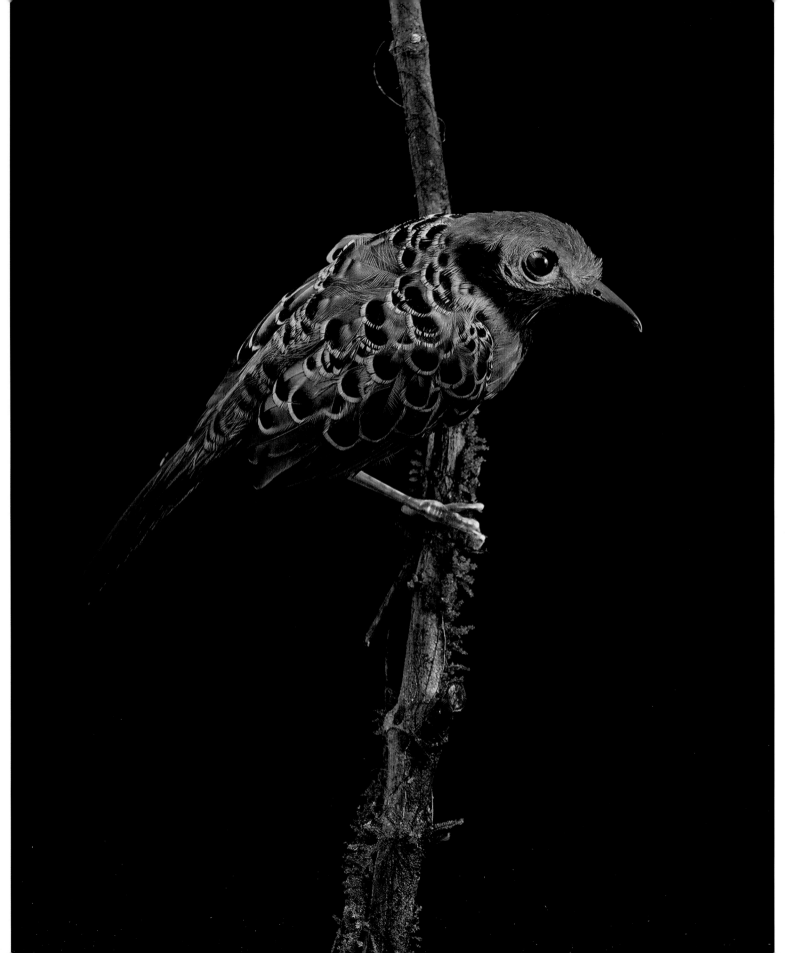

Perhaps the most charismatic of the ant followers is the Ocellated Antbird (*Phaenostictus mcleannani*). With its striking blue orbital skin and elegant plumage scalloped with eyelike markings (the origin of its common name "ocellated" is derived from the Latin *ocellus*, meaning "little eye"), Ocellated Antbirds are unmistakable and represent a prominent example of the ecological interaction between army ants and their avian attendants.

Army ants—predatory ant species that form massive swarms that course through the forest undergrowth consuming arthropods and small vertebrates—are an iconic element of Neotropical forests that have captured the attention of biologists and naturalists alike for over a century.[1] The raiding ants flush escaping prey, providing a readily accessible food resource for dozens of species of birds that attend the swarms.

Ant-following birds vary in their level of dependency on army ants, ranging from species that forage only opportunistically at swarms to highly specialized species (termed "obligate ant followers") that depend exclusively on swarms for food. Ocellated Antbirds are obligates among obligates—they are almost always found in association with army ants. However, obligate dependence on army ants can be a challenging prospect because of the unique life cycle of the ants. Once an ant colony's queen has laid the next generation of eggs, the colony forms a sort of living nest called a bivouac, usually located in a tree hollow or decaying log, and swarming is greatly reduced while the eggs pupate into adults during this "statary" period.[2] This phasic life cycle makes army ants an ephemeral resource for attendant birds. Thus, following a single colony is simply not a viable strategy for an obligate species like the Ocellated Antbird.

The evolution of obligate ant-following behavior has been the subject of detailed investigation seeking to understand just how birds like the Ocellated Antbird can become so wholly dependent on the ants for survival. It is thought that a predilection for disturbance foraging may predispose species to become ant followers; indeed, other such obligates have been recorded foraging at various disturbances, for example,

a northern tamandua (*Tamandua mexicana*) anteater excavating a termite nest or even a human (the renowned tropical ornithologist Alexander Skutch) walking through the forest. In the 1960s and 1970s in Central Panama, Edwin O. Willis used colored leg bands to monitor individual Ocellated Antbirds and found that they have the remarkable ability to track multiple ant colonies over vast tracts of forest (i.e., up to 100 ha [247 ac]).[3] They also exhibit specialized behaviors, such as bivouac checking (i.e., periodic inspection of colonies that are in the statary phase), which has now been documented in other obligate species as well. Bivouac-checking allows them to have constant access to at least a couple of actively swarming colonies. The obligate ant-follower lifestyle is so profitable that it has evolved independently on no fewer than three separate occasions within the typical antbirds (family Thamnophilidae), and its evolution is highly conserved (i.e., once a species becomes an obligate ant follower, it never reverts back to a less dependent, more facultative relationship with the ants).[4]

Once they find a swarm, birds become privy to a veritable smorgasbord of fleeing insects, arthropods, and small vertebrates such as frogs and lizards. In Central America, the large (~50 g [1.75 oz]) Ocellated Antbirds are behaviorally dominant at swarms and rule a pecking order dictated by body size—they occupy the choicest foraging locations at the center of the swarm front, with smaller, more subordinate species relegated to the periphery of the raiding ants. As many as twenty individual Ocellated Antbirds have been recorded foraging at a single swarm, which may seem surprising given the competitive dynamics at swarms. However, such high densities are permitted by a phenomenon sometimes termed the "dear enemy" effect—a system of reciprocal tolerance whereby Ocellated Antbirds exhibit reduced aggression toward neighbors that allows multiple family groups to forage at swarms simultaneously.[5] Nevertheless, swarms are still battlegrounds for food resources and can often be heard from afar as birds vie for position and emit territorial vocalizations, particularly the Ocellated Antbird. Experiments using acoustic playback to simulate vocalizing Ocellated Antbirds have shown that

Ocellated Antbird
(*Phaenostictus mcleannani*)
HENRY S. POLLOCK

other birds eavesdrop on these acoustic cues to find and recruit to swarms, which makes sense given the Ocellated Antbird's penchant for foraging at swarms and thus high signal reliability.[6]

The geographic distribution of Ocellated Antbirds is fairly wide ranging, spanning lowland forests from Honduras to northwestern Ecuador.[7] Nevertheless, their obligate lifestyle is somewhat of a double-edged sword in that their survival is entwined with that of the ants. Army ant colonies have extremely large home ranges, an aversion to crossing gaps, and low dispersal ability, making them susceptible to forest fragmentation.[8] The extirpation of Ocellated Antbirds also has cascading consequences on other ant followers, altering the soundscape and inhibiting the formation of bird flocks in the absence of the acoustic cues they provide to other birds about swarm presence.[9]

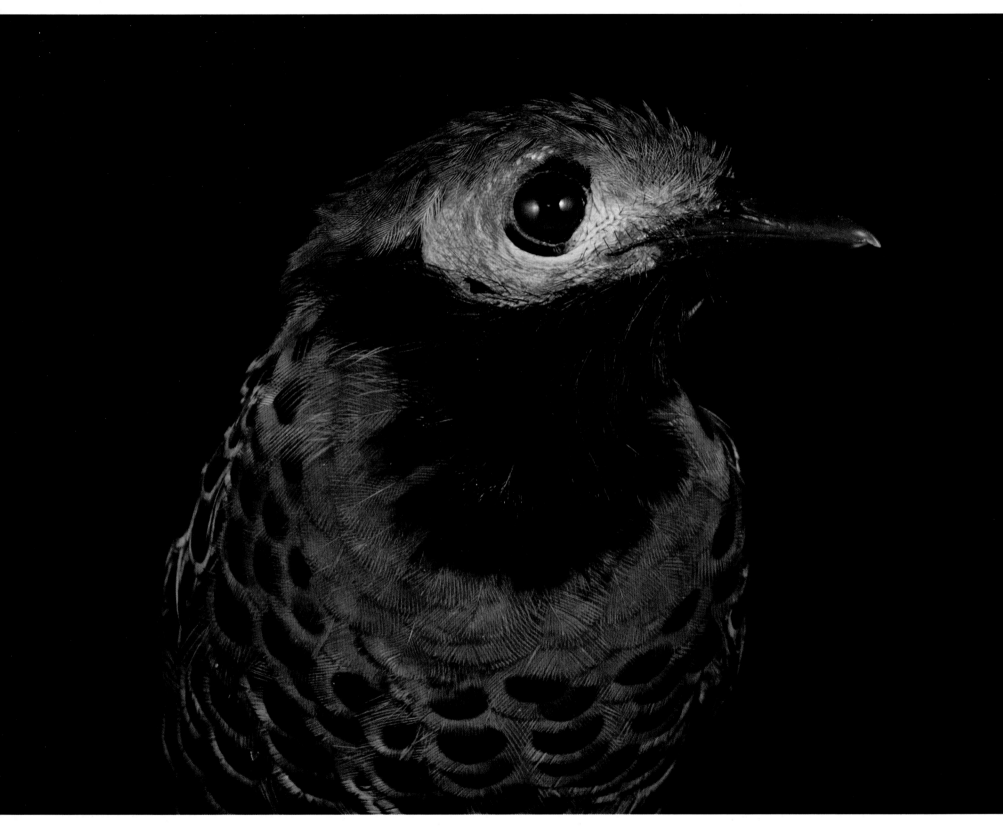

Ocellated Antbird (*Phaenostictus mcleannani*)

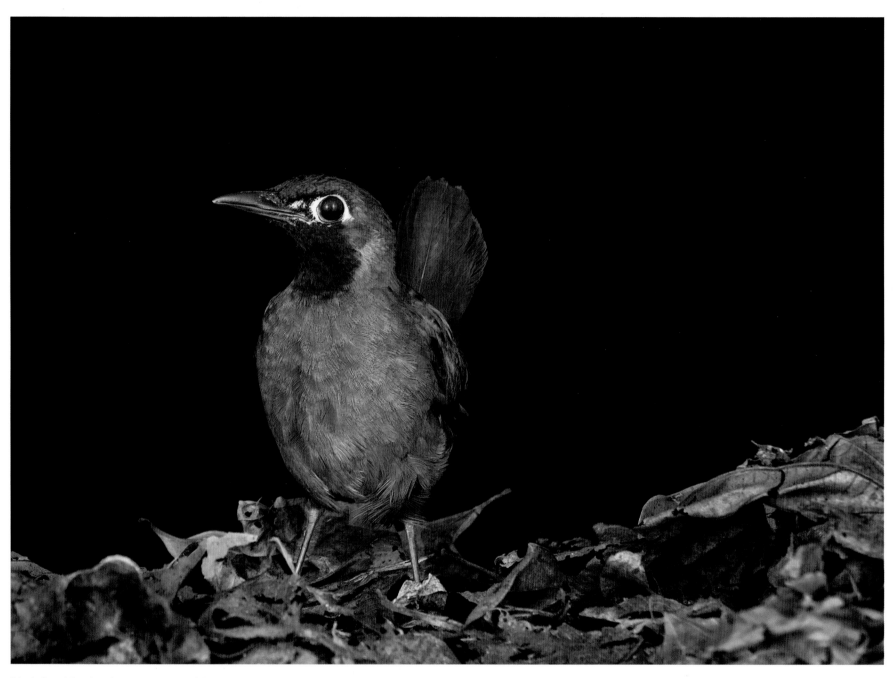

Black-faced Antthrush (*Formicarius analis*)

The difficulty of spotting a Black-faced Antthrush (*Formicarius analis*) in the forest understory is aptly described by the ornithologist Alexander Skutch: "With dainty, deliberate steps, it walks over the litter of the forest floor, the short, abruptly erect tail tilting forward with each step. The dark brown, black, olive, and gray of the plumage blend so well with the fallen dead leaves of the background that whenever the bird pauses for a moment its form can be distinguished only with difficulty in the dim light that has been filtered through more than a hundred vertical feet of heavy foliage."[1]

Just as personality differs among humans, birds exhibit their own idiosyncrasies and peculiarities that set them apart from their counterparts. The Black-faced Antthrush could be described as a wandering recluse, walking serenely and sedately across the forest floor in its seemingly endless search for food. It leads a mostly solitary life and is constantly on the move, taking a variety of prey ranging from arthropods to frogs and small snakes.[2] In the bird world, the Black-faced Antthrush is often likened in its behavior to the secretive rails (family Rallidae), long-legged waterbirds that share its delicate, mincing walk and erect tail posture.[3] Its black "beard" and prominent spectacles stand out in photographs, but its drab, grayish plumage makes it difficult to observe from afar.

The astute birder, however, can use an old ornithological trick to facilitate a greater intimacy with the retiring Black-faced Antthrush. The song is easy to imitate, consisting of an initial note followed by a series of two to four clear whistles at a slightly lower pitch, and this antthrush can be called in for a closer look by simulating a nearby rival.[4] Often, an inquisitive bird will gradually approach, zigzagging back and forth and eventually coming into view of a patient observer, lured in by the siren's song. Once the jig is up, the antthrush continues its daily trek, a mere shadow melding almost seamlessly with the undergrowth.

For such a small bird, the Black-faced Antthrush can cover a lot of ground. Individuals in Amazonia defend territories 12–16 ha (30–40 ac) in size, an impressive area for a 50 g (1.75 oz) bird.[5] The territory is a multifunctional piece of real estate used to find food, attract mates, and reproduce. Male antthrushes generally remain on their territories whereas females float from one to the next.[6] Despite spending most of their time alone, males and females do come together during the breeding season and cooperate to raise their young. They build their nests deep inside the cavities of hollow trees, hidden away from the potential predators that abound in the tropics. Both sexes incubate the eggs, switching off every 2–4 hours during the 17–20 day incubation period.[7] Upon hatching, the nestlings spend another few weeks developing feathers and fledge the nest, eventually undertaking their own lonely forest perambulations.

The Black-faced Antthrush occupies primary forest and mature secondary forests from Mexico to Amazonia.[8] Although it is not a species of immediate conservation concern, the Black-faced Antthrush's large home range requirements and preference for older closed-canopy forest make it vulnerable to fragmentation. Indeed, it has been extirpated from some regions of its geographic distribution and is declining in others where logging and forest fragmentation have occurred.[9] Preservation and stewardship of Neotropical forests will be essential for protecting the Black-faced Antthrush and other tropical bird species in an increasingly urbanized world.

Black-faced Antthrush
(*Formicarius analis*)
HENRY S. POLLOCK

Plain-brown Woodcreeper

(*Dendrocincla fuliginosa*)

HENRY S. POLLOCK AND

JEFFREY D. BRAWN

Woodcreepers (subfamily Dendrocolaptinae) are members of the ovenbirds (family Furnariidae), a hyperdiverse family of Neotropical passerines represented by more than three hundred species.[1] About sixty of these are the woodcreepers, tropical counterparts of the more familiar temperate-zone woodpeckers (family Picidae). Woodcreepers resemble woodpeckers in their stiffened tail feathers adapted for climbing vertically along tree trunks, but they differ in their foraging strategy—woodcreepers tend to probe and glean on the bark's surface rather than drilling and pecking as woodpeckers do. Most woodcreepers are drab, and one of the most nondescript is the aptly named Plain-brown Woodcreeper (*Dendrocincla fuliginosa*), which has virtually no distinguishing field marks.

Like most of its congeners in the genus *Dendrocincla*, the Plain-brown Woodcreeper is a regular follower of predatory army ants (*Eciton burchellii* and *Labidus praedator*). Level of dependence on ant swarms varies greatly among populations, with birds in Trinidad obtaining as much as 60–90% of their food from ant swarms.[2] Behavioral studies of this species were seminal in demonstrating the importance of army ants as a food source for birds as well as the intense competition that takes place among individuals vying for resources at an active swarm. In the absence of behaviorally dominant terrestrial species such as Ocellated and Bicolored Antbirds, Plain-brown Woodcreepers forage lower to the ground and congregate in greater numbers (i.e., up to twelve individuals) at swarms, a clear example of competitive release.[3]

As with most other tropical birds, the Plain-brown Woodcreeper lays clutches of two eggs in cavities, often in the bole of a tree or a hollow stump.[4] Parental care is carried out exclusively by females, which are behaviorally dominant to males.[5] The Plain-brown Woodcreeper is largely insectivorous and overlaps heavily in diet with other woodcreeper species, although it exhibits a particular predilection for beetles.[6] Woodcreepers can be quite long-lived, as demonstrated by a mark–recapture study from central Panama that documented a banded Plain-brown Woodcreeper of at least 16 years of age.[7]

Despite its monochromatic plumage, recent studies of the Plain-brown Woodcreeper have found substantial genetic variation throughout its geographic range, and no fewer than eleven subspecies are currently recognized.[8] Much of this diversification occurred because of South American populations being separated by the uplift of the Andes Mountains and also isolated by large rivers in Amazonia.[9] Most of these subspecies vary only slightly in body size, overall coloration, and extent of facial markings. Future research may very well end up splitting the Plain-brown Woodcreeper into multiple species, as has occurred with some of the other species included in this volume.

The Plain-brown Woodcreeper has a very broad geographic range, spanning from eastern Honduras to southern Ecuador west of the Andes and central Bolivia east of the Andes, and encompassing large swaths of northern South America and Amazonia. It is found in humid forests at elevations from sea level to 2000 m (6500 ft) and is relatively tolerant of fragmentation compared with other woodcreepers.[10] Therefore, the Plain-brown Woodcreeper is less vulnerable to anthropogenic change than most understory insectivores. Its conservation status is Least Concern.[11]

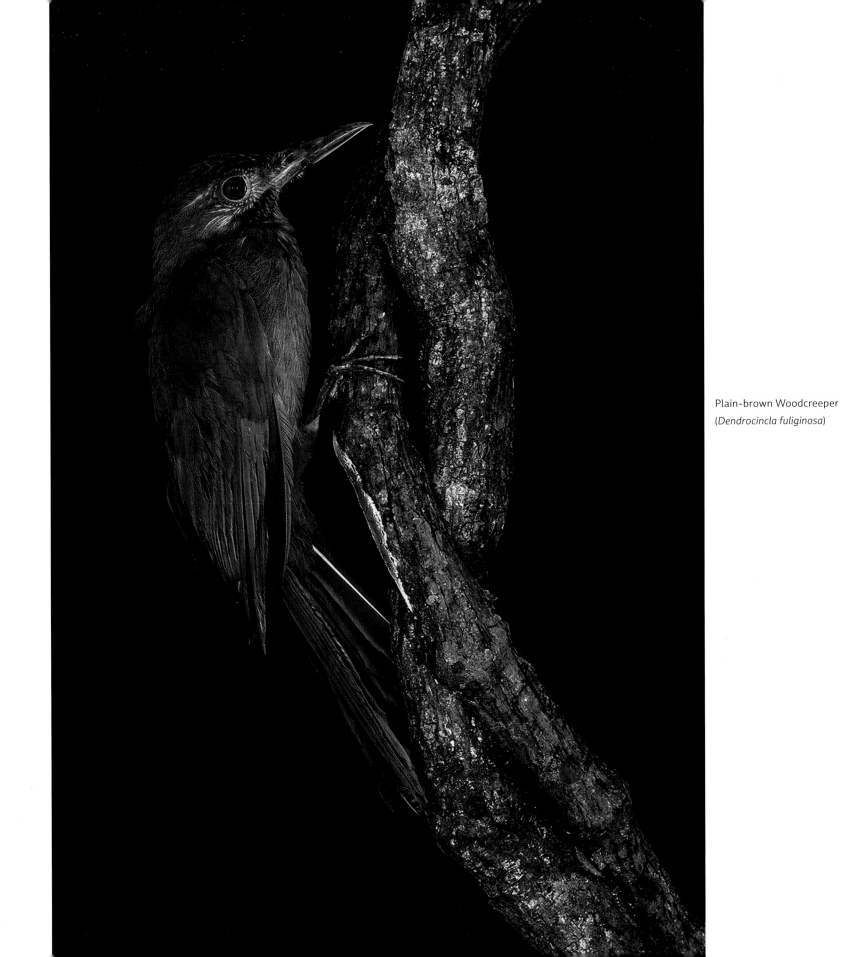

Plain-brown Woodcreeper
(*Dendrocincla fuliginosa*)

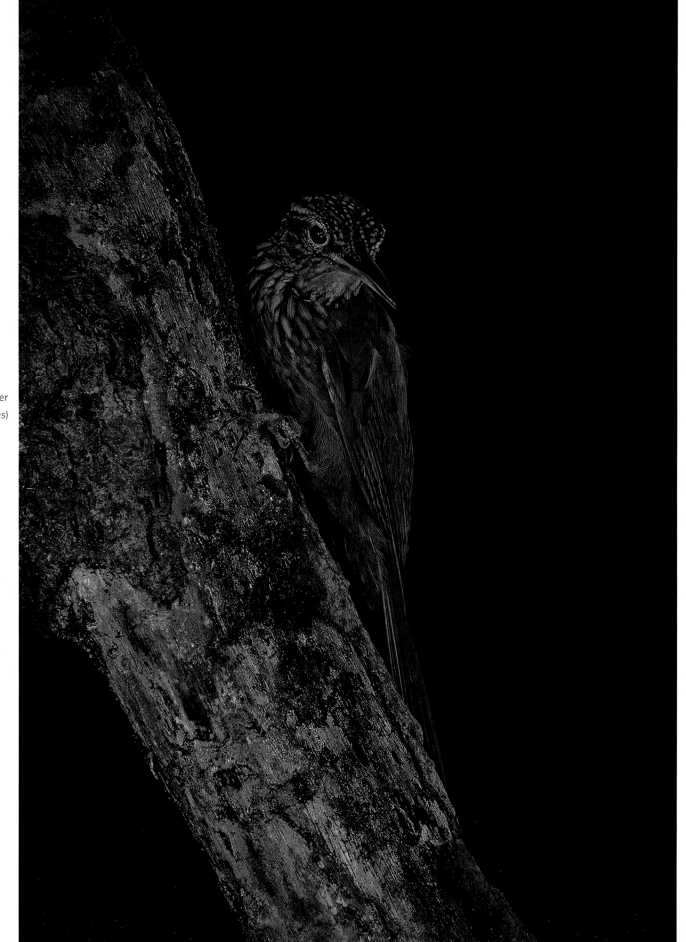

Cocoa Woodcreeper
(*Xiphorhynchus susurrans*)

Despite birds of tropical forests often being more readily heard than seen—especially in a dark understory—the frequent and loud vocalizations of the Cocoa Woodcreeper make it extraordinarily apparent as compared with most species. Males give their loud and unmistakable song, described as a series of *kee-kee* notes that rise and then fall in pitch, throughout mornings and late afternoons and sometimes all day during the breeding season.[1] This song, as well as the striking call notes uttered by both sexes, can be heard for several hundred meters. Being a rather common species throughout its range from Central America north to Guatemala and northern South America, the Cocoa Woodcreeper is rarely overlooked. Its conservation status is Least Concern.[2]

An inhabitant of the lowland tropics, the Cocoa Woodcreeper is found in forests that range in age from mature to younger second growth.[3] It is a mid- to large-sized bird for a woodcreeper (family Dendrocolaptidae), with a fairly long, largely straight bill. It is distinguished in the field by its light-colored throat patch, which is why it was formerly called the Buff-throated Woodcreeper across much of Central America. Unlike many understory species, it is often observed in forest openings and edges and will even venture out into clearings with isolated trees.[4] Studies in central Panama have shown that this species does well in landscapes with fragmented habitat and is able to utilize tracts of forest as small as a half hectare within a home range that averages about 6 ha (15 ac).[5]

Clearly, the Cocoa Woodcreeper is not one of the species that conservation biologists call "area sensitive." It is also somewhat of a vertical generalist; that is, it nests in tree cavities that are low to the ground but will typically forage all the way up into the midcanopy. Thus, the Cocoa Woodcreeper is only a "part-time" inhabitant of the understory.

Like other woodcreepers, this species is thought to subsist almost exclusively on animal prey. It often forages alone or in pairs by "hitching" up tree trunks or out on large branches and by probing into clumps of dead leaves for arthropods.[6] However, the foraging behavior of the Cocoa Woodcreeper is flexible, as they will also find food by joining mixed-species flocks that are following swarms of army ants advancing across the forest floor. The birds attend these swarms so they can pick off arthropods and small vertebrates flushed up by the voracious ants. Cocoas are not a "professional" or obligate ant-following species and attend swarms opportunistically when other species have already located the ants. Passive observations and experimental evidence indicate that Cocoas locate the swarms by hearing the loud chattering and calls of other, more specialized species that are adept at locating ants. While participating in the mixed-species flocks, the Cocoa Woodcreeper can be something of a bully and will aggressively supplant other species to secure a good spot for capturing prey.

Cocoa Woodcreeper
(*Xiphorhynchus susurrans*)
JEFFREY D. BRAWN

Plain Xenops

(*Xenops minutus*)

PHRED M. BENHAM

Birding in a lowland tropical rainforest can seem surprisingly bird-less, until one stumbles upon an energetic flock of tiny birds flitting, climbing, gleaning, sallying, and creeping all around. While the species composition of these flocks varies widely across tropical forests, in many flocks, from southern Mexico to northern Argentina, birders will encounter a strange, nondescript, brown bird foraging in the outer branches, twigs, and vine tangles by use of its peculiar wedge-shaped bill to probe and hammer at the vegetation. This is the Plain Xenops (*Xenops minutus*), a member of the endemic Neotropical family Furnariidae, or ovenbirds. The European ornithologists who first encountered this species were obviously struck by its odd-shaped bill, as they named it *Xenops*, which means "strange face" in Greek. Apart from the odd bill shape, only subtle plumage patterning distinguishes the three species of *Xenops* from other ovenbirds. All three species possess a whitish crescent extending diagonally downward from the bill (i.e., the malar, or mustache) and a second, thinner, white stripe extending behind the eye. *Xenops* species also share the unique features of a brown-and-rufous-striped tail with a buffy wing stripe observable in flight.

The nearly three hundred species of Neotropical ovenbirds may appear to differ only by subtle shades of brown and the distribution of streaking across the body; in reality, however, they are one of the most morphologically and ecologically diverse groups of birds on the planet. Ovenbirds are considered an adaptive radiation similar to such island radiations as the Hawaiian honeycreepers and Darwin's finches of the Galapagos, but on a grander, continent-wide scale. The seeds of this radiation sprouted, grew, and blossomed in the long and "splendid isolation" of the South American continent.[1] Over tens of millions of years in isolation, the Neotropical ovenbirds diversified to fill ecological niches typically occupied by different bird families in other parts of the world. As a result, ovenbirds will often be compared with distantly related bird species, such as woodpeckers, thrashers, creepers, warblers, wrens, dippers, and sandpipers, rather than to other more closely related ovenbird species.

Indeed, members of the genus *Xenops* are routinely compared with titmice, nuthatches, or piculets (tiny tropical woodpeckers).[2] In the under- to midstory of tropical forests, *Xenops* will be found clinging closely to branches, twigs, and vines while avoiding the main trunks of trees. Like chickadees, they will grasp the vegetation at the best angle from which to capture their insect prey, whether upside down, sideways, or right-side up. The bird will then proceed to hammer away at the decaying wood or use its bill as a wedge to pry open the ends of twigs, dead branches, or large leaves to extract its meal.[3] The nesting ecology of *Xenops* also resembles temperate zone chickadees and nuthatches. *Xenops* are cavity nesters, with pairs excavating their own cavity or exploiting cavities created by woodpeckers and other hole-nesting birds. Cavities of the Plain Xenops will be found in the rotten wood of narrow branches or snags between 1 and 10 m (3–33 ft) above the ground.[4] Inside, the cavity is lined with fine plant fibers that will house two glossy white eggs. This species is monogamous, and both sexes will assist with the nest excavation, the 15–17 days of egg incubation, and 13–14 days of feeding nestlings.[5] Individual Plain Xenops will also use these cavities for their nightly roosts, arriving at last light and quickly entering the cavity.[6] Remarkably, the similarity between the Plain Xenops and the piculets even extends to their songs, with both delivering a rapidly accelerating, staccato trill that slows in the final notes.[7]

Across the broad range of the Plain Xenops, ten different subspecies have been described that vary subtly in plumage.[8] Ornithologists have recently analyzed variation in DNA sequences sampled from many Plain Xenops populations, which suggest that these Plain Xenops populations can be clustered into three groups that differ in their songs and plumage: (1) birds from southern Mexico to Colombia west of the Andes; (2) birds residing in the Amazon basin east of the Andes Mountains; and (3) birds from the Atlantic forest of southeast Brazil.[9] Populations on either side of the Andes Mountains began diverging about 4.5 million years ago, corresponding closely to the final formation of the northern Andes between 3 and 5 million years ago.[10] The Andean uplift thus isolated different *Xenops* populations and set them on the path to becoming the three species we now recognize.

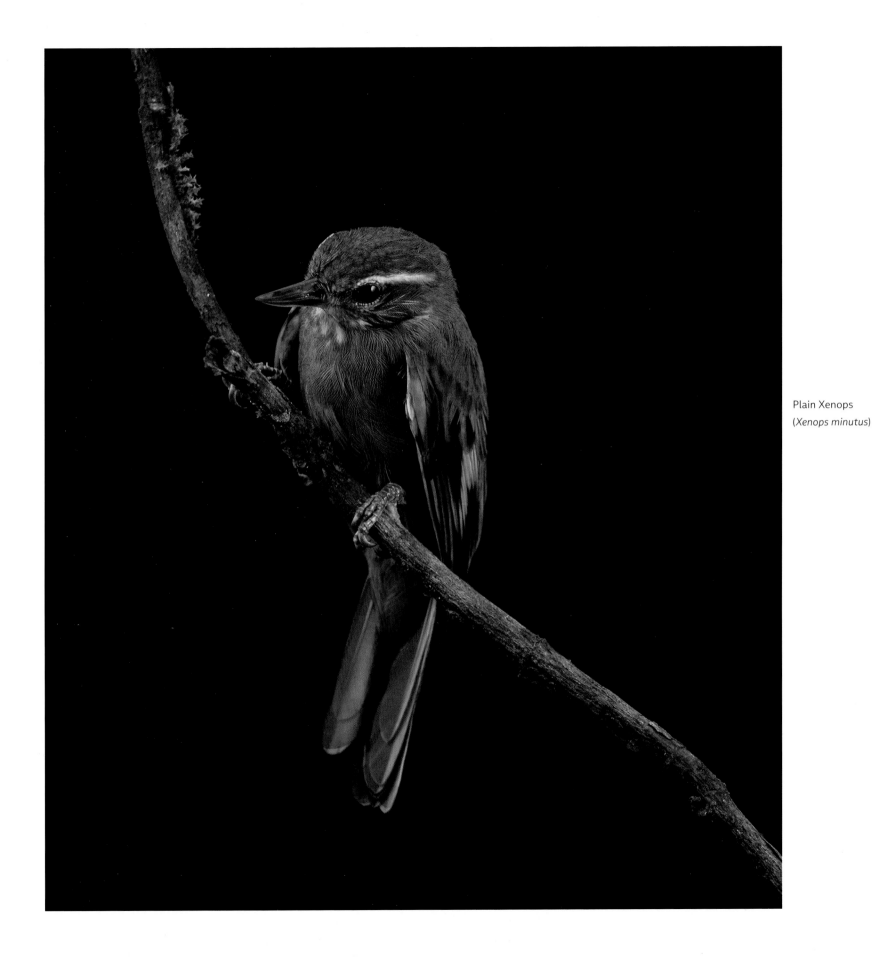

Plain Xenops
(*Xenops minutus*)

Buff-throated
Foliage-gleaner
(*Automolus
ochrolaemus*)

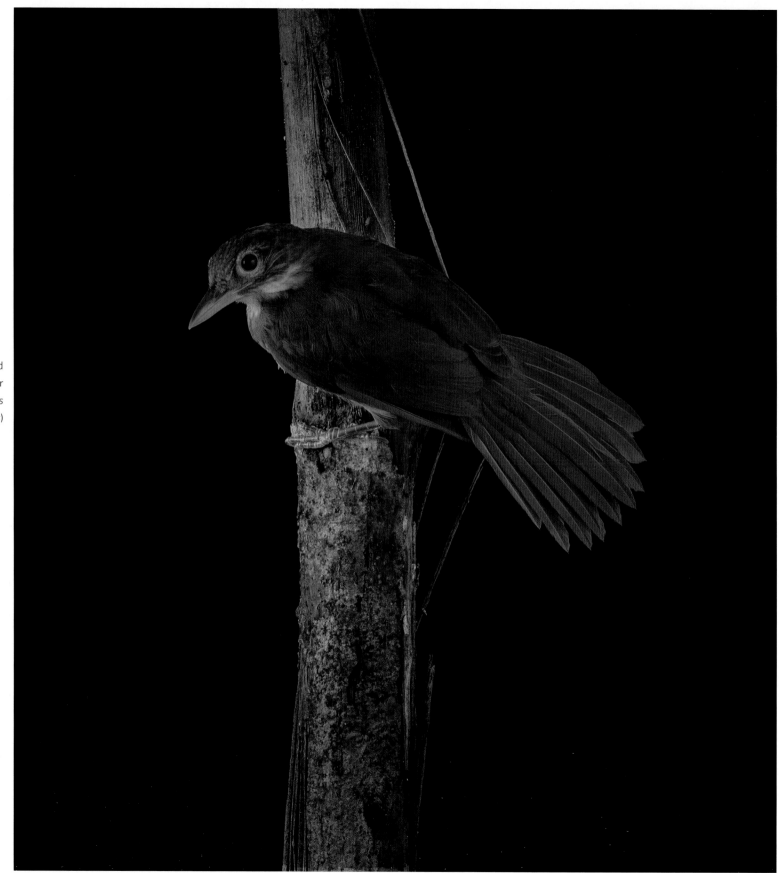

For spotting and avoiding predators, many pairs of eyes are better than one. In the tropics, some birds gather in mixed-species flocks to avoid forest-falcons, hawks, snakes, and other marauders. In order to locate and elude predators, these flocks usually have a leader—a species with great eyesight—surrounded by dissimilar bird species that capture arthropod prey in different ways: eating bugs on the wing, pecking insects off bark, or flicking over dead leaves. For birdwatchers, mixed-species flocks in tropical forests are a source of elation because birders can observe a dizzying array of species within a short period of time. A trick for finding mixed-species flocks is to learn the songs of noisier flock participants. One such species is the drab, yet charmingly vocal, Buff-throated Foliage-gleaner (*Automolus ochrolaemus*). Tan above, buffy below, with a strikingly pale eye ring and a reddish tail, Buff-throated Foliage-gleaners betray their presence with a distinct song, which varies across their range. In the lowland forests of the Amazon basin and Guiana Shield, Buff-throated Foliage-gleaners produce a halting and descending song, *ke-ke-ke-keer*, each note becoming progressively lower in tone. In Central America, their song changes to a downward trill, lasting several seconds. Buff-throated Foliage-gleaners love to sing, repeating their songs every few seconds.[1]

Most often found in mixed-species flocks, Buff-throated Foliage-gleaners are gregarious foragers, using strong and agile legs to climb on epiphytes, branches, and debris, often pulling insects out of dead leaves. These birds are larger than many of their flockmates, weighing in at around 40 g (1.4 oz), and consume anything they can overpower, including large insects and small reptiles and amphibians. Within mixed-species flocks, Buff-throated Foliage-gleaners often forage in pairs. They are monogamous breeders, and both sexes incubate two or three eggs in subterranean nests, located 0.3–0.6 m (1–2 ft) underground, usually on the side of a small dirt bank.[2]

Given that Buff-throated Foliage-gleaners are widespread and relatively common throughout much of South and Central America, they have been subject to multiple scientific studies leading to several insights and discoveries, including a newly described species of internal parasite found in their droppings![3] Long-term studies have contributed much to understanding the species' sensitivity to habitat change. For example, scientists found that Buff-throated Foliage-gleaners became locally extinct on Barro Colorado Island (a forested isle created during the construction of the Panama Canal) that, unfortunately, served as a bellwether for other species. Throughout Central and South America, tropical ornithologists found that understory insectivores in mixed-species flocks—birds with behaviors and dietary patterns similar to those of the Buff-throated Foliage-gleaners'—are sensitive to forest fragmentation and loss.

Buff-throated Foliage-gleaners are members of the Furnariidae family, an impressively large group of birds made up of diverse genera and species including leaftossers, woodcreepers, cinclodes, horneros, and spinetails, among many others. Buff-throated Foliage-gleaners are restricted to tropical forest and, sometimes, coffee plantations, from southern Mexico, throughout Central and South America, to central Brazil and Bolivia.[4]

Buff-throated Foliage-gleaner
(*Automolus ochrolaemus*)
JARED WOLFE

Ruddy-tailed Flycatcher

(*Terenotriccus erythrurus*)

THOMAS W. SHERRY

In shady, wet forested habitats and second growth, the Ruddy-tailed Flycatcher (*Terenotriccus erythrurus*) is easily overlooked because of its olive-gray upper parts and head and its small size (8.9–10.2 cm [3.5–4.0 in.], about 6–7 g [0.1–0.2 oz]). It is, in fact, one of the smallest non-hummingbirds, even smaller than some of the larger hummingbirds. Foraging almost invariably alone, generally away from flocks, and not staying long in any one spot, it appears restless. As well, the species' vocalization is inconspicuous, consisting of a wispy, three-syllable call note, given infrequently, and an annotated *teeu-téép*, the latter syllable(s) higher than the first.[1] It also has a song of repeated single notes and a continuous repetition of its call note at dawn.[2]

With patience, however, this bird is not so difficult to spot owing to its relative abundance throughout most of its extensive geographic range, from southeast Mexico to the Choco region of northwest Colombia and south to central Brazil and Bolivia, at elevations ranging from sea level to 1200 m (3900 ft).[3] Detection is aided by its bright rufous rump, tail, and wings, its white eye ring, and its habit of foraging in the midstory to understory, within binocular range. Its beak is flattened like that of most other flycatchers and rather short. Between foraging attacks, it can sit for seconds to minutes, periodically lifting both wings vertically above its back, then making a sudden flit at vegetation, often followed by a spectacular aerobatic chase of its quarry.[4]

Descriptions and pictures of the Ruddy-tailed Flycatcher often overlook its foraging behavior and diet and its distinctive morphological features. It is one of the most evolutionarily specialized insect feeders in Neotropical forests.[5] One of its most notable features is its relatively long, stiffened bristles that automatically configure themselves into a basket around the opened beak, serving either to help funnel and trap an insect or to prevent its escape from the side as the bird prepares to swallow it. These specialized feathers are referred to as "rictal bristles" because they emerge from the tissue forming the rictus, the region between upper and lower beaks. This feature makes sense when considered alongside the bird's almost total reliance on jumping bugs (Hemiptera), such as leaf, plant, and tree hoppers.[6] Once jumping bugs are flushed, their pursuit requires aerobatic agility, which is facilitated by the bird's small body size, and explains the long and sometimes tortuous chases seen when Ruddy-tailed Flycatchers are foraging. Like other aerobatic pursuers within thick forest vegetation, the Ruddy-tailed Flycatcher's round-tipped wings and tail area are large relative to its body size, more so than any rainforest bird, helping it bank and turn quickly while pursuing a fleeing insect's initial jump and subsequent erratic flight. While this bird is diurnal, its relatively prominent dark eyes are well adapted to the low light levels where it typically forages.

Like dozens of other Neotropical forest insect-feeding birds, such as spadebills, this species has evolved a variety of appropriately shaped specialized body structures to exploit the evasive behavior of its prey.[7] The Ruddy-tailed Flycatcher's pursuit and capture of jumping Hemiptera is dependent upon and triggered by the insects' leaping behavior to evade capture by the less aerobatic birds (and likely other small animals) that have selected it. Thus, the Ruddy-tailed Flycatcher has participated unwittingly, apparently for tens of millions of years, in an evolutionary arms race between the insectivorous birds and their insect prey, as the former evolve specialized body traits for pursuit and capture, and the latter evolve better evasive mechanisms.[8]

The rufous coloration of the Ruddy-tailed Flycatcher is a puzzle requiring further study. The brightness of its wings and tail may well be adapted to flush Hemiptera, but its generally rufous colors are unlikely to be strictly adapted to feeding.[9] Since a variety of other Neotropical rainforest birds, including pihas, becards, woodcreepers, antbirds, ovenbirds, and motmots, are curiously similar in their rufous coloration, and feed in a variety of ways on different foods, perhaps a more plausible explanation is that the coloration readily conceals these birds from their own predators within the somber greens of rainforests.

In common with its closest relatives, the Sulphur-rumped

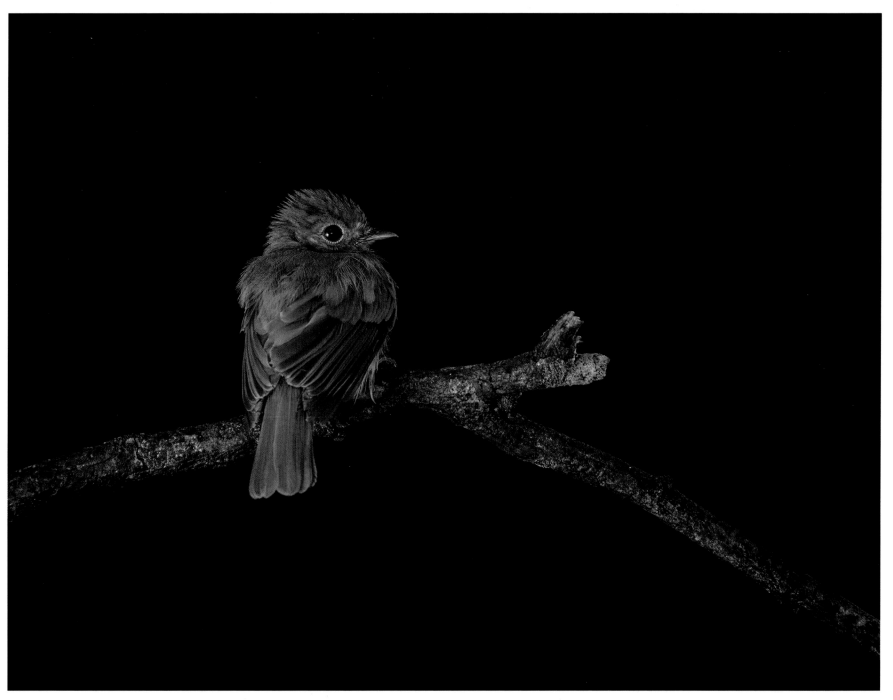

Ruddy-tailed Flycatcher (*Terenotriccus erythrurus*)

Flycatcher (*Myiobius sulphureipygius*) and Royal Flycatcher (*Onychorhynchus coronatus*), the Ruddy-tailed Flycatcher has other notable characteristics.[10] While this ancient group's affinities with other insectivores have been variously defined, all these species have the pronounced rictal bristles previously described. They also have distinctively long incubation periods (18 days for the Ruddy-tailed Flycatcher) for unknown reasons, linked to whatever advantages accrue to slow embryo development. Their hanging nests, which appear to allow this extended incubation, probably evolved to protect them from snakes, an important group of predators in the rainforest understory.[11] The female suspends her pear-shaped nest from a twig or vine, usually 1.5–2 m (5–6.5 ft) aboveground.[12] The nest typically includes a visor-like projection immediately above a side entrance to the lower main chamber, presumably as shelter from rain and possibly from the eyes of predators.

The female Ruddy-tailed Flycatcher alone builds the nest, incubates the usual clutch of two eggs, and feeds the nestlings and fledglings.[13] The reasons for this are unknown but could be related to the Ruddy-tailed Flycatcher's specialization on relatively reliable prey that can be pursued in various tropical wet forest locales not limited to a particular season.[14]

The group members' many life history traits are consistent with their distinctive phylogenetic position and with their ancient age, which probably also has contributed to the multiple subspecies identified. Eight subspecies have been described for the Ruddy-tailed Flycatcher, although the plumage differences among them are subtle, and the validity of some of them is disputed.[15]

Ants and Ant Followers

JOHN P. WHITELAW

Many of the species included in this volume are associated to a greater or lesser degree with army ant swarms, a phenomenon worthy of further discussion. A number of these species will be examined more fully in "Portraits in Words and Pictures."

The study of this fascinating ecological spectacle was begun by, among others, the eighteenth-century French zoologist George-Louis Leclerc (Comte de Buffon), who was definitely onto something when he suspected there was a link between swarming ants and certain birds in Neotropical forests. For years, the accepted explanation was that the ants were good eating. Actually, the birds are opportunistic freeloaders—they don't touch the ants. Rather, their prey is whatever appeals to them from the myriad small critters flushed by the ants.

Eciton burchelii is Panama's predominant army ant, whose swarms are dynamic, ebbing and flowing hordes of as many as 500,000 aggressive carnivores that periodically flood the forest floor like a roiling river. Lacking a permanent home, they cycle through nomadic and stationary phases, always holing up for the night by assembling themselves into a living nest, or "bivouac," stuck to a limb, tree trunk, or hollow log—a brownish-black ball composed of an organized tangle of jiggling ants held together by their interlocking tarsal claws. At daybreak, the mass disperses as an efficient, marauding, superorganism set upon capturing, dismembering, and carting away any animal they succeed in getting their jaws around. As the swarm, clocked at 20 m (65 ft) per hour, overruns, kills, and butchers its prey, it kicks up a delicatessen of other denizens, mainly arthropods, including spi-

ders, centipedes, and such. In their desperation to escape the marauding ants, myriad critters scramble or fly to higher ground. For ant followers, they are easy pickings: and that is the connection.

Unlike all other army ants, *Eciton burchelii* does not raid in thin, discrete columns. Seen from above, their swarms resemble a gigantic, self-propelled push broom. The beginning of the march forms the handle, a thick column, twelve ants abreast. Soon afterwards, the parade splits over and over again, until it forms a 15 m (50 ft) wide front, like the broom's brush, and about a meter deep. It sweeps over and through leaf litter, spreads to low-standing vegetation, even climbing trees of up to 18 m (60 ft) in height. Almost everything that moves is attacked; even tapirs and coatis have been seen giving such swarms a wide berth.

The freeloaders are of three types. Some belong to a select guild of hardcore "professionals" that rely on the fleeing prey for the bulk of their diet. When not foraging, these "obligate" ant followers, such as the Ocellated Antbird, search for bivouacs, spy on them, and alert other ant followers when the ant mob begins to move. Their cries attract other professionals and a second sect of ant followers called "facultative" followers—species such as the Spotted Antbird, which do not depend solely on swarms for food. A third, smaller miscellany of species, such as the Chestnut-backed Antbird, are "opportunists" that engage in short, inconspicuous feeding dalliances at the periphery of the advancing army.

Once at the swarm, the birds establish an organized, three-dimensional spatial hierarchy based

on whether they are perchers, clingers, climbers, or ground feeders. These subsets are further arranged according to species size, with larger birds assuming dominant positions. Among the clingers, larger species like the Ocellated Antbird occupy the area of the wave front, where the density of flushed insects is highest. Intermediate-sized species, like the Bicolored Antbird, are forced into positions just behind the front, leaving smaller clingers, like the Spotted Antbird, to forage even farther back.

The birds are further organized based on the height and quality of perch they favor, thus establishing independent niches on or above the forest floor. Ground-feeding birds, such as the Rufous-vented Ground-Cuckoo (*Neomorphus geoffroyi*) and the Black-faced Antthrush, although large and robust, are relegated to foraging at the perimeter of the swarm. Climbers, like woodcreepers, establish dominant niches on tree trunks and thick vines. Clingers like the Bicolored Antbird take charge of slender, horizontal twigs, and vertical branches. Strictly perching species, such as the Gray-headed Tanager, sit higher in the understory, waiting for clingers to vacate more desirable positions.

"After dismembering a large arthropod, the bird [a Bicolored Antbird] hops about and peers at the ground. It picks up and then swallows tiny fragments. Then it looks up, flies to a perch above the ground, and returns to the swarm. Like a typical member of an affluent society, a bird which has fed at a swarm for some time is likely to leave its litter for the ants to clean up."[1]

Alexander Skutch enjoyed a unique friendship with

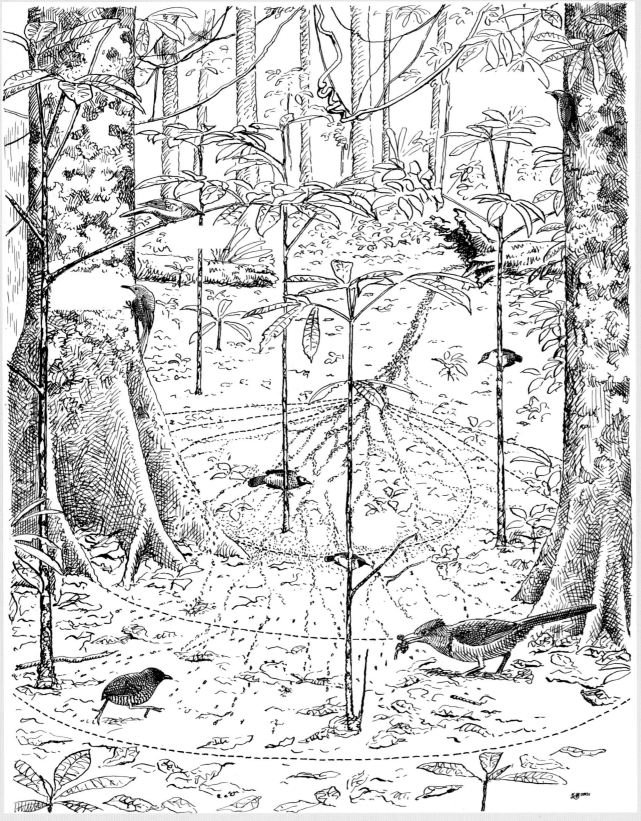

Ant swarm shape. Illustration by N. John Schmitt,
© Cornell Lab of Ornithology.

Bicolored Antbird following
Alexander Skutch. Drawing
by Dana Gardner.

a Bicolored Antbird he named "Jimmy" (after the bird's scientific name *Gymnopithys bicolor*). This individual behaved as though Skutch was a one-man surrogate ant swarm. As he walked through the forest, his boots, or a stick he dragged behind him, disturbed insects in the leaf litter, which Jimmy snapped up. Several times he was able to reach out and gently touch the bird with the stick. He described his many encounters in great detail, an adventure that lasted for 16 months.[2]

The five hundred or so animals now known to "live" with army ants are called associates because neither affects the other adversely. They include birds, mites, beetles, flies, wasps, and butterflies. Of these, over three hundred depend on the ants for their very existence. Scientists speculate that many more undiscovered animals are affected by the army ant community. Among the butterflies are three species of the tribe Ithominii, associates who are interested in neither the ants nor the bugs they flush—they glean nourishment from the ant followers themselves, by dining on their droppings. The diminutive Bat Falcon (*Falco rufigularis*) spends a portion of its time hunting the ant-following birds at swarms.

Alexander Humboldt, the German naturalist, explorer, writer, and polymath whose life straddled the eighteenth and nineteenth centuries, was the first to propose that the world was akin to a giant living organism, each component knitted to others, forming a complex, functioning, cohesive, interconnected, and interdependent fabric.[3] He predicted that, on every scale, the destruction of a single stitch or element could have a catastrophic effect on other linked dependents. He would have been mesmerized by these ant connections that are a micro-example of his global concept. And he would have warned us that, should man render *Eciton burchelii* extinct, hundreds of other native animal species would also surely disappear.

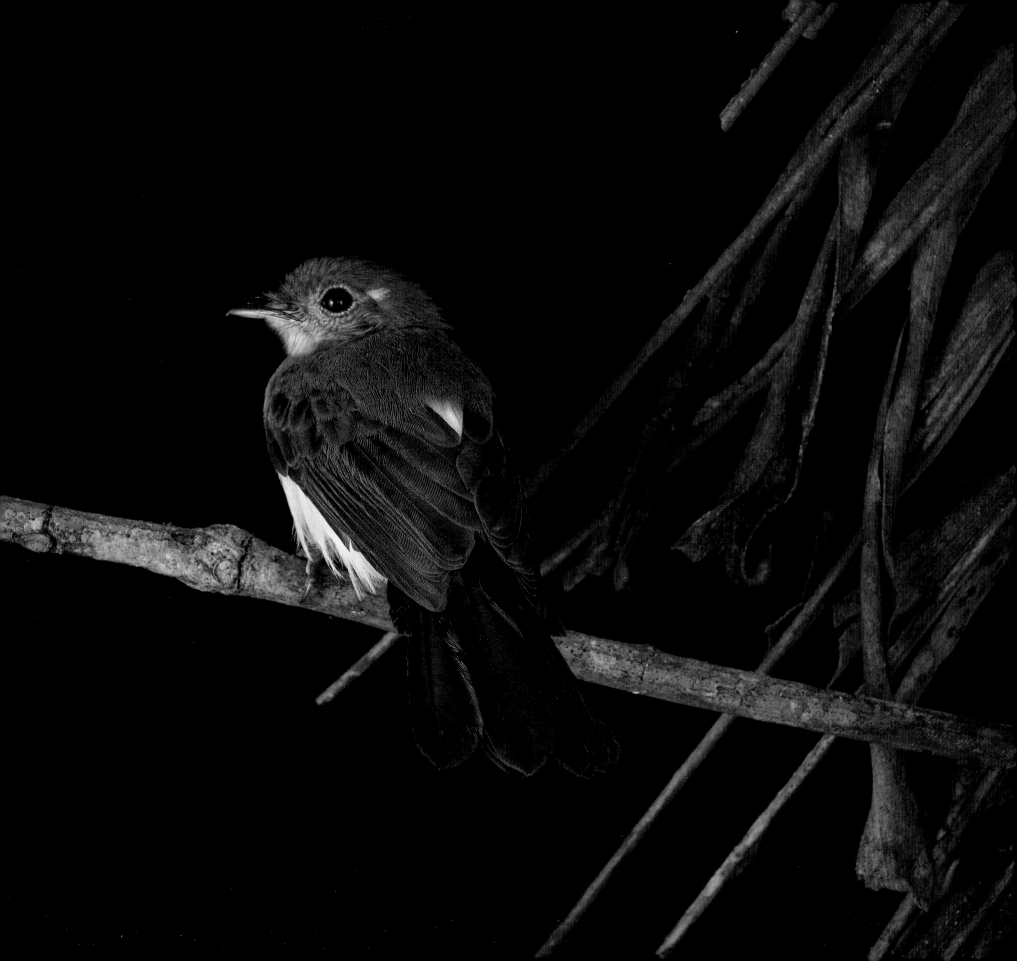

Considering its small size, its infrequent and low, sharp *tsip* call notes coupled with rare "song" vocalizations, and its preference for dense understory of lowland, humid tropical forests, the unmistakable Sulphur-rumped Flycatcher can be challenging to encounter; the likelihood is enhanced, however, if one comes across an understory mixed-species flock.[1] "It has the habit, almost unique among the flycatchers, of hopping and flitting about with its tail spread fanwise and its wings slightly lowered. In this fashion the yellow dorsal area is completely revealed."[2]

The current conservation status of the Sulphur-rumped Flycatcher is Least Concern.[3] It ranges from southern Mexico southward, largely on the Caribbean coast throughout Central America and on the western side of the Andes into western Ecuador. Two subspecies, which meld into each other, have been described based on subtle plumage differences: the first (*M. s. sulphureipygius*) from southeast Mexico to northwest Honduras, the second (*M. s. aureatus*) from northeast Honduras south to west Ecuador. It prefers subtropical and tropical wet, lowland forests generally ranging in elevation to 1000 m (3300 ft).[4] Although partial to undergrowth in more mature lowland rainforest and semideciduous forest, it may venture out into second-growth near-mature forest.

The Sulphur-rumped Flycatcher belongs to a distinctive, ancient clade of genetically related species whose affinity with other insect-dependent birds is unclear, as reflected in attempts to situate this species taxonomically.[5] It is currently placed in the family Oxyruncidae but was formerly in the Tityridae and, before that, in the Tyrannidae.[6] Some consider it to belong to the family Onychorhynchidae based on its close evolutionary affinity with the Royal Flycatcher (*Onychorhynchus coronatus*), whereas others consider *M. sulphureipygius* to be conspecific with *M. barbatus* (Whiskered Flycatcher), of eastern South America.

Among several inherited traits, all members of this clade are aerobatic insect pursuers, aided by relatively large tails and rounded wings—ideal for maneuvering quickly within vegetation while pursuing a fleeing insect's erratic flight—and

prominent rictal bristles.[7] Relatively large eyes for its body size appear to adapt the Sulphur-rumped Flycatcher to low light levels in its habitat.[8]

All members of this clade also share distinctively long incubation and nestling periods (22 days each for the Sulphur-rumped Flycatcher's incubation and nestling period; up to 68 days in total for nesting!).[9] Probably owing to, in part, its long nesting period, the Sulphur-rumped Flycatcher produces, at most, one brood per season. The extended incubation and nestling periods of all members of this clade, together with their hanging nests, probably evolved for protection from snakes, which are some of the most important predators in the tropical rainforest understory.[10]

The female Sulphur-rumped Flycatcher takes about 3 weeks to build her suspended, distinctly pear-shaped nest from a hanging twig or vine, usually 1.2–10.5 m (4–35 ft) aboveground and typically over open ground or a stream so as to provide as little access as possible to snakes and other predators attempting to enter the nest from the ground or nearby vegetation.[11] The nest usually features an entrance below and to the side, beneath an apron-like structure that protects the brood from rain and probably also from the eyes of predators flying overhead by concealing the brightly colored rump of the incubating or brooding female. Wet weather can also threaten nesting success by causing the heavier nest to droop to the ground or fall from its support.[12]

While it is unknown why the female Sulphur-rumped Flycatchers alone build the nest, lay and incubate the two eggs, and feed the nestlings and fledglings, it is plausible that this results from specialization on relatively reliable prey that can be pursued in association with the mixed-species flocks they almost invariably attend while feeding and which probably help protect them from predators by providing many eyes to spot and signal predator presence.[13] This flycatcher also occasionally follows and feeds over army ant swarms.[14]

The Sulphur-rumped Flycatcher's active foraging style, including aerobatic pursuits of fleeing prey, explains its frequent consumption of winged prey such as beetles, bees, homopter-

Sulphur-rumped Flycatcher
(*Myiobius sulphureipygius*)
THOMAS W. SHERRY

ans, and flies.[15] It feeds winged insects, including moths and lacy-winged species, to nestlings and fledglings.[16] Its brightly colored rump also likely triggers many prey to jump or fly away, explaining the prevalence of winged and jumping (hemipteran) insects in its diet.[17] However, the Sulphur-rumped Flycatcher has a broad diet, in contrast with the highly restricted, specialized diet of its relative, the Ruddy-tailed Flycatcher, even though both species are similar in their use of aerobatic prey pursuits.[18] Its diet has been characterized as "a wide variety of active insects, many of which were fleeing from members of mixed-species bird flocks," which may be partly explained by its almost invariable following of such flocks (and occasional army ant swarms), members of which act as "beaters," flushing a variety of fleeing insects, which this flycatcher is better adapted to pursue and capture in flight.[19]

The Sulphur-rumped Flycatcher has evolved a specialized ability, based on a variety of body structures, to exploit the evasive behavior of prey that flee other flock members, including its contrasting rump displays and coloration, which likely evoke startle responses. Thus, this species has participated unwittingly for tens of millions of years in an evolutionary arms race between the insectivorous birds and their insect prey, as the former evolve specialized body traits for pursuit and capture, and the latter evolve better evasive mechanisms.[20]

Leaf litter in the tropical forest understory

Golden-crowned
Spadebill
(*Platyrinchus
coronatus*)

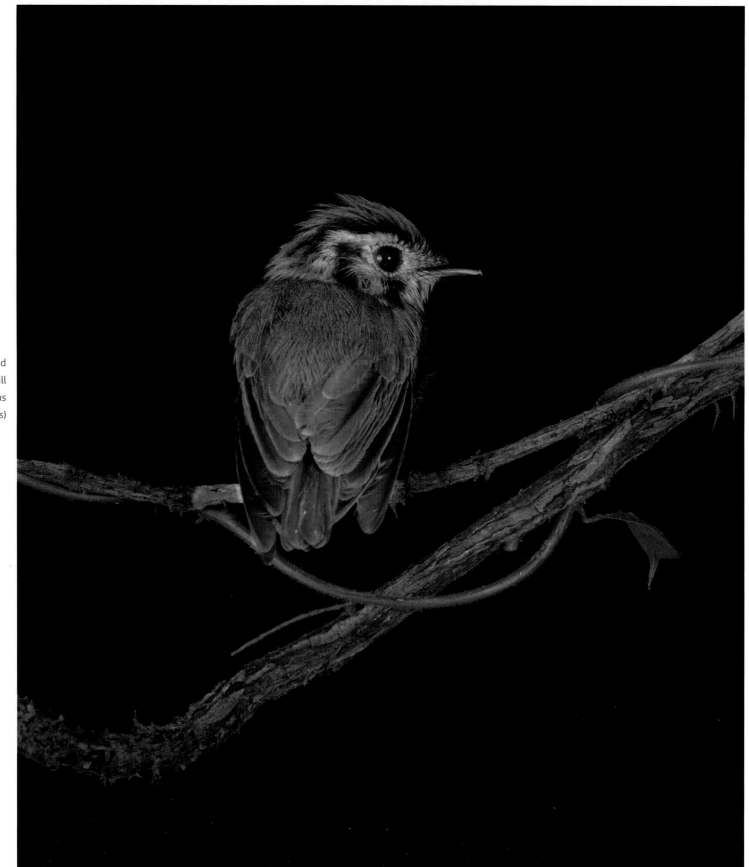

The American field naturalist Alexander Skutch (1904–2004) wrote over thirty books, scores of scientific papers, and some three hundred detailed life histories of Neotropical birds. Philosopher, recluse, ornithologist, autobiographer, evolution theorist, yet unknown to most—he was described in his obituary as one of the most famous unknown men in science.[1] His methodology was limited to persistent surveillance, but he was no ordinary birdwatcher. In the jargon of the spy novelist John le Carré, he fit the definition of a "pavement artist"—an agent armed with keen eyes and patient cunning who inconspicuously follows and observes.[2]

Skutch's *Life of the Flycatcher* is sprinkled with charming references to the tiny Golden-crowned Spadebill (*Platyrinchus coronatus*):

Most frequently these birds snatch prey from the undersides of leaves, where in tropical rainforests insects tend to be more abundant than on the upper faces. Moreover, the birds appear to enjoy an ampler view looking upward from the leafy twig on which they rest, which may screen much of the foliage beneath them. By a sharp upward dart, perhaps followed by a brief hover, the bird secures its prey before dropping to another perch. . . .

Among the crowds of birds of diverse kinds that gather over and around a swarm of army ants, snatching up insects and other small creatures that the hunting horde drives from concealment in the ground litter or from crevices in the bark of trees, flycatchers are occasionally present. None that I know is a regular follower of the army ants but a Golden-crowned Spadebill, meeting one of these swarms as it flows over the forest floor, may remain on the outskirts long enough to catch a few escaping insects. . . .

In the interior of rain forests, Golden-crowned Spadebills find other materials to fashion nests as soft and neat as those of hummingbirds. Situated in the upright forks of shrubs or saplings, the beautiful little cups are composed of leaf skeletons, large fern scales of chestnut color, light-colored bast fibers, richly branched stems of mosses and liverworts from which their minute leaves have fallen, and fungal rhizomorphs that creep over decaying stems and are called vegetable horsehair. The outside is plastered with few or many shreds of white spiders' egg cases.[3]

In early 1986, Skutch sent a group of amateur birders along a narrow path on his finca in Costa Rica. Fifty yards in, they bunched up in a small clearing trying to spot and identify a tanager. Only one of them (myself) ever saw the short-statured, dark-browed, motionless figure standing just inside the undergrowth, a machete dangling from his belt. A birdwatcher of a different kind—a "pavement artist."

Golden-crowned Spadebill

(*Platyrinchus coronatus*)

JOHN P. WHITELAW
AND EXCERPTS FROM THE
WORKS OF ALEXANDER F.
SKUTCH

Olive-striped Flycatcher

(*Mionectes olivaceus*)

SCOTT ROBINSON

Birdwatchers visiting the Panamanian foothills quickly become habituated to seeing the Olive-striped Flycatcher (*Mionectes olivaceus*), one of the characteristic birds of the Neotropical foothill forests, as they are not quite so difficult to see and identify as most of the obscure flycatchers that live in these forests. Indeed, it is likely that a phrase equivalent to "just another [expletive] olive-striped" has been uttered countless times by birdwatchers in many different languages. Even bird banders working in montane forests can rapidly tire of this abundant species, which appears to move around a lot, thereby readily encountering mist nets. Nevertheless, this species has several traits that make it exceptionally interesting and set it apart from other flycatchers.

Unlike most flycatchers in the vast family of New World flycatchers (Tyrannidae), Olive-striped Flycatchers primarily consume fruit.[1] They also eat spiders, but their breeding behavior is likely constrained by the availability of abundant fruit. Males sing endlessly from perches in the forest midstory during the breeding season, which suggests possible lekking behavior, but it appears that both males and females care for the young, a behavior that is often an indication of monogamy.[2] Their close relative, the abundant lowland Ochre-bellied Flycatcher (*Mionectes oleagineus*), similarly forms leks, but only the females appear to engage in parental care.

Olive-striped Flycatchers build a complex and rather elaborate hanging nest made partly of moss, often above forest streams and adjacent to rock faces.[3] Their nests look very much like debris hanging from vines.[4] In Peru, at least, they suffer extremely high predation rates despite the fact that their nest placement should make it difficult for many predators to reach.[5] As is typical of foothill birds, they breed during the wet season when fruit is most abundant.

Olive-striped Flycatchers also appear to be altitudinal migrants that move to lower elevations during the nonbreeding season, at which time they even occur in lowland sites such as Gamboa in Panama and the Cocha Cashu Biological Station in Amazonian Peru.[6]

When perched, they raise one or both wings at irregular intervals, a good field mark to complement the bold stripes that set them apart from most other foothill birds.[7] The function of this behavior is unknown as yet.

The Olive-striped Flycatcher is generally replaced at higher elevations by the Streak-necked Flycatcher (*Mionectes striaticollis*) and at lower elevations by the Ochre-bellied Flycatcher (*M. oleagineus*), but there are elevation ranges where they seem to overlap, which suggests that they do not actively engage in interspecific territoriality.[8]

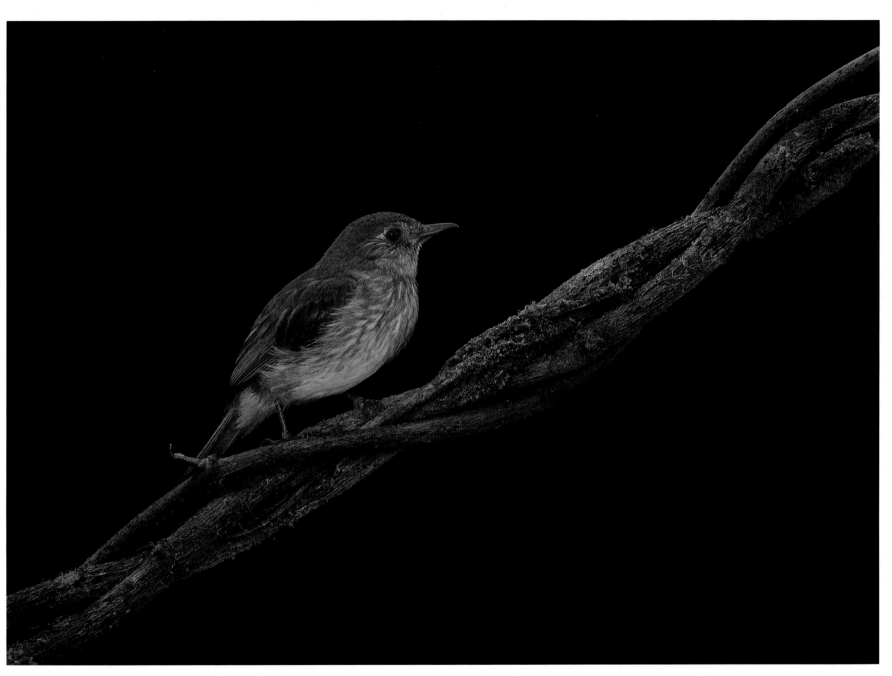

Olive-striped Flycatcher (*Mionectes olivaceus*)

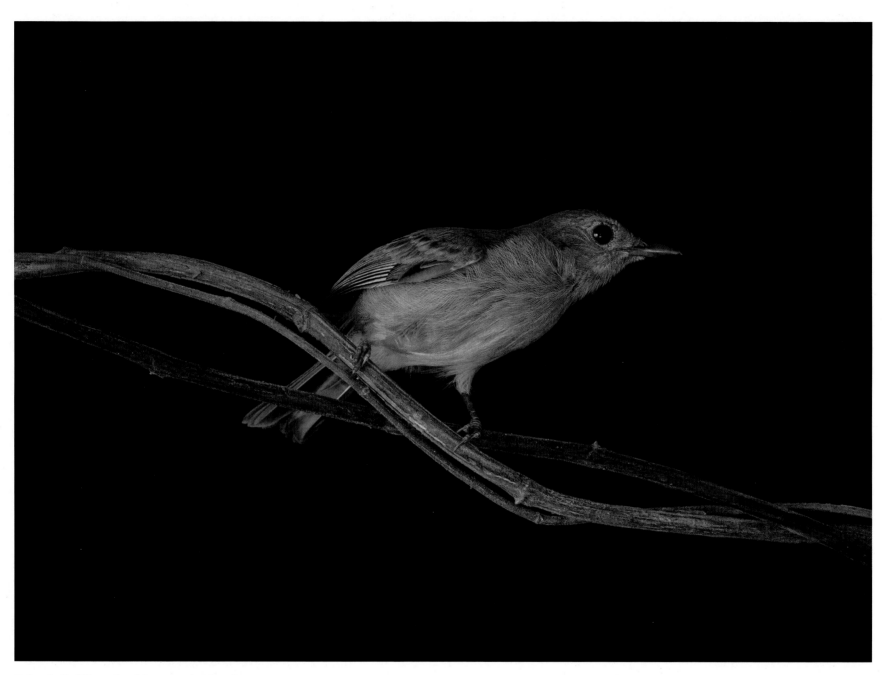

Ochre-bellied Flycatcher (*Mionectes oleaginous*)

In the dappled shade of the Neotropical forest understory, one of the commonest little flycatchers can also be among the hardest to find. The Ochre-bellied Flycatcher (*Mionectes oleagineus*) is a true oddball. Yes, it's a flycatcher—but it catches far more fruit than it does flies. In fact, this drab olive bird, with orange-tinted undersides and a pinkish base to its bill, is as much an obligate fruit eater as are its much gaudier cousins of the same habitat, the manakins. Indeed, at many a copiously fruiting melastome shrub, lucky observers can catch glimpses of a solitary, shadowy Ochre-bellied Flycatcher distinctively bobbing and peering about, then sallying up to hover and pluck plump, purple berries just a meter or two away from the vibrantly vermillion heads, incandescent-white eyes, and butter-yellow thighs of Red-capped Manakins (*Ceratopipra mentalis*).[1]

The remarkable ecological convergence between manakins and Ochre-bellied Flycatchers was even reflected in this flycatcher's earlier generic name, *Pipromorpha*, which—not surprisingly—means "manakin-like." Two other closely related species also bore this generic name, including the extremely similar McConnell's Flycatcher (*Mionectes macconnelli*), which differs from the Ochre-bellied mainly by lacking the ochraceous tips to the inner flight feathers and is limited to the Amazon basin. The Gray-hooded Flycatcher (*M. rufiventris*) also looks astonishingly similar to the Ochre-bellied but has a gray head and occurs only in southeastern Brazil. Rounding out this very distinctive, five-species group of flycatchers are the two original *Mionectes*—the Olive-striped Flycatcher (*M. olivaceus*) and the Streak-necked Flycatcher (*M. striaticollis*)—both of them mostly olive green and heavily streaked. These five species are all highly unusual flycatchers in their being largely frugivorous, mainly solitary birds of the forest understory.[2]

Ochre-bellied Flycatchers are common, nonmigratory residents of forest understory habitats at tropical elevations mainly below 1000 m (3250 ft), from southern Mexico, on south through Central America, and across much of tropical South America. They occur in wet forests on both sides of the Andes, the inter-Andean valleys of Colombia, the entire Amazon basin, and even along a narrow corridor of Atlantic forest in eastern Brazil.[3]

In addition to melastome fruits, Ochre-bellied Flycatchers commonly feed on mistletoe berries and on myriad small fruits of other understory shrubs and midstory trees. They consume these fruits whole and evacuate the seeds by regurgitating the larger ones and passing the many smaller ones through the gut. Thus, because this relatively common species deposits so many intact seeds around the forest, Ochre-bellied Flycatchers are among the most important dispersal agents for a host of understory plant species all across the Central and South American lowland evergreen forests.[4]

Around the world, birds that eat mainly fruit have broken free from the standard, monogamous pair-bond social formula of the typical songbird. In this respect especially, the Ochre-bellied Flycatcher is one of the true behavioral anomalies within its huge family, the New World flycatchers (Tyrannidae). During breeding season, males occur in loose clusters of rather miniature-sized but vigorously defended territories.[5] Each of these clusters constitutes a lek—an exploded "arena" of competing males, each vying all season long to be selected for mating by the many nonterritorial females that move far more widely throughout the forest understory (and who neither require, nor desire, the services of males in rearing their young).[6] At a few regularly used perches within his little territory, mostly within a few meters of the ground, each male spends many hours daily vocalizing with an irregular series of utterly unmelodious notes, variously described as *whit!* or *chi-WIK* and brief upward rattles, *r-r-r-IP*. These incessant calls are sometimes interspersed with a rapid-fire series of more nasal and urgent-sounding notes, *Teew!-Teew!-Teew!-Teew!-Teew!* All the while, these males are bobbing the head, glancing around in all directions, and—very curiously—rapidly lifting and lowering one wing. This unique, microsecond-long "single-wing-flick" is a dead giveaway to any curious birder who might otherwise be confused about the identity of this quite drab understory flycatcher.[7]

Detailed studies of this unusually fascinating bird have

Ochre-bellied Flycatcher
(*Mionectes oleagineus*)
JOHN W. FITZPATRICK

shown that the social intrigue of Ochre-bellied Flycatchers gets even more complicated in areas where the species is especially common. In rich understory habitats that contain lots of fruiting shrubs, about half the males follow the lek strategy outlined above, often clustering their small territories tightly together so that their accumulated, piercing call notes attract the largest possible number of prospecting females.[8] Other males do not defend territories at all but become interlopers, acting as "satellite males" around clusters of territory holders. Despite being repeatedly chased by the resident birds, they occasionally do succeed in mating with the females attracted by the actively lekking birds. Yet another strategy for some males is to remain solitary and to roam widely round the forest, calling at temporary sites without attaching themselves to any place for very long and not attending as satellites to the lekking males.[9]

Nests of Ochre-bellied Flycatchers are as distinctive as their social system. Constructed and attended exclusively by the female, they are large, bulky affairs that are built almost entirely out of moss. They may be ball shaped but often are vertically elongated, always with an entrance hole on the side, and usually attached to a suspended root or thin vine. The overall effect is extraordinarily camouflaged to look like a random mat of moss amidst the leafy tangles of the dark forest understory. Females lay two or three eggs.[10] The males—busy over many months of the year competing with one another for all-important but momentary encounters with females—never get to see these amazing, mossy nests that bear their offspring.

Avian Malaria in the Forest Understory

EMMA I. YOUNG

The tropical forest understory can be quite the buffet for insectivorous birds. A Rufous Motmot (*Baryphthengus martii*) enjoying a cicada and antbirds foraging for insects kicked up by an army ant swarm are typical examples. However, the buffet runs two ways. Ticks, lice, midges, biting flies, and mosquitoes are pests just as troublesome to birds as they are to the human birder and carry similar health risks. More specifically, mosquitoes (and many of their relatives) are capable of transmitting malaria to human and avian subjects alike.[1] As such, understory birds are often not only meals for blood-sucking arthropods but also for the "bugs" those arthropods, in turn, carry.

Malaria is widely thought of as a human-centric disease, but it is quite common in wildlife and actually plagued birds long before it made the jump to humans.[2] Although human malaria is generally confined to tropical areas, avian malaria is distributed worldwide, even in temperate environments.[3] Regardless of patient or location, the disease is caused by a single-celled parasite called *Plasmodium* that invades tissue and red blood cells.[4] *Plasmodium* is merely the genus name—there are many different species and strains of the parasite, mirroring the diversity of the animals it infects. This is why there is no concern about humans contracting avian malaria. While avian and human malaria are close relatives, each group of parasites has evolved to exploit different hosts, thus there is no crossover.[5] With over six thousand species of passerine birds to infect, avian malaria has evolved accordingly, diversifying into hundreds of unique strains found across the globe.[6]

Malaria is a chronic disease for most birds, short-ening lifespan and reducing reproductive output.[7] The disease can also reduce fat stores and therefore inhibit travel in migratory species.[8] Although malaria infects birds worldwide, some remote islands were only recently exposed. The result of the parasite traveling into a naïve bird population can be catastrophic: since birds carrying parasites were introduced to the Hawaiian Islands by humans, avian malaria has expedited the extinction of several endemic species of honeycreeper and threatens many more.[9] In many areas, birds are only safe above a certain altitude, where temperatures inhibit parasite transmission.[10]

The complex life cycle of malaria can make understanding the disease a daunting task, as birds and mosquitoes are much more than simple receptacles for malaria parasites. In many ways, birds and mosquitoes can be considered habitats for the disease, and they must offer the correct set of resources for the parasite to survive. It can be quite a long journey; for infection to occur, the parasite must transition from a bird (known as the "host") to an insect (known as the "vector") and into a second bird, surviving and reproducing at each step. Just as a bird might not survive in a novel habitat, a parasite strain that is picked up by the "wrong" vector or deposited into the "wrong" host will not survive transmission. Some strains are quite specialized, infecting only one or two bird species, whereas others are seemingly indiscriminate.[11]

In the canal region of Panama, hundreds of different bird species use the forest understory.[12] This area is also home to over fifty species of mosquito alone; this doesn't account for other insects that can transmit malaria, such as biting midges.[13] Once compounded with the complex lifecycle of *Plasmodium*, the level of avian and insect diversity in these habitats makes understanding avian malaria in the Neotropics an extremely intricate puzzle.

The bird species themselves can react quite differently when faced with infection. It is generally thought that abundant bird species are more likely to be infected, but there are exceptions to this trend.[14] Some common species, like the Clay-colored Thrush (*Turdus grayi*), have very high rates of infection, sometimes as high as 70%.[15] Interestingly, they share this trait with their relative the American Robin (*Turdus migratorius*).[16] Others, such as the less common Red-capped Manakin (*Ceratopipra mentalis*) and several of its sister species, have considerably lower prevalence, around 10%.[17] Many avian life history traits can influence these differences, including sociality and nest characteristics, but the role of the many vector species in these habitats is not yet well understood.[18]

Avian malaria is a riddle that scientists have long worked to unravel. To a disease ecologist, avian malaria poses an intriguing opportunity to understand how diseases evolve and how parasites interact with insect and avian hosts, habitat, and climate to influence infection. To a conservationist, this study is imperative: as climate change causes temperature and rainfall patterns to change, the distribution and impacts of avian malaria may similarly shift, exposing bird populations to further risk.[19] To an ornithologist, the disease is a fascinating reminder that birds can interact with each other in much more subtle ways than meet the eye.

Scale-crested Pygmy-Tyrant

(Lophotriccus pileatus)

JOHN W. FITZPATRICK

Of all the little green birds that abound in Neotropical understories, the Scale-crested Pygmy-Tyrant (*Lophotriccus pileatus*) is among the most charming and also among the most mysterious. Its charm is obvious, with its combination of elfin size (at 7 to 8 g [0.25–0.35 oz] this bird is smaller than many hummingbirds), its creamy-white eyes, and its crazy ornament—a shaggy crest consisting of elongated blackish feathers rimmed with rusty orange, presenting a scaly appearance. The distinctive, helmet-like crest explains this miniature bird's generic name, *Lophotriccus*—*lophos* is the Greek word for "crest" and *trikkos* means "tiny bird."

The social function of this pygmy-tyrant's crest is mysterious, as it is raised so rarely that very few people—from hobby birders to career specialists who study understory birds—have ever seen it held vertically during a natural encounter. Just as with its even more ornamented, distant relative, the Royal Flycatcher (*Onychorhynchus coronatus*), this pygmy-tyrant's orange crest is mainly seen elevated when the bird is held in the hand after being mist netted. In its elevated position, the crest is a bit longer on the sides than at the center, presenting the impression of two "horns" that, together with its pale eyes, provide this miniscule bird with a comically ferocious appearance.

Charming as it is visually, the diminutive and well-camouflaged Scale-crested Pygmy-Tyrant is far more frequently heard than seen. Indeed, its voice is astonishingly loud and sharp for so tiny a bird, accomplished with a syrinx (avian voice box) that is unusually robust for a bird of this size. In Central America, its most common calls are single, double, or a short series of ringing, metallic or reedy notes, uttered either at a steady pitch or slightly rising. The sound is distinctive but difficult to describe. Various authors have used words such as *preet*, *trik*, *kreek*, *chick*, and *trit*.[1] One especially colorful effort to describe these sounds in Costa Rica includes this excerpt: "rising and falling dry trill; a sharp, stuttering, 'picket-fence' rattle; a quick series of ascending 'kwlick''s staggering to a close; a series of sharp 'tchrik''s either stammering or run together like a rattling traffic whistle . . . a short sharp 'djit'

or clipping 'chit' . . . a rippling, rattling 'tsftrk,' not unlike the little trill of a tree frog, which may arise from all sides of the listener, and the little 'pink' of a tree frog."[2]

In the Andes, from Venezuela to southeastern Peru, this bird is widely known as the "police-whistle bird" because its loud song is a long, very rapid series of these metallic notes, offered in such a ringing trill that the sound easily recalls that of a police or football-referee whistle.

It is a mystery exactly why this little bird has such an unexpectedly loud, ringing call. One speculation is that the species maintains an "exploded lek" social system, in which males compete for females but do not form lasting pair bonds and play no role at the nest (as in many manakins and the Ochre-bellied Flycatcher).[3] This hypothesis originated with Alexander Skutch's general failure to find males and females acting together like mated pairs.[4] Remarkably, however, despite decades of careful observations by this acclaimed naturalist, Skutch reported finding only a single nest of this species, at which, indeed, he observed no visits by a presumed male.

The nest that Skutch observed was a hanging, purse-like structure with a hole near the top shielded above by a small visor. The nest was about 4 m (13 ft) above the forest floor and covered with moss that extended nearly a foot below the purse to form a thin, dangling "tail." Few other reports of nests of this species exist in the literature, but all evidence points to its pendant nest being structurally typical of the many other pygmy-tyrant and tody-tyrant relatives throughout the humid Neotropics.[5] Like all these relatives, the Scale-crested Pygmy-Tyrant is entirely insectivorous (see below), not frugivorous or nectivorous as would be typical for a forest-dwelling lekking species. The hypothesis of lek behavior seems extraordinary and far-fetched for a pygmy-tyrant and remains unsupported by any direct observations. The mystery lingers.

Most tyrant flycatchers (members of the family Tyrannidae) forage with variations on a strategy that is extremely common among insectivorous birds the world over. They perch and search, then either sally out to capture a prey item with their bill or give up and make a flight to a new perch.[6]

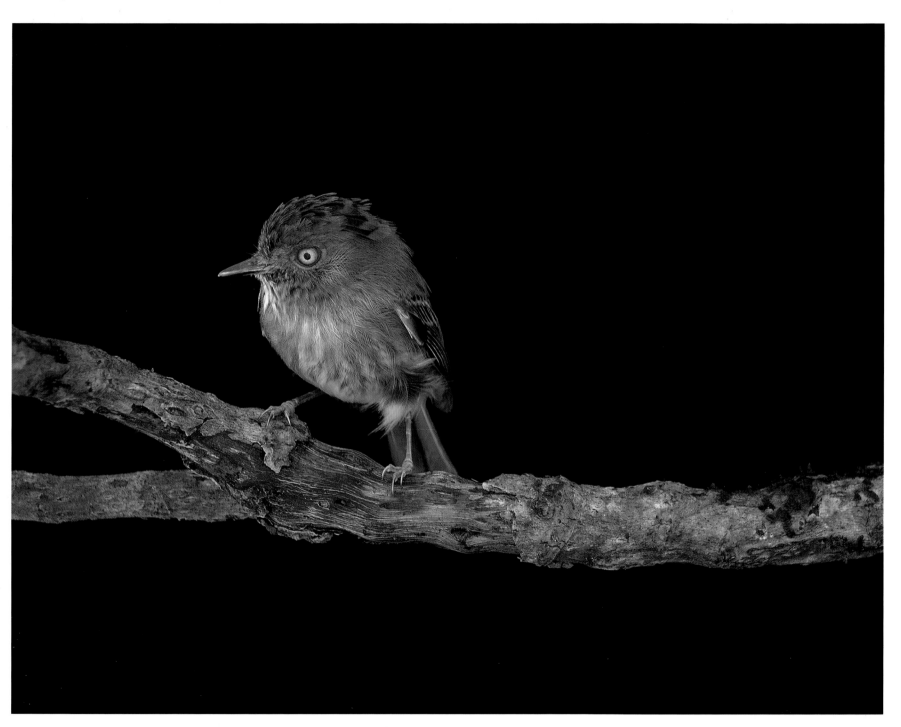

Scale-crested Pygmy-Tyrant (*Lophotriccus pileatus*)

Large, open country or canopy-dwelling flycatchers such as kingbirds (genus *Tyrannus*) habitually perch for extended periods, search wide areas, and frequently sally long distances to capture prey. Flycatchers that make their living down in the forest understory, where vegetation density is much higher, search for prey amidst much more confined spaces, so their search times and sally distances are much shorter.[7] The Scale-crested Pygmy-Tyrant is in the latter group and belongs to a large assemblage of tiny flycatchers, all of which use a specialized foraging habit and have a suite of physical traits to match.

The fifty-three species of Neotropical pygmy- and tody-tyrants are all "upward strike" specialists, systematically moving through the vegetation with pauses of 20 to 30 seconds at each perch, during which they peer upward at the undersides of leaf surfaces, where many small insects hide. When an insect is spotted, the pygmy-tyrant darts upward to snatch or scoop the prey item, then flies off to a new perch to handle the prey and start another search. The bills of pygmy-tyrants are somewhat broad and flattened to aid the scooping action at the leaf underside, and this trait is even more exaggerated in the tody-tyrants.[8] The wings of both pygmy-tyrants and tody-tyrants are short and round, with pronounced camber (curved like a spoon), which facilitates these quick-as-a-wink upward darts. The legs are long and sturdy, helping the jump-start action. Pygmy-tyrants do not have much of a tail, as no aerodynamic maneuvering is required by these short upward bursts. Indeed, a close relative of the Scale-crested Pygmy-Tyrant is the Short-tailed Pygmy-Tyrant (*Myiornis ecaudatus*), which is the smallest passerine bird in the world and barely has a tail at all.

The three other members of the genus *Lophotriccus* are all limited to the Amazon basin. Unlike them, Scale-crested Pygmy-Tyrants extend as far north as Honduras, and rarely occur in the tropical lowlands. They occupy the forested foothills and middle elevation cloud forests, mainly between 500 and 2000 m (1600–6500 ft). Commensurate with the foraging habits described above, they favor dense thickets and even thick second growth, which helps explain why they are so hard for us to see. In the Andes, the species is especially fond of dense stands of bamboo, but in Central America it occurs commonly in the lowest strata of many types of humid evergreen vegetation.

Happily, the Scale-crested Pygmy-Tyrant is presently classified as Least Concern in the IUCN Red List of Threatened Species.[9]

Tropical forest
understory, Chiriqui
Province, Panama

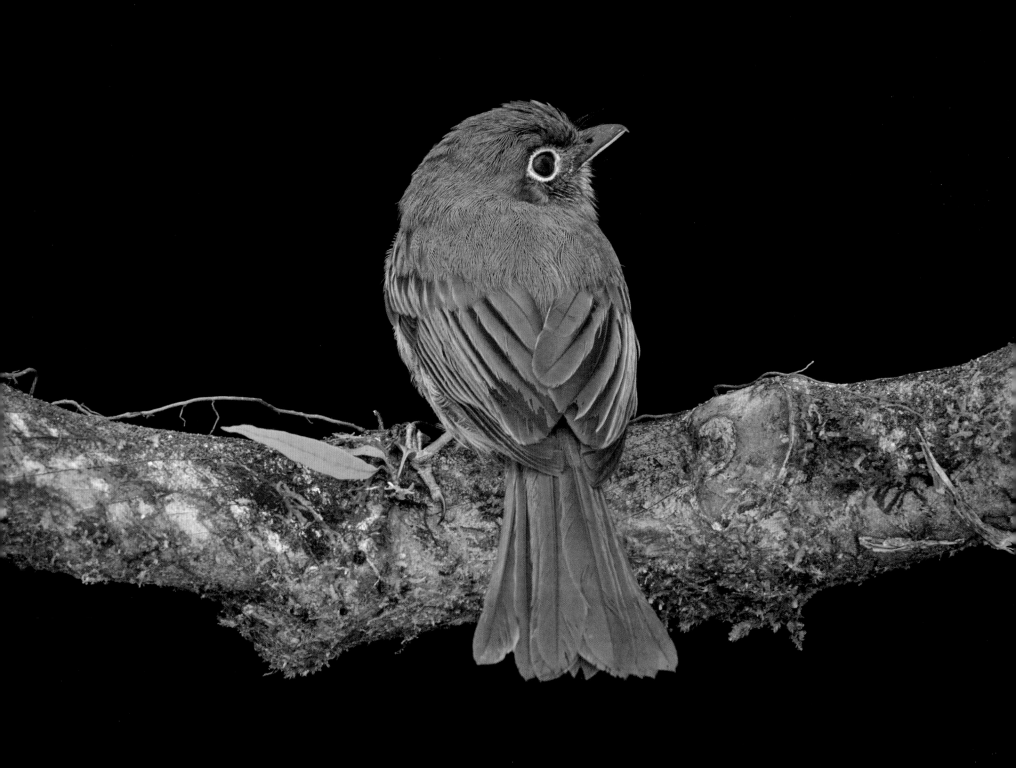

Some birds are easily seen and heard because they are bright, colorful, and loud, while others are drab, retiring, and quiet. Variations in how conspicuous the color and song are result from an evolutionary dance between a bird's success and failure in acquiring food, avoiding becoming food, soliciting a mate, and fending off competitors. Among those birds that appear to care little about flashy plumage and booming songs is the Eye-ringed Flatbill (*Rhynchocyclus brevirostris*). This bird appears well suited to frustrating birdwatchers: its drab plumage, coupled with its habit of sitting motionless, makes it difficult to locate in the forest understory or canopy. To locate an Eye-ringed Flatbill successfully and repeatedly, one must familiarize oneself with its unique vocalizations, which often consist of a single (sometimes double) ascending raspy whistle.

Up close, Eye-ringed Flatbills are quite beautiful in their unique morphology. They are olive above, pale below, with a crisp white eye ring and, perhaps most noticeably, an abnormally wide yet stubby bill, which is responsible for the species' moniker. Their unique bill is used to capture insects on the wing or to pluck arthropods from the underside of foliage while hovering.

Besides foraging alone, Eye-ringed Flatbills sometimes accompany mixed-species flocks and ant swarms, to capture insects fleeing marauding swarms of army ants.

Eye-ringed Flatbills are found in mature forest, second growth, and forest edges, where they construct large and oblong nests that dangle from a branch. The nests are fashioned from roots, rhizomes, and dead leaves, with an entrance hole near the bottom of the structure. In Costa Rica, famed ornithologist and writer Alexander F. Skutch observed these birds using nests outside the breeding season as a dormitory, "sleeping singly in these hanging structures, some of which have scarcely any entrance tube, while the chamber is so shallow that an egg would probably roll out, so that they could not be used for breeding."[1] During the breeding season, watchful parents try to avoid the catastrophe of brood parasitism—by which their nest is used by a foreign bird species to lay its eggs. If the parasite is successful, unwitting parents are tricked into raising the young of another species. Eye-ringed Flatbills have been known to fall victim to the Pheasant Cuckoo (*Dromococcyx phasianellus*), a prolific brood parasite.

Little is known about the population trends of Eye-ringed Flatbills throughout their range, although they are classified as Least Concern by the IUCN Red List of Threatened Species.[2] However, at La Selva, the famed biological station in Costa Rica, Alice Boyle and Bryan Sigel used 23 years of Christmas Bird Count data to show a precipitous decline in the number of Eye-ringed Flatbills and other understory insectivores.[3] The loss of understory insectivores at La Selva has been linked to habitat fragmentation and the degradation of understory vegetation.

Eye-ringed Flatbills are members of the flycatcher family (Tyrannidae), a large group of more than four hundred species spread throughout the Americas. Eye-ringed Flatbills can be found from southern Mexico throughout Central America, where their range abruptly stops just beyond the Panamanian border in Colombia.

Eye-ringed Flatbill
(*Rhynchocyclus brevirostris*)
JARED WOLFE

Eye-ringed Flatbill (*Rhynchocyclus brevirostris*)

Olivaceous Flatbill

(*Rhynchocyclus olivaceus*)

J. PATRICK KELLEY

Usually masked by the cacophonous vocalizations of toucans and parrots, the understory of tropical forests is alive with the short screeches, mechanical clacks, and quiet melodies of hundreds of smaller bird species, seldom seen but often heard. Among these species, perched in the midcanopy and camouflaged by yellow-green plumage, is the Olivaceous Flatbill (*Rhynchocyclus olivaceus*). Though the Olivaceous Flatbill is distributed widely across the lowland forested tropics, it, like most tropical bird species, has received very little attention from ornithologists.[1]

Inhabiting many forest types but preferring those with dense understory, the Olivaceous Flatbill is surprisingly charismatic in behavior and appearance. Similar to understory birds like puffbirds and motmots, these flatbills are reserved in their movements. They can perch very still for long stretches, only moving their heads and eyes, scanning the leaves around them for concealed insect prey, their inactivity making them easy quarry for the photographer's lens. But faster than one can blink, their long stretches of lethargic scanning are interrupted by a sally–glean, a sudden leap and flight into the air to grab an ill-veiled insect. They are more active in the Amazon, at least enough to travel with mixed-species flocks.

Olivaceous Flatbills can vary greatly in body weight, even at the same locale, ranging from 14 to 24 g (0.49–0.84 oz). When viewed from its side, the Olivaceous Flatbill has the typical appearance of many inconspicuous forest flycatchers. But viewing this species from ground level allows one to gain full appreciation of the hallmark trait of the *Rhynchocyclus* genus: the "shield bill," or the exceedingly flat and widened bill seemingly ready to trap easily any small insect passing by. Despite being dull colored when viewed through the vegetation, the plumage of the Olivaceous Flatbill is subtly spectacular. Illustrations in bird guides seldom do justice to the rich-colored plumage of this little bird. Its pale eye ring surrounds its large dark eye, complementing the exaggerated size of its bill. The dark olive of its head and back contrast beautifully with the pale-yellow chest and belly, and the dusky wing coverts and secondary feathers exhibit an elegant yellow edging. Across the six subspecies presently defined, there are subtle variations in plumage and behavior.[2]

Though its nasal and buzzy calls and song are unmistakable, the vocal repertoire of the Olivaceous Flatbill remains poorly understood.[3] Songs and calls from across its wide range can sound markedly different, aligning with different subspecies; some songs have a distinctive ascending tempo ending in a short *skrit* sound (*wee wee wee wee-whiwhi-skrit*) while others may be consistently tonal and end rather abruptly. Calls can also be varied across the distribution, ranging from very short *skrits* to short tonal whistles. Cueing into just a few of these vocalizations can thrill and help the casual observer appreciate the cryptic nature and charismatic behavior of the Olivaceous Flatbill.

Like many other tropical flycatchers, the nests of Olivaceous Flatbills are rather bulky and coarse in appearance, constructed from small to medium-sized twigs.[4] To the human observer (but most likely not to predators), these pear-shaped nests are conspicuous, hanging from the end of a few small branches, typically separated from other vegetation. The Olivaceous Flatbill enters its nest through a hole on the nest's side and bottom to incubate and brood its two to three offspring.[5]

Olivaceous Flatbills can be found in a wide variety of forested areas in the lowlands of Central and South America at elevations up to 1000 m (3300 ft). Their northern range limit occurs in Panama, where it has been most well studied, yet its distribution extends throughout northern South America and southward to the Atlantic forest in Brazil. They are designated as Least Concern by the IUCN Red List of Threatened Species.[6]

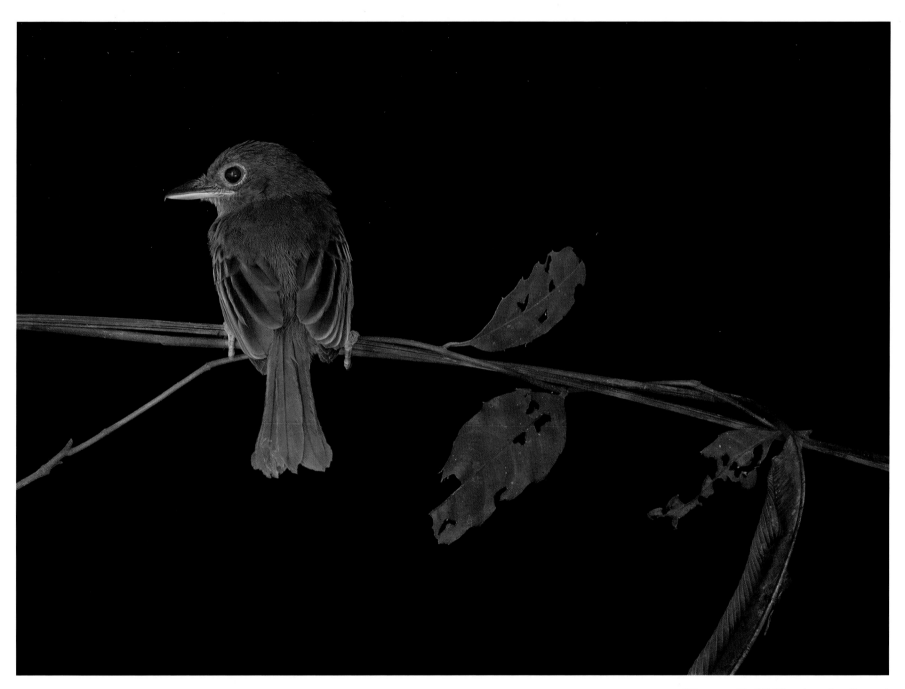

Olivaceous Flatbill (*Rhynchocyclus olivaceus*)

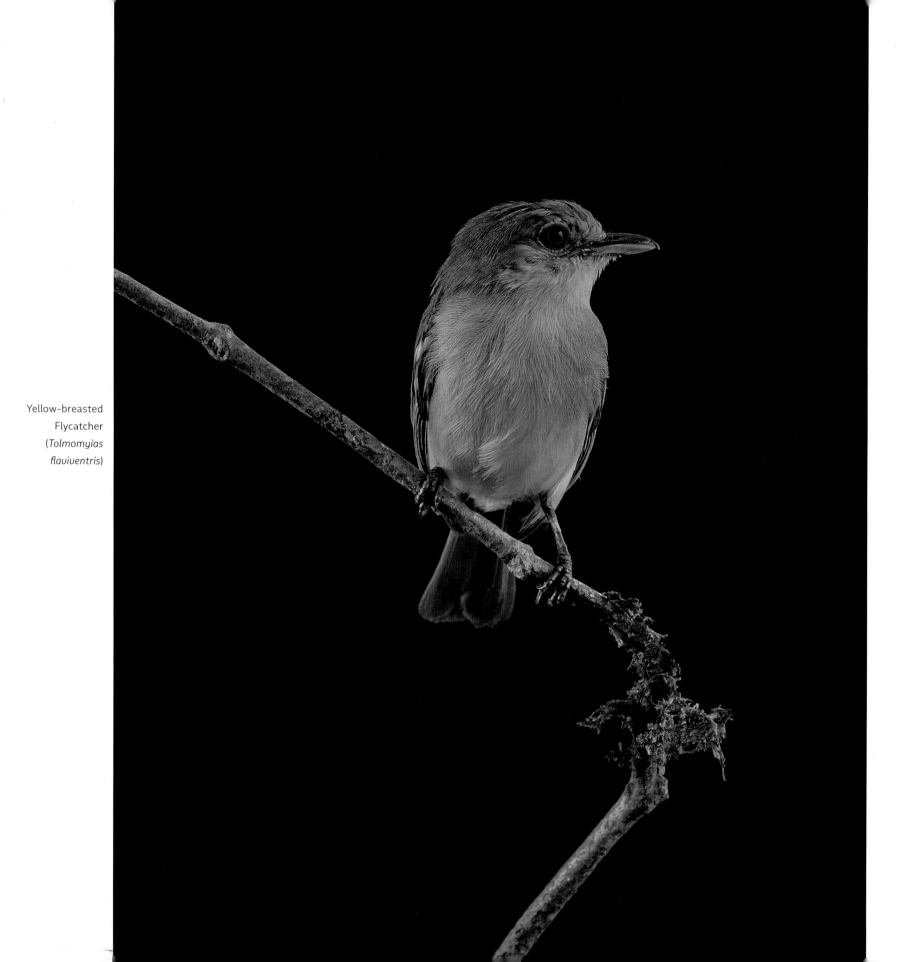

Yellow-breasted
Flycatcher
(*Tolmomyias
flaviventris*)

This relatively small flycatcher continues to be a challenge for taxonomists because of some subtle phenotypic variations across its wide range from the base of eastern Panama (Darién Province) to the northern half of South America. One simplistic approach splits the species into two other true species: those north of the Amazon, named Ochre-lored Flatbills, and those south of the Amazon, Ochre-faced Flatbills. A second, and currently favored solution, is to regard the Yellow-breasted Flycatcher as a single species with six subspecies, divided into two groups of three.[1] The bird pictured here, which was photographed in southeastern Panama, is *Tolmomyias flaviventris aurulentus* (*aurulentus* from the Latin for "golden"), as determined by its intensely yellow coloration. One can also see in the image, albeit faintly, ochre coloring between the eye and the bill (the lores).

Interestingly, the species was apparently not referred to in Ridgely's first edition of *A Guide to the Birds of Panama*, either as a flycatcher or as a flatbill.[2] In contemporary Panama field guides, the illustrations do not do justice to this bird's bright yellow breast, even though Angehr describes it as "much yellower overall than all other flycatchers except the Yellow Tyrannulet."[3] In fact, it is this saturated lemon yellow, especially brilliant in the studio setting, that justifies the species' scientific name. Indeed, the color is so brilliant that it appears in the digital capture as an almost specular washout. The intense yellow color and subtle orange lores are the main features that differentiate this subspecies from its five congeners.

The foraging repertoire of the Yellow-breasted Flycatcher includes upward sally strikes, sally gleaning (hence the name *Tolmomyias* from the Greek *tolma* for "bold" or "daring," and from the Latin *myias* for "fly"), and hover gleaning to pluck prey from twigs and the undersides of leaves. Its diet includes cockroaches, beetles, ants, wasps, and spiders, as well as some berries.[4] As it captures prey, its bill makes a distinct snapping sound.

The Yellow-breasted Flycatcher's nest is a yellowish, pensile, pear-shaped bag, with an entrance on one side close to the bottom. It is built, by both the male and the female, of fine fibrous roots, referred to by Alexander Skutch as "vegetable horsehair," and it can take over a month to construct. A clutch consists of two to three creamy-white eggs with purplish spots, the incubation of which apparently falls solely to the female.[5]

The species often employs the antipredator strategy of nesting close to wasp nests (76% of the time in one study) and has been reported in several cases to be actually cohabiting a large vespiary of social *Pison* wasps.[6] Common neighbors include members of the genus *Synoeca*, which are aggressive wasps with a powerful sting, and members of the genus *Polybia*, whose venom contains a neurotoxin. Nests have also been found amid a colony of Yellow-rumped Caciques (*Cacicus cela*).[7]

The Yellow-breasted Flycatcher's present IUCN Red List of Threatened Species status is Least Concern.[8]

Yellow-breasted Flycatcher
(*Tolmomyias flaviventris*)
JOHN P. WHITELAW

Southern Bentbill

(*Oncostoma olivaceum*)

THOMAS W. SHERRY

Nearly everything about the Southern Bentbill (*Oncostoma olivaceum*) is unremarkable, making it easy to overlook. Just like most other suboscine passerine birds (non-songbird perching birds), the Southern Bentbill's song is plainly unmusical, described as a "guttural insect-like or toad-like trill, *'grrrrrrr,'* sometimes with an introductory note, *'pt-trrrrrrr.'*"[1] "Usually they are timid, so that their presence is known only from their calls, uttered by the birds that remain hidden among the leaves."[2]

The Southern Bentbill looks like, and is challenging to distinguish from, many other New World flycatchers (Tyrannidae)—painted in olive, green, and some yellow and white colors, streaky on the breast with a yellowish-green background color. Like many other tyrannids, the Southern Bentbill has two indistinct yellowish wing bars and yellow wing feather edgings.[3] It is also easy to overlook because of its small size (6–7 g [0.2–0.25 oz], 8.9 cm [3.5 in.]), and its foraging behavior, which is marked by long periods of sitting, followed by sudden "upward strikes," by which the bird quickly attacks prey on a leaf or branch from below and then continues on to a new perch. What makes it relatively easy for birdwatchers to encounter, with a little patience, is its abundance (a species of Least Concern to conservationists), "loquacious" vocalizations, wide range of habitat from constantly humid tropical forests to more seasonal forests, and distribution, primarily in the lowlands to an elevation of 1000 m (3300 ft).[4] It forages low, typically within 4.6 m (15 ft) of the ground. What is remarkable about this small flycatcher is its eponymous "bent" bill. The bill is flattened overall, that is, wider than deep throughout its length, but has a conspicuous downward bend toward its tip, particularly in the upper bill (mandible).[5] This unique bill shape, and other peculiar traits including aspects of its life history, bear explanation.

The Southern Bentbill ranges from central and eastern Panama into northwest Colombia. It is replaced further westward in Panama by the Northern Bentbill (*O. cinereigulare*), which is common throughout Costa Rica and ranges as far north as southern Mexico, from the lowlands to higher elevations throughout. Almost all species accounts, including recent field guides, treat both bentbills as separate species but add that some authorities consider them subspecies. Morphologically, vocally, and ecologically they are almost indistinguishable. Their distribution is patchy, particularly that of the Southern Bentbill, and a gap exists between their nonoverlapping ranges in western Panama for reasons still being investigated, including possible shared parasites and consequences of hybridization. The most conspicuous difference between these two "species" is their plumage: the breast background coloration of the Northern Bentbill is grayish-white, as opposed to the yellowish-white breast of the Southern Bentbill, although the latter also has a slightly shorter wing and longer bill than the former.[6] The sexes are indistinguishable in both species. The differences between the Northern and Southern Bentbills are so subtle as to call into question whether they are, in fact, true species. One way to address this question is with molecular sampling, but unfortunately this has not yet been done extensively enough for definitive results. However, based on molecular data from two Southern and one Northern Bentbill individuals, we do know that the divergence between them is not much different from that between subspecies within other tyrannid species.[7] Thus, it is not yet known conclusively whether the Southern versus Northern Bentbills are true species or just subspecies. Given their ecological similarities, the conservative conclusion is that they represent subspecies of the same species. Regardless of their taxonomic status, both populations inherited a similarly bent bill from a shared ancestor.

Skutch hypothesized that Bentbills are adapted for upward-striking foraging behavior, noting that while foraging "the upper surface of the terminal portion of its bill is more or less parallel to the lower surface of the leaf."[8] The only problem with Skutch's hypothesis is that it ignores the fact that many upward-striking flycatchers use this same foraging behavior but have straight rather than bent bills. An alternate hypothesis might be that it is adapted to feeding from harder substrates than leaves, such as woody vines, which are fre-

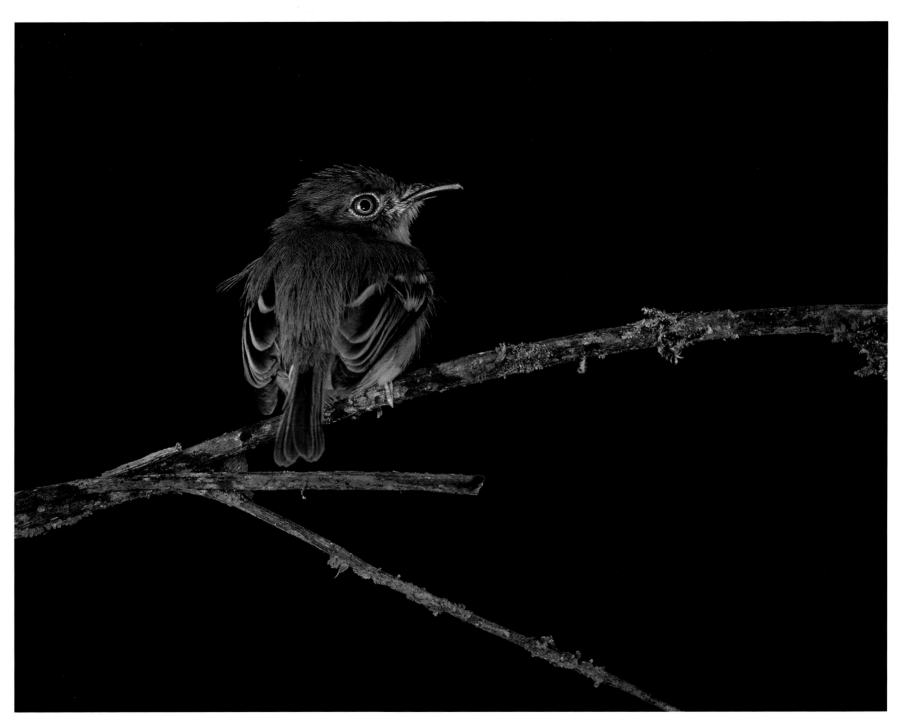

Southern Bentbill (*Oncostoma olivaceum*)

quented by Northern Bentbills. While this group and many other tyrannids, are generalists in feeding on insects, they are specialized in terms of their habitats, elevations, and foraging substrates. This specialization is ultimately driven by widespread competition among all these flycatchers for many of the same insect prey.[9]

Both the Northern and Southern Bentbills tend to nest near the ground, the female alone carrying out all the reproductive activities from nest building to caring for fledged young. The incubation period is long (typically 19 days), especially for such a small flycatcher.[10] The nest is a small, globular structure, made of pale-colored plant fibers, typically suspended from a live leaf or branch, anywhere from a few centimeters to 4 m (13.1 ft) aboveground. Typically, it has a visor-like structure above its side entrance, likely to protect the one or two eggs, and then the nestlings, from rain.[11] It is presumed that the long incubation periods are possible because of the relatively safe (at least from snakes) nesting behavior associated with the suspended nests of many lowland Neotropical birds, and protection from a variety of nest predators in such habitats is an important selective pressure on such birds.[12] Female-only nesting and rearing of chicks and fledglings is also characteristic of some other New World tropical flycatchers, for unknown reasons, but possibly related to the intense competition for food with other species and the need to keep commotion at a minimum near the nest given the threat of various nest predators.[13]

Ectoparasites on Panamanian Birds

SERGIO E. BERMÚDEZ CASTILLERO

From coastal seabirds that nest on islets, to perching birds that inhabit the highlands' treeless plateaus, through the Harpy Eagle (*Harpia harpyja*) to tiny hummingbirds, the birds of Panama, like those of the entire world, are parasitized by different groups of ectoparasites.[1]

But what are the ectoparasites? The word refers to external parasites; however, it is commonly used to refer to arthropods that permanently or semipermanently parasitize vertebrates. In this sense, ectoparasitic arthropods are a taxonomically diverse group of mites and insects that have different levels of specificity to their bird hosts and also to their environments.

A wide variety of mite families have been reported in Panama, from those that are hematophagous (blood eating) to the highly specialized commensals (i.e., the parasite benefits and the host derives neither benefit nor harm) that live permanently on birds. Of the hematophagous mites, five genera of chiggers (*Blankaartia, Eutrombicula, Neoschoengastia, Odontacarus*, and *Trombicula*) have been recorded as parasites of a wide variety of birds, including nearly fifty arboreal, terrestrial, aquatic, and marine bird species. Several species of chiggers are not host specific, parasitizing multiple species of birds and mammals, including humans, although some species have been reported only in birds (e.g., *Neoschoengastia electron* on *Electron platyrhynchum*, the Broad-billed Motmot). These chiggers attach themselves to birds when they forage for food on the ground, and dozens can be observed parasitizing a single bird.[2] There is a closer relationship with birds in the genera *Pellonyssus* and *Ornithonyssus* (family Macronyssidae), which are also hematophagous mites on Panamanian birds.[3] Of these, *O. bursa* may parasitize humans. Unlike chiggers, the *Pellonyssus* and *Ornithonyssus* species inhabit the nests of birds.

More than thirty species of eight families of feather or quill mites are present in Panamanian birds (Alloptidae, Crypturoptidae, Freyanidae, Proctophyllodidae, Pterolichidae, Pteronyssidae, Syringophilidae, and Trouessartiidae) and maintain a strong species-specific relationship.[4] These are permanent commensal parasites, highly specific to certain types of feathers and even to sites within the feathers. In recent years, several species and genera of feather mites have been described in Panama; however, their high specificity suggests that there are many more species or genera yet to be described. Owing to their tiny size, feather mites often go unnoticed.

Ticks represent the most conspicuous mites because they are largest in size. They have three postembryonic stages (larvae, nymphs, and adults) that, with a few exceptions, are all hematophagous, but they have nonparasitic phases between their parasitic phases.[5] This group of mites includes close to 950 species divided into three families: Nuttalliellidae (one species), Argasidae (ca. 215 species), and Ixodidae (ca. 735 species). Nearly fifty species of ticks inhabit Panama.[6] Of these, Argasidae has been little reported in wild birds; in fact, of ten Argasidae present in this country, only *Ornithodoros capensis* has been reported on the seabirds of rocky shores and islets.[7] Another two species, *Argas persicus* and *Ornithodoros rudis*, have been found in poultry; the latter was implicated in the transmission of relapsing fever to humans (*Borrelia recurrentis* group).[8] In all their stages, these ticks are closely related to birds and, in the case of *O. capensis*, to their environment.[9]

In contrast, out of thirty-seven Ixodidae confirmed in Panama, twelve species are well known to parasitize birds, and their presence is not in doubt. In addition, *Ixodes brunneus* has been reported, but its presence has not been confirmed.[10] Of these, *I. auritulus* and *I. bequaerti* use wild birds as their main hosts. In Panama, both species inhabit the highlands. *Ixodes auritulus* has a wide distribution that includes Afrotropical, Australasian, Nearctic, and Neotropical zoogeographic regions and has been found in a wide diversity of birds, both marine and terrestrial. In Panama, it was found parasitizing Mountain Thrush (*Turdus plebejus*) and Spotted Wood-Quail (*Odontophorus guttatus*). These birds forage on the ground, which favors parasitism. The distribution of *I. bequaerti* is confined to mountains in Mexico and Central America, where it has been found parasitizing trogons and quetzals, although it has also been found in Panama on a *Catharus*. *Ixodes bequaerti* appears to be nidicolous (i.e., it remains in the nest for a time after hatching) and a canopy dweller.

Unlike the close bird–*Ixodes* relationship in the highlands, tick parasitism in the Panamanian lowlands can be opportunistic and linked to immature stages, whereas the adults feed on mammals or ectothermic vertebrates. In this country, larvae and nymphs of nine species of *Amblyomma* ticks feed on a variety of birds but also on small mammals, reptiles, or amphibians. Birds seem to be the main hosts for the immature of *Amblyomma* species, such as *A. lon-*

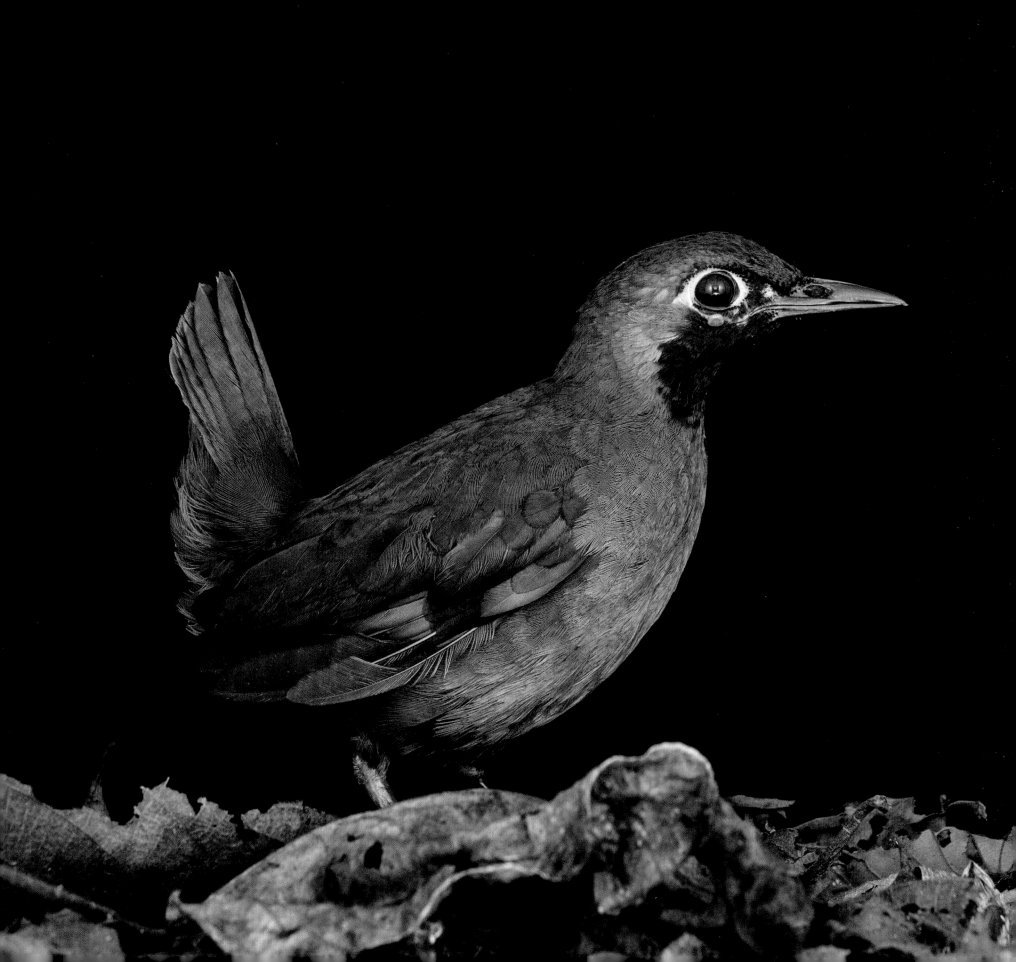

girostre, *A. nodosum*, and, to a lesser extent, *A. cal-caratum*, *A. geayi*, and *A. varium*. Of these, arboreal and scansorial (i.e., adapted for climbing) mammals such as porcupines (*A. longirostre*), anteaters (*A. cal-caratum* and *A. nodosum*), and sloths (*A. geayi* and *A. varium*) are their main hosts. Moreover, for at least five species of ticks, birds are opportunistic hosts, since the principal hosts of these ticks are terrestrial mammals (*A. naponense*, *A.* cf. *oblongoguttatum*, and *Haemaphysalis juxtakochi*), reptiles, or amphibians (*A. sabanerae* and *A. dissimile*).[11] Immature of these species have been reported in various groups of birds, including raptors such as the Harpy Eagle. In Panama ticks can cause serious diseases such as spotted fever via *Rickettsia rickettsii*. Other species of *Rickettsia* have been found in ticks that parasitize birds in Panama, but up until now the role of birds as reservoirs of pathogens transmitted to humans by ticks has not been established.[12]

The insects associated with the birds of Panama are fleas, flies, and lice. Two genera and three species of fleas have been reported in the highlands: *Cerato-phyllus albus* on the Andean Pygmy-Owl (*Glaucidium jardinii*), *Dasypsyllus gallinulae* on Rufous-collared Sparrows (*Zonotrichia capensis*) and a nest of Brown-capped Vireos (*Vireo leucophrys*), and *D. lasius* in swallows' nests.[13] Of the flies found in Panama, Hippoboscidae are obligate parasites of birds and a few species of mammals; of these, nine genera and twenty-two species have been reported in Panamanian birds.[14]

Lice are species-specific and highly specialized insects, and it is estimated that there are more than eighty species, corresponding to forty-four genera divided into two families in Panama. In fact, most wild birds in Panama have one or more host-specific species of chewing lice, some as yet undescribed.

Black-faced Antthrush (*Formicarius analis*) with facial ectoparasite directly under the eye

Mountain Elaenia
(*Elaenia frantzii*)

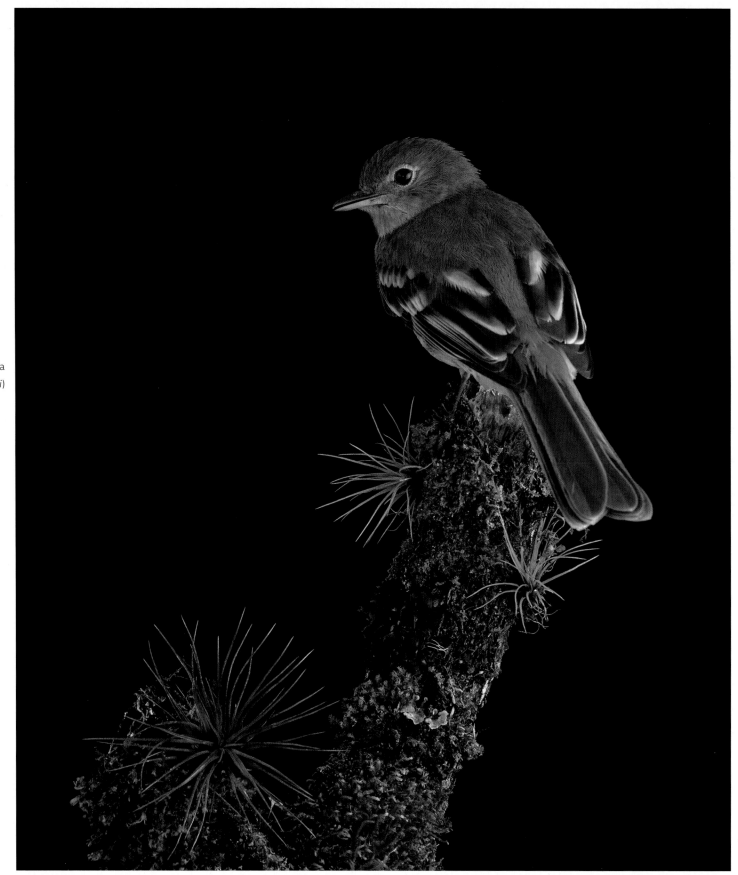

A host of Neotropical birds are inadequately known because they are difficult to observe. They occur only in remote locations or quietly lurk in dense vegetation. Others, like Mountain Elaenias, are easy to observe but remain obscure because they are drab and difficult to identify. Indeed, when researchers working in southern Mexico discovered a new population of Mountain Elaenias, the first recorded in the country, they relied on DNA sequencing for confirmation.[1]

Voice is also key to identifying and revealing the presence of the Mountain Elaenia. Like many tyrannid flycatchers, Mountain Elaenias sing a distinctive "dawn song," uttered by territorial males throughout the breeding season, beginning while it is still dark. Perching males incessantly repeat a soft, burry *zee-eww-zzep!* until the rising sun produces enough light for other activities, such as foraging or defending territory from rivals. Once it is light, Mountain Elaenias change to a simple *see-weeooo*, the first note so high-pitched that it can be difficult to hear, as well as varied descending burry or cleanly whistled single notes, which seem more frequent when other Mountain Elaenias are present, either during a territorial dispute when they are breeding or while congregating at fruiting trees when they are not.

Antagonistic disputes are common among breeding Mountain Elaenias. Unlike the related Yellow-bellied Elaenias (*Elaenia flavogaster*), which are sedentary and hold stable territories year-round, they wander widely in nonbreeding season, thus having to win territories anew when the breeding season commences. Alexander Skutch was so taken with these birds' quarrels that he dedicated an entire section of his Mountain Elaenia species account to "pugnacity," describing one of the breeding season battles thus: "On an afternoon in late May, I saw four elaenias fall in a cluster from a shade tree to the pasture grass beneath it. Then, while two remained here close together, a third pounced down on one or both of them from a height of a few inches, repeating this several times. Meanwhile the fourth elaenia rested on the grass a few inches from the victims of this assault. In less than a minute, all flew away."[2]

The Mountain Elaenia's foraging behavior is basically true to its classification as a tyrant flycatcher. Perching on branches at the edge of small trees and shrubs, they sally forth to capture passing insects, and return to the same or a similar perch nearby. Besides arthropods, they ingest large volumes of fruits, using almost the same foraging methods as those used for capturing flying insects—darting out from a perch to pluck small berries from their stems while on the wing. In the nonbreeding season small groups sometimes gather at a particularly enticing fruit tree.

In the Monteverde Cloud Forest Reserve, Mountain Elaenias eat twenty different native plants, including some that are toxic to other organisms.[3] Pokeweed (*Phytolacca rivinoides*), for example, a shrub easily identified by its beautiful clusters of blackish fruits set on striking magenta stems, contains alkaloid compounds that are toxic to mammals but do not affect birds that eat the berries whole and disperse viable seeds. Another example is *Acnistus arborescens* of the nightshade family. This small tree or shrub has the unusual habit of flowering and fruiting simultaneously. Clusters of small white flowers, ripe, and unripe fruits all grow together right along the branch. Although the ripe, bright orange berries are problematic to humans, Mountain Elaenias consume them with vigor and impunity.

The ecology of the Mountain Elaenias becomes broadly relevant to the state of the environment since forest restoration time can be greatly reduced by the introduction of seeds by frugivores to facilitate plant growth. On the Pacific Slope of Costa Rica's Volcán Barva, Mountain Elaenias were found to be one of the most common seed-dispersing birds.[4] Importantly, they are not strictly tied to forests, venturing out to small remnant patches and isolated trees in pastures, passively dispersing seeds all along the way.[5] Mountain Elaenias undertake seasonal movements in response to local changes and differences in fruit abundance. Hence, they can disperse fruit seeds over long distances and across different elevations. Montane organisms are moving upslope in response to climate change, and mobile organisms like Mountain Elaenias have all the tools they need to shift upslope when warranted and also to provide seed transport, which plants need to respond to environmental change.[6] While Mountain Elaenias may be drab in appearance, they deliver valuable ecosystem services that promote the return of diverse forested montane landscapes.

Mountain Elaenia
(*Elaenia frantzii*)
PETER A. HOSNER

Long-billed Gnatwren

(Ramphocaenus melanurus)

JEFFREY D. BRAWN AND

HENRY S. POLLOCK

The Long-billed Gnatwren (*Ramphocaenus melanurus*) is a diminutive insectivorous forest bird with an outsized bill. Louis Pierre Vieillot, the renowned French naturalist who described the species, was clearly impressed by said bill, as evidenced by the name that he chose to bestow upon the genus (Greek *Rhamphos*, "beak," and *caenos*, "strange"). Gnatwrens are an exclusively Neotropical clade consisting of only four species, currently placed within the small, twenty-species family Polioptilidae (gnatwrens and gnatcatchers).[1]

Long-billed Gnatwrens are most often found foraging actively in the forest understory or midstory, swinging their cocked tails back and forth "as if on a loose hinge" and using their long bills as needle-like appendages to peck and probe for small arthropods.[2] They are often difficult to observe because of their rapid locomotion and predilection for thick vine tangles. They forage in pairs and sometimes participate in mixed-species flocks with other birds. Males and females are similar in appearance, and both sexes take care of the young. They lay two delicate white eggs with reddish-brown spots in nests constructed of green moss and fine bark on the outside and cemented with cobwebs on the inside.[3] They have a typical incubation period (17 days) and a short nestling period (12 days), but little else is known about their ecology or life history.

As one of the lesser known understory species featured in this volume, the Long-billed Gnatwren's taxonomic placement has been in a constant state of flux since the species was first described in 1819. They were first considered wrens (family Troglodytidae) owing to superficial similarities in their scolding calls, upright tail posture, and inquisitive behavior.[4] By the 1850s, they were placed in the now defunct family Formicariidae based on morphological similarities to modern antbirds (family Thamnophilidae).[5] In 1920, they were moved again, into the Old World warbler family (Sylviidae), and remained a taxonomic enigma until recent advances in molecular technology firmly designated them in Polioptilidae, sister to the wrens.[6]

Despite the recent advances in systematics at the family level, however, the *R. melanurus* species complex is still an evolutionary puzzle of sorts. Originally classified as a single species, no fewer than twelve subspecies are recognized, many of which differ in plumage characteristics and vocalizations.[7] Indeed, recent studies of species relationships within Polioptilidae have identified multiple potential cryptic species and actually elevated one former subspecies of the South American Long-billed Gnatwren to a full species, the Chattering Gnatwren (*R. sticturus*).[8] Future studies will most likely result in more species being identified—for example, a totally isolated population that lives in the Atlantic forest of Brazil is probably a separate species as well.[9]

Long-billed Gnatwrens inhabit a variety of forest types spanning from southern Mexico southward to southern Brazil. They are a lowland species, typically occurring below 750 m (2500 ft) in elevation, and appear to be relatively resistant to fragmentation.[10] They are currently classified as a species of Least Concern on the IUCN Red List, although elevation of geographically restricted subspecies to full species could result in the need to re-examine this designation.[11]

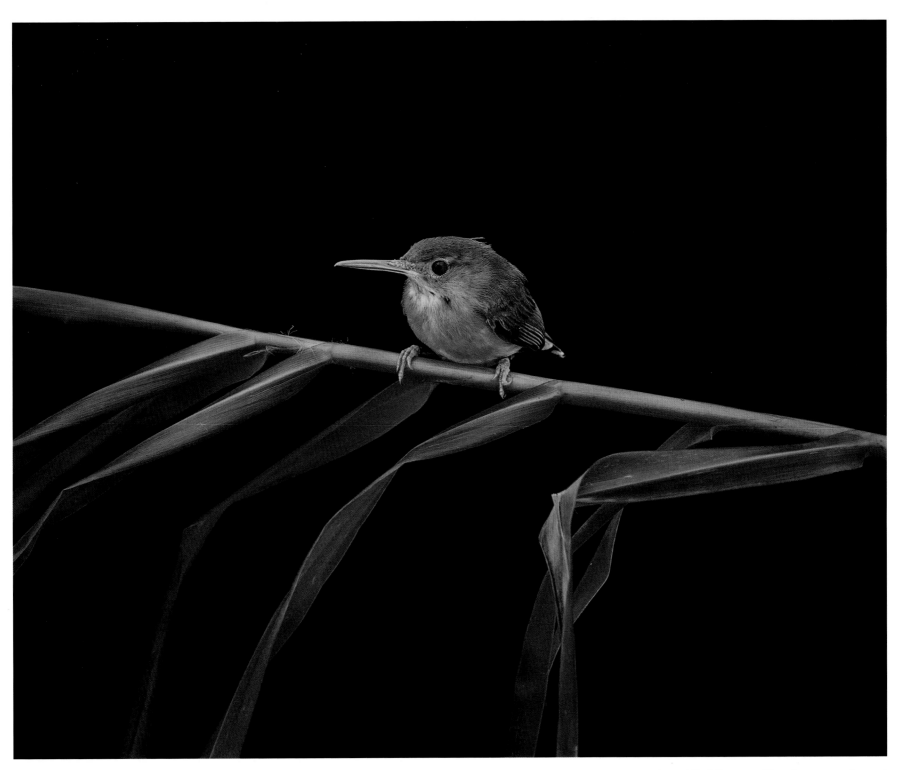

Long-billed Gnatwren (*Ramphocaenus melanurus*)

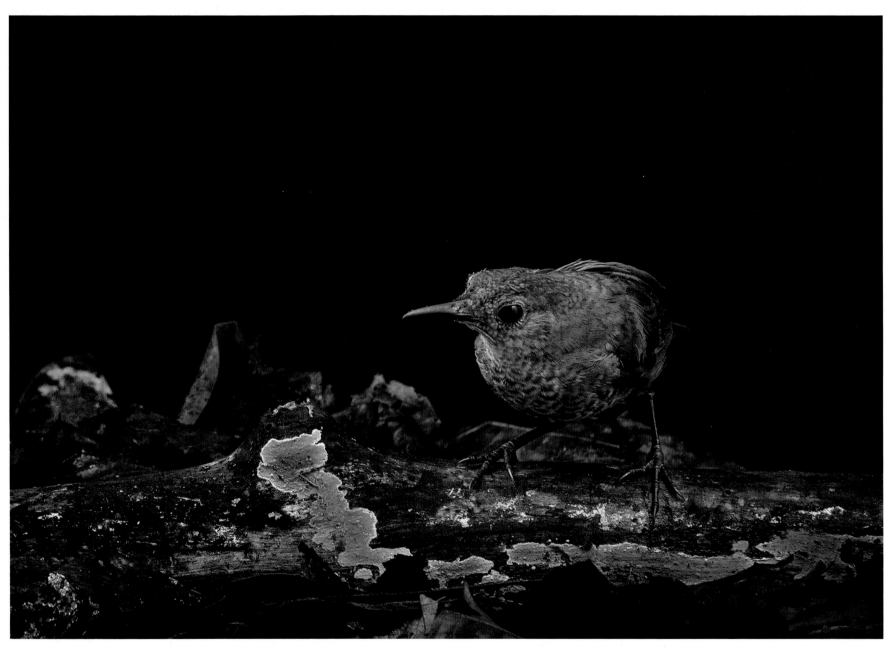

Scaly-breasted Wren (*Microcerculus marginatus*)

The Scaly-breasted Wren (*Microcerculus marginatus*) is perhaps one of the most elusive and overlooked "underdogs of the understory." A slender, dull-brown wren with subtly scalloped breast feathers, the genus *Microcerculus* (from the Greek *micro*, "small," and *cerculus*, "little tail") aptly describes its only defining physical feature—an exceedingly short tail, often held upright like a small rail (family Rallidae). This shy and retiring species, as with many of the others included in this volume, is far more often heard than seen. As described by Slud, the wren "is most often met with accidentally, and the encounters are usually infrequent."[1] As a result, very little information exists on any aspect of its behavior or natural history.

The Scaly-breasted Wren is found on the floor of humid tropical forests, especially in ravines, throughout Central and South America. A generally solitary forager, it bobs its tail as it walks along the ground, seeking its prey low down in dense vegetation.[2] This "teetering" gait has drawn comparisons to other bird species, including the Spotted Sandpiper (*Actitis macularius*) and the waterthrush warblers.[3] Little data are available on its diet, although it has been observed carrying spiders and grasshoppers to its nestlings. The species appears to have a fairly protracted breeding season, with adults seen feeding fledged young as early as February in Costa Rica and with nests found in late May and early July in Panama. They lay clutches of two or three white eggs, with an incubation period of 16–17 days and a nestling period of 19–20 days.[4] Scaly-breasted Wrens are among the few wrens (family Troglodytidae) that build simple cup nests and locate them in earthen banks, whereas most others nest in free-standing dome nests or tree cavities.[5] The only two nests documented in the scientific literature from Panama were placed in burrows that had been excavated by other species.[6]

The Scaly-breasted Wren's unique and highly variable song has been the subject of most of the attention it has received in the scientific literature. The distinctive song consists of a series of high-pitched, pure whistles, rapidly accelerating at the beginning then gradually slowing down and becoming more drawn out. These songs can last up to 2.5 minutes and the birds will terminate it at any point in the sequence, rarely producing complete songs. They vary the frequency of their songs by as much as 1 kHz, a phenomenon that has also been documented in North American songbirds such as chickadees (family Paridae).[7] The piercing quality of the Scaly-breasted Wren's loudsong is unmistakable and a hallmark of the tropical forest soundscapes it inhabits.

The geographic variation in the song of the Scaly-breasted Wren belies questions about its taxonomic placement, which has been debated and is still unclear.[8] The species has a broad geographic distribution ranging from Costa Rica south to northern Bolivia and eastward across large swaths of Amazonia in northern Brazil. In Central America, the species was formerly known by its alternate and possibly more apt common name, the Southern Nightingale-Wren, but was subsequently divided into Nightingale Wren (*M. philomela*, northern Central America) and Scaly-breasted Wren (southern Central America and South America) based on morphology and vocalization differences.[9] Currently there are no fewer than six subspecies that will likely also be divided into multiple species with continued study and the application of modern molecular genetics.[10]

While population density is typically low, the Scaly-breasted Wren has a broad elevational (0–3100 m [0–10,000 ft]) and latitudinal distribution and is not considered globally threatened. It appears to be able to persist in some forest fragments although also having disappeared from others, such as Barro Colorado Island, Panama.[11] These contradictory results emphasize the need for more research on the poorly understood and little appreciated Scaly-breasted Wren.

Scaly-breasted Wren
(*Microcerculus marginatus*)

HENRY S. POLLOCK AND
JOHN P. WHITELAW

White-breasted Wood-Wren

(Henicorhina leucosticta)

JEFFREY D. BRAWN AND

HENRY S. POLLOCK

Wrens are a large group of birds in the family Troglodytidae, which currently includes roughly twenty genera and eighty-eight species worldwide. They are especially diverse in the Neotropics, where 95% of the species occur. Wrens, as a group, tend to be small- to medium-sized birds that are somewhat secretive (their family name means "cave dweller"). Whereas wrens can be hard to see, their loud and complex songs are often heard, and they are renowned for their vocal prowess.

One of five species in the Neotropical genus *Henicorhina*, the White-breasted Wood-Wren is the lowland (up to about 1500 m [4900 ft]) counterpart of the higher-elevation *H. leucophrys* (the Gray-breasted Wood-Wren, also featured in this volume) and is widely distributed throughout Central America south to central Peru and northern Brazil.[1] Thirteen subspecies have been described, with the form found in central Panama having an especially dark crown in striking contrast to the white stripe over its eye. This species favors dense understories of humid to wet forests, especially those on steep hillsides or ravines, where it actively forages for invertebrate prey. A common bird—a population study in central Panama found nine territories on a 100 ha (247 ac) census plot—it maintains territories and pair bonds year-round and builds enclosed nests on, or very close to, the ground.[2] Young White-breasted Wood-Wrens remain with their parents for several months and roost in family "dormitory nests" built a meter or two off the ground.

Like most wrens, an apt descriptor of the White-breasted Wood-Wren is "noisy" with a distinctive *bweer* call that is commonly given when family groups are present on their territory.[3] Their singing behavior is similar to that of the congeneric Gray-breasted Wood-Wren, in which both sexes sing and pairs will engage in "duetting" behavior, a near seamless integration of male and female song that reinforces the pair bond and territory defense.[4] Playback experiments in South America have shown that aggression between lower-elevation White-breasted and higher-elevation Gray-breasted Wood-Wrens may dictate elevational range limits, demonstrating the importance of competition in structuring some Neotropical bird communities.[5]

Ornithologists have applied many descriptors to the song of this species, but perhaps the most imaginative is that of Dr. Luis Baptista, who described the song's beginning as reminiscent of the famous opening notes of Beethoven's Fifth Symphony.[6] Fortunately, these notes will be heard for the foreseeable future, as the White-breasted Wood-Wren is apparently doing well throughout its range and is not currently of conservation concern.

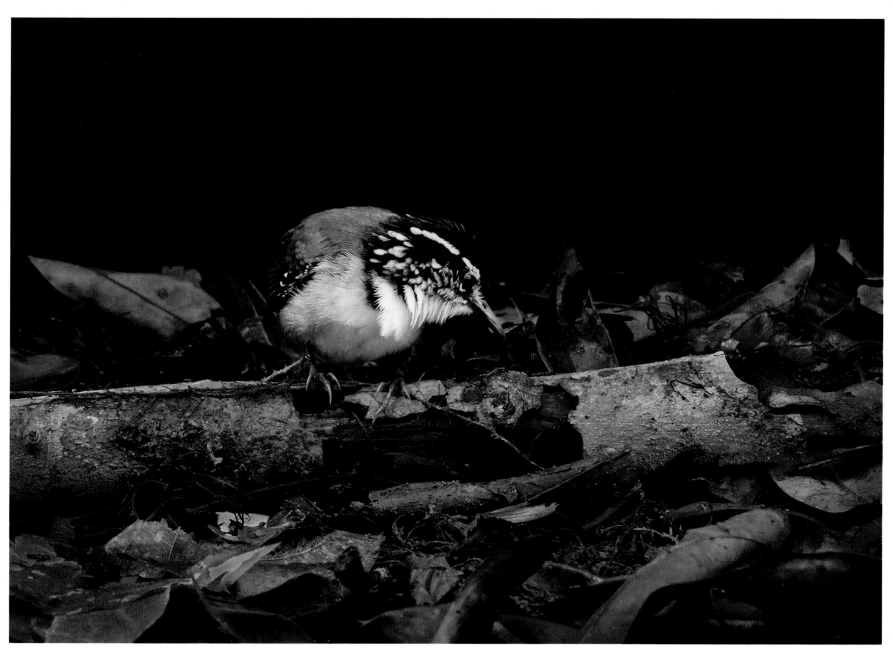

White-breasted Wood-Wren (*Henicorhina leucosticta*)

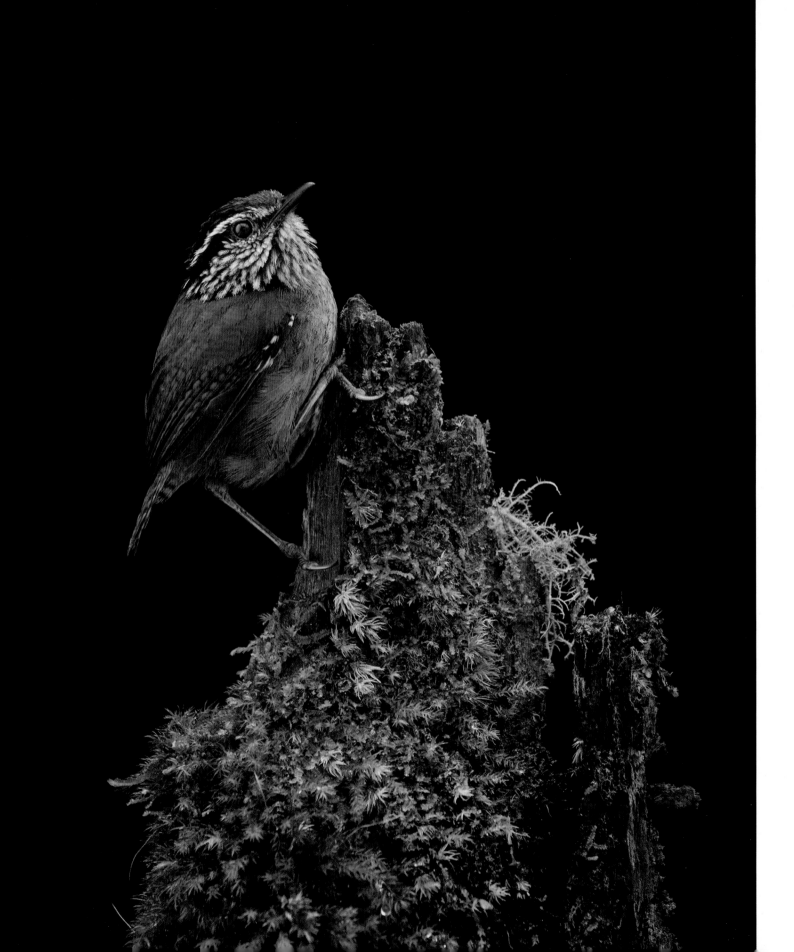

Gray-breasted
Wood-Wren
(*Henicorhina
leucophrys*)

"In the dense undergrowth of the humid mountain forests of tropical America, from Mexico to Bolivia, lurks a small, short-tailed wren with retiring habits and an unforgettable song."[1]

Gray-breasted Wood-Wrens (*Henicorhina leucophrys*) are one of the most common residents of Neotropical cloud forests from Mexico through to Bolivia (classified as Least Concern in the IUCN Red List of Threatened Species) but are surprisingly difficult to see because of their habit of skulking deep in the tangled and dense understory. Perhaps owing to this habit, the birds have not developed the showy ornate plumage signals as seen in other cloud forest species, such as tanagers and toucans. But what they lack in brightly colored plumage, they make up for with their exuberant song. In his account of his time spent in Central America watching birds, Alexander Skutch describes hearing a Gray-breasted Wood-Wren song deep in a Costa Rican forest: "[Their clear ringing song] sounded wildly beautiful as it rose from the banks of some unseen mountain rill murmuring gently along the bottom of its deeply cut, fern-draped channel."[2]

Upon listening to the Gray-breasted Wood-Wren's song, you would be forgiven for believing that you are listening to a single bird singing. However, this song is often the product of two singers—the male and female of a bonded pair—alternating their songs in a coordinated duet with such a high degree of precision that there is little to no overlap between the end of one bird's contribution and the start of the next. This behavior may seem unusual to those of us who spend most of our time in temperate habitats where male song is seemingly more common (although we are learning that females of some temperate species also sing!) and usually occurs during the breeding season. However, as you move toward the equator, female song becomes more common, and in at least 4% of songbird species, males and females combine their songs into coordinated duets with varying degrees of precision.[3]

There are many hypotheses about why duetting is more common in the tropics than in temperate habitats, but one of the most important factors seems to be a stable and sedentary lifestyle—species are most likely to sing duets if they have long-term pair bonds and jointly defend their territory throughout the year.[4] Gray-breasted Wood-Wrens fit the bill perfectly—they have long-term pair bonds, defend territories with song throughout the year, and are monomorphic, meaning that it is not possible to determine the male from the female based on visual cues. Males and females do, however, sing sex-specific songs, which once learnt allow the observer to distinguish between the two.

Duets range in complexity: in some species the duet is a relatively simple affair involving a single call followed by a quick response from the initiator's partner. In other species, particularly in Neotropical wrens, duets can be extremely complex, precisely timed songs with multiple contributions from both members of the pair. The Gray-breasted Wood-Wrens sing some of the most complex duets known in which male and female songs intertwine often with mere milliseconds between the end of one bird's song and the start of the next.[5]

Decades of scientific studies have aimed to decipher the meaning and function of duets. One major aim of this research has been to understand what advantage these coordinated duets provide over what could be achieved by both individuals simply singing independently. The degree of coordination seems to imply that both sexes must cooperate in order to achieve such precision and so must both benefit from the duet. Indeed, the current consensus of behavioral ecologists is that duets are used primarily for the defense of joint resources, where the resource could be the territory or the pair bond. It is possible that there is also an element of conflict, whereby one bird might answer its partner's song in order to advertise its mated status and thus prevent its place in the partnership being usurped.[6]

Duets are formed when one bird initiates a song and that song is answered by its partner. If the function of duets is cooperative, the responder might answer its partner to send a stronger signal to intruders: "We are here, we are strong—

Gray-breasted Wood-Wren

(*Henicorhina leucophrys*)

CAROLINE DINGLE

be gone!" If duets are formed as a result of conflict between the pair, then the answering bird might be singing to prevent its partner from gaining any extra-pair mating opportunities. Song playback, the broadcasting of recorded song into a territory, is often used to simulate potential intruders or suitors with the resulting behavior scored in an effort to understand the function of duets. In the Gray-breasted Wood-Wrens, playback studies such as these found evidence of multiple functions for duets.[7] Pairs responded strongly to playback of duets, approaching the speaker together and answering each other's calls to form their own duets, as expected if pairs jointly defend resources. While males responded strongly to every playback they heard, females responded most strongly only when female song was involved—either to a female solo or a duet, while almost completely ignoring male solos. Crucially, females answered more of their partner's songs in response to playbacks containing female song, suggesting that duets in this species may also result in part from conflict between the pair.[8]

So, on your next trip to the cloud forests of Central or South America, particularly on a dreary day when nothing else is stirring, listen for the melodic rollicking song from deep inside the bush and allow it to bring "a note of cheer and good hope into the midst of so much gloom and despondency."[9]

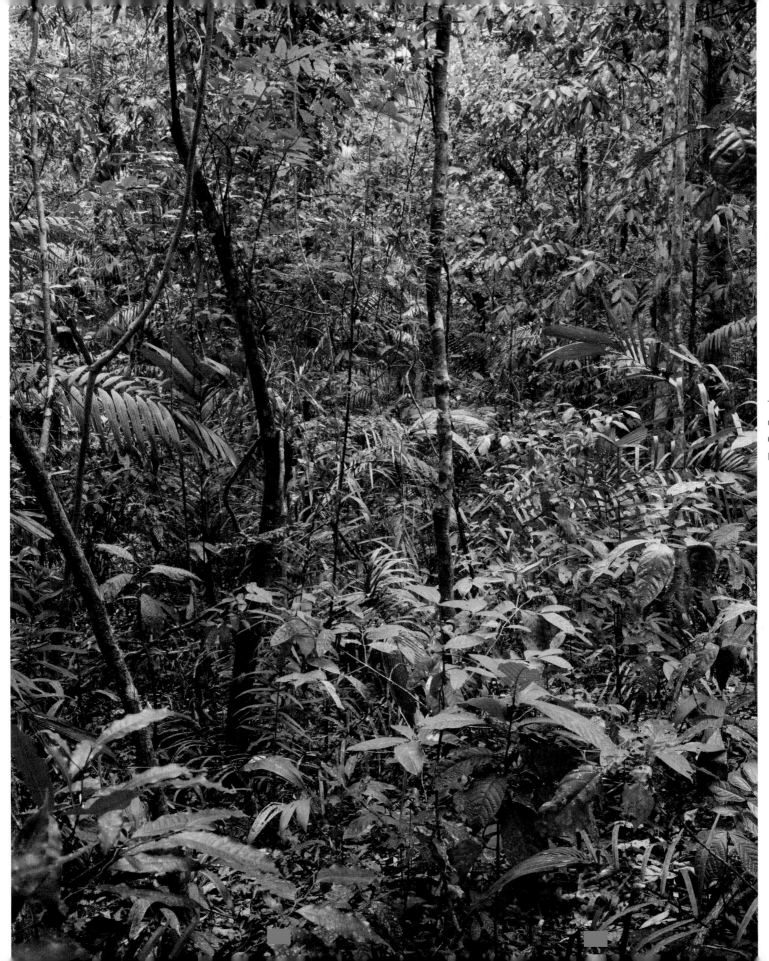

Tropical forest understory, Chiriqui Province, Panama

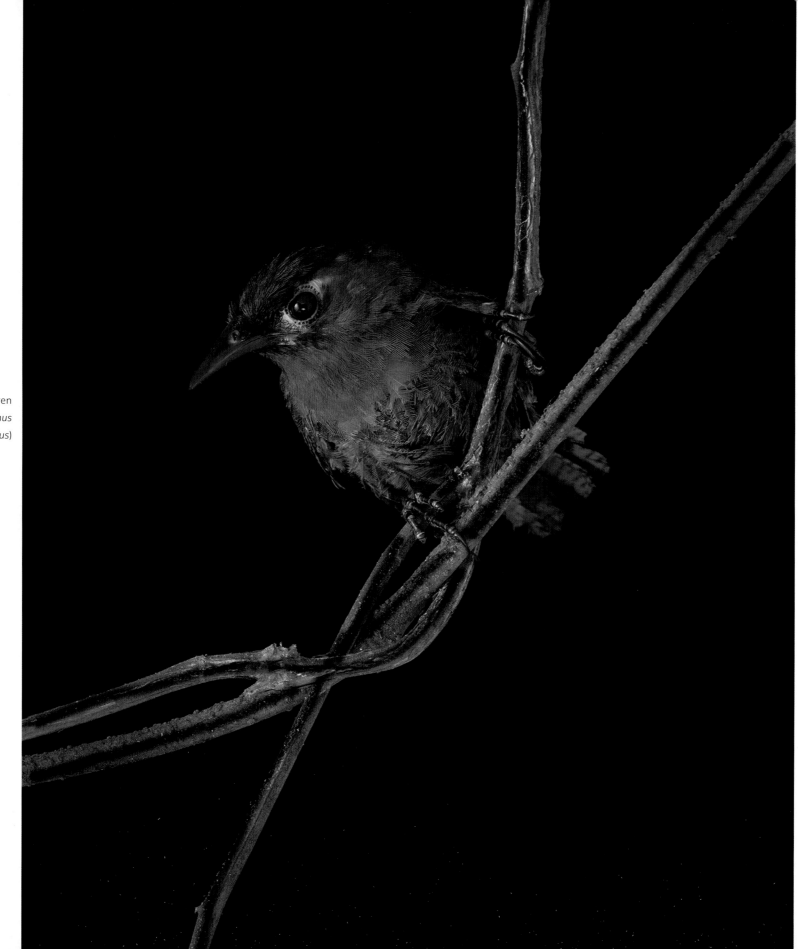

Song Wren
(*Cyphorhinus
phaeocephalus*)

In the dark understory of Neotropical forests, small, cryptically colored bird species abound and perennially plague novice birders. The Song Wren (*Cyphorhinus phaeocephalus*) is no exception to the rule. A small, nondescript brown bird with black barring, the Song Wren spends most of its time foraging in the leaf litter, flicking leaves aside, or peering carefully under them to expose the arthropods lying beneath. Despite its drab plumage, the Song Wren, like many other members of the wren family (Troglodytidae), is renowned for its melodious vocalizations that enrich the tropical forest soundscape. Described as "a series of sweet clear whistles of varying pitches, interspersed with guttural clucks and churrs" or, perhaps more aptly, as a "haywire cuckoo clock," the Song Wren's song is most often heard in the early morning or late afternoon, as it traverses its territory in search of food.[1]

Song Wrens are family-oriented birds, spending most of their time in groups comprising mother, father, and one to three youngsters. These clans are tight-knit, foraging within 3–6 m (10–20 ft) of each other most of the time and clucking vigorously when intruded upon by overzealous birders that approach too closely.[2] Interestingly, this familial proximity may increase foraging efficiency by reducing the probability of their arthropod prey's escape. Song Wrens spend more than 80% of their time foraging, illustrating how the forest understory environment can further obfuscate the already camouflaged prey of understory birds.[3] During the rare breaks between these almost continuous foraging bouts, family members can be seen perched side by side on a thin understory liana, carefully taking turns preening each other's hard-to-reach spots, providing a fresh context for the old adage "you scratch my back, I'll scratch yours."

Like so many understory insectivorous bird species of Neotropical forests, Song Wrens are highly influenced by patterns of seasonal precipitation. Thus, the onset of their breeding is roughly timed to coincide with the start of the tropical rainy season, when their arthropod prey are at their most abundant and active.[4] Their bulky, misshapen dome nests of rootlets, small twigs, and decaying plant matter that hang pendulously from small understory trees are unmistakable. However, predators abound in the Neotropics, and Song Wrens exhibit two interesting behavioral adaptations that may make their nests less conspicuous to predators. First, they have two distinct nest types—breeding nests, where they care for their eggs and fledglings, and dormitory nests, where they sleep during the nonbreeding season. Cleverly, Song Wrens will often create empty dummy nests within their own territories, to diminish the likelihood of losing their eggs or maybe even their lives to a hungry predator.[5] Second, they construct their breeding nests in small understory trees of the genus *Acacia*. These trees are renowned for their mutualism with ants of the genus *Pseudomyrmex*, which ferociously defend their host and receive nutritional benefits (lipid-rich "Beltian bodies" that grow on the tree's leaflets) and shelter (in hollow thorns called "domatia") in return for their mercenary services. Surprisingly, these ants tolerate the Song Wren nests in their *Acacia* trees, and their painful stings may deter prospective predators.[6]

The Song Wren inhabits lowland wet forest from southern Honduras to northern Ecuador and rarely occurs at elevations above 1000 m (3300 ft). Additionally, this species may be sensitive to humidity—its populations decline with increasing seasonal drought and individuals exhibit signatures of physiological stress in drier habitats.[7] Furthermore, Song Wrens experience population declines following forest fragmentation, and they have even been extirpated from relatively large forest tracts following isolation from contiguous forest.[8] Therefore, although the Song Wren is listed as a low conservation priority and of Least Concern on the IUCN Red List of Threatened Species, it may be disproportionately sensitive to future anthropogenic disturbances such as fragmentation and climate change.[9]

Song Wren
(*Cyphorhinus phaeocephalus*)
HENRY S. POLLOCK

Black-faced Solitaire

(*Myadestes melanops*)

K. GREG MURRAY

When visiting a Central American cloud forest above about 1400 m (4600 ft) elevation, one of the most distinctive sounds you'll hear is the ethereal song of *Myadestes melanops*, the Black-faced Solitaire. Considered the voice of the cloud forest by some, this rather drab bird turns out to be one of the most important components of a healthy forest.

When most people think of birds that eat fruits and disperse seeds in tropical forests, it's the big, flashy birds like trogons or toucans that come to mind. While these large species are indeed important to the dominant forest trees, Black-faced Solitaires rival their importance in maintaining the forests in which they occur. In the early 1980s, several biologists worked extensively with fruit-eating birds at Monteverde in Costa Rica, and Black-faced Solitaires figured prominently in my own work. Of the several hundreds of bird species in the region above about 1200 m (3900 ft) elevation, approximately seventy-five include a significant amount of fruit in their diet. The largest ones, such as Resplendent Quetzals (*Pharomachrus mocinno*), get the most attention for their importance as seed dispersers, and indeed they *are* disproportionately important in these ecosystems. Because of their size, they can swallow the fruits of most primary forest trees—like those in the avocado family—that happen to have large fruits and seeds. At Monteverde, Northern Emerald Toucanets (*Aulacorhynchus prasinus*) are known to eat at least ninety-five species of fruits, and they are able to do so because their gape—the width of their mouth—measures about 26 mm (1 in.).[1] But the importance of different species as seed dispersers isn't measured solely by their gape size, which only determines what fruits they are *able* to eat. What they *actually* eat, and where they deposit the seeds, are also governed by their gut's capacity and by such aspects of their behavior as habitat choice. Resplendent Quetzals, for example, have a gape size of 21 mm (0.8 in.) but are known to eat only thirty-eight species of fruits, in part because they rarely descend to the lower levels of the forest and because they rarely consume small fruits. Black-faced Solitaires, on the other hand, have a gape width of only 11 mm (0.4 in.) but are known to eat at least fifty-one species of fruits because they forage at all levels in the forest, feeding on the fruits of large trees, epiphytes, vines, and understory shrubs alike. Also, as it turns out, many of the fruits they eat have few other known dispersers. An index was developed of the relative significance of seventy-five different fruit-eating birds' consumption of the fruits of 179 plant types by weighting each species' consumption of each variety of fruit by the number of different birds also known to consume each of these fruit types.[2] Of all the fruit-eating birds at Monteverde, Black-faced Solitaires were second only to Emerald Toucanets in their overall importance as fruit consumers and, thereby, as seed dispersers.

By combining data from Black-faced Solitaires fitted with radio transmitters and data from feeding experiments involving Black-faced Solitaires held captive for a few days, it was possible to estimate the distances over which they disperse seeds.[3] These solitaires foraged day to day over a home range averaging 5.1 ha (12.6 ac). The small seeds of most of their food plants take 10–80 minutes to transit a bird's digestive system, with emergence by defecation peaking at about 15–25 minutes. Combined with the data on their movements, these gut transit times indicate that Black-faced Solitaires disperse seeds from an individual plant from zero to over 350 m (0–1150 ft). Most seeds are deposited within 50–60 m (160–200 ft) of the parent plant, but about 20% are dispersed beyond 120 m (400 ft).

Interestingly, it has also been found that some plants can influence bird digestive physiology and hence control both the treatment of seeds in the bird's gut and their dispersal distance. Noting that the seeds of *Witheringia meiantha* (a common understory shrub in the potato family) transit Black-faced Solitaire guts faster than similar-sized seeds from other fruit species, experiments were performed with captive individuals and artificial fruits composed of natural seeds either with or without the juice from natural fruits.[4] Even though both types of artificial fruits had the same nutritional content, seeds from those made with juice from *W. meiantha* fruits passed through solitaire guts 12 minutes faster, on average, than those made

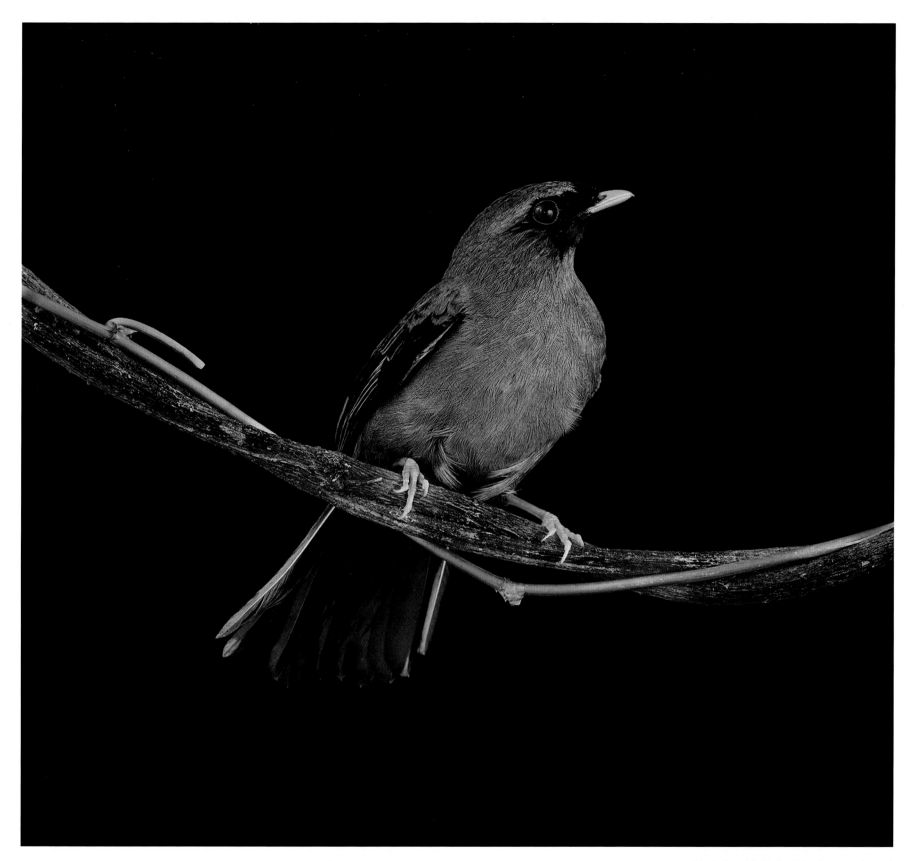

Black-faced Solitaire (*Myadestes melanops*)

without fruit juice. Given that seeds travel farther the longer they stay in a bird's gut, and given that seeds traveling farther away from their source are more likely to survive and grow, why would plants package their seeds with a laxative chemical that makes the seeds exit sooner? To find out, germination experiments were also performed with seeds that had spent differing amounts of time in the guts of solitaires, and it was found that those that remained longer in the gut were *less* likely to germinate—probably as a result of chemical and mechanical damage during gut transit. When the effects of seed transit rate on dispersal distance and germination success were modeled at the same time, it was found that the (as yet unidentified) chemical laxative serves to optimize plant reproductive success by balancing the advantages of long dispersal distance against the disadvantages of seed damage. This was the first known demonstration that fruits contain a soluble chemical that mediates seed passage rate, probably by stimulating gut motility. As far as is known, the laxative effects of other fruits have been attributed to fiber.

Working with Black-faced Solitaires has been an inspiring demonstration to researchers of how the details matter. The particulars of the behavior and ecological interactions of this drab little bird—one that many people might easily overlook—turn out to be both fascinating in their own right and illustrative of the roles played by individual species in the maintenance of the most complex ecosystems on earth. Imagine how much more there is to be learned about the lives of other species, most of which have still not been extensively studied!

Hummingbird Tongues: An Ingenious Adaptation

JOHN P. WHITELAW

When nature has work to be done, she creates a genius to do it.

RALPH WALDO EMERSON

Hummingbird tongues are, anatomically and functionally, like no others. They are used primarily to extract floral nectar, which has the high caloric content necessary to fuel the birds' high-speed aerobatic maneuvers. Nearly two centuries ago, it was reasonably posited that this extraction was accomplished by simple capillary action. That is, the fluid is drawn into the tongue's twin tubular structure as passively as juice is spontaneously drawn up to a predictable height in a drinking straw.[1] Using high speed cinematography and fluid dynamic mathematical modeling, researchers have shown that simple capillarity does not reconcile with, among other factors, the effect of gravity (such as in flowers that hang vertically), nectar concentration, and the observed rapidity of nectar extraction.[2] The tongues are not simple static tubes. Rather, nectar is extracted by two different mechanisms, often synergistically. By one, the fluid is forcibly trapped and hauled in. By the other, it is sucked in by an ingenious "elastic micropump." Both are achieved as the tongue flicks in and out of the beak with a licking motion.[3]

The tongue's anatomy is complex. The lateral midportion features two parallel, longitudinal, open-sided grooves (semicylinders or tubes) that do not extend to the base of the tongue. About 6 mm (0.24 in.) from its tip, the tongue becomes forked or bifurcated and the mid-tongue lateral grooves give way to flexible rods, from which are suspended a series of membranous curved flaps (or lamellae) that give the tips a fringed appearance. The lamellae can be closed tightly (furled) or kept open (unfurled). The most distal lamellae (which are progressively smaller than the proximal ones) form a cone shape when they are tightly furled, resulting in a liquid-tight seal at the very tip of the tongue. The unfurled state allows nectar to enter the open cylinder-shaped space (also described as a groove) formed by the row of lamellae. As the tongue exits the small aperture at the mostly closed beak's tip, the load from the previous lick is squeezed off into the beak, the wet rods (tines of the fork) adhere to each other, and the lamellae are furled and squeezed flat. When the tongue touches the surface of the nectar, the two rods widely separate, the lamellae unfurl and splay outward, whereupon physical forces draw liquid into the now open cylindrical space. As the tongue is withdrawn from the fluid, the fork returns to its single, pointed state, the lamellae roll inward (refurl), forming a fluid-tight cylinder, thus trapping the nectar. The tongue is retracted into the bill through the now larger aperture at its tip, which is caused by the beak being slightly more open. As the tongue cycles in and out of the beak and nectar, as many as fourteen times per second, nectar is extracted more quickly and efficiently than is predicted by capillary forces. This mechanism predominates when the distance from the tip of the beak to the nectar pool is short or when nectar lies in a thin layer upon the surface.[4]

In some plants, however, the nectar lies deep within the flower's corolla. In this case, a second mechanism engages. When relaxed, the two laterally situated elastic grooves in the midportion of the tongue resemble cylinders opened along their length. As the tongue extends toward the nectar through the bill tip's narrow aperture, the cylinders are forcibly collapsed, simultaneously squeezing nectar off into the beak from the previous lick and storing elastic potential energy. As the tongue traverses the air, the tubes maintain this shape until they contact the nectar, at which point they return to their original, uncompressed, relaxed shape, pulling the liquid into their entire length by conversion of the stored potential energy to kinetic energy. Thus, they behave like the rubber squeeze bulb on a simple pipette. This "expansive filling" by means of elastic pumping results in nectar extraction even when the tongue is not fully immersed. The two mechanisms work in concert but not necessarily equally; the distance from bill tip to nectar surface determines the relative contribution of each. How the nectar is off-loaded from the beak into the oral pharynx remains, to date, unknown.[5]

Understanding the way hummingbirds draw up nectar may have a role in the relatively new discipline called biomimicry, "an approach to innovation that seeks sustainable solutions to human challenges by emulating nature's time-tested patterns and strategies."[6]

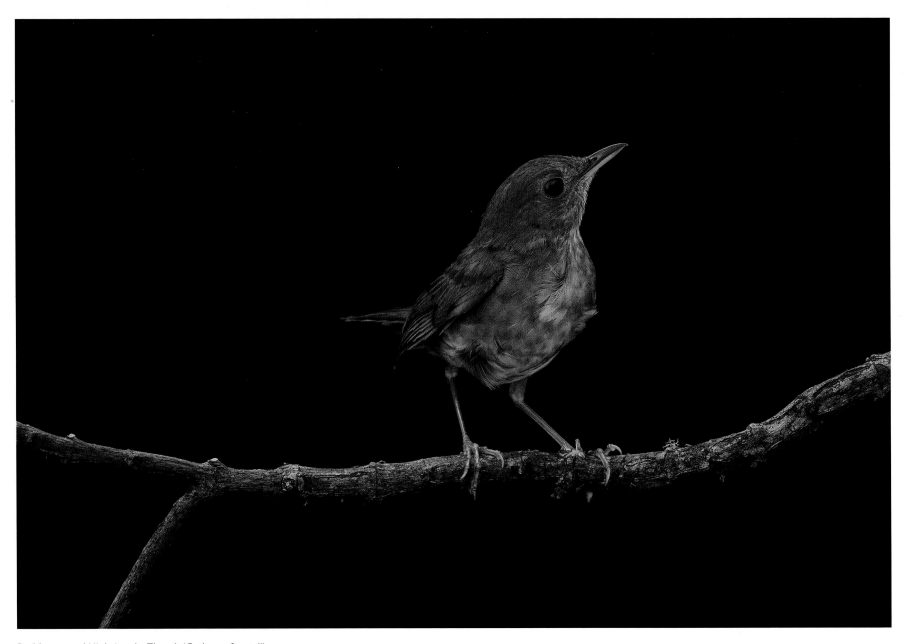

Ruddy-capped Nightingale-Thrush (*Catharus frantzii*)

The Ruddy-capped Nightingale-Thrush (*Catharus frantzii*) is a tropical bird that has a familiar gestalt to most bird-watchers from the temperate zone because it is closely related to several common, widespread North American birds, including the Veery (*C. fuscescens*) and the Swainson's (*C. ustulatus*), Hermit (*C. guttatus*), and Gray-cheeked (*C. minimus*) thrushes. Like these North American relatives, the Ruddy-capped Nightingale-Thrush is classified as a songbird (oscine). It has an elaborate song, much of which is presumably learned, as opposed to the rather simple, stereotypical, and genetically programmed songs of the sub-oscines (antbirds, ovenbirds, New World flycatchers) that so dominate tropical forest understories.

Ruddy-capped Nightingale-Thrush live in cooler montane forests, bamboo and second-growth thickets in the cloud forest, and even range close to the tree line in some tropical mountain ranges.[1] They seem to prefer to sing at the gloomiest times of day—very early in the morning or when the fog is so thick that there is almost no visibility—and their haunting song is one of the characteristic sounds of the cloud forest. As described by Wetmore, "The song is liquid and long-continued, far-ranging, but not nearly so loud as those of the local solitaire. The song is reminiscent of the northern Hermit Thrush, the effect melancholy, the quality liquid, but rather throaty; the phrases are deliberate with pauses of 2 to 3 seconds between them, and the song so long continued that over a hundred phrases may be given before there is a rest of more than a very few seconds."[2]

Ruddy-capped Nightingale-Thrushes are quite difficult to see as they skulk in dense cover and can usually be seen only along trails and roads at first light and at dusk. They blend in so well with the dark, dense undergrowth they favor that they are very easily overlooked. As with most thrushes, this species is insectivorous and frugivorous, eating a combination of arthropods and fruit obtained both by digging in the leaf litter and by searching from the ground or low branches for insects on the forest floor, tree trunks, and foliage. They sometimes make "sallying" flights of more than a meter (3 ft) to attack their prey.[3]

Perhaps the most interesting scientific trait of Ruddy-capped Nightingale-Thrushes and the twelve other species in the genus *Catharus* (Greek for "cleanser," which possibly relates to its song) is their apparent inability to coexist with each other when breeding. Studies of these thrushes have provided some of the strongest evidence that interspecific competition limits their distributions and habitat selection.[4] It is exceedingly rare to find more than one species nesting in any single habitat, and many species replace each other along elevational gradients. The Ruddy-capped Nightingale-Thrush, for example, lives at the middle of the upper elevations of Central American slopes. It is replaced at lower elevations by the Orange-billed Nightingale-Thrush (*Catharus aurantiirostris*), which may respond aggressively to the songs of the Ruddy-capped Nightingale-Thrush, suggesting that their elevation distribution might be limited by interspecific territoriality.[5] The peculiar, patchy range of the Ruddy-capped Nightingale-Thrush, which is absent from entire mountain ranges within Central America, may reflect its incompatibility with an as-yet unknown *Catharus* nightingale-thrush.[6] Indeed, in some species pairs, only one of them (usually the larger of the two) responds aggressively, suggesting that one species is socially dominant over the other.[7] This trait has raised concerns that the subordinate species might be pushed off the top of some mountain ranges as rising temperatures force species to move upslope. Nevertheless, the Ruddy-capped Nightingale-Thrush is not currently considered threatened as it is locally quite common, even in disturbed habitats.[8]

Ruddy-capped Nightingale-Thrush
(*Catharus frantzii*)
SCOTT ROBINSON

Slate-throated Redstart

(*Myioborus miniatus*)

RONALD L. MUMME

Of the hundreds of bird species that inhabit the cool, wet highlands of Central and South America, one of the easiest to find and see well is the Slate-throated Redstart, *Myioborus miniatus*. This species, a tropical and nonmigratory New World warbler (family Parulidae), has four attributes that make it an especially conspicuous member of the highland avifauna. First, the Slate-throated Redstart is common and widespread; it is found in montane tropical and subtropical forest, usually at elevations of 1200–2500 m (3900–8200 ft), from northern Mexico south through Central America and South America to Bolivia, including the tepuis of southern Venezuela, northern Brazil, and western Guyana. Second, the Slate-throated Redstart adapts well to moderate levels of habitat disturbance by humans; it generally favors forest edges, wooded roadsides, treefall gaps, and semi-open forest rather than undisturbed closed-canopy forest. Third, unlike many tropical birds that mostly frequent the high treetops, they generally forage in the lower canopy and upper understory and frequently descend to binocular level in the lower understory.[1]

The fourth attribute that makes the Slate-throated Redstart relatively easy to find is also its most remarkable and distinctive feature: while hopping through vegetation in search of food, it frequently performs conspicuous and exaggerated movements, pivoting from side to side with drooped wings and an erect spread tail, strikingly displaying its black tail feathers, broadly and contrastingly tipped in white. Many have suggested that the purpose of this odd behavior might be related to the species' diet, which consists almost entirely of flying insects—primarily flies, planthoppers, and moths—that are nearly always captured in flight and often taken following intricate aerial pursuits. Slate-throated Redstarts are particularly skillful at catching insects in flight, due to such characteristics as their broad wings and long tail, which increase their maneuverability, and are more efficient at prey capture, due to their broad bill with long rictal bristles at its base. The animated displays of the striking black-and-white tails could function in startling and flushing winged insects, a hypothesis that has been tested and supported by field experiments in Monteverde, Costa Rica, where the white tail tips of nesting pairs were temporarily blackened, resulting in these birds capturing fewer prey and delivering less food to their nestlings than controls.[2]

Another notable feature of the Slate-throated Redstart is its extensive geographic variation in plumage pattern. The color of the underparts varies, as does the extent of white in the tail, as shown in this figure.

Given the critical role of the tail white in foraging, it is curious why its extent varies geographically. Additional experiments in the field, where reducing or increasing the extent of white in

Guatemala Costa Rica Bolivia

Geographic variation in the tail pattern of the Slate-throated Redstart (*Myioborus miniatus*). Sketch by R. Mumme.

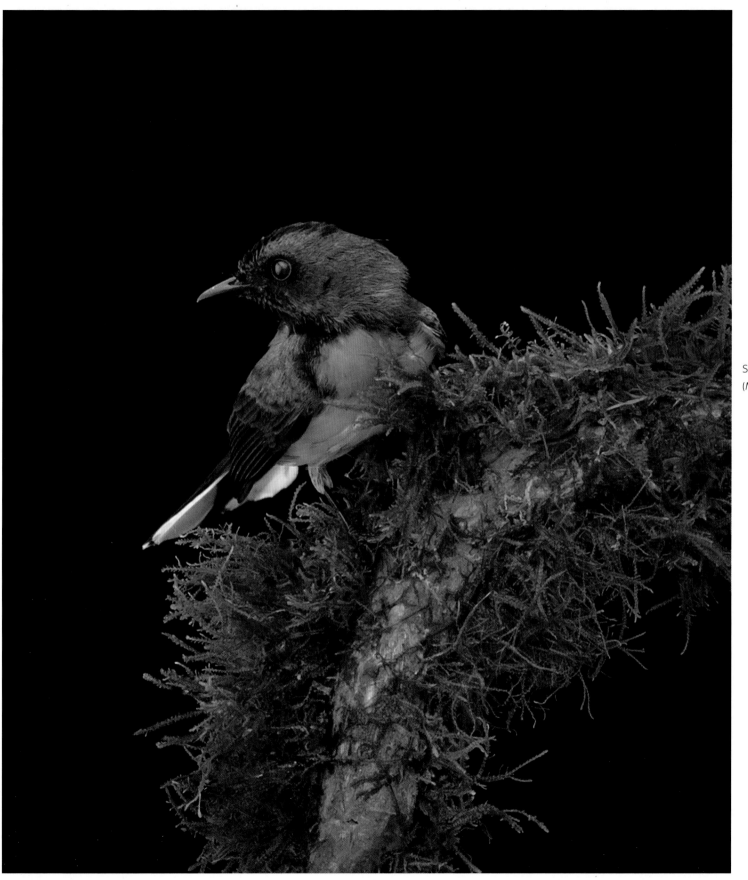

Slate-throated Redstart
(*Myioborus miniatus*)

the tail of Costa Rican birds to mimic Guatemalan or Bolivian redstarts reduced foraging success, would appear to indicate that the tail pattern has been finely tuned by natural selection to maximize this species' foraging success in its native environment.[3]

Slate-throated Redstarts typically live year-round on permanent territories as mated pairs. They regularly join mixed-species foraging flocks that may move through their territories, including flocks that are attending swarms of army ants, feasting on the flying insects flushed by the ants. Distinguishing between the male and female of the pair is not easy, as the sexes do not differ in plumage, and females regularly sing the same weak and variable song produced by males. Males, however, generally sing more frequently and vigorously.[4]

Unlike the nests of many Neotropical birds, those of Slate-throated Redstarts are not usually too difficult to find. Females build domed nests among ferns, grasses, and other herbaceous vegetation on open steep slopes, often in the banks along roads and trails. They can frequently be found by simply walking forested mountain roads and trails, alert for adults flushing from the well-hidden nests. At 10° N latitude in both Costa Rica and Venezuela, nesting is strongly seasonal, extending from March through June. Limited data from Bolivia suggest that nesting far south of the equator is also strongly seasonal but concentrated in the Southern Hemisphere spring months of October through December. Closer to the equator, however, nesting appears to be more variable and much less seasonal, and nests may be encountered in almost any month.[5]

Throughout Central and South American, clutch size of the Slate-throated Redstart is typically two or three eggs, considerably smaller than those of warblers breeding at high latitudes in North America. The incubation and nestling periods are 14–15 days and 11–12 days, respectively, each about 2–4 days longer than those of North American warblers. Although females alone are responsible for building nests, incubating eggs, and brooding young, males are active participants in feeding nestlings and fledglings, which do not become independent of their parents until they are about 40–45 days old.[6]

Rictal Bristles

JOHN W. FITZPATRICK

It seems incongruous that such a conspicuous and variable plumage feature as facial adornment could still be as mysterious today as it was a century ago, but this describes our current understanding of the exact function of rictal bristles. Among many groups of birds these simple, often elegantly curved, hairlike structures grace the gape—or "rictus"—of the mouth and, in some species, are also worn as delicate eyelashes around the eye.

Structurally these rictal bristles are true feathers, not hair, but most consist only of the central shaft (rachis) without the barbs and barbules that characterize body and flight feathers. Rictal bristles are especially numerous and long among flycatchers, nightjars, puffbirds, and other groups of birds that forage for insects via active sallies into the air or against leafy vegetation. For this reason, and given their characteristic lateral positioning along the base of both the upper and the lower mandibles, it is widely assumed that these bristles must function as insect nets that effectively widen the gape and thus enhance the ability of birds to snag insect prey during the sally. Such is the lore that has been passed down through generations of ornithology texts.

A number of champion bristle bearers occur in Panama's understory. Among these, two closely related flycatchers stand out, namely the Sulphur-rumped Flycatcher and the Ruddy-tailed Flycatcher. Intriguingly, both of these species are flush-chase specialists that sally against the undersurfaces of leaves and then actively pursue escaping planthoppers and leafhoppers. Two other flycatchers that practice the "upward strike" foraging technique—the Olivaceous Flatbill and the Golden-crowned Spadebill—also possess elegantly curved rictal bristles immediately below the eye. Another bristle champion is the White-whiskered Puffbird, which makes explosive sallies to capture large beetles, moths, caterpillars, and cicadas within the dark, open understory. By comparison, birds such as warblers and certain flycatchers that glean insect prey without sallying typically have greatly reduced rictal bristles or lack them entirely.[1]

Correlation between foraging behavior and bristle profusion among sallying birds lends intuitive credence to the insect-snagging function of rictal bristles.[2] Intuition, however, is not always a sound way to ferret out adaptive function. Three lines of approach to the evidence suggest that the function of rictal bristles lies elsewhere. First, ultra-slow-motion films of bristle-bearing flycatchers have failed to document that the rictal bristles have any role in capturing prey.[3] Indeed, most birds that sally to capture insects in flight or against leaves snap the bill shut and capture the prey at the tip of the bill, often with an audible snapping sound. Second, experiments that involved spraying sawdust against manipulated and unmanipulated flycatcher specimens in a wind tunnel show that those lacking rictal bristles suffer much more extensive physical disturbance to the eye than those with intact bristles.[4] Accordingly, eye protection may be a key function of facial bristles, a hypothesis that is consistent with the copious bristling of the faces of many insectivorous birds that routinely forage on large-winged or noxious insects all over the world.

Third, and most interesting, is a curious anatomical feature that is unique to birds, the awareness of which has been long established. Rictal bristles emerge from rows or clusters of feather follicles bordering the beak, nares, and eyes. Histological examinations of these follicles reveal nerve endings with concentric layers of connective tissue known as Herbst corpuscles, which have long been recognized to be vibration-sensitive mechanoreceptors.[5] These corpuscles are very similar in form and function to the Pacinian corpuscles associated with highly touch-sensitive mammalian whiskers. Indeed, recent comparative studies across the bird world, from kiwis and nightjars to barbets and flycatchers, provide mounting evidence that a principal role of rictal bristles for many species is tactile. Thus, in the case of

Typical rictal-enhanced gape. Sketch by Thomas W. Sherry from a photograph.

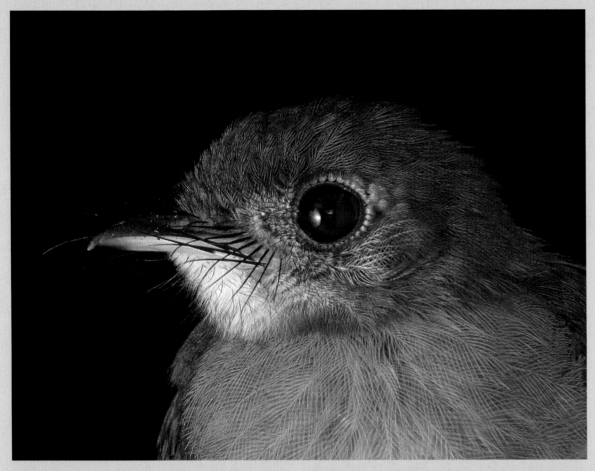

tropical understory birds that flush-chase insects or handle large noxious prey, these highly sensitive bristles may provide multiple functions ranging from fine-scale information about the escape direction of prey to eye protection and collision avoidance. To quote one recent study, however, "identifying rictal bristle function is challenging and demands further investigation in many species."[6]

Delicate and elegant, rictal bristles remain among the countless research opportunities hiding in plain sight within the richness of our tropical forests.

Rictal bristles on the
Sulphur-rumped Flycatcher
(*Myiobius sulphureipygius*)

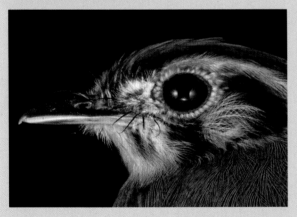
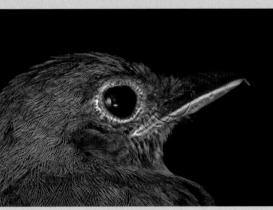

(left) Rictal bristles on the Golden-crowned
Spadebill (*Platyrinchus coronatus*)

(right) Rictal bristles on the Olivaceous
Flatbill (*Rhynchocyclus olivaceus*)

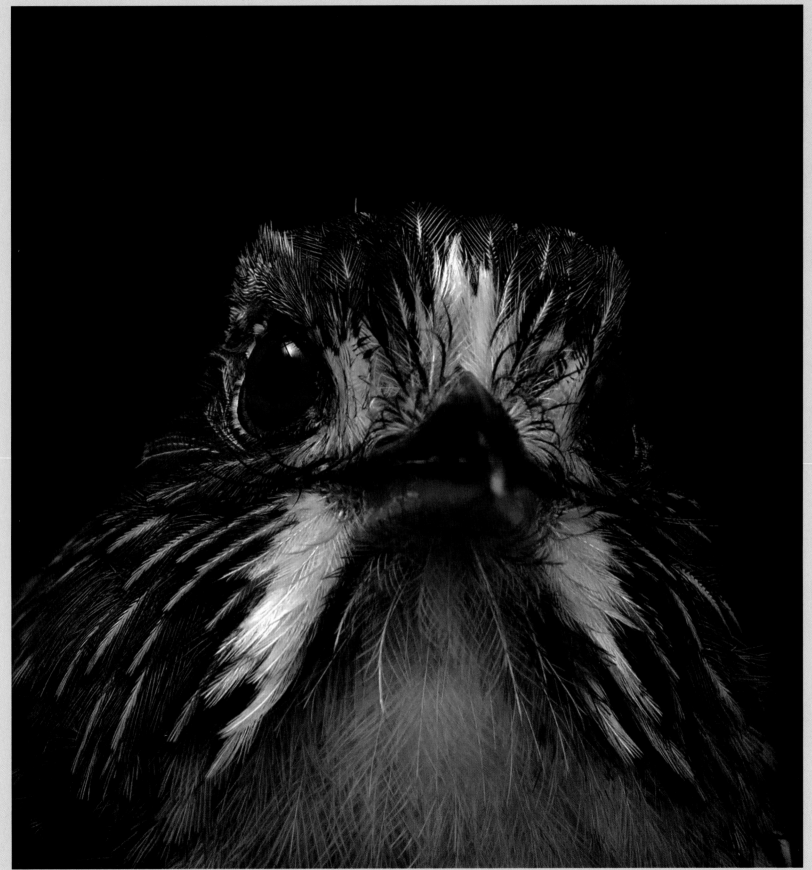

Rictal bristles on the White-whiskered Puffbird (*Malacoptila panamensis*)

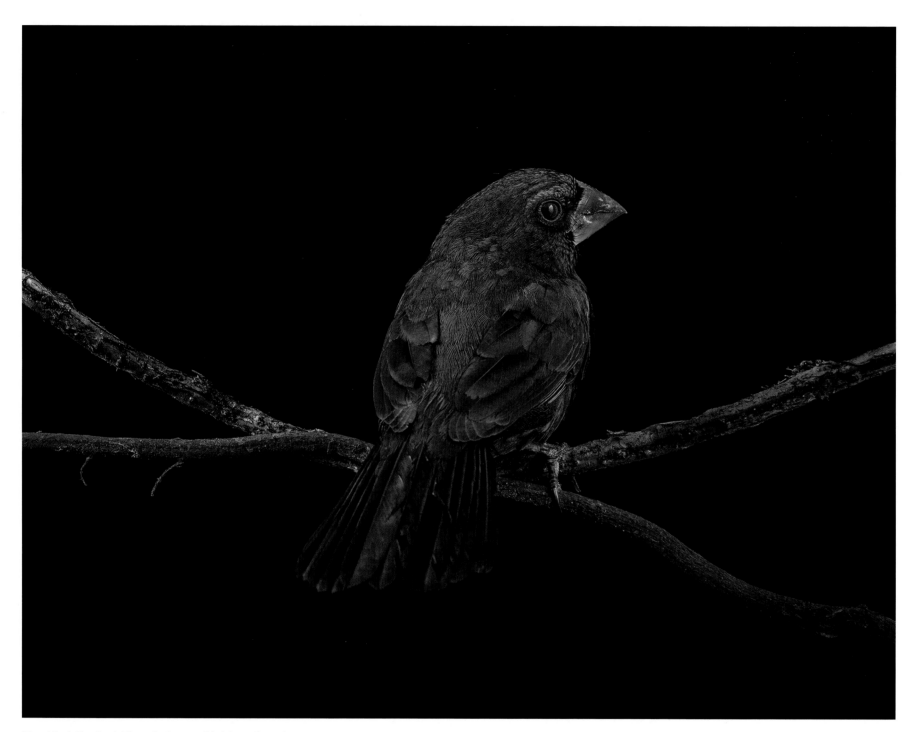

Blue-black Grosbeak (*Cyanoloxia cyanoides*), juvenile male

The adage "a bird in the hand is worth two in the bush" is a trite but useful way of counseling one to be content with what one has, rather than seeking a less certain, if more profitable, outcome. This proverb was almost certainly not written by anyone who has had a Blue-black Grosbeak (*Cyanoloxia cyanoides*) in the hand. The aptly named Grosbeak (from the French *gros*, meaning "large") is best identified by its fearsome bill, almost comically large relative to its body. Indeed, this bird packs a powerful punch when it latches onto the fingers of the unsuspecting ornithologist extracting it from a mist net. Its oversized beak is used to crack open seeds, an important part of its diet, which it supplements with large quantities of fruits and some insects.[1]

Similar to the iconic Northern Cardinal (*Cardinalis cardinalis*), Blue-black Grosbeaks are sexually dimorphic—male plumage is a dark, iridescent blackish blue as described by their eponymous common name, whereas females are a deep, chocolate brown. Immature males are indistinguishable from the drabber females for the first year of their life but thereafter slowly begin to acquire their blue-black feathers as they molt into basic plumage. The more cryptic coloration of the female likely aids in reducing their detectability by potential nest predators since she is exclusively responsible for incubation duties.[2] Nevertheless, males do not shirk parenting altogether—they help females build the nests, provision the young, and even occasionally bring nuptial gifts to the female as she incubates their clutch.

Seasoned Neotropical birders know that Blue-black Grosbeaks are more often heard than seen. This is because they are treefall gap specialists, and mist net data have revealed that they are far more commonly captured in gaps relative to the forest interior.[3] It is uncertain why they exhibit such a predilection for the tangled, incipient vegetation typical of treefall gaps, although they may be attracted to the high diversity of fleshy-fruited plants that spring up in the exposed gaps.[4] Even when they are skulking out of sight, they can be easily identified by their distinctive call (a metallic *chink* similar to that of the Northern Cardinal) or song (a series of sweet, descending whistles with a squeaky twitter at the end).

Depending on where you are in the Neotropics, however, the song of the Blue-black Grosbeak may sound slightly different. This is no trick of the ear—there are multiple different subspecies, all with their own song variation. These subspecies have been the subject of recent genetic studies, which have indicated that, in fact, some subspecies are divergent enough in song and genetic sequence to merit being classified as separate species.[5] Therefore, as of 2018, all birds in the lowland Amazon basin are now classified as a separate species, the Amazonian Grosbeak (*Cyanoloxia rothschildii*).[6] Blue-black Grosbeaks exemplify the current state of flux in avian taxonomy, with many cryptic new bird species being identified based on advances in DNA sequencing technology.

The Blue-black Grosbeak ranges in distribution from southeastern Mexico to northern South America.[7] They inhabit lowland forest up to 1200 m (3900 ft), and because of their gap-loving habits, they can tolerate and even thrive in disturbed areas such as forest edges and successional habitats. For example, they have been seen visiting garden plots outside the forest to consume corn, and their population has experienced over a 70% decline on Barro Colorado Island in Panama due to maturation of their preferred successional habitats on the island.[8] Therefore, unlike many of the other species in this book, the Blue-black Grosbeak is likely not as vulnerable to forest fragmentation and other anthropogenic disturbances.

Blue-black Grosbeak
(*Cyanoloxia cyanoides*)
HENRY S. POLLOCK

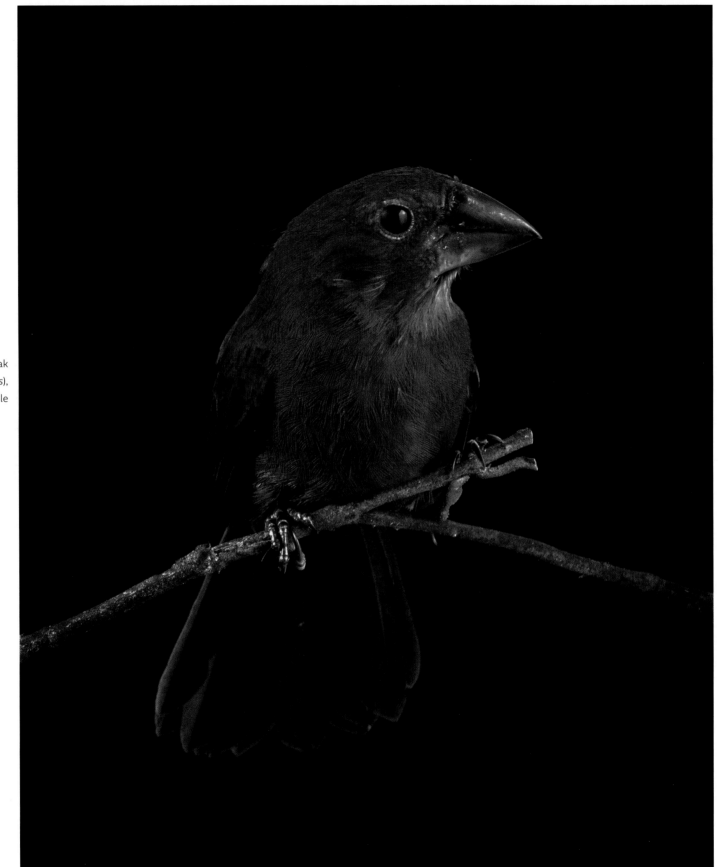

Blue-black Grosbeak
(*Cyanoloxia cyanoides*),
adult female

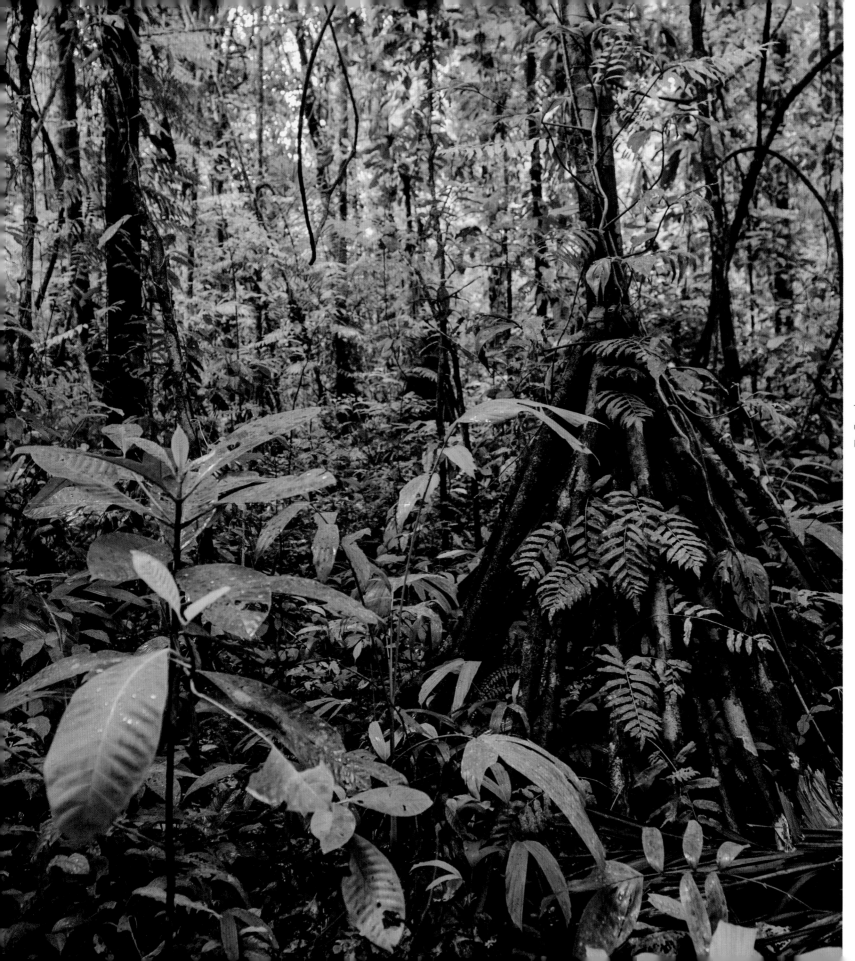

Tropical forest
understory, Rancho Frio,
Darién Province, Panama

Gray-headed Tanager

(*Eucometis penicillata*)

JEFFREY D. BRAWN

Tanagers (family Thraupidae) are a large group of species that account for about 4% of the world's birds.[1] While they occur in North America—well-known temperate species such as the Scarlet and Summer Tanagers (genus *Piranga*) are now known to be more related to the cardinals—in the Neotropics they are remarkably diverse and make up over 10% of the region's bird species. Neotropical tanagers fall into two major groups that can be generally described as "dull or colorful," and it is the latter group that provides birdwatchers with their most memorable sightings—especially in highland areas with numerous species in the genus *Tangara*. With its bright yellow underparts and a head and neck that are entirely gray, the Gray-headed Tanager falls somewhere between in terms of color. When excited, it often raises its crown feathers, giving it the appearance of having a crest.[2]

Alexander Skutch described the Gray-headed Tanager's voice thus: "The Gray-headed Tanager is one of the most gifted minstrels in its family. Long-continued, complex in form, always sweet and appealing, its song is most often delivered in a modest, subdued voice. . . . But one Gray-headed Tanager who sang profusely while he followed army ants on a sunny morning in June had a song far longer and more elaborate than that just described. It flowed smoothly on from verse to verse, and now and again it rose into a jubilant crescendo. It was as fine a song as I have heard from any tanager and would have done credit to a thrush."[3]

Although its coloration is somewhat unremarkable when compared with many other tanagers, the Gray-headed Tanager is a unique species. The genus *Eucometis* is what is called "monotypic," which means it includes just one species. Many tanagers have small geographic ranges, but the Gray-headed Tanager's is comparatively widespread, with a patchy distribution extending from southern Mexico down to Paraguay.[4] It is generally restricted to lowland habitats of less than 600 m (2000 ft) but has been observed up to 1700 m (5500 ft). Within its range, it has diversified, and seven subspecies are currently recognized. The subspecies from Panama pictured here (*E. p. cristata*) is known for its faintly olive-colored throat.[5]

The Gray-headed Tanager is found within its range in a variety of forest types, varying in age and structure from young second growth to mature stands.[6] With regard to precipitation, this species is also a generalist, occurring from dry forests to wetter, swampy areas, especially in South America. Although widespread and not of conservation concern, the Gray-headed Tanager is not especially abundant. A study of bird communities in central Panama found only two pairs of Gray-headed Tanagers on a 100 ha (247 ac) study plot, although more recent work suggests they are more common.[7]

This species maintains territories and feeds on a mixture of fruits and arthropods. Most unusual for a tanager, in Central America and northern South America west of the Andes, the Gray-headed Tanager will join mixed-species flocks attending swarms of army ants.[8] The frequency of this behavior seems to vary, since the bird has been described as both an obligate and an occasional ant follower. Outside of the flocks at ant swarms, this species is not especially social, although three or four birds can be observed together. It is likely that these are family groups consisting of parents and their offspring born during the preceding breeding season. Young birds will remain on their natal territories with their parents for several months after leaving the nest, before dispersing in search of their own territory.

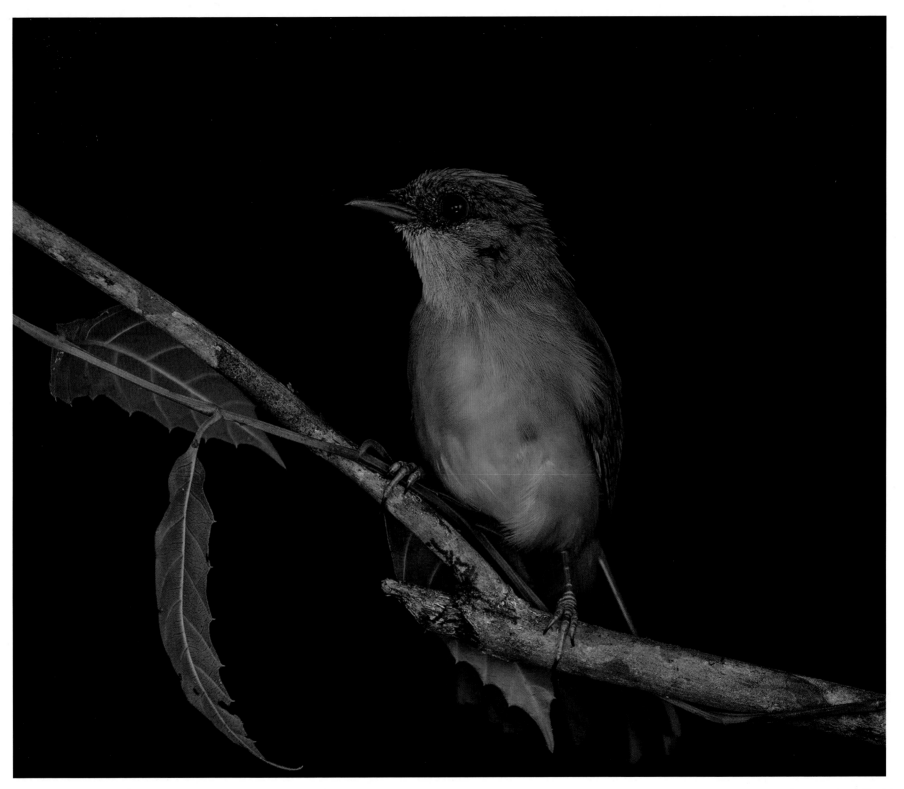

Gray-headed Tanager (*Eucometis penicillata*)

Afterword

Whither Bedford Falls?

In the now classic 1946 Frank Capra film, *It's a Wonderful Life*, the lead character, George Bailey (played admirably by James Stewart), tries repeatedly to take leave of his small town of Bedford Falls and the Bailey Building and Loan Association to go out and "see the world." But circumstances always arise such that George is held back, must cancel his plans, all because of his pure human decency and compassion for others. George never does leave Bedford Falls, eventually falls into despair, contemplating taking his own life. But with the help of a guardian angel named Clarence, George comes to learn that in his small patch of planet earth, he has indeed had "a wonderful life."

Neotropical understory birds are, in some ways, the George Baileys of the bird world. Most of the bird species featured in this book live their surprisingly long lives in but a single patch of forest, a patch each individual comes to know very well. Like most birds, Neotropical understory bird species court, mate, and hold territories. But among these species, the same territory is used every day of the year and, for an avian lifetime, that may exceed a decade. Quite literally, the "bird's world" is a few hectares of understory forest for as long as it may live. Pair bonds endure not merely for a nesting season but throughout the year, and sometimes for many years. This is in sharp contrast with the life cycles of the various long-distance migrant thrushes, wood-warblers, and flycatchers that are present in the lowland tropics part of the year but travel thousands of miles twice a year as they migrate to and from their high-latitude breeding grounds. It might be said that a Blackpoll Warbler (*Setophaga striata*) indeed sees the world, while a Chestnut-backed Antbird (*Poliocrania exsul*) remains in its little version of Bedford Falls, in the shaded understory of a Neotropical moist forest. It might also be said that the average Blackpoll Warbler will, in all probability, live a far shorter life than the average Chestnut-backed Antbird. As has been well documented, clutch sizes are larger for long-distance migrants compared with Neotropical resident species—where clutch size is usually two eggs—and Neotropical resident species also suffer considerably greater annual nest failure rates than is the case with species typical of higher latitudes. This translates to mean that a pair of Chestnut-backed Antbirds may try annually for a decade or more to reproduce but succeed only perhaps once, perhaps twice, in fledging young that survive to adulthood. Charles Darwin saw clearly the incred-

ibly high mortality rates commonplace in nature. Whether driven by the rigors of long-distance migration or, in the case of the sedentary antbird, from repeated nest failure caused by a diverse array of animals that includes coatis, snakes, monkeys, and toucans. The difference is that proportionally more Blackpoll Warblers die as adults, while proportionally more Chestnut-backed Antbirds die in the egg or before fledging.

Some bird species obligately follow army ants, in which case the single most important resource of their environment is . . . army ants. To ensure that this diverse assemblage of ant-following birds is conserved, army ants, and the varied animal food upon which these ants depend, must be preserved. There appear to be no other options. Army ants are the keystone species for ant-following birds; thus, army ants are essential to maintaining the richness of a sizeable chunk of lowland forest bird species. Rainforest ecosystems are not complexly balanced ecosystems in any profound sense, but they are, indeed, biologically complex and are also subject to perturbations of varying severity the likes of which quickly alter diversity, usually diminishing it, at least for a period of time. Initially, ecologists believed, mostly intuitively, that species diversity begat ecosystem stability, that is, the more species rich the ecosystem, the more stable it would be, the more it would resist perturbation. The late Sir Robert May, among others, showed this hypothesis to be a false assumption. Natural perturbations at various scales of intensity and area are commonplace in nature regardless of species richness, but if ecosystems are sufficiently large in area, extinction of species is usually avoided even if populations sizes are temporarily diminished. However, for many Amazonian bird species, their geographic range is limited even within vast Amazonia. Part of the high overall bird species richness on a regional scale is accounted for by species with relatively small ranges, such that species replace each other across a river or some other natural barrier.

It is not possible to say that understory birds such as those treated in this volume have a wonderful life. The degree to which the fast-paced avian mind perceives pleasure and satisfaction is not known. And it does not really matter, since these creatures do not live with the concepts of good and evil. But we humans do. Amazonian lowland forests clearly face an uncertain future. To stretch the metaphor upon which this essay is based to the near breaking point, Bedford Falls not only had its hero in the form of George Bailey, the good guy, but also a villain, Henry F. Potter, a thoroughly greedy man who cared little for the friendly people of the town. What drove Potter was his quest for ever more power and wealth. George Bailey fought the good fight against uneven odds, and, in the end, he won and Potter lost. That is how it usually works in Hollywood movies. But for the Bedford Falls of Amazonian understory birds, as well as the cornucopia of biodiversity of which they are a part, it seems that various forms of Henry Potter may loom large in their future. Deforestation has rapidly and dramatically accelerated in Brazil, including within indigenous reserves, since the election in October 2018 of Jair Bolsonaro as president. The future appears to be dubious, offering only increasing deforestation, more fragmentation, more monocultures, more mining, as well as significant alteration of the annual flood cycle due to increasing hydroelectric and flood control dam projects. None of this bodes well for the ecology of the region or, for that matter, its indigenous resident humans. Yes, the angel Clarence saved George Bailey who saved Bedford Falls, a lovely story that was pure fiction. There appears to be no Clarence or George Bailey in the future of Amazonian lowland forest ecosystems. This is real life in the twenty-first century, not a feel-good movie. And, in Amazonia's future, there appears to be no shortage of would-be Henry Potters.

Whither the Bedford Falls that is Amazonia?

JOHN KRICHER

The following descriptions give the bird's length from the tip of the beak to the end of the tail, elevation, and range.[1]

Antbird, Bicolored
Passeriformes, Thamnophilidae (*Gymnopithys bicolor*)
5.5 in. (13.97 cm), mostly up to 4900 ft (1500 m) elevation, from Honduras to northern Peru and Brazil. Uncommon to common, in moist undergrowth of lowlands and foothills. The most numerous obligate ant follower at ant swarms, rarely forages elsewhere. Feeds on arthropods, small frogs, and lizards.

Antbird, Chestnut-backed
Passeriformes, Thamnophilidae (*Poliocrania exsul*)
5.5 in. (13.97 cm), up to 3300 ft (1000 m) elevation, from Nicaragua to Ecuador. A common inhabitant of lowland forest but secretive and more easily heard than seen. Not an obligate ant follower. Darién race female has a distinguishing rusty breast.

Antbird, Ocellated
Passeriformes, Thamnophilidae (*Phaenostictus mcleannani*)
8 in. (20.32 cm), up to 3300 ft (1000 m) elevation, from Honduras to Colombia and western Ecuador. Uncommon inhabitant of the lower strata of lowland humid forest. An obligate ant follower, rarely seen away from swarms, wary, pumps tail up and down.

Antbird, Spotted
Passeriformes, Thamnophilidae (*Hylophylax naevioides*)
4.5 in. (11.43 cm), up to 3300 ft (1000 m) elevation, from Honduras to western Ecuador. An uncommon to locally common inhabitant of undergrowth in lowland forest. Frequents ant swarms but not an obligate ant follower; it also forages independently.

Antshrike, Black-crowned
Passeriformes, Thamnophilidae (*Thamnophilus atrinucha*)
5.5 in. (14 cm), up to 3000 ft (900 m) elevation, very common on entire Caribbean slope and on Pacific slope from western Panama Province eastward. Found in lower levels of forest and woodland; frequently travels with mixed-species flocks.

Antshrike, Russet
Passeriformes, Thamnophilidae (*Thamnistes anabatinus*)
5.5 in. (13.97 cm), up to 4900 ft (1500 m) elevation, from southeastern Mexico to central Bolivia. A reclusive, uncommon to fairly common inhabitant of humid lowlands and foothills. A foliage gleaner, forages actively with mixed flocks, often takes several short hops up a tree before flying to an adjacent tree.

Antthrush, Black-faced
Passeriformes, Formicariidae (*Formicarius analis*)
6.5 in. (16.51 cm), up to 3300 ft (1000 m) elevation, from Mexico to South America. Fairly common understory resident of humid lowlands. The most common and widespread antthrush, often at swarms. Terrestrial, not easy to see. Walks on the forest floor with a slow jerky gait, with tail cocked nearly vertically. A wary forager of insects in the leaf litter.

Antwren, Checker-throated (*Epinecrophylla fulviventris*)
—see Stipplethroat, Checker-throated

Antwren, White-flanked
Passeriformes, Thamnophilidae (*Myrmotherula axillaris*)
3.5 in. (8.89 cm), up to 3300 ft (1000 m) elevation, in Central and South America. Uncommon to fairly common and widespread in mid- and understory of humid lowlands and foothills. Active, changes position and flicks wings rapidly.

Forages in mixed flocks with Dot-winged Antwrens and Checker-throated Stipplethroats.

Barbthroat, Band-tailed
Caprimulgiformes, Trochilidae (*Threnetes ruckeri*)
4.5 in. (11.43 cm), up to 3300 ft (1000 m) elevation. Uncommon from Central to South America, inhabits understory of humid forests.

Bentbill, Southern
Passeriformes, Tyrannidae (*Oncostoma olivaceum*)
3.5 in. (8.89 cm), up to 3300 ft (1000 m) elevation, in Central and South America in understory of humid forests. Common to fairly common but inconspicuous and hard to see. Tends to sit quietly for long periods. Usually detected by call.

Elaenia, Mountain
Passeriformes, Tyrannidae (*Elaenia frantzii*)
5.5 in. (13.97 cm), up to 4000–8000 ft (1200–2500 m) elevation, from Guatemala to Colombia and western Venezuela. Uncommon to common, usually in highlands. Very active and noisy.

Flatbill, Eye-ringed
Passeriformes, Tyrannidae (*Rhynchocyclus brevirostris*)
6 in. (15.24 cm), up to 6500 ft (2000 m) elevation, from Central America to northern South America. Uncommon, its color and habit of sitting still make it very difficult to see.

Flatbill, Olivaceous
Passeriformes, Tyrannidae (*Rhynchocyclus olivaceus*)
5.5 in. (13.97 cm), up to 2000 ft (600 m) elevation. Fairly common in Panama and northern South America in lower levels of the forest. Not very active, tends to perch quietly.

Flycatcher, Ochre-bellied
Passeriformes, Tyrannidae (*Mionectes oleagineus*)
5 in. (12.70 cm), up to 3900 ft (1200 m) elevation, from Mexico to South America, common in lower levels of forest.

Unlike most flycatchers its diet consists primarily, but not exclusively, of fruit, particularly mistletoe. Frequently flicks wings up over its back.

Flycatcher, Olive-striped
Passeriformes, Tyrannidae (*Mionectes olivaceus*)
5 in. (12.70 cm), up to 6500 ft (2000 m) elevation. Uncommon to locally common in Central and South America. Inhabits lower levels of humid forests. Inconspicuous, favors shady ravines, flicks one wing at a time.

Flycatcher, Ruddy-tailed
Passeriformes, Oxyruncidae (*Terenotriccus erythrurus*)
4 in. (10.16 cm), up to 2600 ft (800 m) elevation, from Mexico to South America. Common and widespread, inhabits lower to middle levels in humid forest. Inconspicuous, sits still for long periods.

Flycatcher, Sulphur-rumped
Passeriformes, Oxyruncidae (*Myiobius sulphureipygius*)
4.5 in. (11.43 cm), up to 3900 ft (1200 m) elevation, from southern Mexico to western Colombia and Ecuador. Fairly common in lower forest levels near streams. Fans tail and droops wings, very active. Inconspicuous, best located by voice.

Flycatcher, Yellow-breasted
Passeriformes, Tyrannidae (*Tolmomyias flaviventris*)
4.5 in. (11.43 cm), up to 3600 ft (1100 m) elevation, in Central and South America. Common near forest edge second growth.

Foliage-gleaner, Buff-throated
Passeriformes, Furnariidae (*Automolus ochrolaemus*)
6 in. (15.24 cm), up to 3200–3900 ft (1000–1200 m) elevation, from Mexico to the Amazon basin. Inhabits lower levels of humid forests, active in dense vegetation, furtive, secretive, not often seen, usually located by voice.

Gnatwren, Long-billed
Passeriformes, Polioptilidae (*Ramphocaenus melanurus*)
4.5 in. (11.43 cm), up to 3900 ft (1200 m) elevation, from Mexico to South America. Inhabits understory and lower midstory in humid forests. Fairly common, favors vine tangles, secretive, skulking, can be difficult to see.

Grosbeak, Blue-black
Passeriformes, Cardinalidae (*Cyanoloxia cyanoides*)
6 in. (15.24 cm), up to 3900 ft (1200 m) elevation, from Mexico to South America. Common and widespread in semihumid forest understory. Reclusive, often difficult to see, remains under cover, more often heard than observed.

Hermit, Green
Caprimulgiformes, Trochilidae (*Phaethornis guy*)
6 in. (15.24 cm), up to 2000 ft (600 m) elevation, from Central America to northern South America. Inhabits lower levels in humid forests.

Hermit, Long-billed
Caprimulgiformes, Trochilidae (*Phaethornis longirostris*)
4.5 in. (11.43 cm), up to 300 ft (1000 m) elevation, in Central and South America. Inhabits lowlands and foothills, in humid forests. Fairly common, found around flowering herbs, can be curious and hover close to observers.

Nightingale-Thrush, Ruddy-capped
Passeriformes, Turdidae (*Catharus frantzii*)
6.5 in. (16.51 cm), up to 6900 ft (2100 m) elevation. Common on floor and in undergrowth of humid forests from southern Mexico to Panama but found only in the Chiriquí highlands in Panama.

Puffbird, White-whiskered
Galbuliformes, Bucconidae (*Malacoptila panamensis*)
7.5 in. (19.05 cm), up to 3900 ft (1200 m) elevation, from southern Mexico to northern South America. Fairly common inconspicuous resident of midstory humid forests. Sits motionless for long periods and allows observers to come close, habits that have led to their being described as "stupid."

Pygmy-Tyrant, Scale-crested
Passeriformes, Tyrannidae (*Lophotriccus pileatus*)
4 in. (10.16 cm), up to 2000–3900 ft (600–1200 m) elevation, from Honduras to northern Venezuela and southern Peru. Common in understory of humid forests, has a loud call for a tiny bird, and is inconspicuous when quiet. Can perch motionless for long periods.

Quail-Dove, Ruddy
Columbiformes, Columbidae (*Geotrygon montana*)
8.5 in. (21.59 cm), up to 3900 ft (1200 m) elevation, in Central and South America from Mexico south to Argentina. Found on ground in semihumid and humid forests. Tends to be shy.

Redstart, Slate-throated
Passeriformes, Parulidae (*Myioborus miniatus*)
4.5 in. (12 cm), 2000–6900 ft (600–2100 m), inhabits lower and middle levels of forest. Active, often found with mixed-species flocks.

Sicklebill, White-tipped
Caprimulgiformes, Trochilidae (*Eutoxeres aquila*)
4.5 in. (11.43 cm), up to 4900 ft (1500 m) elevation, in Costa Rica, Panama, Colombia, Ecuador and far northern Peru. One of two sicklebill species worldwide. Uncommon, inhabits understory of humid forests, rarely hovers, prefers *Heliconia* flowers.

Solitaire, Black-faced
Passeriformes, Turdidae (*Myadestes melanops*)
6.5 in. (16.51 cm), up to 3400 ft (1500 m) elevation, in highlands of Costa Rica and western Panama. Fairly common inhabitant in understory of cloud forests. Perches upright, remains motionless for long periods, not shy, but often difficult to see.

Spadebill, Golden-crowned
Passeriformes, Tyrannidae (*Platyrinchus coronatus*)
3.5 in. (8.89 cm), up to 3400 ft (1050 m) elevation, from Honduras to Peru. A tiny, inconspicuous, fairly common inhabi-

tant of the undergrowth of humid forests. Sits motionless for long periods, difficult to see.

Stipplethroat, Checker-throated
Passeriformes, Thamnophilidae (*Epinecrophylla fulviventris*)
4 in. (10.16 cm), up to 2400 ft (750 m) elevation, from Honduras south to northern Colombia and to western Ecuador. Uncommon to locally fairly common in humid lowlands and foothills. Forages for insects in hanging clusters of dead leaves in pairs and in mixed flocks including other antwren species.

Tanager, Gray-headed
Passeriformes, Thraupidae (*Eucometis penicillata*)
6–7 in. (15.24–17.78 cm), up to 4900 ft (1500 m) elevation, in Mexico and Central America. Uncommon resident of humid undergrowth. Often seen at ant swarms. Excitable.

Woodcreeper, Cocoa
Passeriformes, Furnariidae (*Xiphorhynchus susurrans*)
8.5 in. (21.59 cm), up to 2000 ft (600 m) elevation. Very common and widespread from Central America to northern South America. Can be seen at ant swarms.

Woodcreeper, Plain-brown
Passeriformes, Furnariidae (*Dendrocincla fuliginosa*)
8.5 in. (21.59 cm), up to 4600 ft (1400 m) elevation. Uncommon to fairly common inhabitant of understory in Central and South America. Seen in groups at ant swarms.

Woodpecker, Golden-olive
Piciformes, Picidae (*Colaptes rubiginosus*)
8.5 in. (21 cm), fairly common in foothills and highlands in western Panama. Lives in middle and upper levels of forest, woodland, and clearings with trees.

Wood-Wren, White-breasted
Passeriformes, Troglodytidae (*Henicorhina leucosticta*)
4 in. (10.16 cm), up to 6400 ft (1950 m) elevation, from Mexico to South America. Common on floor of humid forests. Active in leaf litter and dead wood.

Wood-Wren, Gray-breasted
Passeriformes, Troglodytidae (*Henicorhina leucophrys*)
4.5 in. (11.43 cm), up to 3300 ft (1000 m) elevation, from southern Mexico to northern South America. Common in humid highlands, forages on or close to the ground. Inquisitive.

Wren, Scaly-breasted
Passeriformes, Troglodytidae (*Microcerculus marginatus*)
4 in. (10.16 cm), up to 9800 ft (3000 m) elevation. Fairly common from Central to South America. Tiny, furtive, incessant habit of bobbing rear end up and down. Walks on ground, inconspicuous, very difficult to see.

Wren, Song
Passeriformes, Troglodytidae (*Cyphorhinus phaeocephalus*)
4.5 in. (11.43 cm), up to 3300 ft (1000 m) elevation, from Honduras to western Ecuador. Fairly common, found on or near the ground in humid forests, often travels with family. Known for its melodious song.

Xenops, Plain
Passeriformes, Furnariidae (*Xenops minutus*)
4.5 in. (11.43 cm), up to 3300 ft (1000 m) elevation. Common in lowland woodlands. Gleans acrobatically on small branches, often hangs upside down.

The photographs were taken in a portrait-studio-like setting. Unbeknownst to me at the time, John S. Dunning (1916–1981), a field collaborator of the Cornell Laboratory of Ornithology, used the technique in the mid-1960s and described it in his books, *Portraits of Tropical Birds* and *South American Birds—A Photographic Aid to Identification*. The idea is to photograph birds in a bird-tight "set" that can be adjusted for lighting, background, and perch type. His many wonderful images suffer only from the photographic technology limitations of his time. Present day lenses are sharper and faster: digital single-lens reflex cameras (DSLRs) allow for more rapid focusing and can also adjust ISO values (film speed) from one frame to the next, whereas photographic film has a basically fixed ISO value. Today's cameras make it possible to minimize the time between exposures, which means capturing multiple images in a short time—an advantage when dealing with moving subjects. Memory cards (the DSLR's "film") permit editing images "on the fly." It is instructive to compare conventional artists' renderings of the same species across different field guides with those made using the studio method with digital capture.

For my purposes, a collapsible white 0.5 in. (1.27 cm) PVC pipe framework, measuring 22 in. × 22 in. × 38 in. (55.8 cm × 55.8 cm × 96.5 cm), was covered with photographic diffusion cloth. A square cone of fabric measuring 32 in. (81 cm) in length extended from the front end in order to accommodate the shortest focusing distance of the lens. Light from electronic flashes outside the "box" was modified with soft boxes and a homemade reflector. A piece of black upholstery fabric backed with black-out material was used as a backdrop inside the studio. The rear one-third of the studio floor was fitted with a 0.19 in. (3 mm) plywood platform. Numerous small, adjustable clamping gadgets were affixed to the frame or placed on the floor in order to attach branches and slim tree trunks as props. The enclosing fabric was sealed with a combination of stitching, zippers, and Velcro. The studio was supported by a four-legged stand with a 0.5 in. (1.27 cm) PVC pipe frame; camera monopods were used as legs, thus allowing the stu-

dio to be leveled and its height adjusted. The stand also anchored the flashes, whose direction could also be adjusted. The rig (minus cameras, flashes, lens, and camera accessories) weighed about 40 lb (18 kg) and was easily packed into a wheeled duffel bag.

All the images were taken with a Nikon 800e DSLR and a Nikon 70–200 mm lens. The two Nikon Speedlight SB-910s were fired remotely by a Nikon Wireless Speedlight Commander SU-800. The camera was supported by a Really Right Stuff tripod and ball head. All images were shot in RAW (unmodified digital format).

Minor modifications were made over time as I learned to cope with the changing characteristics of the forest floor's available light. As is necessary with digital images, some post-capture adjustments were performed using Adobe Camera Raw and Adobe Photoshop.

Traditional mist nets, mounted at ground level, were used to catch the birds. The average time the birds spent in the studio was 5 to 10 minutes, during which they exhibited a limited repertoire of behaviors. Most of the birds flitted about briefly before alighting on a perch, then sat inquisitively and quietly surveying their surroundings. An uncommon reaction was to fly around the enclosure, perching or clinging to the fabric but never long enough to get a suitable image. Obviously stressed, these birds were promptly released. A rare reaction was to go immediately to the studio floor and sit hunched down, motionless. There they sat, even after gently jiggling the studio floor. Once the studio was opened widely, they immediately flew out. Tiny species, such as the Golden-crowned Spadebill (*Platyrhincus coronatus*), sometimes sought refuge within the camera's lens hood. Tapping on the metal "burrow" was enough to dislodge them. For the White-breasted Wood-Wren (*Henicorhina leucosticta*) a layer of leaf litter was strewn on the studio floor. Immediately upon being introduced into the enclosure the bird began foraging frenetically amongst the dead leaves and twigs, not ceasing until the litter was apparently stripped of every edible bug. Once sated, the wren repaired to a piece of dead wood and preened. The

About the Photographs

JOHN P. WHITELAW

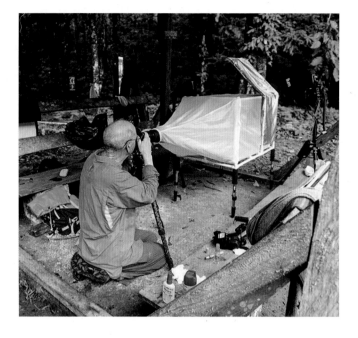

John Whitelaw using a portable photography studio on-site in the Darién.

woodcreepers quickly clung comfortably to vertically oriented pieces of rotting wood and soon began picking at them, flicking aside bits of soft bark in search of insects. Of the fifty or so species photographed, none were harmed.

While this technique might seem more comfortable then trekking through the forest searching for these elusive species, it was not without its perils. In the Darién Province, Red-throated Caracaras (*Ibycter americanus*) were seen flying around a nest of Africanized honeybees high in the canopy. The giveaway was the rustle of leaves and branches, the muttering of the Caracaras, and the yellow glint of angry bees in the sunlight. The birds feed on the bee larvae. The next morning the studio contained about a half-dozen "killer" bees, their presence explained by their propensity for seeking cavity-like spaces to nest. My Panamanian colleagues warned that in-

jured bees can release a chemical that attracts more of the dangerous insects. Fortunately, after gentle persuasion with a large leaf, they left. And on one occasion, a small, active wasp's nest was inadvertently included in the vegetation harvested for a prop.

In their native habitat most of these understory species either are in almost constant motion as they forage for prey or sit motionless and camouflaged. Their often optically impenetrable forest environment makes it challenging to get a decent view with binoculars, let alone a camera. The studio technique is, therefore, often the best, and sometimes the only, way to capture ideal portraits of these photographically elusive species. In the interest of conservation and the increasing number of threatened species, especially those not easily seen in the wild, this technique should be used more frequently.

Notes

Preface

Epigraph: Sartore 2017, 42.

Epigraph: Gell-Mann 1995, 129. Quotation reprinted by permission of Counterpoint Press; from *Last of the Curlews*, copyright © 1995 by Fred Bosworth.

1 Koren 1994.
2 US Fish and Wildlife Service 2016.
3 Thoreau 1993, xi. Quotation reprinted by permission of Beacon Press.
4 Thoreau 1993, xiii. Quotation reprinted by permission of Beacon Press.

Introduction

1 Martinez et al. 2018.
2 Jankowski et al. 2010.
3 Austin et al. 2019.
4 Powell et al. 2015.
5 Moore et al. 2008.
6 Brawn et al. 2017.

Challenges to Biodiversity Conservation in Panama

1 Wright et al. 2017.

Ruddy Quail-Dove (*Geotrygon montana*)

1 Kuecker et al. 2020.
2 Terborgh et al. 1990; Stouffer and Bierregaard 1993.
3 Ballarini et al. 2013.
4 Skutch 1949; Kuecker et al. 2020.
5 Kuecker et al. 2020.
6 Moller et al. 2006.
7 Kuecker et al. 2020.
8 G.A. Londoño, pers. comm., 2020.
9 Kuecker et al. 2020.
10 Kuecker et al. 2020.

White-tipped Sicklebill (*Eutoxeres aquila*)

1 Hinkelmann 1999c, 537.
2 Fogden et al. 2014, 37.
3 McMullan 2016, 2.

Band-tailed Barbthroat (*Threnetes ruckeri*)

1 Fogden et al. 2014, 42.
2 Hinkelmann 1999a.
3 McMullan 2016, 4.

Green Hermit (*Phaethornis guy*)

1 McMullan 2016, 7.
2 Hinkelmann 1999b, 540.
3 Fogden et al. 2014, 54.
4 IUCN 2020.

Long-billed Hermit (*Phaethornis longirostris*)

1 del Hoyo et al. 2020d.
2 del Hoyo et al. 2020d.
3 Stiles and Wolf 1979, 78.
4 Araya-Salas and Wright 2013.
5 Miller and Taube 1997.
6 Rico-Guevara and Araya-Salas 2015.
7 Skutch 1964, 5.
8 McGuire et al. 2014.
9 Skutch 1964.

White-whiskered Puffbird (*Malacoptila panamensis*)

1 Brisson 1760.
2 Sclater 1883.
3 Wetmore 1968.
4 Skutch 1958, 212.
5 Smith 1969.
6 Skutch 1980, 314.

Golden-olive Woodpecker (*Colaptes rubiginosus*)

1 Hilty 2003.
2 Skutch 1956.
3 Skutch 1956, 119.
4 Hilty 2003.
5 Skutch 1956.
6 del Hoyo et al. 2020e.

Black-crowned Antshrike (*Thamnophilus atrinucha*)

1 Tarwater and Brawn 2010a; Tarwater and Kelley 2010.
2 Oniki 1975; Tarwater and Kelley 2010.
3 Tarwater and Kelley 2010.
4 Roper 2005.
5 Tarwater et al. 2013.
6 Tarwater and Brawn 2010b.
7 Tarwater and Brawn 2008.
8 Murray 2000.
9 Moore et al. 2008; Tarwater 2012.

Russet Antshrike (*Thamnistes anabatinus*)

1 Zimmer and Isler 2003.
2 Skutch 1969, 197.
3 Ohlson et al. 2011.
4 Bravo et al. 2014.
5 Brumfield et al. 2007.
6 Slud 1964; Karr 1971.
7 Skutch 1969.
8 Zimmer and Isler 2003.

Checker-throated Stipplethroat (*Epinecrophylla fulviventris*)

1 Gradwohl and Greenberg 1982.
2 Isler et al. 2006, 525.

White-flanked Antwren (*Myrmotherula axillaris*)

1 Bravo et al. 2014.
2 del Hoyo et al. 2020f.
3 Ord and Stamps 2008.
4 Munn and Terborgh 1979; Gradwohl and Greenberg 1980; Munn 1985; Greenberg and Gradwohl 1986.
5 Munn and Terborgh 1979; Gradwohl and Greenberg 1980; Munn 1985; Greenberg and Gradwohl 1986.
6 Mokross et al. 2014.
7 Powell 1989.
8 Greenberg and Gradwohl 1980.
9 Gradwohl and Greenberg 1980.
10 Munn and Terborgh 1979; Munn 1985.
11 Pearson 1977; Greenberg and Gradwohl 1980.
12 Pearson 1977; Greenberg and Gradwohl 1980.
13 del Hoyo et al. 2020f.

Chestnut-backed Antbird (*Poliocrania exsul*)

1 Woltmann et al. 2020.
2 Woltmann et al. 2020.
3 Woltmann et al. 2020.
4 Rompré and Robinson 2008; Greeney et al. 2013; Visco et al. 2015.
5 Sherry, "Ruddy-tailed Flycatcher," this volume.
6 Woltmann and Sherry 2011; Woltmann et al. 2012a, 2012b, 2020; Greeney et al. 2013; Visco et al. 2015.
7 Robinson and Robinson 2001; Robinson et al. 2005; Greeney et al. 2013; Visco et al. 2015.
8 Robinson et al. 2005; Greeney et al. 2013; Visco et al. 2015; Woltmann et al. 2020.
9 Woltmann et al. 2020.
10 Rompré and Robinson 2008; Woltmann et al. 2020.
11 Rompré and Robinson 2008.
12 Woltmann et al. 2020.
13 Moore et al. 2008; Greeney et al. 2013; O'Malley 2013; Visco et al. 2015; Sherry et al. 2020.
14 Visco and Sherry 2015.
15 Woltmann and Sherry 2011; Woltmann et al. 2012a, 2012b.
16 Woltmann and Sherry 2011; Woltmann et al. 2012a, 2012b.
17 Moore et al. 2008; O'Malley 2013; Sherry et al. 2020.
18 Moore et al. 2008; O'Malley 2013; Sherry et al. 2020.

Bicolored Antbird (*Gymnopithys bicolor*)

1 Willis 1967, 1974.
2 del Hoyo et al. 2020c.
3 del Hoyo et al. 2020c.

Spotted Antbird (*Hylophylax naevioides*)

1 Willis 1972b.
2 Willis 1972b.
3 Wikelski et al. 1999; Hau et al. 2000b; Bard et al. 2002; Styrsky 2003.
4 Hau et al. 1998.
5 Hau et al. 2000a.
6 Willis 1972b.
7 Willis 1972b.
8 Styrsky 2003.
9 IUCN 2020.

Ocellated Antbird (*Phaenostictus mcleannani*)

1 Willis and Oniki 1978.
2 Rettenmeyer et al. 2011.
3 Willis 1973.
4 Brumfield et al. 2007.
5 Chaves-Campos et al. 2009.
6 Martínez et al. 2018.
7 Batcheller 2017.
8 Willis and Oniki 1978.
9 Pollock et al., unpublished manuscript.

Black-faced Antthrush (*Formicarius analis*)

1 Skutch 1945, 122.
2 Skutch 1945; Patten 2020.
3 Patten 2020.
4 Patten 2020.
5 Stouffer 1997.
6 Kirschel et al. 2011.
7 Skutch 1945.
8 Patten 2020.
9 Shaw et al. 2013, 179; Boyle and Sigel 2015.

Plain-brown Woodcreeper (*Dendrocincla fuliginosa*)

1 Winkler et al. 2020b.
2 Willis 1972a.
3 Willis 1966, 1972a.
4 Winkler et al. 2020b.
5 Willis 1972a.
6 Chapman and Rosenberg 1991.
7 Brawn, unpublished data.
8 Winkler et al. 2020b.

9 Weir and Price 2011.
10 Bierregaard and Lovejoy 1989.
11 IUCN 2020.

Cocoa Woodcreeper (*Xiphorhynchus susurrans*)

1 Marantz 2020.
2 IUCN 2020.
3 Stiles and Skutch 1989.
4 Ridgely and Tudor 1994.
5 Whithey 2013.
6 Marantz 2020.

Plain Xenops (*Xenops minutus*)

1 Simpson 1980.
2 Skutch 1969; Karr 1971; Decker 2020.
3 Skutch 1969.
4 Remsen 2003.
5 Skutch 1969.
6 Skutch 1969.
7 Decker 2020.
8 Remsen 2003.
9 Harvey and Brumfield 2015.
10 Gregory-Wodzicki 2000.

Buff-throated Foliage-gleaner (*Automolus ochrolaemus*)

1 Remsen and Greeney 2020.
2 Remsen and Greeney 2020.
3 McQuistion et al. 1999.
4 Remsen and Greeney 2020.

Ruddy-tailed Flycatcher (*Terenotriccus erythrurus*)

1 Farnsworth and Lebbin 2020.
2 Skutch 1960e.
3 Skutch 1960e; Farnsworth and Lebbin 2020.
4 Skutch 1960e.
5 Sherry 1983, 1984; Ohlson et al. 2008.
6 Sherry 1983, 1984; Ohlson et al. 2008; Farnsworth and Lebbin 2020.
7 Sherry et al. 2020.
8 Ohlson et al. 2008.
9 Farnsworth and Lebbin 2020.
10 Ohlson et al. 2008.
11 Visco and Sherry 2015.
12 Farnsworth and Lebbin 2020.
13 Skutch 1960e.
14 Skutch 1960e.
15 Farnsworth and Lebbin 2020.

Ants and Ant Followers

1 Willis 1967, 31.
2 Skutch 1980, 103–106.
3 Wulf 2016.

Sulphur-rumped Flycatcher (*Myiobius sulphureipygius*)

1 Skutch 1960f; Schafer 2020.
2 Skutch 1960f, 539.
3 IUCN 2020.
4 Schafer 2020.
5 Ohlson et al. 2008.
6 Schafer 2020.
7 Sherry 1984; Schafer 2020.
8 Skutch 1960f.
9 Skutch 1960f.
10 Visco and Sherry 2015.
11 Skutch 1960f; Schafer 2020.
12 Skutch 1960f.
13 Ohlson et al. 2008; Schafer 2020.
14 Skutch 1960f.
15 Schafer 2020.
16 Skutch 1960f; Schafer 2020.
17 Sherry 1982, 1984.
18 Sherry 1982, 1984.
19 Sherry 1984.
20 Sherry et al. 2020.

Golden-crowned Spadebill (*Platyrinchus coronatus*)

1 Marren 2004.
2 Le Carré 1977 (2011).
3 Skutch 1997, 19 and 71.

Olive-striped Flycatcher (*Mionectes olivaceus*)

1 Fitzpatrick et al. 2020.
2 Fitzpatrick et al. 2020.
3 Londoño 2014.
4 Greeney and Gelis 2007.
5 G.A. Londoño, pers. comm., 2020.
6 Hilty 1997; Fitzpatrick et al. 2020.
7 Fitzpatrick et al. 2020.
8 Fitzpatrick et al. 2020.

Ochre-bellied Flycatcher (*Mionectes oleagineus*)

1 Fitzpatrick 1980.
2 Skutch 1960a; Moermond and Denslow 1985.
3 Standish et al. 2020.
4 Skutch 1960a; Moermond and Denslow 1985.
5 Westcott and Smith 1994.

6 Westcott 1997.
7 Westcott 1992.
8 Westcott 1993; Westcott and Smith 1997.
9 Snow and Snow 1979.
10 Skutch 1960a; Standish et al. 2020.

Avian Malaria in the Forest Understory

1 Lee et al. 1985; Valkiūnas 2005.
2 Lutz et al. 2016.
3 LaPointe et al. 2012.
4 Valkiūnas 2005.
5 Lutz et al. 2016.
6 Gill 2020.
7 Davidar and Morton 1993; Dufva 1996; Merino et al. 2000; Asghar et al. 2012, 2015.
8 Valkiūnas 1989; Dawson and Bortolotti 2000; Valkiūnas et al. 2006.
9 van Riper et al. 1986; Atkinson et al. 1995.
10 LaPointe et al. 2010.
11 Svensson-Coelho et al. 2016.
12 Robinson et al. 2004.
13 Loaiza et al. 2017.
14 Isaksson et al. 2013; Drovetski et al. 2014; Fecchio et al. 2017.
15 Young, unpublished data.
16 Young, unpublished data.
17 Young, unpublished data.
18 Gonzáles et al. 2014.
19 Rogers and Randolph 2006; Brawn et al. 2017.

Scale-crested Pygmy-Tyrant (*Lophotriccus pileatus*)

1 Hilty and Brown 1986; Ridgely and Gwynne 1989; Garrigues and Dean 2007.
2 Slud 1964, 266.
3 Hilty and Brown 1986.
4 Skutch 1967.
5 Greeney and Gelis 2007.
6 Fitzpatrick 1980.
7 Fitzpatrick 1981.
8 Fitzpatrick 1985.
9 IUCN 2020.

Eye-ringed Flatbill (*Rhynchocyclus brevirostris*)

1 Skutch 1961, 55.
2 IUCN 2020.
3 Boyle and Sigel 2015.

Olivaceous Flatbill (*Rhynchocyclus olivaceus*)

1 del Hoyo et al. 2020a.
2 del Hoyo et al. 2020a.
3 Skutch 1960c.
4 Skutch 1960c.
5 Skutch 1960c.
6 IUCN 2020.

Yellow-breasted Flycatcher (*Tolmomyias flaviventris*)

1 del Hoyo et al. 2020b.
2 Ridgley 1976.
3 Angehr and Dean 2010, 234.
4 Skutch 1997.
5 Skutch 1997.
6 Haverschmidt 1974.
7 Haverschmidt 1974.
8 IUCN 2020.

Southern Bentbill (*Oncostoma olivaceum*)

1 Clock and Christie 2020.
2 Wetmore 1972, 528.
3 Clock and Christie 2020.
4 Skutch 1960d, 1997.
5 Sherry 1982.
6 Clock 2020a; Clock and Christie 2020.
7 Harvey et al., 2020.
8 Skutch 1960d, 555; 1997.
9 Sherry et al. 2020.
10 Clock and Christie 2020.
11 Skutch 1960d, 1997; Clock 2020a; Clock and Christie 2020.
12 Sherry (see Ruddy-tailed Flycatcher, this volume); Sherry and Visco (see Chestnut-backed Antbird, this volume).
13 Sherry (see Ruddy-tailed Flycatcher, this volume); Sherry and Visco (see Chestnut-backed Antbird, this volume); Sherry et al. 2020.

Ectoparasites on Panamanian Birds

1 Wenzel and Tipton 1966, 861; Muñoz-Leal et al. 2020.
2 Brennan and Yunker 1966.
3 Yunker and Radovsky 1966.
4 Mironov and Bermúdez 2017, 2018, 2020; Skoracki et al. 2019.
5 Guglielmone et al. 2003.
6 Brennan and Yunker 1966; Fairchild et al. 1966; Bermúdez et al. 2018, 129.
7 Brennan and Yunker 1966.
8 Fairchild et al. 1966.
9 Brennan and Yunker 1966.
10 Bermúdez et al. 2015.

11 Fairchild et al. 1966; Domínguez et al. 2019.

12 Bermúdez et al. 2020.

13 Tipton and Méndez 1966.

14 Fairchild 1966.

Mountain Elaenia (*Elaenia frantzii*)

1 Hanna et al. 2016.

2 Skutch 1967, 96.

3 Wheelwright et al. 1984.

4 Barrantes and Pereira 2002.

5 Gomes et al. 2008.

6 Moritz et al. 2008.

Long-billed Gnatwren (*Ramphocaenus melanurus*)

1 Winkler et al. 2020a.

2 Greeney et al. 2020.

3 Greeney et al. 2020.

4 Rand and Traylor 1953.

5 Rand and Traylor 1953.

6 Rand and Traylor 1953; Barker 2004.

7 Greeney et al. 2020.

8 Harvey et al. 2014; Smith et al. 2018.

9 Greeney et al. 2020.

10 Boyle and Sigel 2015.

11 IUCN 2020.

Scaly-breasted Wren (*Microcerculus marginatus*)

1 Slud 1958, 243.

2 Kroodsma and Brewer 2020.

3 Christian and Roberts 2000.

4 Kroodsma and Brewer 2020.

5 Christian and Roberts 2000.

6 Kroodsma and Brewer 2020.

7 Leger et al. 2000.

8 Slud 1958.

9 Stiles 1983.

10 Kroodsma and Brewer 2020.

11 Willis 1974; Leck 1979.

White-breasted Wood-Wren (*Henicorhina leucosticta*)

1 Ridgley and Gwynne 1989, 534; Kroodsma and Brewer 2020.

2 W.D. Robinson et al. 2000a.

3 Ridgley and Gwynne 1989, 534.

4 Ridgley and Gwynne 1989, 534.

5 Jankowski et al. 2010.

6 Gravitz 2000.

Gray-breasted Wood-Wren (*Henicorhina leucophrys*)

1 Skutch 1960b, 146.

2 Skutch 1960b, 147.

3 Hall 2009.

4 Hall 2009.

5 Dingle and Slabbekoorn 2018.

6 Dahlin and Benedict 2014.

7 Dingle and Slabbekoorn 2018.

8 Dingle and Slabbekoorn 2018.

9 Skutch 1960b, 147.

Song Wren (*Cyphorhinus phaeocephalus*)

1 Angehr and Dean 2010, 206.

2 Pollock and Agin 2020.

3 Pollock and Agin 2020.

4 Wikelski et al. 2000.

5 T.R. Robinson et al. 2000.

6 T.R. Robinson et al. 2000.

7 Busch et al. 2011; Brawn et al. 2017.

8 Robinson 1999.

9 IUCN 2020.

Black-faced Solitaire (*Myadestes melanops*)

1 Wheelwright et al. 1984; Murray 2000.

2 Murray 2000.

3 Murray 1988.

4 Murray et al. 1994.

Hummingbird Tongues

1 Martin 1833.

2 Rico-Guevara and Rubega 2011; Rico-Guevara et al. 2015.

3 Rico-Guevara and Rubega 2011; Rico-Guevara et al. 2015.

4 Rico-Guevara et al. 2015.

5 Rico-Guevara et al. 2015.

6 Biomimicry Institute 2015.

Ruddy-capped Nightingale-Thrush (*Catharus frantzii*)

1 Taylor et al. 2020.

2 Wetmore et al. 1984, 158.

3 Rangel-Salazar et al. 2008a, 2008b.

4 Noon 1981; Jankowski et al. 2010.

5 Jankowski et al. 2010.

6 Ortiz-Ramírez et al. 2016; Taylor et al. 2020.

7 Jankowski et al. 2010.

8 Taylor et al. 2020.

Slate-throated Redstart (*Myioborus miniatus*)

1 Harrod and Mumme 2020.

2 Mumme 2002.

3 Mumme et al. 2006.

4 Harrod and Mumme 2020.

5 Harrod and Mumme 2020.

6 Harrod and Mumme 2020.

Rictal Bristles

1 Fitzpatrick 1985.

2 Sherry 1984.

3 Lederer 1972.

4 Conover and Miller 1980.

5 Küster 1905.

6 Delaunay et al. 2020, 355.

Blue-black Grosbeak (*Cyanoloxia cyanoides*)

1 Stiles and Skutch 1989.

2 Skutch 1954.

3 Schemske and Brokaw 1981; Levey 1988.

4 Levey 1988.

5 Bryson et al. 2014.

6 Fitzgibbon and Block 2018.

7 Fitzgibbon and Block 2018.

8 Robinson 2001.

Gray-headed Tanager (*Eucometis penicillata*)

1 Burns et al. 2014.

2 Ridgely and Gwynne 1989, 534.

3 Skutch 1954, 183.

4 Baker and Burns 2020.

5 Baker and Burns 2020.

6 Baker and Burns 2020.

7 W.D. Robinson et al 2000a.

8 Baker and Burns 2020.

Brief Descriptions of the Species

1 The information in this section has been drawn from Ridgely and Gwynne 1989; Angehr and Dean 2010; Vallely and Dyer 2018.

References

Angehr, G.R., and R. Dean. 2010. *The Birds of Panama: A Field Guide.* Ithaca, NY: Cornell University Press.

Araya-Salas, M., and T. Wright. 2013. "Open-ended Song Learning in a Hummingbird." *Biology Letters* 9:20130625. https://doi.org/10.1098/rsbl.2013.0625.

Asghar, M., D. Hasselquist, B. Hansson, P. Zehtindjiev, H. Westerdahl, and S. Bensch. 2015. "Hidden Costs of Infection: Chronic Malaria Accelerates Telomere Degradation and Senescence in Wild Birds." *Science* 347(6220): 436–438.

Asghar, M., H. Westerdahl, P. Zehtindjiev, M. Ilieva, D. Hasselquist, and S. Bensch. 2012. "Primary Peak and Chronic Malaria Infection Levels are Correlated in Experimentally Infected Great Reed Warblers." *Parasitology* 139(10): 1246–1252.

Atkinson, C.T., K.L. Woods, R.J. Dusek, L.S. Sileo, and W.M. Iko. 1995. "Wildlife Disease and Conservation in Hawaii: Pathogenicity of Avian Malaria (*Plasmodium relictum*) in Experimentally Infected Iiwi (*Vestiaria coccinea*)." *Parasitology* 111: S59–S69.

Austin, S.H., W.D. Robinson, V.A. Ellis, T.R. Robinson, and R.E. Ricklefs. 2019. "Nest Attendance by Tropical and Temperate Passerine Birds: Same Constancy, Different Strategy." *Ecology and Evolution* 9(23): 13555–13566.

Baker, C.S., and K.J. Burns. 2020. "Gray-headed Tanager (*Eucometis penicillata*)," version 1.0. In *Birds of the World*, edited by T.S. Schulenberg. Ithaca, NY: Cornell Lab of Ornithology. https://doi.org/102173/bow.grhtan1.01.

Ballarini, Y., M.R. Frizzas, and M.A. Marini. 2013. "Stomach Contents of Brazilian Non-passerine Birds." *Revista Brasileira de Ornitologia* 21(4): 235–242.

Bard, S.C., M. Hau, M. Wikelski, and J.C. Wingfield. 2002. "Vocal Distinctiveness and Response to Conspecific Playback in the Spotted Antbird, a Neotropical Suboscine." *Condor* 104(2): 387–394.

Barker, F.K. 2004. "Monophyly and Relationships of Wrens (Aves: Troglodytidae): A Congruence Analysis of Heterogeneous Mitochondrial and Nuclear DNA Sequence Data." *Molecular Phylogenetics and Evolution* 31(2): 486–504.

Barrantes, G., and A. Pereira. 2002. "Seed Dissemination by Frugivorous Birds from Forest Fragments to Adjacent Pastures on the Western Slope of Volcán Barva, Costa Rica." *Revista de Biologia Tropical* 50(2): 569–575.

Batcheller, H. 2017. "Ocellated Antbird (*Phaenostictus mcleannani*)," version 1.0. In *Birds of the World*, edited by T.S. Schulenberg. Ithaca, NY: Cornell Lab of Ornithology. https://doi.org/10.2173/bow.oceant1.01.

Bermúdez, S., D. Apanaskevich, L. Domínguez, and A. Guglielmone, eds. 2018. *Garrapatas Ixodidae de Panamá.* Panama City, Panama: Secretaría Nacional de Ciencia, Tecnología e Innovación.

Bermúdez, S., L. Domínguez, I. Ochoa, J. Oliveira, E. de Lemos, B. Castillo, D. Smith, J. Herrera, and M. Ogrzewalska. 2020. "Molecular Detection of Rickettsial Agents of Hard Ticks (Acari: Ixodida) Collected from Wild Birds of Panama." *Systematic and Applied Acarology* 25(4): 622–632. https://doi.org/10.11158/saa.25.4.3.

Bermúdez, S., S. Torres, Y. Aguirre, L. Domínguez, and J. Bernal. 2015. "A Review of *Ixodes* (Acari: Ixodidae) Parasitizing Wild Birds in Panama, with the First Records of *Ixodes auritulus* and *Ixodes bequaerti*." *Systematic and Applied Acarology* 20(8): 847–853.

Bierregaard R.O., Jr., and T.E. Lovejoy. 1989. "Effects of Forest Fragmentation on Amazonian Understory Bird Communities." *Acta Amazonica* 19:215–241.

Biomimicry Institute. 2015. https://www.biomimicry.org.

Boyle, W.A., and B.J. Sigel. 2015. "Ongoing Changes in the Avifauna of La Selva Biological Station, Costa Rica: Twenty-three Years of Christmas Bird Count." *Biological Conservation* 188:11–21.

Bravo, G.A., J.V. Remsen Jr., and R.T. Brumfield. 2014. "Adaptive Processes Drive Ecomorphological Convergent Evolution in Antwrens (Thamnophillidae)." *Evolution* 68:2757–2774.

Brawn, J.D., T.J. Benson, M. Stager, N.D. Sly, and C.E. Tarwater. 2017. "Impacts of Changing Rainfall Regime on the Demography of Tropical Birds." *Nature Climate Change* 7(2): 133–136. https://doi.org/10.1038/nclimate3183.

Brennan, J., and C. Yunker. 1966. "The Chiggers of Panama (Acarina: Trombiculidae)." In *Ectoparasites of Panama*, edited by R.L. Wenzel, and V.J. Tipton, 221–265. Chicago: Field Museum of Natural History.

Brisson, M.J. 1760. *Ornithologie ou Méthode Contenant la Division des Oiseaux en Ordres, Sections, Genres, Espece & Leur Variétés* 4: 92–94, pl. 6, fig. 2. Paris: Jean-Baptiste Bauche.

Brumfield, R T., J.G. Tello, Z.A. Cheviron, M.D. Carling, N. Crochet, and K.V. Rosenberg. 2007. "Phylogenetic Conservatism and Antiquity of a Tropical Specialization: Army-ant-following in the Typical Antbirds (Thamnophilidae)." *Molecular Phylogenetics and Evolution* 45(1): 1–13.

Bryson R.W., Jr., J. Chaves, B.T. Smith, M.J. Miller, K. Winker, J.L. Pérez-Emán, and J. Klicka. 2014. "Diversification across the New World within the 'Blue' Cardinalids (Aves: Cardinalidae)." *Journal of Biogeography* 41:587–599. https://doi.org/10.1111/jbi.12218.

Burns, K.J., A.J. Shultz, P.O. Title, N.A. Mason, F.K. Barker, J. Klicka, S.M. Lanyon, and I.J. Lovette. 2014. "Phylogenetics and Diversification of Tanagers (Passeriformes: Thraupidae), the Largest Radiation of Neotropical Songbirds." *Molecular Phylogenetics and Evolution* 75:41–77.

Busch, D.S., W.D. Robinson, T.R. Robinson, and J.C. Wingfield. 2011. "Influence of Proximity to a Geographic Range Limit on the Physiology of a Tropical Bird." *Journal of Animal Ecology* 80:640–649.

Chapman, A., and K.V. Rosenberg. 1991. "Diets of Four Sympatric Amazonian Woodcreepers (Dendrocolaptidae)." *Condor* 93(4): 904–915.

Chaves-Campos, J., Y. Araya-Ajoy, C.A. Lizana-Moreno, and K.N. Rabenold. 2009. "The Effect of Local Dominance and Reciprocal Tolerance on Feeding Aggregations of Ocellated Antbirds." *Proceedings of the Royal Society B: Biological Sciences* 276(1675): 3995–4001. https://doi.org/10.1098/rspb.2009.0730.

Christian, D.G., and D. Roberts. 2000. "First Description of Nest and Nesting Behavior of the Nightingale Wren." *Wilson Journal of Ornithology* 112(2): 284–287.

Clock, B. 2020a. "Northern Bentbill (*Oncostoma cinereigulare*)," version 1.0. In *Birds of the World*, edited by J. del Hoyo, A. Elliott, J. Sargatal, D.A. Christie, and E. de Juana. Ithaca, NY: Cornell Lab of Ornithology. https://doi.org/10.2173/bow.norben1.01.

Clock, B. 2020b. "Scale-crested Pygmy-Tyrant (*Lophotriccus pileatus*)," version 1.0. In *Birds of the World*, edited by J. del Hoyo, A. Elliott, J. Sargatal, D.A. Christie, and E. de Juana. Ithaca, NY: Cornell Lab of Ornithology. https://doi.org/10.2173/bow.scptyr1.01.

Clock, B., and D.A. Christie. 2020. "Southern Bentbill (*Oncostoma olivaceum*)," version 1.0. In *Birds of the World*, edited by J. del Hoyo, A. Elliott, J. Sargatal, D.A. Christie, and E. de Juana. Ithaca, NY: Cornell Lab of Ornithology. https://doi.org/10.2173/bow.souben1.01.

Conover, M., and D.E. Miller. 1980. "Rictal Bristle Function in Willow Flycatcher." *Condor* 82(4): 469–471.

Cunningham, S.J., R.A. Alley, and I. Castro. 2011. "Facial Bristle Feather Histology and Morphology in New Zealand Birds: Implications for Function." *Journal of Morphology* 272:118–128.

Dahlin, C.R., and L. Benedict. 2014. "Angry Birds Need Not Apply: a Perspective on the Flexible Form and Multifunctionality of Avian Vocal Duets." *Ethology* 120(1): 1–10.

Davidar, P., and E.S. Morton. 1993. "Living with Parasites: Prevalence of a Blood Parasite and its Effect on Survivorship in the Purple Martin." *Auk* 110(1): 109–116.

Dawson, R.D., and G.R. Bortolotti. 2000. "Effects of Hematozoan Parasites on Condition and Return Rates of American Kestrels." *Auk* 117(2): 373–380.

Decker, S. 2020. "Plain Xenops (*Xenops minutus*)," version 1.0. In *Birds of the World*, edited by T.S. Schulenberg. Ithaca, NY: Cornell Lab of Ornithology. https://doi.org/10.2173/bow.plaxen1.01.

Delaunay, M.G., C. Larsen, H. Lloyd, M. Sullivan, and R.A. Grant. 2020. "Anatomy of Avian Rictal Bristles in Caprimulgiformes Reveals Reduced Tactile Function in Open-habitat, Partially Diurnal Foraging Species." *Journal of Anatomy* 237(3): 355–366.

del Hoyo, J., J. Bates, G.M. Kirwan, and N. Collar. 2020a. "Olivaceous Flatbill (*Rhynchocyclus olivaceous*)," version 1.0. In *Birds of the World*, edited by S.M. Billerman, B.K. Keeney, P.G. Rodewald, and T.S. Schulenberg. Ithaca, NY: Cornell Lab of Ornithology. https://doi.org/10.2173/bow.olifla1.01.

del Hoyo, J., I. Caballero, G.M. Kirwan, and N. Collar. 2020b. "Yellow-breasted Flycatcher (*Tolmomyias flaviventris*)," version 1.0. In *Birds of the World*, edited by S.M. Billerman, B.K. Keeney, P.G. Rodewald, and T.S. Schulenberg. Ithaca, NY: Cornell Lab of Ornithology. https://doi.org/10.2173/bow.yebfly1.01.

del Hoyo, J., N. Collar, and G.M. Kirwan. 2020c. "Bicolored Antbird (*Gymnopithys bicolor*)," version 1.0. In *Birds of the World*, edited by J. del Hoyo, A. Elliott, J. Sargatal, D.A. Christie, and E. de Juana. Ithaca, NY: Cornell Lab of Ornithology. https://doi.org/10.2173/bow.bicant2.01.

del Hoyo, J., A. Elliot, and D.A. Christie, eds. 2004. *Handbook of the Birds of the World*. Vol. 9, *Cotingas to Pipits and Wagtails*. Barcelona: Lynx Edicions.

del Hoyo, J., C. Hinkelmann, N. Collar, P.F.D. Boesman, and G.M. Kirwan. 2020d. "Long-billed Hermit (*Phaethornis longirostris*)," version 1.0. In *Birds of the World*, edited by S.M. Billerman, B.K. Keeney, P.G. Rodewald, and T.S. Schulenberg. Ithaca, NY: Cornell Lab of Ornithology. https://doi.org/10.2173/bow.lobher.01.

del Hoyo, J., H. Winkler, D.A. Christie, and N. Collar. 2020e. "Golden-olive Woodpecker (*Colaptes rubiginosus*)," version 1.0. In *Birds of the World*, edited by S.M. Billerman, B.K. Keeney, P.G. Rodewald, and T.S. Schulenberg. Ithaca, NY: Cornell Lab of Ornithology. https://doi.org/10.2173/bow.goowoo1.01.

del Hoyo, J., K. Zimmer, N. Collar, M.L. Isler, and G.M. Kirwan. 2020f. "White-flanked Antwren (*Myrmotherula axillaris*)," version 1.0. In *Birds of the World*, edited by S.M. Billerman, B.K. Keeney, P.G. Rodewald, and T.S. Schulenberg. Ithaca, NY: Cornell Lab of Ornithology. https://doi.org/10.2173/bow.whfant2.01.

Dingle, C., and H. Slabbekoorn. 2018. "Multiple Functions for Pair Duets in a Neotropical Wren *Henicorhina leucophrys*." *Animal Behaviour* 145:67–76.

Domínguez, L., R. Miranda, S. Torres, R. Moreno, J. Ortega, and S. Bermúdez. 2019. "Hard Ticks (Acari: Ixodidae) Survey of Oleoducto Trail, Soberania National Park, Panama." *Tick and Tick-Borne Diseases* 10:830–837. https://doi.org/10.1016/j.ttbdis.04.001.

Drovetski, S.V., S.A. Aghayan, V.A. Mata, R.J. Lopes, N.A. Mode, J.A. Harvey, and G. Voelker. 2014. "Does the Niche Breadth or Trade-off Hypothesis Explain the Abundance-occupancy Relationship in Avian Haemosporidia?" *Molecular Ecology* 23(13): 3322–3329.

Dufva, R. 1996. "Blood Parasites, Health, Reproductive Success, and Egg Volume in Female Great Tits *Parus major*." *Journal of Avian Biology* 27(2): 83–87.

Dunning, J.S. 1970. *Portraits of Tropical Birds*. Wynnewood, PA: Livingston.

Dunning, J.S. 1987. *South American Birds—A Photographic Aid to Identification*. Newton Square, PA: Harrowood Books.

Emerson, R.W. 1841. *The Method of Nature*. Reprint, Scotts Valley, CA: Createspace Independent Publishing Platform, 2013.

Fairchild, G. 1966. "Checklist of the Hippoboscidae of Panama (Diptera: Hippoboscidae)." In *Ectoparasites of Panama*, edited by R.L. Wenzel, and V.J. Tipton, 387–392. Chicago: Field Museum of Natural History.

Fairchild, G., G. Kohls, and V.J. Tipton. 1966. "The Ticks of Panama (Acarina: Ixodoidea)." In *Ectoparasites of Panama*, edited by R.L. Wenzel, and V.J. Tipton, 167–207. Chicago, IL: Field Museum of Natural History.

Farnsworth, A., and D.J. Lebbin. 2020. "Ruddy-tailed Flycatcher (*Terenotriccus erythrurus*)," version 1.0. In *Birds of the World*, edited by J. del Hoyo, A. Elliott, J. Sargatal, D.A. Christie, and E. de Juana. Ithaca, NY: Cornell Lab of Ornithology. https://doi.org/10.2173/bow.rutfly2.01.

Fecchio, A., V.A. Ellis, J.A. Bell, C.B. Andretti, F.M. D'Horta, A.M. Silva, V.V. Tkach, and J.D. Weckstein. 2017. "Avian Malaria, Ecological Host Traits and Mosquito Abundance in Southeastern Amazonia." *Parasitology* 144(8): 1117–1132.

Fitzgibbon, D., and N.L. Block. 2020. "Blue-black Grosbeak (*Cyanoloxia cyanoides*)," version 1.0. In *Birds of the World*, edited by T.S. Schulenberg. Ithaca, NY: Cornell Lab of Ornithology. https://doi.org/10.2173/bow.bubgro1.01.

Fitzpatrick, J.W. 1980. "Foraging Behavior of Neotropical Tyrant Flycatchers." *Condor* 82(1): 43–57.

Fitzpatrick, J.W. 1981. "Search Strategies of Tyrant Flycatchers." *Animal Behaviour* 29(3): 810–821.

Fitpatrick, J.W. 1985. "Form, Foraging Behavior, and Adaptive Radiation in the Tyrannidae." In *Neotropical Ornithology*, edited by P.A. Buckley, M.S. Foster, E.S. Morton, R.S. Ridgley, and F.G. Buckley. *Ornithological Monographs* 36:447–470.

Fitzpatrick, J.W. 2014. "Saving our Birds." *New York Times*, August 31, 2014.

Fitzpatrick, J.W., J. del Hoyo, N. Collar, E. de Juana, and G.M. Kirwan. 2020. "Olive-striped Flycatcher (*Mionectes olivaceus*)," version 1.0. In *Birds of the World*, edited by S.M. Billerman, B.K. Keeney, P.G. Rodewald, and T.S. Schulenberg. Ithaca, NY: Cornell Lab of Ornithology. https://doi.org/10.2173/bow.olsfly1.01.

Fogden, M., M. Taylor, and S.L. Williamson. 2014. *Hummingbirds: A Life-Size Guide to Every Species*. Lewes, UK: Ivy Press.

García, N.C., A.S. Barreira, P.D. Lavinia, and P.L. Tubaro. 2016. "Congruence of Phenotypic and Genetic Variation at the Subspecific Level in a Neotropical Passerine." *Ibis* 158:844–856. https://doi.org/:10.1111/ibi.12386.

Garrigues, R., and R. Dean. 2007. *The Birds of Costa Rica: A Field Guide*. Ithaca, NY: Cornell University Press.

Garrigues, R., and R. Dean. 2010. *The Birds of Costa Rica*. Ithaca, NY: Cornell University Press.

Gill, F., D. Donsker, and P. Rasmussen, Eds. 2020. IOC World Bird List version 10.1. https://doi.org/10.14344/IOC.ML.10.1.

Gell-Mann, M. 1995. Afterword to *Last of the Curlews*, by Fred Bosworth. Berkeley, CA: Counterpoint Press.

Gomes, L.G.L., V. Oostra, V. Nijman, A.M. Cleef, and M. Kappelle. 2008. "Tolerance of Frugivorous Birds to Habitat Disturbance in a Tropical Cloud Forest." *Biological Conservation* 141(3): 860–871.

González, A.D., N.E. Matta, V.A. Ellis, E.T. Miller, R.E. Ricklefs, and H.R. Gutiérrez. 2014. "Mixed Species Flock, Nest Height, and Elevation Partially Explain Avian Haemoparasite Prevalence in Colombia." *PLoS One* 9(6): e100695.

Gradwohl, J., and R. Greenberg. 1980. "The Formation of Antwren Flocks on Barro Colorado Island, Panama." *Auk* 97(2): 385–395.

Gradwohl, J., and R. Greenberg. 1982. "The Effect of a Single Species of Avian Predator on the Arthropods of Aerial Leaf Litter." *Ecology* 63(2): 581–583.

Gravitz, L. 2000. "Birds and Beethoven." Interview with Luis Baptista. *Living on Earth*, July 28, 2000. http://www.loe.org/shows /shows.html?programID=00-P13-00030#feature4.

Greenberg, R., and J. Gradwohl. 1980. "Leaf Surface Specializations of Birds and Arthropods in a Panamanian Forest." *Oecologia* 46(1): 115–124.

Greenberg, R., and J. Gradwohl. 1986. "Constant Density and Stable Territoriality in Some Tropical Insectivorous Birds." *Oecologia* 69(4): 618–625.

Greeney, H.F., J.L. Atwood, S.B. Lerman, and A.J. Spencer. 2020. "Long-billed Gnatwren (*Ramphocaenus melanurus*)," version 2.0. In *Birds of the World*, edited by T.S. Schulenberg, B.K. Keeney, and S.M. Billerman. Ithaca, NY: Cornell Lab of Ornithology. https://doi.org/10.2173/bow.lobgna5.02.

Greeney, H.F., and R.A. Gelis. 2007. "Breeding Records from the North-east Andean Foothills of Ecuador." *Bulletin of the British Ornithologists' Club* 127:236–241.

Greeney, H.F., C. Sánchez, J.E., Sánchez, and E. Carman. 2013. "A Review of Nest and Egg Descriptions for the Genus *Myrmeciza*, with the First Descriptions of Nest and Eggs of the Dull-mantled Antbird (*M. laemosticta*)." *Journal of Ornithology* 154:1049–1056.

Gregory-Wodzicki, K. 2000. "Uplift History of the Central and Northern Andes: A Review." *Geological Society of America Bulletin* 112(7): 1091–1105.

Guglielmone, A.A., A. Estrada-Peña, J.E. Keirans, and R.G. Robbins. 2003. "Ticks (Acari: Ixodida) of the Neotropical Zoogeographic Region." Atalanta, Houten, the Netherlands: Special Publication, International Consortium on Ticks and Tick-borne Diseases 2.

Hall, M.L. 2009. "A Review of Vocal Duetting in Birds." *Advances in the Study of Behavior* 40:67–121.

Hanna, Z.R., M.F. Ortiz-Ramirez, C.A. Rios-Muñoz, H. Cayetano-Rosas, R.C.K. Bowie, and A.G. Navarro-Sigueñza. 2016. "Phylogenetic and Morphologic Evidence Confirm the Presence of a New Montane Cloud Forest Associated Bird Species in Mexico, the Mountain Elaenia (*Elaenia frantzii*; Aves: Passeriformes: Tyrannidae)." *PeerJ* 4:1598. https://doi.org/10.7717/peerj.1598.

Harrod, W.D. and R.L. Mumme. 2020. "Slate-throated Redstart (*Myioborus miniatus*)," version 1.0. In *Birds of the World*, edited by T.S. Schulenberg. Ithaca, NY: Cornell Lab of Ornithology. https://doi.org/10.2173/nb.sltred.01.

Harvey, M.G., G.A. Bravo, S. Claramunt, A.M. Cuervo, G.E. Derryberry, J. Battilana, G.F. Seeholzer, et al. 2020. "The Evolution of a Tropical Biodiversity Hotspot." *Science* 370(6522): 1343–1348.

Harvey, M.G., and R.T. Brumfield. 2015. "Genomic Variation in a Widespread Neotropical Bird (*Xenops minutus*) Reveals Divergence, Population Expansion, and Gene Flow." *Molecular Phylogenetics and Evolution* 83:305–316.

Harvey, M.G., D.F. Lane, J. Hite, R.S. Terrill, S. Figueroa-Ramirez, B.T. Smith, J. Klicka, and W. Campos. 2014. "Notes on Bird Species in Bamboo in Northern Madre de Dios, Peru, Including the First Peruvian Record of Acre Tody-Tyrant (*Hemitriccus cohnhafti*)." *Occasional Papers of the Museum of Natural Science* 81:1–38.

Hau, M., M.C. Wikelski, K.K. Soma, and J.C. Wingfield. 2000a. "Testosterone and Year-round Territorial Aggression in a Tropical Bird." *General and Comparative Endocrinology* 117:20–33.

Hau, M., M. Wikelski, and J.C. Wingfield. 1998. "A Neotropical Bird Can Measure Changes in Tropical Photoperiod." *Proceedings of the Royal Society B: Biological Sciences* 265:89–95.

Hau, M., M. Wikelski, and J.C. Wingfield. 2000b. "Visual and Nutritional Food Cues Fine-tune Timing of Reproduction in a Neotropical Rainforest Bird." *Journal of Experimental Zoology* 286(5): 494–504.

Haverschmidt, F. 1974. "Notes on the Life History of the Yellow-breasted Flycatcher in Surinam." *Wilson Bulletin* 86(3): 215–220.

Hilty, S.L. 1997. "Seasonal Distribution of Birds at a Cloud Forest Locality, the Anchicayá Valley, in Western Columbia." *Ornithological Monographs* 45:865–885.

Hilty, S.L. 2003. *Birds of Venezuela*. London: Christopher Helm.

Hilty, S.L., and W.L. Brown. 1986. *A Guide to the Birds of Colombia*. Princeton, NJ: Princeton University Press.

Hinkelmann, C. 1999a. "Band-tailed Barbthroat. *Threnetes ruckeri*." In "Family Trochilidae (Hummingbirds)," edited by K.L. Schuchmann. In *Handbook of Birds of the World*. Vol 5, *Barn-owls to Hummingbirds*, edited by J. del Hoyo, A. Elliott, and J. Sargatal: 538–539. Barcelona: Lynx Edicions. https://doi.org/10.2173/bow .batbar1.01.

Hinkelmann, C. 1999b. "Green Hermit. *Phaethornis guy*." In "Family Trochilidae (Hummingbirds)," edited by K.L. Schuchmann. In *Handbook of Birds of the World*. Vol 5, *Barn-owls to Hummingbirds*, edited by J. del Hoyo, A. Elliott, and J. Sargatal: 468–680. Barcelona: Lynx Edicions. https://doi.org/10.2173/bow .greher1.01.

Hinkelmann, C. 1999c. "White-tipped Sicklebill. *Eutoxeres aquila* In "Family Trochilidae (Hummingbirds)," edited by K.L. Schuchmann. In *Handbook of Birds of the World*. Vol 5, *Barn-owls to Hummingbirds*, edited by J. del Hoyo, A. Elliott, and J. Sargatal: 468–680. Barcelona: Lynx Edicions. https://doi.org/10.2173 /bow.whtsic1.01.

Isaksson, C., I. Sepil, V. Baramidze, and B.C. Sheldon. 2013. "Explaining Variance of Avian Malaria Infection in the Wild: The Importance of Host Density, Habitat, Individual Life-History and Oxidative Stress." *BMC Ecology* 13(1).

Isler, M.L., D.R. Lacerda, P.R. Isler, S.J. Hackett, K.V. Rosenberg, and R.T. Brumfield. 2006. "*Epinecrophylla*, a new Genus of Antwrens (Aves: Passeriformes: Thamnophilidae)." *Proceedings of Biological Society of Washington* 119(4): 522–527.

IUCN (International Union for Conservation of Nature) 2020. The IUCN Red List of Threatened Species version 2020–2. https:// www.iucnredlist.org.

Jankowski, J.E., G.A. Londoño, S.K. Robinson, and M.A. Chappell. 2013. "Exploring the Role of Physiology and Biotic Interactions in Determining Elevational Ranges of Tropical Animals." *Ecography* 36(1): 1–12.

Jankowski, J.E., S.K. Robinson, and D.J. Levey. 2010. "Squeezed at the Top: Interspecific Aggression May Constrain Elevational Ranges in Tropical Birds." *Ecology* 91(7): 1877–1884.

Janzen, D.H., ed. 1983. *Costa Rican Natural History*. Chicago: University of Chicago Press.

Karr, J.R. 1971. "Ecological, Behavioral, and Distributional Notes on Some Central Panama Birds." *Condor* 73(1): 107–111.

Kirschel, A.N., M.L. Cody, Z.T. Harlow, V.J. Promponas, E.E. Vallejo, and C.E. Taylor. 2011. "Territorial Dynamics of Mexican Antthrushes *Formicarius moniliger* Revealed by Individual Recognition of Their Songs." *Ibis* 153:255–268.

Koren, L. 1994. *Wabi-Sabi for Artists, Designers, Poets and Philosophers*. Berkeley, CA: Stone Bridge Press.

Kroodsma, D.E. and D. Brewer. 2020. "Scaly-breasted Wren (*Microcerculus marginatus*)," version 1.0. In *Birds of the World*, edited by J. del Hoyo, A. Elliott, J. Sargatal, D.A. Christie, and E. de Juana. Ithaca, NY: Cornell Lab of Ornithology. https://doi.org/10.2173 /bow.scbwre1.01.

Kuecker, Z.C., A. Soberanes-González, C.I. Rodríguez-Flores, M.d.C.

Arizmendi, and T. Johnson. 2020. "Ruddy Quail-Dove (*Geotrygon montana*)," version 1.0. In *Birds of the World*, edited by T.S. Schulenberg. Ithaca, NY: Cornell Lab of Ornithology. https://doi.org/10.2173/bow.ruqdov.01.

Küster, E. 1905. "Die Innervation und Entwicklung der Tastfeder." *Morphologisches Jahrbuch* 34:126–148.

LaPointe, D.A., C.T. Atkinson, and M.D. Samuel. 2012. "Ecology and Conservation Biology of Avian Malaria." *Annals of the New York Academy of Sciences* 1249(1): 211–226.

LaPointe, D.A., M.L. Goff, and D.T. Atkinson. 2010. "Thermal Constraints to the Sporogonic Development and Altitudinal Distribution of Avian Malaria *Plasmodium relictum* in Hawai'i." *Journal of Parasitology* 96(2): 318–324.

Larsen, C., M. Speed, and M. Berenbrink. 2013. "Evolution and Ecological Correlates of Facial Bristles in the Caprimulgiformes with Emphasis on the Nightjars (Caprimulgidae)." Ninth Conference of European Ornithologists' Union, Norwich, 3103.

Le Carré, J. 1977. *The Honourable Schoolboy*. Reprint, Toronto: Penguin Random House, 2011.

Leck, C.F. 1979. "Avian Extinctions in an Isolated Tropical Wet-forest Preserve, Ecuador." *Auk* 96(2): 343–352.

Lederer, R. 2016. *Beaks, Bones, and Bird Songs*. Portland, OR: Timberland Press.

Lederer, R.J. 1972. "The Role of Avian Rictal Bristles." *Wilson Bulletin* 84(2): 193–197.

Lee, J.J., S.H. Hunter, and E.C. Bovee, Eds. 1985. *An Illustrated Guide to the Protozoa*. Lawrence, KS: Society of Protozoologists.

Leger, D.W., K.E. Brooks, and J.E. O'Brien. 2000. "Versatility from a Single Song: The Case of the Nightingale Wren." *Auk* 117(4): 1038–1042.

Levey, D.J. 1988. "Tropical Wet Forest Treefall Gaps and Distributions of Understory Birds and Plants." *Ecology* 69(4): 1076–1089.

Loaiza, J.R., L.C. Dutari, J.R. Rovira, O.I. Sanjur, G.Z. Laporta, J. Pecor, D.H. Foley, et al. 2017. "Disturbance and Mosquito Diversity in the Lowland Tropical Rainforest of Central Panama." *Scientific Reports* 7(1): 1–13.

Londoño, G.A. 2014. "Parque Nacional del Manu, Cusco, Perú: Anidación de Aves en un Gradiente Altitudinal." *Rapid Color Guide* 514, versión 1. Chicago: The Field Museum.

Lovette, I.J. and J.W. Fitzpatrick, eds. 2014. *The Cornell Lab of Ornithology Handbook of Bird Biology*. 3rd ed. Hoboken, NJ: Wiley.

Lutz, H.L., B.D. Patterson, J.C. Kerbis Peterhans, W.T. Stanley, P.W. Webala, T.P. Gnoske, S.J. Hackett, and M.J. Stanhope. 2016. "Diverse Sampling of East African Haemosporidians Reveals Chiropteran Origin of Malaria Parasites in Primates and Rodents." *Molecular Phylogenetics and Evolution* 99:7–15.

Marantz, C.A. 2020. "Cocoa Woodcreeper (*Xiphorhynchus susurrans*)," version 1.0. In *Birds of the World*, edited by T.S. Schulenberg. Ithaca, NY: Cornell Lab of Ornithology. https://doi.org/10.2173/bow.cocw001.01.

Marren, P. 2004. "Obituary: Alexander F. Skutch." *Independent*, June 14, 2004.

Martin, W.C.L. 1833. "Hummingbirds' Tongues." In *The Naturalist's Library*, vol. 42, edited by W. Jardine. Edinburgh, 65–68. UK: W.H. Lizars.

Martinez, A.E., H.S. Pollock, J.P. Kelley, and C.E. Tarwater. 2018. "Social Information Cascades Influence the Formation of Mixed-species Foraging Aggregations of Ant-following Birds in the Neotropics." *Animal Behaviour* 135:25–35.

McGuire, J.A., C.C. Witt, J.V. Remsen Jr., S. Corl, D.L. Rabosky, D.L. Altshuler, and R. Dudley. 2014. "Molecular Phylogenetics and the Diversification of Hummingbirds." *Current Biology* 24(8): 910–916.

McMullan, M. 2016. *Field Guide to the Hummingbirds*. 2016. Quito, Ecuador: Ratty Ediciones.

McQuiston, T.E., C.Y. Barber, and A.P. Capparella. 1999. "*Isospora automoli*, a New Coccidian Parasite (Apicomplexa: Eimeriidae) from the Buff-throated Foliage-gleaner *Automolus ochrolaemus* and the Olive-backed Foliage-gleaner *A. infuscatus* from South America." *Systematic Parasitology* 44(1): 73–75.

Merino, S., J. Moreno, J.J. Sanz, and E. Arriero. 2000. "Are Avian Blood Parasites Pathogenic in the Wild? A Medication Experiment in Blue Tits (*Parus caeruleus*)." *Proceedings of the Royal Society B: Biological Sciences* 267(1461): 2507–2510.

Miller, M., and K. Taube. 1997. *An Illustrated Dictionary of the Symbols of Ancient Mexico and the Maya*. London: Thames and Hudson.

Mironov, S., and S.E. Bermúdez. 2017. "Feather Mites (Acariformes: Analgoidea) Associated with the Hairy Woodpecker *Leuconotopicus villosus* (Piciformes: Picidae) in Panama." *Acarologia* 57(4): 941–955.

Mironov, S., and S.E. Bermúdez. 2018. "A New Feather Mite Genus of the Family Proctophyllodidae (Acariformes: Analgoidea from the Olivaceous Flatbill *Rhynchocyclus olivaceus* (Passeriformes: Tyrannidae) in Panama." *Systematic and Applied Acarology* 23(8): 1641–1655.

Mironov, S., and S.E. Bermúdez. 2020. "A New Genus of the Feather Mite family Proctophyllodidae (Acariformes: Analgoidea) from Woodcreepers (Passeriformes: Furnariidae: Dendrocolaptinae) in the Neotropics." *Acarina* 28(1): 29–38. https://doi.org/10.21684/0132-8077-2020-28-1-29-38.

Moermond, T.C., and J.S. Denslow. 1985. "Neotropical Avian Frugivores: Patterns of Behavior, Morphology, and Nutrition, with Consequences for Fruit Selection." *Ornithological Monographs* 36:865–897.

Mokross, K., T.B. Ryder, M.C. Côrtes, J.D. Wolfe, and P.C. Stouffer. 2014. "Decay of Interspecific Avian Flock Networks along a Disturbance Gradient in Amazonia." *Proceedings of the Royal Society B: Biological Science* 281. https://doi.org/10.1098/rspb.2013.2599.

Moller, A.P., J.T. Nielsen, and J. Erritzue. 2006. "Losing the Last Feather; Feather Loss as an Anti-predator Adaptation in Birds." *Behavioral Ecology* 17:1046–1056.

Moore, R.P., W.D. Robinson, I.J. Lovette, and T.R. Robinson. 2008. "Experimental Evidence for Extreme Dispersal Limitation in Tropical Forest Birds." *Ecology Letters* 11:960–968.

Moritz, C., J.L. Patton, C.J. Conroy, J.L. Parra, G.C. White, and S.R. Beissinger. 2008. "Impact of a Century of Climate Change on Small-Mammal Communities in Yosemite National Park, USA." *Science* 322:261–264.

Mumme, R.L. 2002. "Scare Tactics in a Neotropical Warbler: White Tail Feathers Enhance Flush-pursuit Foraging Performance in the Slate-throated Redstart (*Myoborus miniatus*)." *Auk* 119(4): 1024–1035.

Mumme, R.L., M.L. Galatowitsch, P.G. Jabłoński, T.M. Stawarczyk, and J.P. Cygan. 2006. "Evolutionary Significance of Geographic Variation in a Plumage-based Foraging Adaptation: An Experimental Test in the Slate-throated Redstart (*Myioborus miniatus*)." *Evolution* 60:1086–1097.

Munn, C.A. 1985. "Permanent Canopy and Understory Flocks in Amazonia: Species Composition and Population Density." In *Neotropical Ornithology*, edited by P.A. Buckley, M.S. Foster, E.S. Morton, R.S. Ridgely, and F.G. Buckle. *Ornithological Monographs* 36:683–712.

Munn, C.A., and J. Terborgh. 1979. "Multi-species Territoriality in Neotropical Foraging Flocks." *Condor* 81(4): 338–347.

Muñoz-Leal S., L. Domínguez, B. Armstrong, M. Labruna, and S. Bermúdez. 2020. "*Ornithodoros capensis* Sensu Stricto (Ixodida: Argasidae) in Coiba National Park: First Report for Panama, with Notes on the *O. capensis* Group in Panamanian Shores and Costa Rica." *Experimental and Applied Acarology* 81:469–481. https://doi.org/10.1007/s10493-020-00516-z.

Murray, K.G. 1988. "Avian Seed Dispersal of Three Neotropical Gap-dependent Plants." *Ecological Monographs* 58:271–298.

Murray, K.G. 2000. "The Importance of Different Bird Species as Seed Dispersers." In *Monteverde Ecology and Conservation of a Tropical Cloud Forest*, edited by N.M. Nadkarni and N.T. Wheelwright, 294–295. New York: Oxford University Press.

Murray, K.G., S. Russell, C.M. Picone, K. Winnett-Murray, W. Sherwood, and M.L. Kuhlmann. 1994. "Fruit Laxatives and Seed Passage Rates in Frugivores: Consequences for Plant Reproductive Success." *Ecology* 75(4): 989–994.

Noon, B.R. 1981. "The Distribution of an Avian Guild Along a Temperate Elevational Gradient: The Importance and Expression of Competition." *Ecological Monographs* 51:105–124.

Ohlson, J., J. Fjeldsa, and P.G.P. Ericson. 2008. "Tyrant Flycatchers Coming Out in the Open: Phylogeny and Ecological Radiation of Tyrannidae (Aves, Passeriformes)." *Zoologica Scripta* 37:315–335.

Ohlson, J.I., M. Irestedt, G.P. Ericson, and J. Fjeldsa. 2011. "Phylogeny and Classification of the New World Suboscines (Aves, Passeriformes)." *Zootaxa* 3613(1): 1–35.

O'Malley, B. 2013. "Natural History of the Bird-eating Snake (*Pseustes poecilonotus*) and Its Impact on Neotropical Understory Nesting Birds." Unpublished senior undergraduate thesis, Tulane University, 2013.

Oniki, Y. 1975. "Behavior and Ecology of Slaty Antshrikes (*Thamnophilus punctatus*) on Barro Colorado Island, Panama Canal Zone." *Anais da Academia Brasileira de Ciências* 47:477–515.

Ord, T.J., and J.S. Stamps. 2008. "Alert Signals Enhance Animal Communication in 'Noisy' Environments." *Proceedings of National Academy of Sciences USA* 1005:18830–18835.

Ortiz-Ramírez, M.F., M.J. Andersen, A. Zaldívar-Riverón, J.F. Ornelas, and A.G. Navarro-Sigüenza. 2016. "Geographic Isolation Drives Divergence of Uncorrelated Genetic and Song Variation in the Ruddy-capped Nightingale-Thrush (*Catharus frantzii*; Aves: Turdidae)." *Molecular Phylogenetics and Evolution* 94(part A): 74–86.

Patten, M.A. 2020. "Black-faced Antthrush (*Formicarius analis*)," version 1.0. In *Birds of the World*, edited by T.S. Schulenberg. Ithaca, NY: Cornell Lab of Ornithology. https://doi.org/10.2173/bow.blfant1.01.

Pearson, D.L. 1977. "Ecological Relationships of Small Antbirds in Amazonian Bird Communities." *Auk* 94(2): 283–292.

Peterson, R.T. 1941. *A Field Guide to Western Birds*. Boston: Houghton Mifflin.

Pollock, H.S., and T.J. Agin. 2020. "Song Wren (*Cyphorhinus phaeocephalus*)," version 1.0. In *Birds of the World*, edited by T.S. Schulenberg. Ithaca, NY: Cornell Lab of Ornithology. https://doi.org/10.2173/bow.sonwre1.01.

Pollock, H.S., A.E. Martinez, J.P. Kelley, J.M. Touchton, and C.E. Tarwater. "Loss of a Keystone Species Disrupts Information Cascades in a Tropical Forest Fragment." Unpublished manuscript.

Poulin, B., and G. Lefebvre. 1996. "Dietary Relationships of Migrant and Resident Birds from a Humid Forest in Central Panama." *Auk* 113(2): 277–287.

Powell, G.V.N. 1989. "On the Possible Contribution of Mixed Species Flocks to Species Richness in Neotropical Avifaunas." *Behavioral Ecology and Sociobiology* 24:387–393.

Powell, L.L., N.J. Cordeiro, and J.A. Stratford. 2015. "Ecology and Conservation of Avian Insectivores of the Rainforest Understory: a Pantropical Perspective." *Biological Conservation* 188:1–10.

Rand, A.L., and M.A. Traylor. 1953. "The Systematic Position of the Genera *Ramphocaenus* and *Microbates*." *Auk* 70(3): 334–337.

Rangel-Salazar, J.L., K. Martin, P. Marshall, and R.W. Elner. 2008a. "Influence of Habitat Variation, Nest-site Selection, and Parental Behavior on Breeding Success of Ruddy-capped Nightingale-Thrushes (*Catharus frantzii*) in Chiapas, Mexico." *Auk* 125(2): 358–367.

Rangel-Salazar, J.L., K. Martin, P. Marshall, and R.W. Elner. 2008b. "Population Dynamics of the Ruddy-capped Nightingale-Thrush (*Catharus frantzii*) in Chiapas, Mexico: Influences of Density, Productivity and Survival." *Journal of Tropical Ecology* 24:583–593.

Remsen, J.V., Jr. 2003. "Family Furnariidae (Ovenbirds)," version 1. In *Handbook of Birds of the World*. Vol. 8, *Broadbills to Tapaculos*, edited by J. del Hoyo, A. Elliot, and D. Christie, 448–681. Barcelona: Lynx Edicions.

Remsen, J.V., Jr., and H.F. Greeney. 2020. "Buff-throated Foliage-gleaner (*Automolus ochrolaemus*)," version 1.0. In *Birds of the World*, edited by S.M. Billerman, B.K. Keeney, P.G. Rodewald, and T.S. Schulenberg. Ithaca NY: Cornell Lab of Ornithology. https://doi.org/10.2173/bow.btfgle1.01.

Rettenmeyer, C.W., M.E. Rettenmeyer, J. Joseph, and S.M. Berghoff. 2011. "The Largest Animal Association Centered on One Species: The Army Ant *Eciton burchellii* and Its More Than 300 Associates." *Insectes Sociaux* 58(3): 281–292.

Rico-Guevara, A., and M. Araya-Salas. 2015. "Bills as Daggers? A Test for Sexually Dimorphic Weapons in a Lekking Hummingbird." *Behavioral Ecology* 26:21–29.

Rico-Guevara, A., T. Fan, and M.A. Rubega. 2015. "Hummingbird Tongues Are Elastic Micropumps." *Proceedings of the Royal Society B: Biological Sciences* 282. https://doi.org/10.1098/rspb.2015,1014.

Rico-Guevara, A., and M.A. Rubega. 2011. "The Hummingbird Tongue is a Fluid Trap, Not a Capillary Tube." *Proceedings of National Academy of Science USA* 108(23): 9356–9360.

Ridgely, R.S. 1976. *A Guide to the Birds of Panama*. Illustrations by J.A. Gwynne Jr. Princeton, NJ: Princeton University Press.

Ridgely, R.S., and J.A. Gwynne Jr. 1989. *A Guide to the Birds of Panama: with Costa Rica, Nicaragua, and Honduras*. 2nd ed. Princeton, NJ: Princeton University Press.

Ridgely, R.S., and G. Tudor. 1994. *Birds of South America*. Vol. 2, *The Suboscine Passerines*. Austin: University of Texas Press.

Robinson, T.R., W.D. Robinson, and E.C. Edwards. 2000. "Breeding Ecology and Nest-site Selection of Song Wrens in Central Panama." *Auk* 117(2): 345–354.

Robinson, W.D. 1999. "Long-term Changes in the Avifauna of Barro Colorado Island, Panama, a Tropical Forest Isolate." *Conservation Biology* 13(1): 85–97.

Robinson, W.D. 2001. "Changes in Abundance of Birds in a Neotropical Forest Fragment over 25 Years: A Review." *Animal Biodiversity and Conservation* 24:51–65.

Robinson, W.D., G.R. Angehr, T.R. Robinson, L.J. Petit, D.R. Petit, and J. D. Brawn. 2004. "Distribution of Bird Diversity in a Vulnerable Neotropical Landscape." *Conservation Biology* 18(2): 510–518.

Robinson, W.D., J.D. Brawn, and S.K. Robinson. 2000a. "Forest Bird Community Structure in Central Panama: Influence of Spatial Scale and Biogeography." *Ecological Monographs* 70:209–235.

Robinson, W.D., and T.R. Robinson. 2001. "Observations of Predation Events at Bird Nests in Central Panama." *Journal of Field Ornithology* 72:43–48.

Robinson, W.D., T.R. Robinson, S.K. Robinson, and J.D. Brawn. 2000b. "Nesting Success of Understory Forest Birds in Central Panama." *Journal of Avian Biology* 31(2): 151–164.

Robinson, W.D., G. Rompré, and T.R. Robinson. 2005. "Videography of Panama Bird Nests Shows Snakes are Principal Predators." *Ornitologia Neotropical* 16:187–195.

Rogers, D.J., and S.E. Randolph. 2006. "Climate Change and Vector-borne Diseases." *Advances in Parasitology* 62:345–381.

Rompré, G., and W.D. Robinson. 2008. "Predation and Long Incubation Periods of Two Neotropical Antbirds." *Biotropica* 14:81–87.

Roper, J.J. 2005. "Try and Try Again: Nest Predation Favors Persistence in a Neotropical Bird." *Ornitologia Neotropical* 16:253–262.

Sartore, J. 2010. *Rare: Portraits of America's Endangered Species*. Washington, DC: Focal Point, National Geographic.

Sartore, J. 2017. *The Photo Ark*. Washington, DC: National Geographic Partners.

Schafer, T. 2020. "Sulphur-rumped Flycatcher (*Myiobius sulphureipygius*)," version 1.0. In *Birds of the World*, edited by T.S. Schulenberg. Ithaca, NY: Cornell Lab of Ornithology. https://doi.org/10.2173/bow.surfly1.01.

Schemske, D.W., and N. Brokaw. 1981. "Treefalls and the Distribution of Understory Birds in a Tropical Forest." *Ecology* 62(4): 938–945.

Schulenberg, T.S., D.F. Stotz, D.F. Lane, J.P. O'Neill, and T.A. Parker III. 2010. *Birds of Peru*. Princeton, NJ: Princeton University Press.

Sclater, P.L. 1883. *A Monograph of the Jacamars and Puffbirds or Families Galbulidae and Bucconidae*. London: R.H. Porter and Dulau.

Shaw, D.W., P. Escalante, J.H. Rappole, M.A. Ramos, R.J. Oehlenschlager, D.W. Warner, and K. Winker. 2013. "Decadal Changes and Delayed Avian Species Losses Due to Deforestation in the Northern Neotropics." *PeerJ* 1: e179.

Sherry, T.W. "Ecological and Evolutionary Inferences from Morphology, Foraging Behavior, and Diet of Sympatric Insectivorous

Neotropical Flycatchers (Tyrannidae)." PhD diss., University of California–Los Angeles, 1982.

Sherry, T.W. 1983. "*Terenotriccus erythrurus* (*Mosqueitero colirrufo*), Tontillo, Ruddy-tailed Flycatcher." In *Costa Rican Natural History*, edited by D.H. Janzen, 605–607. Chicago: University of Chicago Press.

Sherry, T.W. 1984. "Comparative Dietary Ecology of Sympatric, Insectivorous Neotropical Flycatchers (Tyrannidae)." *Ecological Monographs* 54(3): 313–338.

Sherry, T.W., C.M. Kent, N.V. Sánchez, and Ç.H. Şekercioğlu. 2020. "Insectivorous Birds in the Neotropics: Ecological Radiations, Specialization, and Coexistence in Species-rich Communities." *Auk: Ornithological Advances* 137(4). https://doi.org/10.1093/auk/ukaa049.

Simpson, G.G. 1980. *Splendid Isolation. The Curious History of South American Mammals*. New Haven, CT: Yale University Press.

Skoracki, M., S. Mironov, and S. Bermúdez. 2019. "A New Syringophilid Mite (Acariformes: Syringophilidae) from Manakins (Passeriformes: Pipridae) in Panama." *Acarina* 27(2): 229–232. https://doi.org/10.21684/0132-8077-2019-27-2-229-232.

Skutch, A.F. 1945. "On the Habits and Nest of the Ant-thrush *Formicarius analis*." *Wilson Bulletin* 57(2): 122–128.

Skutch, A.F. 1949. "Life History of the Ruddy Quail-dove." *Condor* 51(1): 3–19.

Skutch, A.F. 1954. "Life Histories of Central American Birds." *Pacific Coast Avifauna* 31.

Skutch, A.F. 1956. "Roosting and Nesting of the Golden-olive Woodpecker." *Wilson Bulletin* 68(2): 118–128.

Skutch, A.F. 1958. "Life History of the White-whiskered Puffbird (*Malacoptila panamensis*)." *Wilson Bulletin* 100:209–231.

Skutch, A.F. 1960a. "Life Histories of Central American Birds. Part 2. Families Vireonidae, Sylviidae, Turdidae, Troglodytidae, Paridae, Corvidae, Hirundinidae and Tyrannidae." *Pacific Coast Avifauna* 34:561–570.

Skutch, A. 1960b. *Life Histories of Central American Birds II*. Berkeley, CA: Cooper Ornithological Society.

Skutch, A.F. 1960c. "Eye-ringed Flatbill *Rhynchocyclus brevirostris*." In "Life Histories of Central American Birds: Families Vireonidae, Sylviidae, Turdidae, Troglodytidae, Paridae, Corvidae, Hirundinidae and Tyrannidae." *Pacific Coast Avifauna* 34:508–515.

Skutch, A.F. 1960d. "Northern Bent-bill *Oncostoma cinereigulare*." In "Life Histories of Central American Birds: Families Vireonidae, Sylviidae, Turdidae, Troglodytidae, Paridae, Corvidae, Hirundinidae and Tyrannidae." *Pacific Coast Avifauna* 34:555–560.

Skutch, A.F. 1960e. "Ruddy-tailed Flycatcher *Terenotriccus erythrurus*." In "Life Histories of Central American Birds: Families Vireonidae, Sylviidae, Turdidae, Troglodytidae, Paridae,

Corvidae, Hirundinidae and Tyrannidae." *Pacific Coast Avifauna* 34:534–538.

Skutch, A.F. 1960f. "Sulphur-rumped Myiobius: *Myiobius sulphureipygius*." In "Life Histories of Central American Birds: Families Vireonidae, Sylviidae, Turdidae, Troglodytidae, Paridae, Corvidae, Hirundinidae and Tyrannidae." *Pacific Coast Avifauna* 34:539–551.

Skutch, A.F. 1961. "The Nest as a Dormitory." *Ibis* 103:50–70.

Skutch, A.F. 1964. "Life Histories of Hermit Hummingbirds." *Auk* 81(1): 5–25.

Skutch, A.F. 1967. *Life Histories of Central American Highland Birds*. Cambridge, MA: Nuttall Ornithological Club.

Skutch, A.F. 1969. *Life Histories of Central American Birds III*. Berkeley, CA: Cooper Ornithological Society.

Skutch, A.F. 1980. *A Naturalist on a Tropical Farm*. Berkeley, CA: University of California Press.

Skutch, A.F. 1997. *Life of the Flycatcher*. With illustrations by D. Gardner. Norman: University of Oklahoma Press.

Slud, P. 1958. "Observations on the Nightingale Wren in Costa Rica." *Condor* 60(4): 243–251.

Slud, P. 1964. "The Birds of Costa Rica: Distribution and Ecology." *Bulletin of American Museum of Natural History* 128:1–430.

Smith, B.T., R.W. Bryson Jr., W.M. Mauck III, J. Chaves, M.B. Robbins, A. Aleixo, and J. Klicka. 2018. "Species Delimitation and Biogeography of the Gnatcatchers and Gnatwrens (Aves: Polioptilidae)." *Molecular Phylogenetics and Evolution* 126:45–57.

Smith, N.G. 1969. "Avian Predation of Coral Snakes." *Copeia* 2: 402–404.

Snow, B.K., and D.W. Snow. "The Ochre-bellied Flycatcher and the Evolution of Lek Behavior." *Condor* 81:286–292.

Standish, H., E. Mayne, F. Hall, and W. Tori. 2020. "Ochre-bellied Flycatcher (*Mionectes oleagineus*)," version 1. In *Birds of the World*, edited by T.S. Schulenberg. Ithaca, NY: Cornell Lab of Ornithology.

Stettenheim, P.R. 2000. "The Integumentary Morphology of Modern Birds—An Overview." *American Zoologist* 40:461–477.

Stiles, F.G. 1983. "The Taxonomy of *Microcerculus* Wrens (Troglodytidae) in Central America." *Wilson Bulletin* 95(2): 169–183.

Stiles, F.G., and A.F. Skutch. 1989. *A Guide to the Birds of Costa Rica*. Ithaca, NY: Comstock Publishing Associates.

Stiles, F.G., and L. Wolf. 1979. "Ecology and Evolution of Lek Mating Behavior in the Long-tailed Hermit Hummingbird." *Ornithological Monographs* 27(4). https://doi.org/10.2307/40166760.

Stotz, D.F., J.W. Fitzpatrick, T.A. Parker III, and D.K. Moskovitz. 1996. *Neotropical Birds: Ecology and Conservation*. Chicago: University of Chicago Press.

Stouffer, P.C. 1997. "Interspecific Aggression in *Formicarius* Antthrushes? The View from Central Amazonian Brazil." *Auk* 114(4): 780–785.

Stouffer, P.C., and R.O. Bierregaard Jr. 1993. "Spatial and Temporal Abundance Patterns of Ruddy Quail-Doves (*Geotrygon montana*) near Manaus, Brazil." *Condor* 95(4): 896–903.

Styrsky, J. N. 2003. "Influence of Predation on Nest-site Reuse by an Open-cup Nesting Neotropical Passerine." *Condor* 107(1): 133–137.

Svensson-Coelho, M., B.A. Loiselle, J.G. Blank, and R.E. Ricklefs. 2016. "Resource Predictability and Specialization in Avian Malaria Parasites." *Molecular Ecology* 25(17): 4377–4391.

Tarwater, C.E. 2012. "Influence of Phenotypic and Social Traits on Dispersal in a Family Living, Tropical Bird." *Behavioral Ecology* 23:1242–1249.

Tarwater, C.E., and J.D. Brawn. 2008. "Patterns of Brood Division and an Absence of Behavioral Plasticity in a Neotropical Passerine." *Behavioral Ecology and Sociobiology* 62:1441–1452.

Tarwater, C.E., and J.D. Brawn. 2010a. "Family Living in a Neotropical Bird: Variations in Timing of Dispersal and Higher Survival for Delayed Dispersers." *Animal Behaviour* 80:535–542.

Tarwater, C.E., and J.D. Brawn. 2010b. "The Post-fledging Period in a Tropical Bird: Patterns of Parental Care and Survival." *Journal of Avian Biology* 41(4): 479–487.

Tarwater, C.E., J.D. Brawn, and J.D. Maddox. 2013. "Low Extrapair Paternity Observed in a Tropical Bird Despite Ample Opportunities for Extrapair Mating." *Auk* 130(4): 733–741.

Tarwater, C.E., and J.P. Kelley. 2010. "Black-crowned Antshrike," version 1.0. In *Birds of the World*, edited by T.S. Schulenberg. Ithaca, NY: Cornell Lab of Ornithology.

Taylor, J., C.A. Soberanes-González, C.I. Rodriguez-Flores, and M.d.C Arizmendi. 2020. "Ruddy-capped Nightingale-Thrush (*Catharus frantzii*)," version 1.0. In *Birds of the World*, edited by T.S. Schulenberg. Ithaca, NY: Cornell Lab of Ornithology. https://doi.org/10.2173/bow.rcnthr1.01.

Terborgh, J., S.K. Robinson, T.A. Parker III, C.A. Munn, and N. Pierpont. 1990. "Structure and Organization of an Amazonian Forest Bird Community." *Ecological Monographs* 60:213–238. https://doi.org/10.2307/1943045.

Thoreau, Henry David. 1993. *Thoreau on Birds: Notes on New England Birds from the Journals of Henry David Thoreau*. Edited by F.H. Allen. Boston: Beacon Press.

Tipton, J., and E. Méndez. 1966. "The Fleas (Siphonaptera) of Panama." In *Ectoparasites of Panama*, edited by R.L. Wenzel, and V.J. Tipton, 289–386. Chicago: Field Museum of Natural History.

US Fish and Wildlife Service. 2016. *National Survey of Fishing, Hunting, and Wildlife-associated Recreation*. Washington, DC: US Fish and Wildlife Service.

Valkiūnas, G. 1989. "Characteristics of the Distribution of Birds Infected with Hemosporidians (Sporozoa, Haemosporidia) during

the Fall Migration in Flight Waves." *Parazitologiia* 23:377–382. [Russian with English summary].

Valkiūnas, G. 2005. *Avian Malaria Parasites and Other Haemosporidia*. Boca Raton, FL: CRC Press.

Valkiūnas, G., S. Bensch, T.A. Iezhova, A. Krizanauskiené, O. Hellgren, and S.V. Bolshakov. 2006. "Nested Cytochrome B Polymerase Chain Reaction Diagnostics Underestimate Mixed Infections of Avian Blood Haemosporidian Parasites: Microscopy is Still Essential." *Journal of Parasitology* 92(2): 418–422.

Vallely, A.C., and D. Dyer. 2018. *Birds of Central America*. Princeton, NJ: Princeton University Press.

van Riper, C., S.G. van Riper, M.L. Goff, and M. Laird. 1986. "The Epizootiology and Ecological Significance of Malaria in Hawaiian Land Birds." *Ecological Monographs* 56(4): 327–344.

Visco, D.M., N.L. Michel, A.W. Boyle, B.J. Sigel, S. Woltmann, and T.W. Sherry. 2015. "Patterns and Causes of Understory Bird Declines from Human-disturbed Tropical Forest Landscapes: A Case Study from Central America." *Biological Conservation* 191:117–129.

Visco, D.M., and T.W. Sherry. 2015. "Increased Abundance, but Reduced Nest Predation in the Chestnut-backed Antbird in Costa Rican Rainforest Fragments: Surprising Impacts of a Pervasive Snake Species." In "Special Issue: Ecology and Conservation of Avian Insectivores of the Rainforest Understory: A Pan-Tropical Perspective," edited by L. Powell, N. Cordeiro, and J. Stratford. *Biological Conservation* 188:22–31.

Weir, J.T., and M. Price. 2011. "Andean Uplift Promotes Lowland Speciation through Vicariance and Dispersal in *Dendrocincla* Woodcreepers." *Molecular Ecology* 20(21): 4550–4563.

Wenzel R.L., and V.J. Tipton. 1966. *Ectoparasites of Panama*. Chicago: Field Museum of Natural History.

Westcott, D.A. 1992. "Inter- and Intra-sexual Selection: The Role of Song in a Lek Mating System." *Animal Behaviour* 44(4): 695–703.

Westcott, D.A. 1993. "Habitat Characteristics of Lek Sites and Their Availability for the Ochre-bellied Flycatcher, *Mionectes oleagineus*." *Biotropica* 25:444–451.

Westcott, D.A. 1997. "Lek Locations and Patterns of Female Movement and Distribution in a Neotropical Frugivorous Bird." *Animal Behaviour* 53:235–247.

Westcott, D.A., and J.N.M. Smith. 1994. "Behavior and Social Organization during the Breeding Season in *Mionectes oleagineus*, a Lekking Flycatcher." *Condor* 96(3): 672–683.

Westcott, D.A., and J.N.M. Smith. 1997. "Lek Size Variation and its Consequences in the Ochre-bellied Flycatcher, *Mionectes oleagineus*." *Behavioral Ecology* 8(4): 396–403.

Wetmore, A. 1968. *The Birds of the Republic of Panama*. Part 2. *Columbidae (Pigeons) to Picidae (Woodpeckers)*. Smithsonian Miscellaneous Collections 150.

Wetmore, A. 1972. *The Birds of the Republic of Panama*. Part 3. *Passeriformes: Dendrocolaptidae (Woodcreepers) to Oxyruncidae (Sharpbills)*. Smithsonian Miscellaneous Collections 150.

Wetmore, A., R.F. Pasquier, and S.L. Olson. 1984. *The Birds of the Republic of Panama*. Part 4. *Passeriformes: Hirundinidae (Swallows) to Fringillidae (Finches)*. Smithsonian Miscellaneous Collections 150.

Wheelwright, N.T., W.A. Haber, K.G. Murray, and C. Guindon. 1984. "Tropical Fruit-eating Birds and Their Food Plants: A Survey of a Costa Rican Lower Montane Forest." *Biotropica* 16(3): 173–192.

Whitney, J.C. 2013. "Within-territory Use of Different Land Cover Types by Tropical Forest Birds in a Fragmented Landscape." *Biological Conservation* 167:405–413.

Wikelski, M., M. Hau, and J.C. Wingfield. 1999. "Social Instability Increases Plasma Testosterone in a Year-round Territorial Neotropical Bird." *Proceedings of the Royal Society B: Biological Sciences* 266:551–556.

Wikelski, M., M. Hau, and J.C. Wingfield. 2000. "Seasonality of Reproduction in a Neotropical Rain Forest Bird." *Ecology* 81(9): 2458–2472.

Willis, E.O. 1966. "Interspecific Competition and the Foraging Behavior of Plain-brown Woodcreepers." *Ecology* 47(4): 667–672.

Willis, E.O. 1967. "The Behavior of Bicolored Antbirds." *University of California Publications in Zoology* 79.

Willis, E.O. 1972a. "The Behavior of Plain-brown Woodcreepers, *Dendrocincla fuliginosa*." *Wilson Bulletin* 84:377–420.

Willis, E.O. 1972b. "The Behavior of Spotted Antbirds." *Ornithological Monographs* 10.

Willis, E.O. 1973. "The Behavior of Ocellated Antbirds." *Smithsonian Contributions to Zoology* 144. https://doi.org/10.5479/si.00810282.144.

Willis, E.O. 1974. "Populations and Local Extinctions of Birds on Barro Colorado Island, Panama." *Ecological Monographs* 44(2): 153–169.

Willis, E.O., and Y. Oniki. 1978. "Birds and Army Ants." *Annual Review of Ecology and Systematics* 9(1): 243–263.

Winkler, D.W., S.M. Billerman, and I.J. Lovette. 2020a. "Gnatcatchers (Polioptilidae)," version 1.0. In *Birds of the World*, edited by S.M. Billerman, B.K. Keeney, P.G. Rodewald, and T.S. Schulenberg. Ithaca, NY: Cornell Lab of Ornithology. https://doi.org/10.2173/bow.poliop1.01.

Winkler, D.W., S.M. Billerman, and I.J. Lovette. 2020b. "Ovenbirds and Woodcreepers (Furnariidae)," version 1.0. In *Birds of the World*, edited by S.M. Billerman, B.K. Keeney, P.G. Rodewald, and T.S. Schulenberg. Ithaca, NY: Cornell Lab of Ornithology. https://doi.org/10.2173/bow.furnar2.01.

Wohlschläger, A., R. Jäger, and J.D. Delius. 1993. "Head and Eye Movements in Unrestrained Pigeons." *Journal of Comparative Psychology* 107(3): 313–319.

Woltmann, S., B.R. Kreiser, and T.W. Sherry. 2012a. "Fine-scale Genetic Population Structure of an Understory Rainforest Bird in Costa Rica." *Conservation Genetics* 13(4): 925–935.

Woltmann, S., and T.W. Sherry. 2011. "High Apparent Annual Survival and Stable Territory Dynamics of Chestnut-backed Antbird (*Myrmeciza exsul*) in a Large Costa Rican Rain Forest Preserve." *Wilson Journal of Ornithology* 123(1): 15–23.

Woltmann, S., T.W. Sherry, and B.R. Kreiser. 2012b. "A Genetic Approach to Estimating Natal Dispersal Distances and Self-recruitment in Resident Rainforest Birds." *Journal of Avian Biology* 43:33–42.

Woltmann, S.R., S. Terrill, M.J. Miller, and M.L. Brady. 2020. "Chestnut-backed Antbird (*Poliocrania exsul*)," 1.0. In *Birds of the World*, edited by T.S. Schulenberg. Ithaca, NY: Cornell Lab of Ornithology. https://doi.org/10.2173/bow.chbant1.01.

Wright, J., R. Fu, J.R. Worden, S. Chakraborty, N.E. Clinton, C. Risi, Y. Sun, and L. Yin. 2017. "Rainforest-initiated Wet Season Onset over the Southern Amazon." *Proceedings of National Academy of Sciences USA* 114(32): 8481–8486.

Wulf, Andrea. 2016. *The Invention of Nature*. New York: Knopf.

Yunker, C., and F. Radovsky. 1966. "The Dermanyssid Mites of Panama (Acarina: Dermanyssidae)." In *Ectoparasites of Panama*, edited by R.L. Wenzel, and V.J. Tipton, 83–103. Chicago: Field Museum of Natural History.

Zimmer, K., and M.L. Isler. 2003. "Family Thamnophilidae (Typical Antbirds)." In *Handbook of Birds of the World*. Vol. 8, *Broadbills to Tapaculos*, edited by J. del Hoyo, A. Elliott, and D. Christie, 448–468. Barcelona: Lynx Edicions.

Contributor Biographies

Phred M. Benham is a National Science Foundation Postdoctoral Fellow at the Museum of Vertebrate Zoology, University of California–Berkley. His research integrates physiological, genomic, and ecological data in order to understand adaptation and diversification in birds. He has pursued these interests in a range of systems from Andean hummingbirds to salt-marsh sparrows. Currently, he is analyzing morphological and genomic data from historic bird specimens to document demographic and adaptive responses to human activities over the past century.

Sergio E. Bermúdez Castillero is an entomologist and Senior Health Researcher III at the Gorgas Memorial Institute for Health Research in Panama, an associate researcher at the Academia Interamericana de Panamá's Coiba Scientific Station, and a doctoral student at the University of the Republic (Uruguay). He holds a bachelor of biology with an orientation in animal biology and a master of science with a specialty in agricultural entomology, both from the University of Panama. He has worked at the Gorgas Institute since 2004, starting in the Eustorgio Méndez Zoological Collection and, since 2007, as a researcher developing studies related to the ecology of ticks and their relationship with pathogens. He is the author of seventy-three scientific articles in indexed international specialized journals, thirty-nine as corresponding author, thirteen articles in national journals, and four books.

Jeffrey D. Brawn is an ecologist and currently the Stuart L. and Nancy J. Levenick Professor of Sustainability at the University of Illinois at Urbana–Champaign. His research program is focused on the conservation of populations and communities of birds. After receiving his doctorate from Northern Arizona University, he began his tropical research with the Smithsonian Tropical Research Institute in the Republic of Panama. He first came to the University of Illinois as a research scientist with the Illinois Natural History Survey and later joined the faculty of the Department of Natural Resources and Environmental Sciences. He has worked in Panama for over thirty years where, in collaboration with numerous colleagues and students, he has studied the demography and behavior of tropical forest birds. Recently, he has explored relationships between expected climate change—especially changes in precipitation—and the viability of tropical bird populations.

Caroline Dingle is an ornithologist currently based at the University of Hong Kong's School of Biological Sciences. She has studied birds on five continents, including nearly a decade in the Amazon and the Ecuadorian Andes, Australia, and most recently Southeast Asia and China. She is interested in the ecological and evolutionary processes that maintain and generate biodiversity, particularly in the tropics. Her research aims to understand the impacts of environmental change on behavior and how behavioral change in turn influences the processes of evolution and speciation. Her current research focuses on the function of female song, behavioral adaptation to urbanization, and impacts of wildlife trade.

Victor Emanuel is the executive director of Victor Emanuel Nature Tours (VENT). He was the recipient in 1993 of the Roger Tory Peterson Excellence in Birding Award, given by the Houston Audubon Society in recognition of a lifetime of dedication to careful observation, education, and addition to the body of avian knowledge. In 2004, he received the Roger Tory Peterson Award from the American Birding Association and the Arthur A. Allen Award from the Cornell Laboratory of Ornithology. He is a past board member of the Nature Conservancy of Texas, the National Audubon Society, the American Bird Conservancy, and the Cornell Lab of Ornithology. Birds and natural history have been a major focus throughout his life.

Jay J. Falk received his bachelor's degree from the University of Texas in Austin and subsequently completed his doctorate at Cornell University as a member of the Lab of Ornithology and Smithsonian Tropical Research Institute. His research specializes in evolution and animal behavior, particularly the evolution of plumage coloration in birds. His love of hummingbirds and their natural history began during his doctoral work, when he studied color variation in female White-necked Jacobins in Panama.

John W. Fitzpatrick is professor of ecology and evolutionary biology at Cornell University and, until 2021, was the executive director of the Cornell Lab of Ornithology. A Minnesota native, Fitzpatrick received his bachelor's degree from Harvard University (1974) and doctorate from Princeton University (1978). Through 1989 he was curator of birds and chairman of zoology at Chicago's Field Museum

of Natural History, studying the ecology of tyrant flycatchers and community dynamics in the Andean foothills of Peru. In 1988 he became executive director of Archbold Biological Station in central Florida, where he continues his decades-long collaborative study of the ecology, behavior, landscape genetics, and conservation of the endangered Florida Scrub-Jay.

At Cornell since 1995, Fitzpatrick oversaw development of the Cornell Lab of Ornithology into a world-renowned center for ornithology, conservation biology, and citizen science. He and colleagues pioneered eBird, now the world's largest citizen-science project and a global standard for ecological monitoring. His honors in ornithology and conservation include awards from the American Ornithological Society, The Nature Conservancy, Linnean Society of New York, and National Audubon Society. He was president of the American Ornithological Society (2000–2002), on the board of governors of The Nature Conservancy (1995–2006), trustee of the National Audubon Society (1995–2001), and on three US Endangered Species Recovery Teams. Fitzpatrick lives with his wife, Molly, on a forested hillside in Ithaca, New York.

Christoph Hinkelmann is curator of natural history at the East Prussian State Museum in Lüneburg, Germany. He obtained his doctorate in the taxonomy, biogeography, and geographical variation in hermit hummingbirds at the University of Bonn. His ornithological fields of interest are biographies of ornithologists, and he is a member of the editorial staff of several German journals dedicated to the history of ornithology as well as to aviculture. He has made several trips to observe birds in tropical regions of West Africa, Southeast Asia, as well as Central and South America, including guiding ornithological observation tours to Peru, Costa Rica, and Cuba. He is a member of the International Ornithologists' Union commission on the naming of birds in the German language.

Peter A. Hosner is curator of birds and assistant professor at the Natural History Museum of Denmark and Center for Macroecology, Evolution, and Climate at the University of Copenhagen's Globe Institute. His research interests include resolving evolutionary relationships among birds, understanding how geography influences avian distributions and diversification, and exploring the ornithological component of the megadiverse tropics.

J. Patrick Kelley is a research assistant at the University of Wyoming in Laramie. He obtained his doctorate. in animal behavior from the University of California–Davis and his bachelor in biology from Harvard University. His past work has examined acoustic communication of wild primates, stingless bees, and jumping spiders, and he has studied tundra-breeding birds in the Alaskan Arctic, finches on the Galapagos, and many antbird species in Panama. He currently leads University of Wyoming's Behavioral Complexity Lab, which focuses primarily on birds in Panama and Hawaii, exploring the nature of behavioral variation and how such variation impacts interaction networks and other ecological phenomena. In addition, he teaches a course in introductory biology and a course for first-year undergraduates on making data-driven arguments and leads an annual field course in tropical ecology in Panama.

John Kricher taught ecology and ornithology at Wheaton College (Massachusetts) for forty-eight years and is the author of several books on ecology and ornithology. His quest to learn ecology and to watch birds has taken him to over thirty countries and to all the continents. He is a fellow in the American Ornithological Society and past president of both the Wilson Ornithological Society and the Association of Field Ornithologists. Most notable among the ten books he has authored is *The New Neotropical Companion* (2017). His most recent book is *Peterson Reference Guide to Bird Behavior* (2020). He lives with his wife Martha Vaughan in Hingham, Massachusetts.

Ronald L. Mumme is a professor of biology at Allegheny College in Meadville, Pennsylvania. He has been a member of the Allegheny College faculty since 1990. His current research focuses on the behavioral ecology of Hooded Warblers in northwest Pennsylvania, but his previous ornithological research led to extensive field work in Costa Rica (Slate-throated Redstarts), Florida (Florida Scrub-Jays), and California (Acorn Woodpeckers). He is a fellow of the American Ornithological Society.

K. Greg Murray is the T. Elliot Weier Professor of Plant Science in the Department of Biology at Hope College, Holland, Michigan. He is a tropical ecologist who has studied the interactions between plants and their avian pollinators and seed dispersers since 1980. Working mostly in Central

America, his long-term research concerns how seed dispersers, seed predators and pathogens, and physical disturbance to forests (e.g., landslides and treefalls) interact to sustain populations of pioneer plants and forest biodiversity in general. He has also studied the digestive physiology and bases of fruit-choice behavior in American Robins and Swainson's Thrushes. Before switching to tropical birds, he studied seabird breeding biology in western North America, concentrating on the breeding biology of Scripp's Murrelet and on the phenomenon of female-female pairing in Western Gulls. He was educated at California State University–Northridge and the University of Florida.

Henry S. Pollock is a postdoctoral research associate at the University of Illinois at Urbana–Champaign. He is currently working on a long-term mark–recapture data set from Panama to investigate the long-term population trends of many of the same understory forest bird species included in this book. An ornithologist who has been studying bird ecology and conservation since 2010, he has a passion for natural history and tropical birds and has conducted field work in Latin America, Africa, and Asia.

Scott Robinson is the Ordway Professor of Conservation Biology at the Florida Museum of the University of Florida. He studies the ecology and behavior of tropical birds, especially in South America, and has also collaborated extensively with Jeffrey D. Brawn in Panama. He studies how and why bird communities change along environmental gradients (e.g., urban–rural, elevation, precipitation, fragmentation, human disturbance, and plant succession) and uses these studies to predict the consequences of climate change and increasing human land use. He received his doctorate at Princeton University working with John Terborgh and has worked with the Illinois Natural History Survey and the University of Illinois prior to moving to Florida. He is also a fanatical birdwatcher.

Thomas W. Sherry is a professor in the Department of Ecology and Evolutionary Biology and Siegel Professor of Social Entrepreneurship, Phyllis M. Taylor Center for Social Innovation and Design Thinking, at Tulane University in New Orleans, Louisiana. His lab studies the demography of migratory birds, including reproductive success by American Redstarts and Black-throated Blue Warblers in the Hubbard

Brook Experimental Forest, New Hampshire, and the wintering ecology of these and other species in Jamaica. This research documents multiple population-limiting factors, especially summer nest predation interacting with weather and winter food resources in response to El Niño–La Niña rainfall fluctuations. Sherry's lab also studies diet and foraging ecology, culminating in a review and synthesis in Cornell Lab of Ornithology's *Handbook of Bird Biology*, third edition. Currently he is synthesizing Neotropical insectivorous birds' foraging specializations in response to competition and predator–prey arms races with insects.

Corey E. Tarwater is an assistant professor at the University of Wyoming in Laramie, with over fifteen years of experience working on tropical birds. She first went to Panama in 2003 to begin her master's research and has gone there every year since to continue her research and now that of her students as well. Her research interests include understanding the behavior of organisms, such as breeding and dispersal, and how and why populations and species interactions vary over time and space. She holds a doctorate.in ecology, evolution, and conservation biology from University of Illinois at Urbana–Champaign, a master's degree from the same university in natural resources and environmental sciences, and a bachelor's degree in wildlife, fish, and conservation biology from the University of California—Davis.

Samuel Valdés Díaz is founder and director of the Biodiversity Consultant Group, a firm that develops conservation strategies for diverse groups of organisms and works to communicate the role of biodiversity in providing re-sources for society. A Panamanian biologist, Samuel has two decades of experience in varied topics associated with biodiversity management and conservation. As president of the Panama Private Protected Areas Network, Samuel has contributed to research and publications related to Panama as a biological corridor for the conservation of mammals. His recent interest is in the use of butterflies as a tool for environmental education and raising consciousness about the decline of insect populations. Samuel is the former director of Natural Protected Areas for Panama and has led international initiatives related to biodiversity monitoring and reporting.

Deborah Visco is Restoration Programs director of the Coalition to Restore Coastal Louisiana. She earned a doctorate in ecology and evolutionary biology from Tulane University in 2015, where she studied the demography, ecology, and behavior of Chestnut-backed Antbird populations in fragmented Neotropical rainforest. Originally from New York, she received her bachelor's degree in environmental biology from the State University of New York College of Environmental Science and Forestry in 2006 and gained additional ecology and conservation experience in Dominica (West Indies), Australia, California, and New Hampshire before beginning her graduate studies in New Orleans. In her present position, she leads the Habitat Restoration and Oyster Shell Recycling Programs.

John P. Whitelaw is a retired physician who was chief pathologist of a large regional hospital in British Columbia, Canada. He is a graduate of the University of British Columbia and McGill University and a fellow of the Royal College of Physicians and Surgeons of Canada. He has had a life-long interest in natural history, especially birds, and an equally long interest in photography. He describes his photography as "niche," that is, limited to unique subjects that often require unusual techniques in off-the-beaten-track environments. His other interests have included building and restoring wooden rowing shells, writing, and making grappa. He lives on Vancouver Island with his wife Christine.

Jared Wolfe is an assistant professor at Michigan Technological University's School of Forest Resources and Environmental Science, where he works to integrate bird conservation into working landscapes throughout the Americas and Africa. In addition to conservation, he studies bird molt, an understudied yet critical phase of the avian lifecycle.

Emma I. Young is a doctoral candidate and science communicator at the University of Missouri in St. Louis, where she studies avian malaria parasites in the resident birds of Gamboa, Panama, being primarily interested in how these parasite assemblages change in response to rainfall and over space and time. She also moonlights as a John A. Knauss Marine Policy Fellow in Washington, DC, where she is working on the implementation of the US Endangered Species Act. Her interest in ornithological disease began with Northern Saw-whet Owls and eventually brought her to the Neotropics.

Accipiter hawk, 45
 A. superciliosus (Tiny Hawk), 38, 45
Actitis macularius (Spotted Sandpiper), 105
Amazon Biodiversity Center, 3
Amazonian Grosbeak (*Cyanoloxia rothschildii*), 127
Amblyomma species, 97
 A. calcaratum, 99
 A. geayi, 99
 A. girostre, 97, 99
 A. nodosum, 99
 A. varium, 99
American Robin (*Turdus migratorius*), 83
Andean Pygmy-Owl (*Glaucidium jardinii*), 99
Angehr, G.R., 93
Annonaceae (annonas), 1
ant followers, 4, 69–71, 133
antwrens
 independent evolution of, 32
 See also individual species
Argas persicus, 97
Argasidae, 97
army ants (*Eciton burchellii*), 4, 46, 53, 54, 58, 61, 69, 133
Aulacorhynchus prasinus (Northern Emerald Toucanet), 114
Automolus ochrolaemus (Buff-throated Foliage-gleaner), 64–65, 136
avian malaria, 83

bananas (*Musa*), 20
Band-tailed Barbthroat (*Threnetes ruckeri*), 18–19, 136
Baptista, Luis, 106
Barred Forest-Falcon (*Micrastur ruficollis*), 38
Bat Falcon (*Falco rufigularis*), 71
Behavior of Bicolored Antbirds, The (Willis), 2
Bicolored Antbird (*Gymnopithys bicolor*), 46–49, 50, 69, 71, 135
biodiversity conservation, 9–11
Biological Dynamics of Forest Fragmentation Project, 3
bird-eating snake (*Pseustes poecilonotus*), 45
bivouac-checking, 53
Black-crowned Antshrike (*Thamnophilus atrinucha*), 28–31, 32, 38, 135
Black-faced Antthrush (*Formicarius analis*), 56–57, 69, 98, 135
Black-faced Solitaire (*Myadestes melanops*), 114–116, 137
Blackpoll Warbler (*Setophaga striata*), 132–133
Blankaartia, 97

Blue-black Grosbeak (*Cyanoloxia cyanoides*), 126–128, 137
Bolsonaro, Jair, 133
Borrelia recurrentis group, 97
Boyle, Alice, 89
Brawn, Jeff, 3
Brisson, Mathurin J., 24
bristle feathers, 24
Brown-capped Vireo (*Vireo leucophrys*), 99
Bucconidae, 24
Buff-tailed Sicklebill (*Eutoxeres condamini*), 16
Buff-throated Foliage-gleaner (*Automolus ochrolaemus*), 64–65, 136
Buff-throated Woodcreeper. *See* Cocoa Woodcreeper (*Xiphorhynchus susurrans*)

Cacicus cela (Yellow-rumped Cacique), 93
Cana region, Panama, 10–11
Canna, 20
canopy, 1
capillarity, 117
Cardinalis cardinalis (Northern Cardinal), 127
Catharus species
 C. aurantiirostris (Orange-billed Nightingale-Thrush), 119
 C. frantzii (Ruddy-capped Nightingale-Thrush), 118–119, 137
 C. fuscescens (Veery), 119
 C. guttatus (Hermit Thrush), 119
 C. minimus (Gray-cheeked Thrush), 119
 C. ustulatus (Swainson's Thrush), 119
Ceiba pentandra (kapok tree), 1
Centropogon, 16
Ceratophyllus albus, 99
Ceratopipra mentalis (Red-capped Manakin), 79, 83
Chagres National Park, 9
Chattering Gnatwren (*Ramphocaenus sticturus*), 102
Checker-throated Stipplethroat (*Epinecrophylla fulviventris*), 34–37, 38, 135, 138
Chestnut-backed Antbird (*Poliocrania exsul*), 42–45, 69, 132–133, 135
chiggers, 97
Clay-colored Thrush (*Turdus grayi*), 83
climate change, 6–7
clutch sizes, 6
Cocoa Woodcreeper (*Xiphorhynchus susurrans*), 60–61, 138
cohesion signals, 38
Colaptes rubiginosus (Golden-olive Woodpecker), 26–27, 138

Columnea, 20
Costus, 19
cumaru (*Dipteryx micrantha*), 1
Cyanoloxia species
 C. cyanoides (Blue-black Grosbeak), 126–128, 137
 C. rothschildii (Amazonian Grosbeak), 127
Cyphorhinus phaeocephalus (Song Wren), 112–113, 138

Darién Province, 10–11
Darwin, Charles, 132–133
Dasypsyllus species
 D. gallinulae, 99
 D. lasius, 99
dead-leaf foraging, 35, 37
"dear enemy" effect, 53
deforestation, 6, 9–11, 133
Dendrocincla fuliginosa (Plain-brown Woodcreeper), 58–59, 138
Dipteryx micrantha (cumaru), 1
Dot-winged Antwren (*Microrhopias quixensis*), 35
Double-toothed Kite (*Harpagus bidentatus*), 4
Dromococcyx phasianellus (Pheasant Cuckoo), 89
dry seasons, 7
Drymonia, 20
duetting, 109–110

Eciton burchellii (army ants), 4, 46, 53, 54, 58, 61, 69, 133
ectoparasites, 97–99
El Niño years, 7
Elaenia species
 E. flavogaster (Yellow-bellied Elaenia), 101
 E. frantzii (Mountain Elaenia), 100–101, 136
Electron platyrhynchum, 97
emergents, 1
Epinecrophylla, 37
Epinecrophylla fulviventris (Checker-throated Stipplethroat), 34–37, 38, 135, 138
Eucometis penicillata (Gray-headed Tanager), 69, 130–131, 138
Eutoxeres species
 E. aquila (White-tipped Sicklebill), 15–17, 137
 E. condamini (Buff-tailed Sicklebill), 16
Eutrombicula, 97
exploded lek social system, 84
Eye-ringed Flatbill (*Rhynchocyclus brevirostris*), 88–89, 136

facultative ant followers, 69
Falco rufigularis (Bat Falcon), 71

feather mites, 97
Ficus (fig), 1
fig (genus *Ficus*), 1
flags, 38
Flycatchers, 4–5, 6, 136. *See also individual species*
foraging systems
 among ant followers, 4
 among hummingbirds, 5
forest-falcon, 45
Formicarius analis (Black-faced Antthrush), 56–57, 69, 98, 135
fragmentation of habitat, 6, 9, 28, 65, 133
fright molt, 15
frugivores, 4–5

Geotrygon montana (Ruddy Quail-Dove), 14–15, 137
Glaucidium jardinii (Andean Pygmy-Owl), 99
Golden-crowned Spadebill (*Platyrinchus coronatus*), 76–77, 123, 124, 137–138
Golden-olive Woodpecker (*Colaptes rubiginosus*), 26–27, 138
Gradwohl, Judy, 35, 38
Gray-breasted Wood-Wren (*Henicorhina leucophrys*), 106, 108–110, 138
Gray-cheeked Thrush (*Catharus minimus*), 119
Gray-headed Tanager (*Eucometis penicillata*), 69, 130–131, 138
Gray-hooded Flycatcher (*Mionectes rufiventris*), 81
Great-billed Hermit (*Phaethornis malaris*), 20
Green Hermit (*Phaethornis guy*), 20–21, 137
Greenberg, Russ, 3, 35, 38
ground layer, 2
ground-foraging dove (*Leptotila*), 15
Guide to the Birds of Panama, A (Ridgely), 93
Gymnopithys bicolor (Bicolored Antbird), 46–49, 50, 69, 71, 135

habitat fragmentation and loss, 6, 9, 28, 31, 65, 133
Harpagus bidentatus (Double-toothed Kite), 4
Harpia harpyja (Harpy Eagle), 97, 99
Harpy Eagle (*Harpia harpyja*), 97, 99
Heliconia, 2, 5, 16, 19, 20
hematophagous mites, 97
Henicorhina species
 H. leucophrys (Gray-breasted Wood-Wren), 106, 108–110, 138
 H. leucosticta (White-breasted Wood-Wren), 106–107, 138
Herbst corpuscles, 123
hermit hummingbirds, 5, 16, 19

Hermit Thrush (*Catharus guttatus*), 119
Humboldt, Alexander, 71
hummingbirds
 overview of, 5
 tongues of, 117
 See also individual species
Hylophylax naevioides (Spotted Antbird), 50–51, 69, 135

Ixodes
 I. auritulus, 97
 I. bequaerti, 97
 I. brunneus, 97
Ixodidae, 97

Juncos, 38

kapok tree (*Ceiba pentandra*), 1
Karr, James, 2–3
kingbirds (genus *Tyrannus*), 86

Lauraceae (laurels), 1
laurels (*Lauraceae*), 1
Leclerc, George-Louis, 69
Leptotila (ground-foraging doves), 15
lice, 99
Life Histories of Central American Birds (Skutch), 2
Life of the Flycatcher (Skutch), 77
Long-billed Gnatwren (*Ramphocaenus melanurus*), 102–103, 137
Long-billed Hermit (*Phaethornis longirostris*), 22–23
Lophotriccus pileatus (Scale-crested Pygmy-Tyrant), 84–86, 137
Lovejoy, Thomas, 3

Malacoptila panamensis (White-whiskered Puffbird), 24–25, 123, 125, 137
malaria, avian, 83
manakins, 4–5, 15. *See also individual species*
mating, among frugivores, 4–5
May, Sir Robert, 133
McConnell's Flycatcher (*Mionectes macconnelli*), 79
melastomes, 2
Micrastur ruficollis (Barred Forest-Falcon), 38
Microcerculus species
 M. marginatus (Scaly-breasted Wren), 104–105, 138
 M. philomela (Nightingale Wren), 105
Microrhopias quixensis (Dot-winged Antwren), 35
midstory
 description of, 1–2
 flocks of, 4

Mionectes species
 M. macconnelli (McConnell's Flycatcher), 79
 M. oleagineus (Ochre-bellied Flycatcher), 78, 80–82, 84
 M. olivaceus (Olive-striped Flycatcher), 78–79, 136
 M. rufiventris (Gray-hooded Flycatcher), 79
 M. striaticollis (Streak-necked Flycatcher), 78, 79
mixed-species flocks, 3–4, 35, 37, 38, 41, 61, 65
Monasa spp. (nunbirds), 4, 24
monklets, 24
Moore, Randy, 6
Mountain Elaenia (*Elaenia frantzii*), 100–101, 136
Mountain Thrush (*Turdus plebejus*), 97
Musa (bananas), 20
Myadestes melanops (Black-faced Solitaire), 114–116, 137
Myiobius species
 M. barbatus (Whiskered Flycatcher), 73
 M. sulphureipygius aureatus, 73
 M. sulphureipygius sulphureipygius, 73
 M. sulphureipygius (Sulphur-rumped Flycatcher), 66, 68, 72–74, 123, 124, 136
Myioborus miniatus (Slate-throated Redstart), 120–122, 137
Myiornis ecaudatus (Short-tailed Pygmy-Tyrant), 86
Myrmotherula species, 37
 M. axillaris (White-flanked Antwren), 35, 38–41, 135–136
Myrtle Warblers, 38

Neomorphus geoffroyi (Rufous-vented Ground-Cuckoo), 69
Neoschoengastia, 97
nest predation, 15, 42, 45
nesting behavior, overview of, 5–6
Nightingale-Wren (*Microcerculus philomela*), 105
Northern Bentbill (*Oncostoma cinereigulare*), 94, 96
Northern Cardinal (*Cardinalis cardinalis*), 127
Northern Emerald Toucanet (*Aulacorhynchus prasinus*), 114
northern tamandua (*Tamandua mexicana*) anteater, 53
nunbirds (*Monasa* spp.), 4, 24
nunlets, 24
Nuttalliellidae, 97

obligate ant followers, 46, 53–54, 69, 130, 133
Ocellated Antbird (*Phaenostictus mcleannani*), 50, 52–55, 58, 69, 135

Ochre-bellied Flycatcher (*Mionectes oleagineus*), 78, 80–82, 84
Ochre-faced Flatbill, 93
Ochre-lored Flatbill, 93
Odontacarus, 97
Odontophorus guttatus (Spotted Wood-Quail), 97
Olivaceous Flatbill (*Rhynchocyclus olivaceus*), 90–91, 123, 124, 136
Olive-striped Flycatcher (*Mionectes olivaceus*), 78–79, 136
Oncostoma species
 O. cinereigulare (Northern Bentbill), 94, 96
 O. olivaceum (Southern Bentbill), 94–96, 136
Onychorhynchus coronatus (Royal Flycatcher), 68, 73, 84
Orange-billed Nightingale-Thrush (*Catharus aurantiirostris*), 119
Ornithodoros species
 O. capensis, 97
 O. rudis, 97
Ornithonyssus, 97
oscines (songbirds), 23
ovenbirds, 58, 62

Pale-tailed Barbthroat (*Threnetes leucurus*), 19
Panama, biodiversity conservation challenges in, 9–11
Panama Canal, 9
Parker, Theodore A., III, 3
parrots, 23
Pellonyssus, 97
Phaenostictus mcleannani (Ocellated Antbird), 50, 52–55, 58, 69, 135
Phaethornis species
 P. guy (Green Hermit), 20–21, 137
 P. longirostris (Long-billed Hermit), 22–23
 P. malaris (Great-billed Hermit), 20
 P. syrmatophorus (Tawny-bellied Hermit), 20
 P. yaruqui (White-whiskered Hermit), 20
Pharomachrus mocinno (Resplendent Quetzal), 114
Pheasant Cuckoo (*Dromococcyx phasianellus*), 89
piculets, 62
Piranga (tanagers), 86
Plain Xenops (*Xenops minutus*), 62–63, 138
Plain-brown Woodcreeper (*Dendrocincla fuliginosa*), 58–59, 138
Plasmodium, 83
Platyrinchus coronatus (Golden-crowned Spadebill), 76–77, 123, 124, 137–138
Poliocrania exsul (Chestnut-backed Antbird), 42–45, 69, 132–133, 135

Pseustes poecilonotus (bird-eating snake), 45
Pygiptila stellaris (Spot-winged Antshrike), 32

quill mites, 97

Ramphocaenus species
 R. melanurus (Long-billed Gnatwren), 102–103, 137
 R. sticturus (Chattering Gnatwren), 102
Red-capped Manakin (*Ceratopipra mentalis*), 79, 83
Resplendent Quetzal (*Pharomachrus mocinno*), 114
Rhynchocyclus species
 R. brevirostris (Eye-ringed Flatbill), 88–89, 136
 R. olivaceus (Olivaceous Flatbill), 90–91, 123, 124, 136
Rickettsia rickettsii, 99
rictal bristles, 24, 66, 68, 123–125
Royal Flycatcher (*Onychorhynchus coronatus*), 68, 73, 84
Ruddy Quail-Dove (*Geotrygon montana*), 14–15, 137
Ruddy-capped Nightingale-Thrush (*Catharus frantzii*), 118–119, 137
Ruddy-tailed Flycatcher (*Terenotriccus erythrurus*), 42, 66–68, 74, 123, 136
rufous coloration, 66
Rufous-collared Sparrow (*Zonotrichia capensis*), 99
Rufous-vented Ground-Cuckoo (*Neomorphus geoffroyi*), 69
Russet Antshrike (*Thamnistes anabatinus*), 32–33, 135

satellite males, 82
Scale-crested Pygmy-Tyrant (*Lophotriccus pileatus*), 84–86, 137
Scaly-breasted Wren (*Microcerculus marginatus*), 104–105, 138

Scarlet Tanager (genus *Piranga*), 130
Sclater, Philip L., 24
seed passage rates, 114, 116
Selaginella, 2
semibristles, 24
Setophaga striata (Blackpoll Warbler), 132–133
Short-tailed Pygmy-Tyrant (*Myiornis ecaudatus*), 86
sicklebill hummingbirds, 5
Sigel, Bryan, 89
Skutch, Alexander
 ant followers and, 53, 69, 71
 on Bentbills, 94
 on Black-faced Antthrush, 57
 on Eye-ringed Flatbill, 89
 on Golden-crowned Spadebill, 77
 on Golden-olive Woodpecker, 27
 on Gray-breasted Wood-Wren, 109
 on Gray-headed Tanager, 130
 on Mountain Elaenia, 101
 on Russet Antshrike, 32
 on Scale-crested Pygmy-Tyrant, 84
 on White-whiskered Puffbird, 24
 work of, 2
 on Yellow-breasted Flycatcher, 93
Slate-throated Redstart (*Myioborus miniatus*), 120–122, 137
Slud, P., 105
Smithsonian Migratory Bird Lab, 3
Song Wren (*Cyphorhinus phaeocephalus*), 112–113, 138
songbirds (oscines), 23
Southern Bentbill (*Oncostoma olivaceum*), 94–96, 136
Southern Nightingale-Wren, 105
Spotted Antbird (*Hylophylax naevioides*), 50–51, 69, 135
Spotted Sandpiper (*Actitis macularius*), 105
Spotted Wood-Quail (*Odontophorus guttatus*), 97
Spot-winged Antshrike (*Pygiptila stellaris*), 32

Stipplethroats, mixed-species flocks and, 41
Streak-necked Flycatcher (*Mionectes striaticollis*), 78, 79
Sulphur-rumped Flycatcher (*Myiobius sulphureipygius*), 66, 68, 72–74, 123, 124, 136
Summer Tanager (genus *Piranga*), 130
Swainson's Thrush (*Catharus ustulatus*), 119

Tamandua mexicana (northern tamandua) anteater, 53
Tawny-bellied Hermit (*Phaethornis syrmatophorus*), 20
Terborgh, John, 3
Terenotriccus erythrurus (Ruddy-tailed Flycatcher), 42, 66–68, 74, 123, 136
Thamnistes anabatinus (Russet Antshrike), 32–33, 135
Thamnophilus atrinucha (Black-crowned Antshrike), 28–31, 32, 38, 135
Threnetes species
 T. leucurus (Pale-tailed Barbthroat), 19
 T. ruckeri (Band-tailed Barbthroat), 18–19, 136
ticks, 97, 99
Tiny Hawk (*Accipiter superciliosus*), 38, 45
Tolmomyias species, 6
 T. flaviventris aurulentus, 93
 T. flaviventris (Yellow-breasted Flycatcher), 92–93, 136
tongues, hummingbird, 117
Trans-isthmus Railway, 9
transpiration, 9
traplining, 5, 16, 19
Trogon spp. (trogons), 4
Trombicula, 97
tropical rainforests, structure of, 1–2
tropics, definition of, 1
Turdus species
 T. grayi (Clay-colored Thrush), 83
 T. migratorius (American Robin), 83
 T. plebejus (Mountain Thrush), 97

understory
 description of, 2
 future of birds of, 6–7
 overview of birds of, 3–6

Veery (*Catharus fuscescens*), 119
Vieillot, Louis Pierre, 102
Vireo leucophrys (Brown-capped Vireo), 99
vocal learning, 23

waterthrush warblers, 105
Wetmore, A., 119
Whiskered Flycatcher (*Myiobius barbatus*), 73
White-breasted Wood-Wren (*Henicorhina leucosticta*), 106–107, 138
White-flanked Antwren (*Myrmotherula axillaris*), 35, 38–41, 135–136
Whitelaw, John, 3
White-tipped Sicklebill (*Eutoxeres aquila*), 15–17, 137
White-whiskered Hermit (*Phaethornis yaruqui*), 20
White-whiskered Puffbird (*Malacoptila panamensis*), 24–25, 123, 125, 137
Willis, Edwin O., 2, 50, 53
Witheringia meiantha, 114, 116

Xenops minutus (Plain Xenops), 62–63, 138
Xiphorhynchus susurrans (Cocoa Woodcreeper), 60–61, 138

Yellow-bellied Elaenia (*Elaenia flavogaster*), 101
Yellow-breasted Flycatcher (*Tolmomyias flaviventris*), 92–93, 136
Yellow-rumped Cacique (*Cacicus cela*), 93

Zonotrichia capensis (Rufous-collared Sparrow), 99